FLEMISH PAINTING

FROM THE VAN EYCKS TO METSYS

Overleaf:
1 The Master of Flémalle: portrait of a woman.
Enlarged detail twice actual size. National Gallery, London

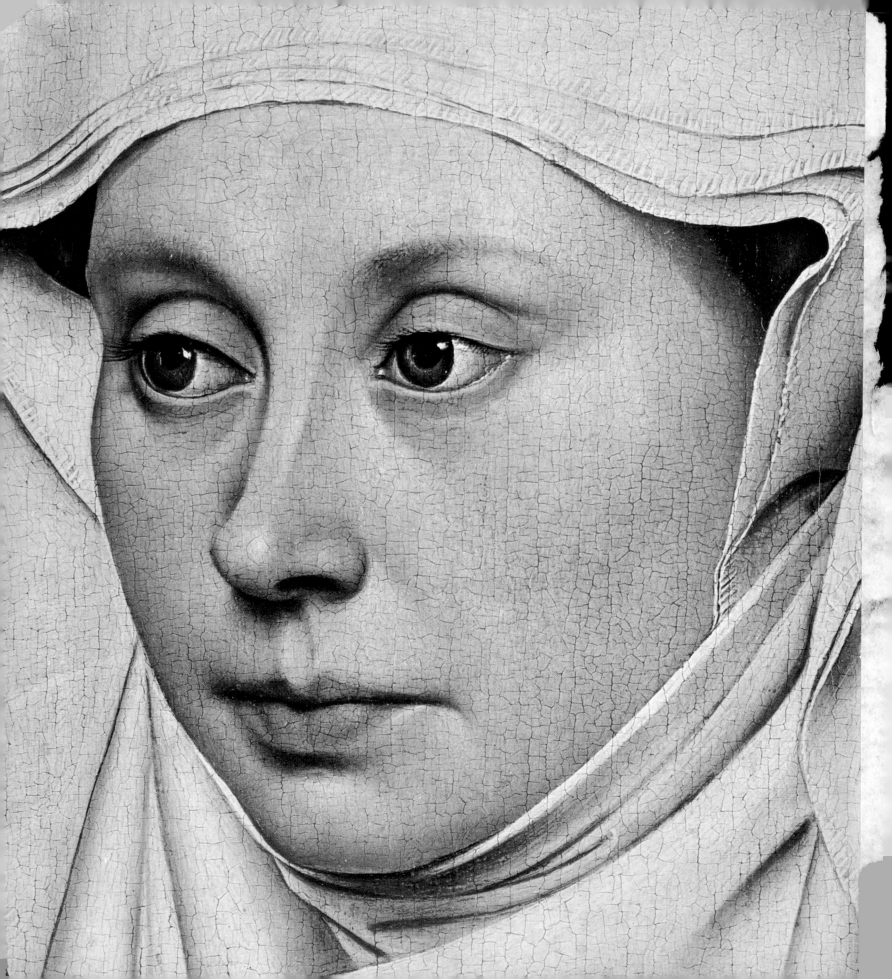

LEO VAN PUYVELDE

FLEMISH PAINTING

FROM THE VAN EYCKS TO METSYS

Translated by Alan Kendall

WEIDENFELD & NICOLSON
5 Winsley Street London W 1

© 1968 Éditions Meddens, Brussels

Original Belgian version entitled « La Peinture Flamande » published by Éditions Meddens, Brussels. English translation © 1970 Weidenfeld and Nicolson Ltd

SBN 297 00203

Printed in Belgium by Les Ateliers d'Art Graphique Meddens, Brussels

CONTENTS

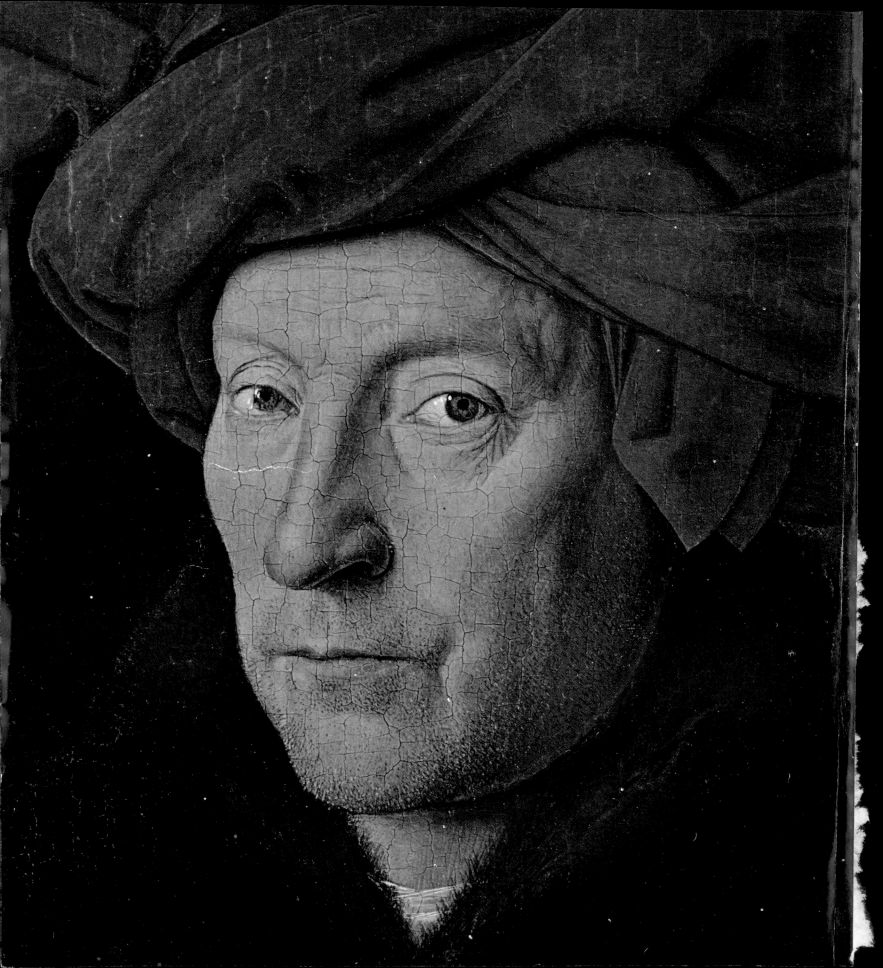

CHAPTER ONE

THE ARTISTIC APPROACH

SPIRITUALITY

Since the beginning of the twentieth century the Flemish Primitives have become more and more popular. This might seem odd if one also considers the simultaneous vogue for the Impressionists and Expressionists, and the parallel victories of the material and the mechanical in our civilisation. But the current success of the Primitives corresponds to certain demands characteristic of our time. We are dazzled by technique, and we admire precision machinery as we admire meticulous science. It is therefore not at all surprising that we appreciate the painstaking work and tireless patience which stamp the painting of the close of the Middle Ages. Such mastery, devotion and integrity demand attention.

It is by its spirituality, first and foremost, that this art awakens mysterious echoes in contemporary man. Present-day materialism, concerned as it is with comfort and the external aspects of life, has turned the masses away from the inner, spiritual life. But the religion of material progress has not entirely suffocated the primordial needs of the soul. In order to develop fully, and to recover his equilibrium and interior calm, modern man needs meditation, a dream, an ideal which enables him to escape from the narrow frontiers within which he feels a little more confined each day. In our civilisation, so eager to turn the most innocent discoveries to utilitarian ends, an almost instinctive reaction urges those who are concerned to hold the treasures of thought and feeling more dear. The sincerity of the Primitives gives them an echo of what is most lacking in the present age: terrestrial order and an inexpressible presence of the invisible. Through commonplace forms they glimpse profoundly human realities, and since these realities are also eternal, they eventually reach up to higher spheres.

The appeal of Flemish Primitive art does not therefore lie in singular intellectual refinement, as seen in the Oriental mind, nor in an idealised humanism on the lines of that of Ancient Greece; the real attraction is the message which speaks of essential, lasting things.

In this domain, learning loses its rights. These works need to be contemplated frequently and at length if one wishes to understand the minds of their creators, and absorb fully what they thought and felt. Leonardo da Vinci said that painting was a *cosa mentale*. The term applies admirably to the works of the Primitives. Of course their technique enabled them to convey formal qualities directly. But their fundamental virtue comes from their characteristic reflection, recollection, gravity and concerted effort towards progress – briefly, from the dedicated character which emerges from all of this. This basic virtue arouses in us the emotion we all feel in moments of private grace, when confronted with the universe and our condition.

This spirituality stems from the activity of two well-balanced faculties: intelligence and will. Satisfaction of the intelligence, in a logical and coherent universe; tranquility of the will, which has imposed its harmony on an order where the spiritual and the material are in tune with each other. Every feeling person aspires to this wisdom, this fullness.

In order to achieve this, the Primitives by no means rejected reality : quite the contrary. They scanned the world so as to exalt its beauty. There is a striking contrast between a Byzantine Virgin – cold incarnation of a symbol – and a Virgin by an Italian Primitive – so lively, exquisitely beautiful, but imprisoned in the richness of the composition; and a Flemish Virgin, every bit as divine, but nearer to us. The Flemish artists brought vivid life into painting. They felt intensely the emotions of the people they painted and, even more intensely, the feelings of their own hearts.

Their characteristic calm does not therefore spring from apathy. One only has to look at their treatment of the Passion of Our Lord. But their spirit was more serene than ours, their heart more stable, and their will ensured the permanence of these two qualities. The certitude of a bond linking the natural to the supernatural, the knowledge of the true values of life, the constant desire to raise oneself – however slowly – from the contemplation of created beauty to that of eternal beauty – all combined to produce a form of art both controlled and full of passion. Gerard David's *Baptism of Christ* is an excellent example of this. The faces convey complete calm. The figures are immobile, eyes fixed in a distant dream or turned inwards. In spite of the many different colours employed, there are no jarring juxtapositions, consequently there is a gentle harmony of shades. The light is even and diffused; the execution is peaceful and extraordinarily regular. Everything is bathed in a pure serenity compounded of mastery and restraint, but above all of the remarkable persistence of recollection during the painting process.

By virtue of this approach, even a painting which could be regarded as a direct representation of reality – a portrait, for example – takes on a transcendent quality. Consider *The Arnolfini Marriage* by Jan van Eyck – a painter reputedly realist *par excellence*. Erwin Panofsky sees learned allegorical allusions in this work. But the artist has simply attempted to produce likenesses. However, in so doing he has also succeeded in portraying the moving significance of marriage, the solemn act in which two people give themselves entirely to each other, for ever. The faces of the two people; their attitude which is both reserved and intimate; the assured poise of the husband and the gentle embarrassment of the wife; and the subtle use of colour, in which nothing jars and which conveys the warm intimacy of the bridal chamber bathed in soft light – all this is marvellously suggestive of a great moment in an existence.

This spiritual approach to subjects – even profane ones – is part of the seduction of Flemish painting for present-day enthusiasts. It is not based on a somewhat childish candour, as the label 'Primitives' might imply, and which is so ill-suited to these particular artists. It rests on the indestructible radiance of soul which remains, according to the wish of Jesus, 'as that of little children.' And it is particularly this mystery which attracts and has an hypnotic power from which even sceptical and rational people are unable to break away.

SINCERITY

If the spirituality of the Primitives is readily accessible, it is because their style of painting has a touching and convincing sincerity.

These artists depict the Childhood and Passion of Jesus Christ as if they had seen them happen in their own country. Giotto is rightly praised for having portrayed the life of St Francis with such frankness in the Upper Church at Assisi; but it was relatively easy for him to do so because he was painting events which were virtually contemporary. Those who emulated him in the North were painting events from a distant past. But they used the world around them, placing Bethlehem in Flanders and Paradise in their

own flower-strewn countryside. Inspiration was dictated to them by a vibrant and unfailing faith. Their heart was steeped in the abundant freshness of the Middle Ages – a basic integrity which is the sacred gift of childhood. To understand them we must recapture something of this gift, of this privilege of being able, each day, to discover the world with incessantly renewed wonder.

The sincerity of the Flemish Primitives was of a different metal from that of many modern artists. Toulouse-Lautrec and Van Gogh unambiguously laid their souls bare, revealing themselves without restraint, in a kind of frenzy, as if they derived a morbid satisfaction from exposing their obsessions and torments to the public. The Primitives, on the other hand, seemed to dislike outburst, and to be afraid of excess or uncouthness. It is precisely this refinement – to which one must constantly redirect one's attention when considering the Primitives – which eventually moves us more surely than any kind of satisfaction in a brutal display of the artist's inner feelings.

The renunciation of all consciously 'artistic' effects is neither lack of creative zeal, nor is it lack of sensitivity. It is the mark of art which cares for dignity, where the mind always rules the heart. In *The Descent from the Cross* by Roger van der Weyden, one can look in vain for the pathos so readily ascribed to the artist. The identical attitudes of the Virgin and Christ are not, as has been suggested, supporting evidence for this. It was common in the Middle Ages to symbolise in this way the fact that the Virgin suffered in her body and soul to the same degree as her son, and the attitude of Mary Magdalene, bending over with one arm raised, is quite simply dictated by the space left for the figure against a neutral background. In fact this picture shows several different ways of depicting human grief in the face of death. All bear the imprint of a deep fervour, but have not the slightest hint of emphasis.

This discretion is not limited to the portrayal of feeling. It reappears in the clarity of the composition, in the evenness of the disposition of events and in the overall delicacy of the painting. Because of this reserve, born of sincerity, the Primitives created a world that is apparently dominated by an imposing silence. In such an atmosphere ideas, like emotions, are purified and sublimate themselves. The art through which they are expressed is spiritualised by them.

OBJECTIVE EXPRESSION

If these are the essential characteristics of the Flemish Primitives, how then do we reconcile them with the realism so often mentioned in connection with their paintings?

The main thing is to define one's terms. Here, realism is a tendency towards rendering objects precisely. In order to make their interior vision seem true they chose simple shapes which were apparently natural. They only used language which was clear, familiar and intelligible to all. In point of fact they restricted themselves to following in the tradition of certain of their compatriots – poets and mystics – such as the great Ruusbroec. These artists also expressed eternal and transcendent truths by applying themselves devoutly to understanding them. Moreover, the Flemish people were discouraged by ideas which were too abstract. They like to be able to grasp something immediately. The Primitives were simply responding to native taste in preferring solid precision to the clever techniques of art which is consciously seeking for effects.

One would be wrong, therefore, to see only an outdated formula or over-simplified anachronism in such an approach, for this approach stems from a desire to reach the spectator directly. The artist combines the great religious inheritance, biblical and historical scenes and aspects of spiritual life, with the realism of his country and his age. Sacred subjects are placed on the level of daily existence.

One comes into close contact with the saints; ones shares their suffering and their glory. There is neither triviality nor profanation: quite the opposite. The Van Eyck brothers' *Mystic Lamb* shows the world renewed at the end of time, at the point where saved humanity gives glory to God, who was both its creator and redeemer. But the setting consists of familiar elements – the heavenly Jerusalem is a collection of Romanesque and Gothic buildings. In the same way, an Annunciation takes place in the familiar setting of a Flemish interior. The clothes of the saints are those worn by the artists' contemporaries.

This propensity for objective expression implies close observation of concrete things. Before beginning to paint, the Primitives studied trees, flowers and animals, the many changing aspects of nature, towns and houses and everyday domestic objects. Once they took up the brush, the mastery with which they were able to preserve in colour this harvest of memories gave them a genuine pleasure which we may still experience today when confronted by the amazing profusion of detail in their works. In the miniatures of the Van Eyck brothers we see a ship cradled on the deep, or sun sparkling on the sea whose waves lap the sand on the shore. In the panels of *The Mystic Lamb* we can distinguish the trees of the North from those of the South. Who has not – with a kind of amused admiration – enjoyed following, in one or other of the old masters, the tiny people walking along a road which winds over rocks and fields; in identifying the different kinds of trees; in recognising the characteristics of their foliage; in examining the meticulous precision of the architecture? Who has not enjoyed the clever way the animals are placed and how deftly the flight of the birds is shown? Who has not enjoyed visually the pile of an Oriental carpet, the thick texture of Ypres cloth, the individual hairs of a fur, the suppleness of a child's skin or the weathered wrinkles of an old man? Who has not gone into ecstasies over an orange glowing on a window-sill? Who has not admired the perspective of the buildings of a town in the background of a picture, the proportions of a landscape which attract the eye and, above all, the atmospheric handling of objects which fade away into the distance?

There is nothing dryly analytical about this objectivity. It comes from acute sensory perception, but is converted into formal terms by the inner vision of the artist. All real art is a convention. Even naturalist artists never produce an exact image of reality. A botanist makes a faithful reproduction of a flower, carefully proportioned, with photographic exactness. The artist, on the other hand, recreating what he has seen, will give a view of the same flower, in which the elements of beauty will be brought into relief. He will replace it with an impression transfigured by his own feelings.

Where should one look for the origins of this tendency towards objectivity of form, which constitutes one of the essential contributions of the Primitives, and which was the point of departure for a renewal of form? Among the Flemish race? There is no Flemish race. There is a Flemish people, the result of the mingling of several ancient races, and this people is no more realist than its neighbours. Was there, then, a certain satisfaction with the environment which reflects its accomplishments and its culture? Such romantic ideas are now out of date. Should one see in it the consequences of a systematic study of nature – a study which was developing at the beginning of the Renaissance? This was still in a very rudimentary stage at the time when painting began to develop in Flanders. It seems then that objectivity of form was rather the achievement of certain very gifted artists. The close observation of nature and the already advanced technique seen in the miniatures from the great workshops of the courts of France (where so many Flemish artists were working at the end of the fourteenth century) are the first indications of this concern with formal realism. The credit for the real renewal goes to Hubert van Eyck, the creative genius whose style Jan van Eyck continued to use and to extend.

In the works of Hubert van Eyck, renewal is evident even in the execution of details. In *The Virgin in a Church* in the Staatlich Museen in Berlin, for example, the light comes from two sides, through the porch and through the stained glass – a delicate bluish tint. By the same token, the play of light amongst the foliage of a little wood, on the panel of the Just Judges in *The Mystic Lamb*, gives consistency to the

clusters of leaves and shows their place in the landscape. It is as if the artist were inviting us to feel the objects with our eyes; to evaluate their volume and take note of their weight, as well as their appearance. Better still, it makes us aware of the air which fills and determines the space, which surrounds objects, showing them in depth at a distance which seems real. A pictorial revolution thus begins. Hubert van Eyck sees and paints differently by comparison with his predecessors. In addition, a very personal technique allows him to express this way of seeing things more satisfactorily. His contribution is considerable. We are now far from the medieval shapes, seen solely in terms of their decorative value; far also from the Limbourg brothers, with whom Hubert van Eyck possibly worked but who, in this domain, made only half-hearted attempts.

Hubert van Eyck did not achieve perfect objectivity at the outset. Neither he nor his immediate successors were able to free themselves from the traditions they inherited. Hubert van Eyck's revolution is sufficiently amazing in itself, without having to label him the last word in pictorial perfection, even in objectivity. In fact, one sees in his works the survival of the clear outline of the silhouette which, in the Middle Ages, was shown by a line, and which he achieved by the juxtaposing of two colours.

In addition, he lacks the ability to synthesise. Occasionally too many details, painted with a rare virtuosity, detract from the overall effect. Even when – as in *The Three Marys at the Sepulchre* – he introduces, in order to suggest depth, aerial perspective imposed on linear perspective (one of his great innovations), he nevertheless fails to achieve perfect unity. The landscape here consists of brown bands of rock and green bands of vegetation. In the same way, the composition of the central landscape in *The Mystic Lamb* is rather artificial. It is a succession of overlapping pieces of stage scenery, one behind another, so as to give an impression – for better or for worse – of depth. The transition from one ground to another is made in a succession of leaps. Hubert van Eyck's successors scarcely did any better, and it was not until Joachim Patenier that a landscape was conceived of in its entirety.

Stimulated by the extraordinary resources of their art, the Primitives did not always avoid errors of judgement. This was notably the case with the Master of Flémalle. He wanted to achieve as sharp a representation as possible of his vision. The results were staggeringly precise, but to the detriment of the emotional expression. Jan van Eyck himself occasionally yielded to this temptation of brutal reality. In *The Madonna with Canon van der Paele*, in the Groeninghe Museum in Bruges, he painted the Virgin as a woman of no refinement, and one feels that he worked without commitment. In such circumstances one is grateful that all he contributed to *The Mystic Lamb* was to add the finishing touches.

It is well worth examining the intrinsic value of the discoveries in objectivity which the Van Eycks and their successors introduced into Western art. Our immediate forebears admired them almost exclusively for their supposed realism. They were praised for having rendered material objects so well. In the eyes of Comte de Laborde, Flemish art was simply portraiture. Taine and Courajod elaborated. The most eminent scholars seemed to want to make realism a distinctive trait of Flemish art.

The doctrine of Claude Bernard, the positivism of Auguste Comte and the determinism of Hippolyte Taine amounted, on all counts, to radical materialism. In art, as in science, the only things which counted were those which could be appreciated by the senses. This was the message of the second half of the nineteenth century. Courbet maintained: 'I have never painted an angel because I have never seen one' – an extremely regrettable admission for an artist to make, for he deprived himself of the greater part of the dream. Yet these theories were so securely anchored that reproduction of reality was taken to be the height of artistic creation. There was a time – and has it completely disappeared? – when the style of a Primitive was judged solely in proportion to the degree of fidelity with which he imitated nature, and when his development was measured by the same norm.

Science has now made this theory – which materialists had taken to be definitive – well and truly obsolete. What remains now of matter since its secrets have been penetrated by man's investigation? According to present-day experts, the atoms which constitute it are scattered, like the stars in the

universe. Matter no longer has the density previously attributed to it. In fact science has unwittingly toppled its own idol.

We must abandon the old idea that the progress of the old masters was concerned above all with the imitation of reality. We must understand artistic development throughout its whole range and depth and try, above all, to appreciate and gauge the power of expression. We see in the Primitives an acute formal objectivity, but this kind of objectivity had nothing in common with realism. Reality was not rendered for its own sake. If there is realism it is not an end in itself, but only a means of sincere expression – a language capable of conveying subtle emotions and transcendent ideas. It was used as an orator might use a common expression, in order to be better understood by the masses. In short, direct, precise and clear-cut forms are only there to convince and move more surely. Is there need of an example? A famous scholar has taken as a typically Flemish gesture – doubtless because it is very familiar – that of St Joseph in Melchior Broederlam's *Flight into Egypt*. St Joseph is lifting a keg and taking his fill of the jet of liquid flowing into his mouth. He is taken to be a precursor of the popular figures of Breughel and the tipplers of Brouwer and Teniers. In fact this gesture is a symbolic way of showing that the travellers are crossing a desert – they had obviously had to provide themselves with a supply of drink. In any case there is nothing specifically Flemish about the gesture. The symbol is already found in a French book of hours dating from about 1420, in the Walters Art Gallery in Baltimore, and in a *Flight into Egypt* carved on the fifteenth-century stalls of the Church of St Andoche at Saulieu in Burgundy, the St Joseph there has a similar keg.

Let us not therefore persist with this legend of Flemish realism. It is doubtless picturesque but it is groundless. The desire to bring artistic form closer to nature had long existed throughout Western Europe. But the gap between the desire and the realisation was wide. In the thirteenth century Villard de Honnecourt wrote – not without a certain amount of presumption – '*al vif*' on a drawing he made of a lion in captivity. The move towards realism is there, but the artist does not succeed in escaping the conventions of his age. His lion bears a curious resemblance to a large poodle, and it is as stylised as a heraldic beast. The Van Eycks managed to catch life in the raw, as it happened. Nevertheless, it was only in order to illustrate the better invisible and unchanging truth.

In Jan van Eyck's beautifully painted *St Francis receiving the Stigmata* in the Johnson Collection of the Philadelphia Museum, every detail of the rocks is visible; they are split and worn by the elements. One feels that if one were to strike them with a hammer they would prove to be as hard as granite. He gives his character the features of a solid Flemish peasant, bursting with health. The environment and the characterisation of the saint make the miracle of the stigmatisation all the more real for the onlooker.

Roger van der Weyden's *Seven Sacraments* in the Musée Royal of Antwerp, presents an analogy. Having studied the church in the painting, one's attention is drawn to the portrayal of the sacraments in the side chapels. The scenes are perfectly natural: the young people go to Confirmation with measured but determined step; the dying man receiving Extreme Unction abandons himself to his fate, whilst the priest devotes himself entirely to his ministry; the bridal couple take part in the ceremony with respect; the Eucharist is recalled by the consecration at the high altar. The artist's language is so direct that everything reads clearly. All the same, one thing offends – at first sight – our modern feeling for form: the enormous crucifix in the foreground between the Virgin and St John and the Holy Women. At this point in the painting, the representation of Calvary is so disproportionate in relation to the church that it collides with our positivist spirit. Only our understanding of abstract ideas allows us to appreciate it in the end. It is the tangible representation of a supernatural doctrine: the Church giving to the faithful, through the Sacraments, the grace merited by the divine sacrifice of Calvary. The artist has found a suitable expression for it. And if we move forward to Memlinc, we will feel ourselves – when confronted by his realistic Virgins – on the shores of a universe of dream and silent meditation.

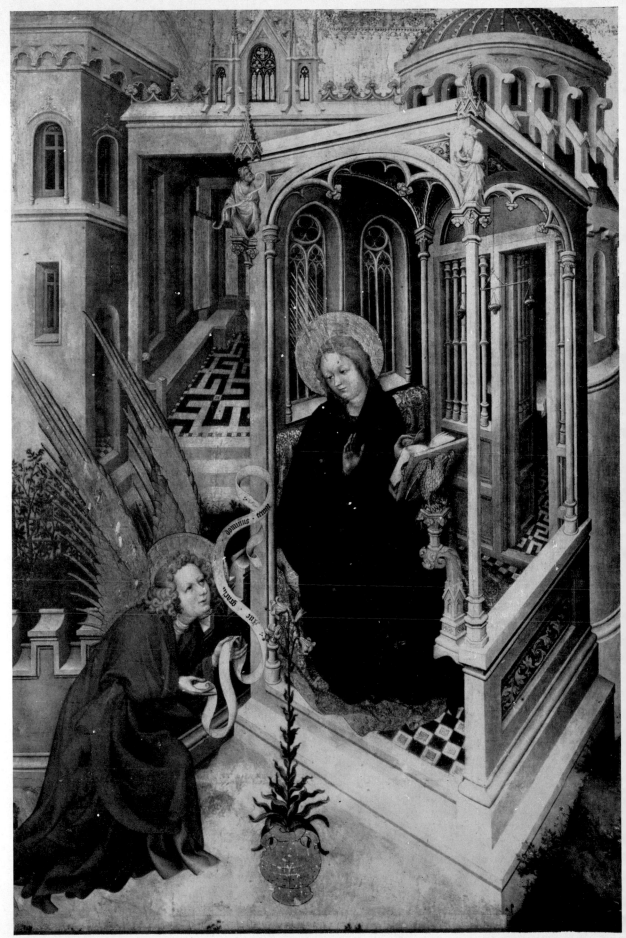

1 Melchior Broederlam : *The Annunciation*
Detail from the Altarpiece of the Charter-
house of Champmol. Musée des Beaux-
Arts, Dijon

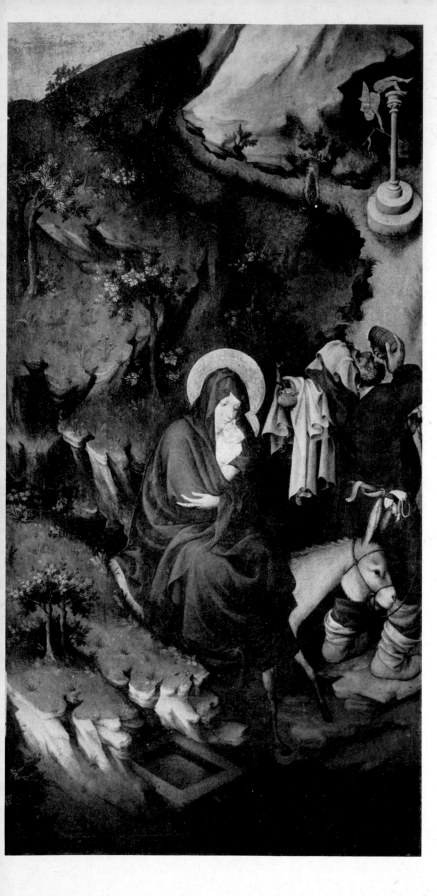

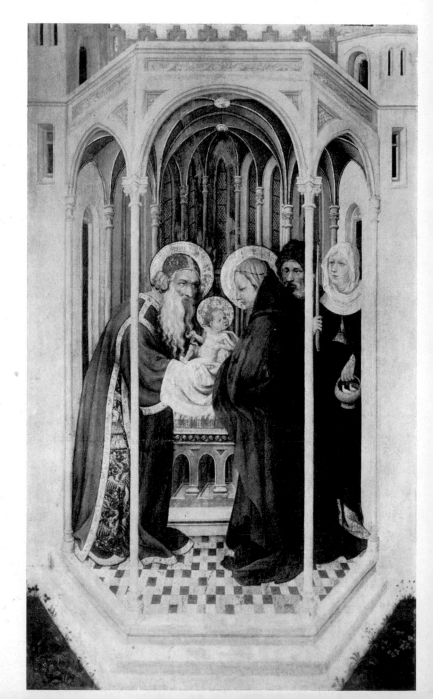

2 Melchior Broederlam: *The Rest on the Flight into Egypt*
Detail from the Altarpiece of the Charterhouse of Champmol.
Musée des Beaux-Arts, Dijon

3 Melchior Broederlam: *The Circumcision*
Detail from the Altarpiece of the Charterhouse
of Champmol. Musée des Beaux-Arts, Dijon

4 The Master of Alken: the Altarpiece of the Virgin.
Detail of 5: the head of the Virgin.
Musées Royaux des Beaux-Arts, Brussels

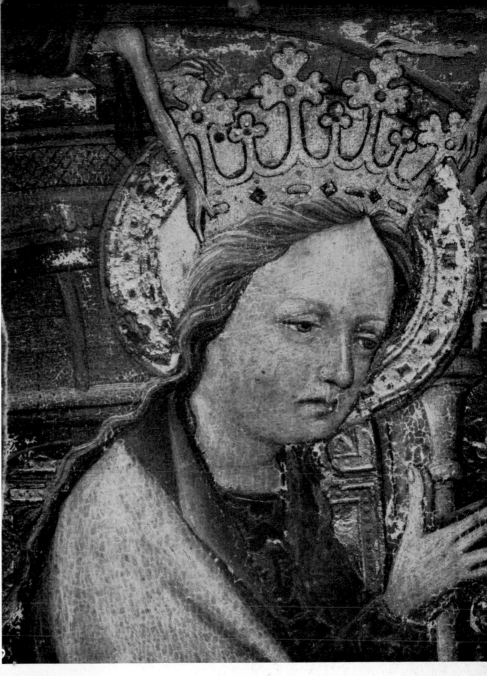

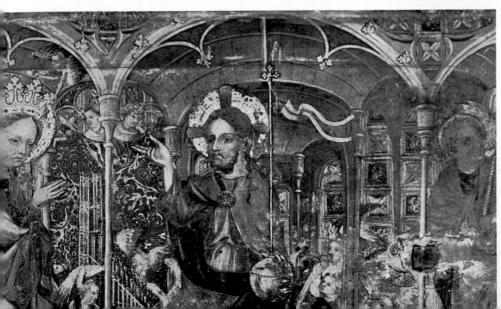

5 The Master of Alken: the Altarpiece of the Virgin.
Detail showing the central section.
Musées Royaux des Beaux-Arts, Brussels

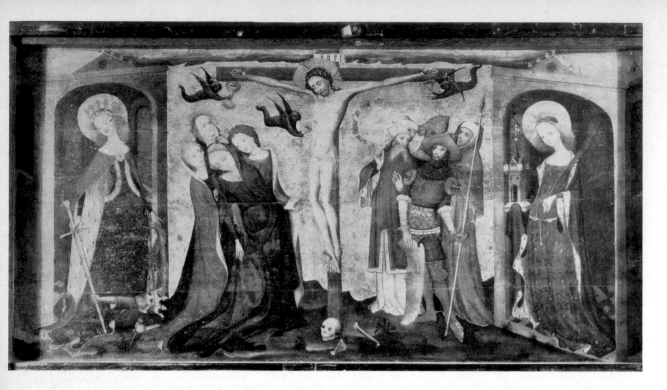

6 Late sixteenth-century Bruges Master:
The Tanners' Crucifixion, commissioned by the tanners' guild.
Musée St Sauveur, Bruges

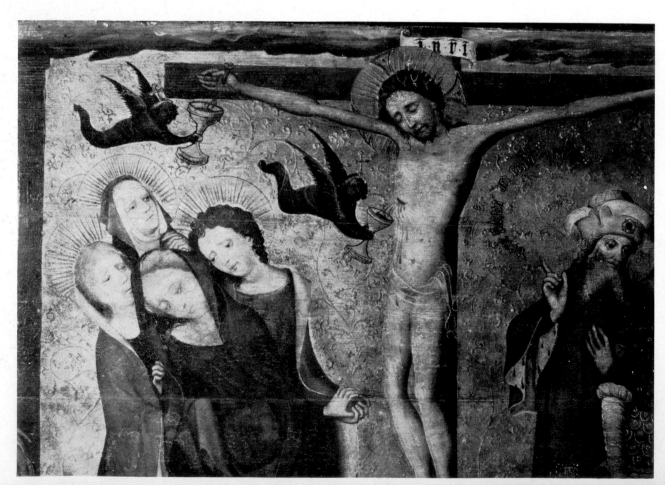

7 Late sixteenth-century Bruges
Master: the Tanners' Crucifixion.
Detail of upper central section.
Musée St Sauveur, Bruges

8 Late sixteenth-century Bruges Master: the Tanners' Crucifixion.
Detail showing St Barbara.
Musée St Sauveur, Bruges

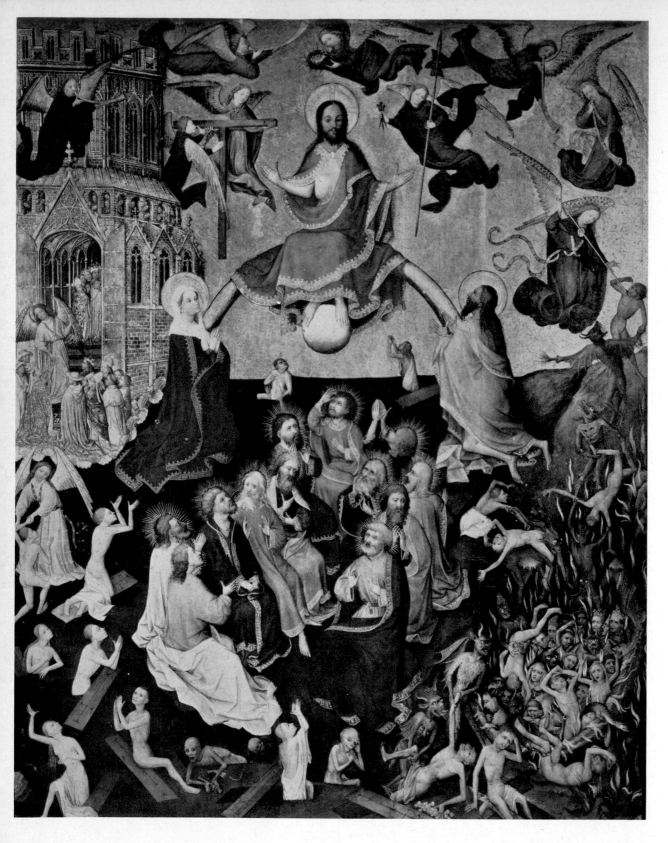

9 The Master of Diest: *The Last Judgment*
Musées Royaux des Beaux-Arts, Brussels, at presents in Diest town hall

10 A Limburg Master: *The Coronation of the Virgin*
Detail from a portable altar.
Boymans-Van Beuningen Museum, Rotterdam

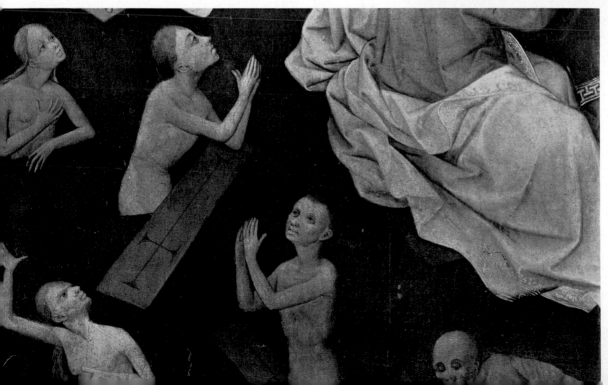

11 The Master of Diest:
The Last Judgment
Detail of the resurrection of the dead.
Musées Royaux des Beaux-Arts,
Brussels, at present in Diest town hall

12 The Master of the Annunciation of Aix-en-Provence: *Isaiah*
Boymans-Van Beuningen Museum, Rotterdam

13 The Master of the Annunciation of Aix-en-Provence: *Jeremiah*
Musées Royaux des Beaux-Arts, Brussels

This brings us to our conclusion. In the works of Hubert van Eyck and his successors there is an amazing encounter between the spiritual and the real. Their ideas and intimate emotions crystalised into precise forms. Leaving behind the rather dessicated formulae of their predecessors, their style was refreshed with penetrating observation. They were sometimes aware of their ability to render material things and they let themselves go on occasions. This was the beginning of still-life in their work. But none of them tried to paint grapes – as did Zeuxis – with such lifelike effect that the birds attempted to peck them or, like one Dutch artist, who painted flies on his works in the hopes that a person attempting to brush them off would be forced to admire his talent. In the works of the Primitives the real – as interesting as it is – kept its subordinate role: to assist recognition or to suggest. Above all, in their objective treatment of things there is still the candour which is the essence of poetry. The numerous nudes they painted are clothed in this virtue of innocence. One only has to think of Adam and Eve in *The Mystic Lamb*, of *Original Sin* by Hugo van der Goes, or Memlinc's *Bathsheba* to agree wholeheartedly.

CHAPTER TWO

TECHNIQUE

The myth by which the discovery of oil painting was attributed to the Van Eycks persisted for centuries. Giorgio Vasari, the first art historian, was responsible for spreading it some hundred years after their death. In order to explain the beautiful colours of the Venetians, Vasari imagined that they had used oil since the fifteenth century, and that Antonello da Messina had brought the secret back from Flanders. Possibly Vasari simply repeated a rumour that was current in the Flemish workshops at the time, and one which he heard from Lampson, his correspondent in Liège. At all events, he repeated it in his *Le Vite de più eccellenti pittori, scultori e architetti*, published in Florence in 1550, and in the second edition, dated 1568, he was even more emphatic:

Jan of Bruges ... with immense application, one day painted one of his works. Having carefully put the finishing touches, he varnished it and put it in the sun to dry, in the usual way. But either the sun was particularly hot, or the wood was badly joined or had been badly seasoned, and the panel unfortunately split. When Jan saw this he decided that in future he would avoid any similar accident. And since he disliked varnish as much as he disliked tempera, he resolved to look for a substance which would dry in the shade, without having to expose his works to the sun. After having tried several substances, either on their own or combined, he finally discovered that, of all the other substances he experimented with, linseed and nut oil dried the most easily. These oils, boiled with his other combinations, gave him the varnish that he had, along with all the painters in the world, so long sought after. After many subsequent experiments, he concluded that the mixing of colours with these types of oil gave the colours a strong consistency which, once dry, was not affected by water and which, moreover, heightened them so much that it made them brilliant by themselves, without varnish. What seemed even more extraordinary was that blending took place much better than with tempera.

At the end of the sixteenth century, Karel van Mander, the first art historian to deal with Flemish painting, and the author of the *Schilderboeck* published in 1604, simply echoed Vasari, strengthening the affirmations of his predecessor.

For the next three hundred years this tradition was accepted unquestioningly. Nevertheless, it does not bear examination.

In the first place, internal discrepancies invalidate Vasari's account. He says first that Jan van Eyck experimented with a medium consisting of varnish and ground colour; then he declares that he used a mixture of oil and other unspecified combinations, but that this mixture also produced a varnish; finally, that the artist had no need of varnish. The least one can say about these explanations is that they are confused and apparently contradictory.

Moreover, documents show that the Van Eycks no longer needed to discover oil painting. It existed long before their time. At the end of the eleventh century the monk Theophilus, in his *Diversarum artium schedula*, gives several recipes for it. Cennino Cennini, who wrote a *Libro del'arte* in 1437, published

by G. Milanesi in Florence in 1859, considers several methods already regarded as traditional in his day. Many references to oil painting are found in accounts from the fourteenth century, dealing with the painting of Northern France and the provinces of present-day Belgium. It should also be pointed out that in the North – until the end of the fourteenth century – the use of oil was restricted to murals and decoration. We also find that Melchior Broederlam, from Ypres, who painted banners with oil for Duke Philippe le Hardi in 1395, did some panels (now in the Dijon Museum) for the duke between 1396 and 1399, using egg.

Many learned theories have been advanced about the mixtures and combinations used by the Van Eycks and their successors. They were collected and reviewed in Alexander Ziloty's excellent book *La Découverte de Jean van Eyck* (The Discovery of Jan van Eyck) 2nd edition, Paris 1947. But no one has yet definitely proved that the Flemish Primitives used an oil base. Examination under the microscope today, revealing egg mixed with ground colour, only confirms the evidence. It is impossible to get the precision of a brushstroke – as in the hair of the characters in *The Mystic Lamb*, for example – if one uses oils. Oil always tends to spread a little. Brushstrokes done with oil smudge, whereas colour mixed with egg stays firm. Various experiments carried out with the help of the restorer attached to the Musées Royaux in Brussels have confirmed this. Moreover, one can see the thickness of the colour. This is because egg covers the particles of colour completely, and is an ideal binder. As a matter of fact the recipe of the Van Eycks and their successors was used for centuries. The ground colour was mixed with the whole egg: the white with its albumen as well as the yolk with its fat content and a little albumen. This method, referred to by medieval authors, was in use until the sixteenth century. But the fifteenth-century Flemish painters handled it with exceptional care and skill, and this is where the whole of their 'secret' lies.

Their panels were of oak (a very few of their works are on canvas), which they covered with a very white mixture of chalk and glue, carefully smoothed down. The colours were then applied extremely thinly, and because of this the light reflected from the white base gives them their glowing quality. In places where they are applied in impasto, they are stronger, and when dry are somewhat like porcelain.

The Flemish painters wanted pure, solid colours, preferably of mineral derivation. Predominant colours are: blue obtained from lapis lazuli which has been ground and has had the malachite removed; white from white lead or lead carbonate; black from calcium carbonate; red from vermilion or lead sulphate; yellow and brown from the decomposition of iron ore and earth; green from verdegris. Experience had shown that these colours crystallise better than those of organic origin. Nevertheless some colours obtained from vegetable substances were in use at the time. Jacques Coene, from Bruges, taught the use of colours in Paris at the end of the fourteenth century, and Alcherius, an Italian living in Paris who made notes during the lessons, mentions among the recommended colours a 'blue of flowers' (1). The *Manuscript of Strasbourg*, which dates from the beginning of the fifteenth century, also mentions vegetable colouring matters, such as yellow from saffron and blue from cornflowers (2).

When the panel had been properly prepared, the artist sketched in the subject with a light brownish colour which Karel van Mander calls *dootverwe* – dead colour. He mentions an unfinished work by Jan van Eyck which he saw in the house of his master, Lucas de Heere, and which depicted a woman with a landscape in the background. Eastlake and others thought that he referred to *St Barbara* in the Musée Royal in Antwerp. But this work is a drawing done with the brush point, and the bluish colour of the sky seems to be by another artist who tried to finish off the work.

I have had the opportunity to examine closely a work by Jan van Eyck left partially in sketch form. It is *The Madonna with Provost van Maelbeke (The Madonna of Maelbeke)*, the artist's last work. It is obvious from the volets that the painting was initially sketched in with a brownish colour (3).

The Flemish Primitives were, moreover, masters in the application of colour to the panel. They used

23

light scumbles which made their work translucent, applying the colour thickly for depth, and using impasto for jewellery, metallic objects and embroidery, which pick up light. They placed complementary colours side by side so that they heightened each other. They achieved tonal harmony by giving colours the same degree of intensity. In the three large figures of the upper panels of *The Mystic Lamb*, Hubert van Eyck gives the most spectacular example of his ability to use colour. The blue, red and green next to each other in the clothing of these three figures produce a marvellous effect. The Primitives were also masters in the choice of shading and half-tones, and so began to solve the difficult problems of painting objects in space. They produced an overall diffuse light by carefully controlling the progression from very light tones to thin shadow. They were careful about rendering the effect of direct sunlight, the shadows it casts and the highlights on certain objects, such as the coat of mail worn by one of the guards in Hubert van Eyck's *Three Marys at the Sepulchre*, or St George's tunic in Jan van Eyck's *Madonna with Canon van der Paele*.

Finally, they varnished their works with a coating of white of egg, which gave a more consistent surface than resin-based varnish, and which was found intact under dark layers of the latter during the cleaning of the volets of Adam and Eve in *The Mystic Lamb* in 1937.

It is therefore the extremely careful execution, and not a mixture of oil and ground colour, which constitutes the particular quality of the technique of the Flemish Primitives.

Can one really attribute this sureness of touch to conditions which are extraneous to art, that is the economic and political situation in Flanders at this time? This would be looking at the question from too wide an angle and exaggerating the influence of the historical context. Certainly the Middle Ages (at least from the twelfth to the fifteenth centuries) was by no means a period of insignificance and decline. There was comparative peace in the countryside, and the towns were generally prosperous. Peace was only intermittently interrupted by feuding noblemen, or by economic struggles setting rival cities against each other, or by social unrest setting workers against merchants.

For Flanders, the thirteenth century was a golden age – both in culture and commerce. Never had there been so much writing, reading, building, sculpture and painting in Flanders. It was at this time that literature was produced in the vernacular. Scholarly works were translated from Latin, *chansons de geste* adapted from French, and native lyric poetry flourished. Vast churches sprang up virtually everywhere, and in the towns, market halls and belfries were built. On civil and religious buildings there was a proliferation of statuary and painting then beginning their development. This process continued right through the fourteenth century and into the fifteenth. The dukes of Burgundy, now counts of Flanders, set the tone. Philippe le Hardi, son of Jean le Bon of France, married the heiress of Flanders in 1383, and often visited the Flemish provinces, frequently commissioning artists. His son Jean sans Peur and his grandson Philippe le Bon – 'the Great Duke of the West' – began patronage of the arts in the Low Countries. Their example was copied by officers of the government, abbots, bishops, parochial clergy, rich burghers, and even guilds and corporations.

So a climate developed which positively encouraged the expansion of artistic talent, and which partially explains the decorative aspect of the painting of the time. But the main reason for technical perfection lies elsewhere, in the strict organisation of Flemish town guilds from the twelfth century onwards. This involved above all the workers and craftsmen – drapers, sculptors and painters – on whom exports depended. Their rules have survived, setting down requirements such as the use of good quality materials; careful execution; inspection of the work by the heads of the guilds; obligatory apprenticeship with a master craftsman; the production of a 'masterpiece' before becoming a master; and the right to sell works to licensed masters. By the fifteenth century there was a lively tradition of excellent work and professional honesty, thanks to the standards which had been in operation for two hundred years. Teaching and technique were handed on from workshop to workshop, constantly improved by innovations.

24

All the same, in spite of its remarkable qualities, the technique of the Flemish Primitives appears to be inferior to that of the Baroque painters, and even of certain more recent painters. Modern painting, which uses oil mixed with turpentine, has at its disposal a more fluid medium, and one that is more suitable for faster work, and therefore more appropriate to the flush of inspiration. Before putting brush to canvas, the Baroque or modern artist has a very clear-cut idea of what he is going to do. In the course of painting he cannot go slowly and laboriously, nor can he make endless changes. If he is really talented his work becomes an artistic projection with his own individual rhythm and accent. Whether it be Baroque or Impressionist, this kind of painting is like old Chinese painting, deft and evocative.

Having made this reservation, one must acknowledge that long experience helped the Primitives in giving their work the finish, the richness and the brilliance which was then the rule, and which we admire so much today. Experience gave their work the freshness and truth which ensure their lasting attraction.

THE ARTISTIC CLIMATE BEFORE AND DURING THE TIME OF THE VAN EYCKS

In this field – as in all others related to art history – one must beware of a tendency to be too systematic and too rigorous, for it was this tendency which dominated several scholars of a previous generation in their concern to establish development of style in relation to scholastic traditions and the theory of unbroken evolution. In their view, spheres of influence were more compelling than individual worth, and the date of a work was fixed in a system of classification which went from the inferior to the best. Their criterion for quality was the fidelity with which nature was reproduced. This was a gross misconception of the very essence of artistic creation.

Artistic evolution has nothing at all in common with the growth of a plant, and is not governed by any rules. It is a succession of complex events which cannot be plotted along a rising curve.

Art is the creation of human beings. It is always in a state of flux, full of the unexpected, and of things which are logically inexplicable. It demonstrates the diversity of personalities – above all of geniuses – whose progress may sometimes involve long and seemingly static periods. Moreover, style is modified by changes in the mental processes of successive generations. Thoughts, habits, morals, tastes, modes of civilisation, the styles of certain periods are so many factors which influence art and mould its ever fluid form. To this, technical problems also add their own particular complications in each generation.

How then can the styles of different schools, or even of individual artists, be rigidly classified? When we are concerned with the Flemish Primitives this approach is made even more difficult because our knowledge of them is so sketchy. In the documents of the fourteenth and fifteenth centuries the names of thousands of painters are mentioned whose works are completely unknown to us, and hundreds of works are mentioned – at Ghent, Bruges, Ypres, Tournai, Brussels, Malines and elsewhere – but we have no idea who painted them. They appear in the guild registers and royal account books, as well as those of towns, churches and corporations and in contracts ratified by magistrates. An incalculable number of works were lost in the religious troubles of the sixteenth century and through the neglect and contempt of succeeding generations. Faced with these gaps in our knowledge, the art historian takes great pains – often to no avail – to establish some connection between the surviving pictures and the historical information, and between the works themselves. Frequently he is forced to speculate. The ever-present danger is that it is too easy to go from speculation to deduction, when in fact there is not sufficient evidence to warrant it. This is how several shaky assertions, constantly repeated on the reputation of recognised authors, are now regarded as unassailable truths.

According to one of these assertions, Flanders was the home of several individual schools of painting. But a totally different state of affairs prevailed there than in, for example, Italy. Towns were much closer together, artists moved about more easily, traditions passed from one to another, and every one of them was able to study the works of his most famous predecessors and contemporaries. Roger van der

Weyden, whether at Tournai or Brussels, could meet Jan van Eyck when he was at Lille or Bruges. When he was working at Bruges, Jan Memlinc seems always to have had access to Roger van der Weyden's most recent works. Hugo van der Goes was painting in Ghent and was full of admiration for the Van Eycks. He went to Louvain to appraise the work of Dieric Bouts, and while he was there finished his triptych of *The Martyrdom of St Hippolytus*, which was begun in Louvain, but intended for a church in Bruges. One man's art and technique was another's inspiration. In this way a common style evolved, which even assimilated foreign artists who came to Flanders from the surrounding countries and settled there. All of them practised the laborious technique specifically required by the rules of the Flemish guilds.

This corporate style invalidates the idea of separate schools of painting, or fluctuations in the general style of the Primitives, and instead one must consider the individual contributions of the more gifted artists among them.

☆

It was Hubert van Eyck's genius which put the finishing touches to what were genuinely new artistic ideas in Flanders at the beginning of the fifteenth century. But in art, as indeed in any other sphere, there is no such thing as spontaneous genesis, and the work of genius is the breaking of a wave that began in the far distance. Hubert van Eyck must have had predecessors.

It would be oversimplifying matters to explain the importance of the Van Eycks as the sudden appearance of the Northern spirit forcing art to look at nature objectively. It is impossible to divorce the Flemish Primitives from Mediterranean civilisation, the birthplace of Western art. Their way of thinking and feeling comes, for the most part, from the Graeco-Roman world transformed by Christianity. Their iconography is inherited from Byzantium. Their technique comes from the Ancient World, kept alive and handed on by medieval monks. Even the refinement of their colour, one of the most marvellous features of their work, was taught them by the French miniaturist Jean Pucelle and his followers.

The flowering of fifteenth-century Flemish painting also owes something to immediate native predecessors. There was a considerable amount of painting in fourteenth-century Flanders. It is true that little has survived, but documentary evidence exists, in particular the account books of monasteries, churches, royal households, municipalities and guilds. Civil and religious buildings were decorated with pictures, statues were coloured, and coloured pictures were painted on banners. In churches sculptured retables were replaced with altarpieces painted *en plate (platte) peinture*, i.e. on panels. Here are only a few details of Flemish artists prior to the Van Eycks.

A certain Peter of Brussels was commissioned by Countess Mahaut of Artois to paint her father's heroic deeds on the walls of the castle at Conflans. The weavers of Ghent had the walls of their chapel decorated with a large frieze showing a victory won by the town's militia. In Ghent alone, between 1338 and 1410, the archives mention 231 artists who reached the status of master under the rules of the guild. There are many artists from Ghent, contemporary with the Van Eycks, for whom no known works survive, but whose fame and activity are evident from the archives. Roger van der Wostine, Jan Ryckaert, Christian van Winckele, Jan van Kalais, Jan van der Rivière, Willem van Lembeke, Josse Waytop, Willem van Axpoele, Pieter van Beervelde, Livinius van den Clite, Jan van Bassevelde, Willem de Ritsere, Jan Martins, Gérard de Stoevere and his son Jan, Roger the Painter, Jan de Coster, Daniel Hoybant and particularly Jan van der Asselt, court painter to Count Louis de Male and Duke Philippe le Hardi (4). At the same time there were several painters of repute in Bruges. Among many

14 The Master of the Annunciation of Aix-en-Provence: *Jeremiah*
Detail of the prophet's head.
Musées Royaux des Beaux-Arts, Brussels

15 The Master of the Annunciation of Aix-en-Provence: *Jeremiah*
Detail of still-life. Musées Royaux des Beaux-Arts, Brussels

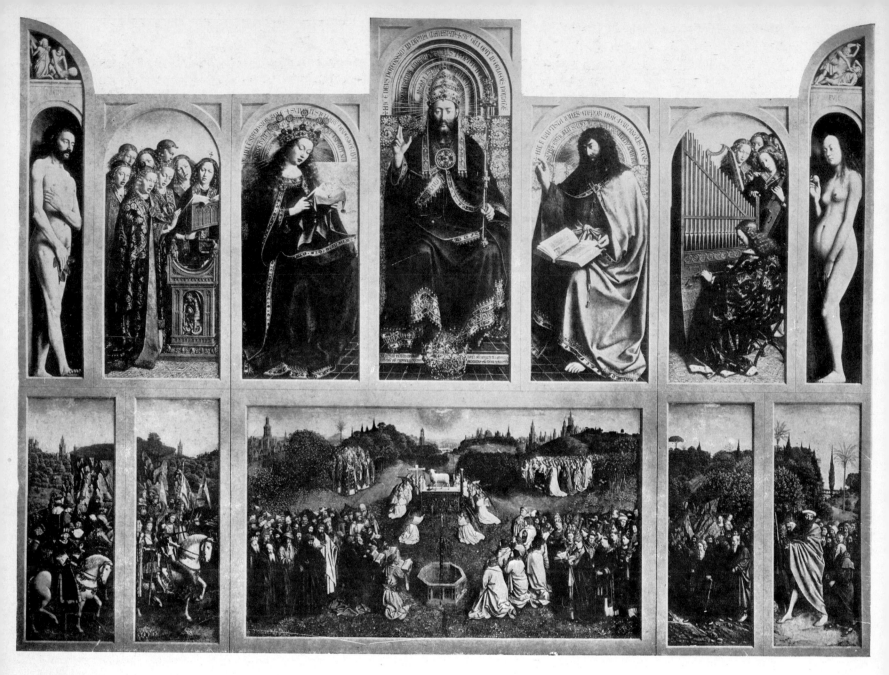

16 Hubert and Jan van Eyck: *The Mystic Lamb*
The polyptych when open. Cathedral of St Bavon, Ghent

17 and 18 Hubert and Jan van Eyck: *The Mystic Lamb*
Details of the heads of Adam and Eve from the far left and right of the upper register.
Cathedral of St Bavon, Ghent

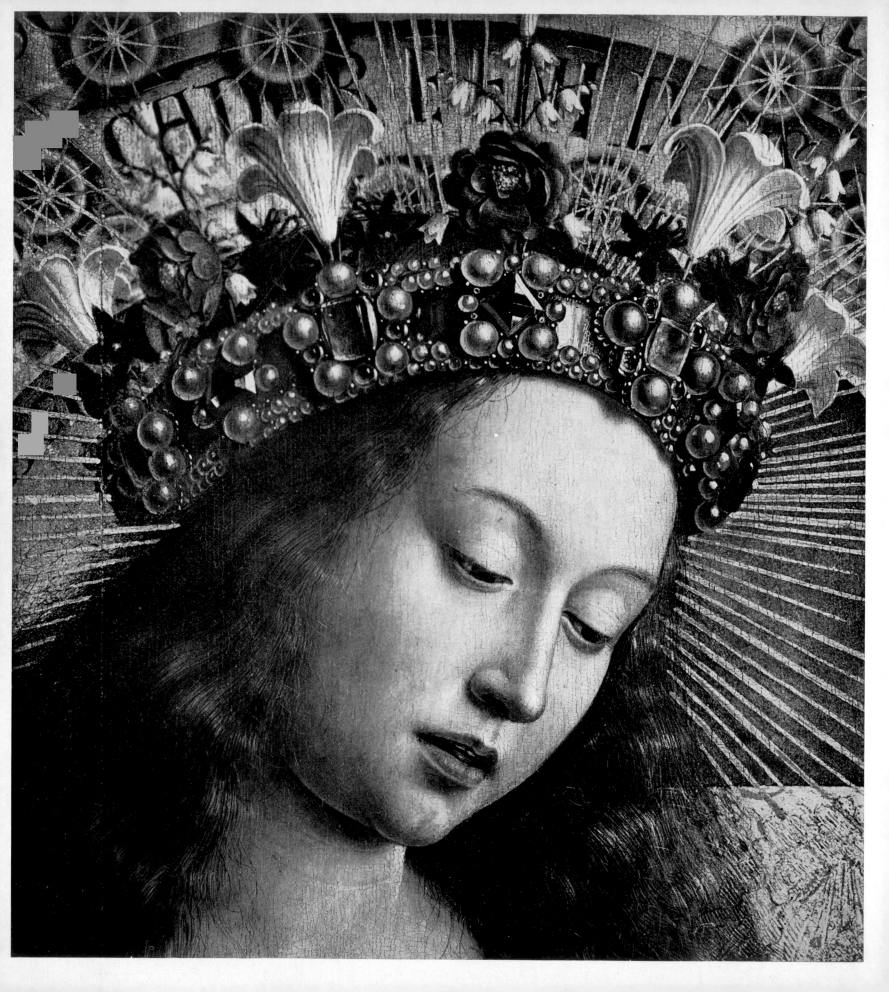

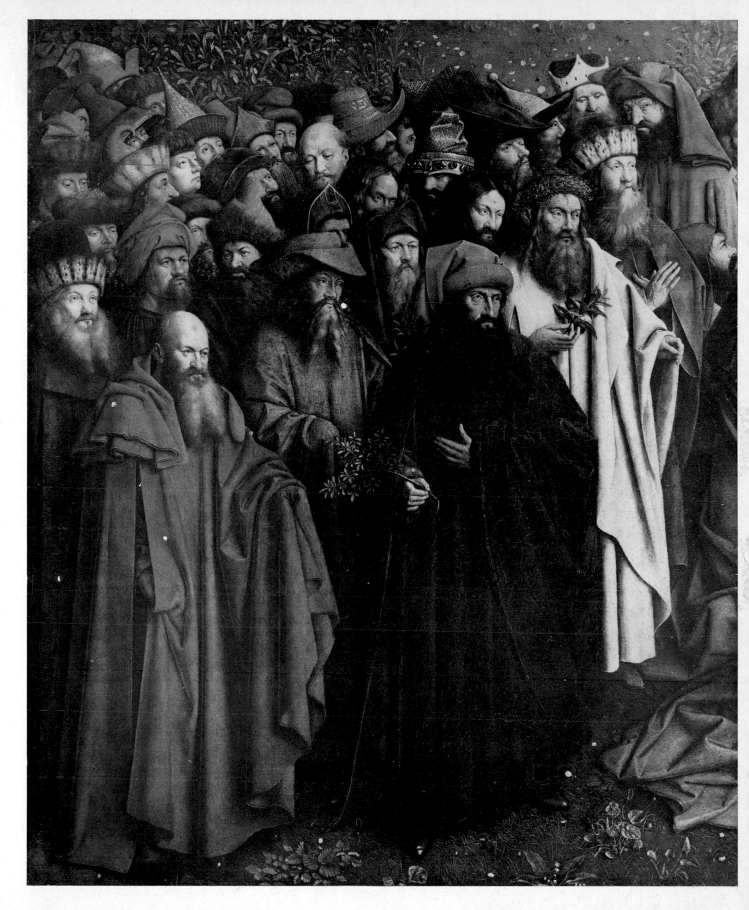

Opposite:

19 Hubert and Jan van Eyck: *The Mystic Lamb*
Detail of the head of the Virgin. Cathedral of St Bavon, Ghent

20 Hubert and Jan van Eyck: *The Mystic Lamb*
Detail of the central panel showing a group of
Gentiles. Cathedral of St Bavon, Ghent

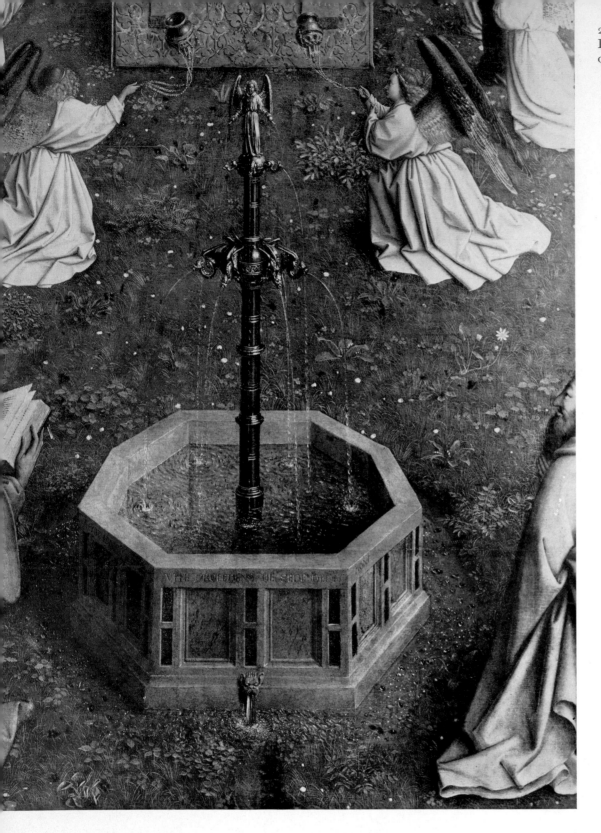

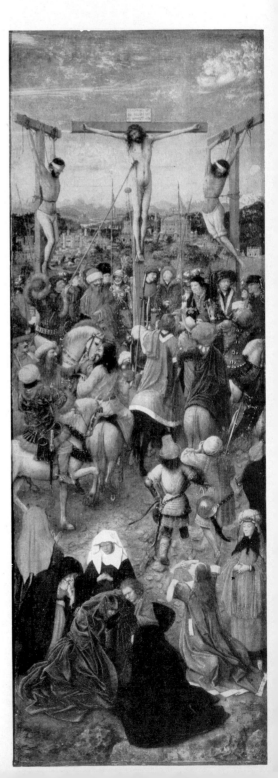

21 Hubert and Jan van Eyck: *The Mystic Lamb*
Detail of the central panel showing the Fountain
of Life. Cathedral of St Bavon, Ghent

22 Hubert van Eyck: *The Crucifixion*
Metropolitan Museum, New York

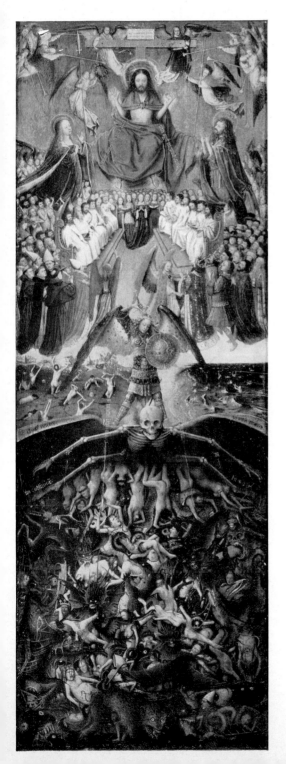

23 Hubert van Eyck: *The Last Judgment*
Detail of the central section of 24.
Metropolitan Museum, New York

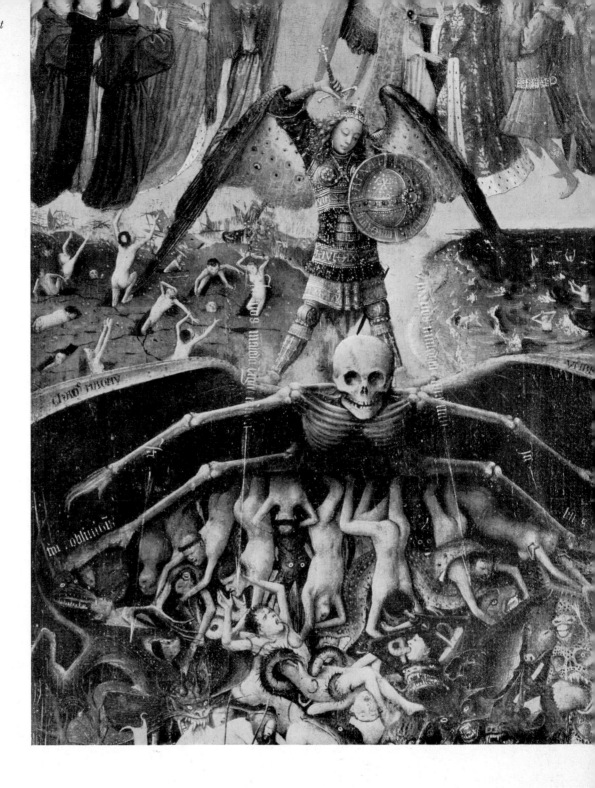

24 Hubert van Eyck: *The Last Judgment*
Metropolitan Museum, New York

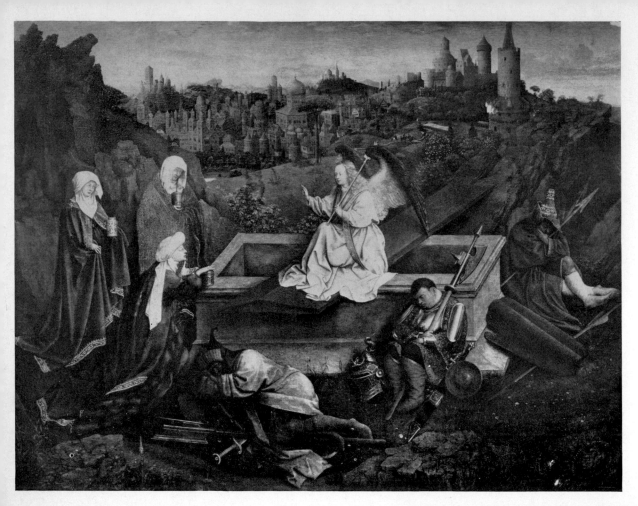

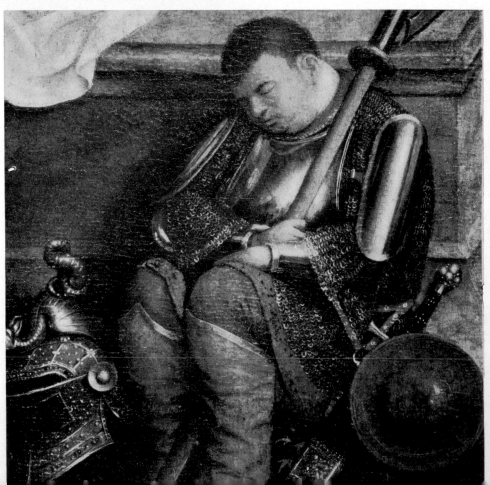

26 Hubert van Eyck: *The Three Marys at the Sepulchre*
Detail from 25 showing a sleeping soldier.
Boymans-Van Beuningen Museum, Rotterdam

others one might mention Jean Coene who, in 1405, painted the arms of the municipality on 200 flags, and then in 1425 painted a room in the *Waterhalle* with oils. He subsequently settled in Paris, then went to Milan.

This does not, however, imply that the many painters working in Flanders before the Van Eycks were all geniuses. Often they only carried out various forms of decoration.

There are, in the Dijon Museum, the volets of a retable carved by Jacques de Baerze for Philippe le Hardi. The duke intended the work for the chapel of the charterhouse of Champmol, near Dijon, which he wanted to turn into a treasure house of art for his mausoleum. He had commissioned Melchior Broederlam, then working at Ypres, to paint the volets, and they were delivered to the charterhouse in 1399. The work deceives no one. Is that really the best that Flanders could produce immediately prior to the Van Eycks? The figures, borrowed from manuscripts common in France in the fourteenth century, are banal. The landscape which the artist has attempted to render is poverty-stricken. It is a heap of brown rocks, one on top of the other, and its trees are made of cardboard sketched in two shades of green. There is no feeling of space and no connection between the figures and the background. There is no harmony between the colours, and the result is a confused mixture. The pure vermilion and blue in the clothing are like splashes against the pink architecture and the dull browns and greens in the landscape. Gold is added to the haloes, to the wings of the red and blue angels, the embroidery on the garments and the floor paving. Only the actual technique, particularly in the figures, is of the quality one would expect.

Some years ago two hitherto unknown paintings were brought to the attention of the public. The style of the first shows that it dates from the second half of the fourteenth century, and that of the second from the end of the century. They come from the region where the Van Eycks were born and provide valuable information about the sort of paintings the artists might have seen when they were young.

The first work is the altarpiece of the Life of the Virgin, which belonged to an old family from Alken in Limburg, and which was acquired in 1930 by the Musées Royaux in Brussels. The artist, whom I shall call the Master of Alken, uses a very archaic idiom. His large panel shows *The Meeting between Joachim and St Anne; The Birth of the Virgin; The Presentation in the Temple* and *The Coronation of the Virgin.* Several stylistic elements recall fourteenth-century miniatures – iconography, attitudes, handling of drapery and the embossed background. Despite its similarity to French painting, this work is definitely Flemish. It has an inscription in the Limburg dialect. There is still no visible evidence of the objectivity of the great Primitives, but it is interesting to note the considerable accomplishment of the technique and the solid contours. But it is fruitless to look for signs of the impending revival.

The second work is a charming little portable altarpiece, formerly the property of the Duke of Norfolk and now in the Boymans-Van Beuningen Museum in Rotterdam. Because of the exquisite richness of the colours, a French scholar took the work to be French (5). But there are not the half-tints and the delicacy of the best fourteenth-century French works. What is more striking is the relationship to the School of Cologne, particularly in the choice of colours and the shortcomings of the figure painting. Furthermore, iconographic studies show that most of the saints depicted were particularly venerated in the Meuse valley, especially in Liège and Maastricht (6). This little masterpiece gives a better impression of painting at the end of the fourteenth century, in the milieu which produced the Van Eycks.

The two works described date from the second half and the end of the fourteenth century. A few pictures survive from the period of the Van Eycks' maturity – round about 1420 – and their style shows they are undeniably of local origin.

Two come from important centres of old Flanders. An inscription on the frame of the first indicates that it was painted in memory of the donor, who died on 1 February 1420, in the hospital at Ypres founded by her father. *The Virgin of the Donors Josse Brid and Yolande Belle* is still in the Hôpital Belle

in Ypres, for which it was painted. The Virgin stands in the centre of the painting in front of a rich cloth emblazoned with coats-of-arms, and is flanked by two saints who are presenting the donors and their children to her. The artist has simply copied a formula current throughout Western Europe at the end of the fourteenth century. The donors are reduced in scale by comparison with the saints, and the background is covered in heraldic devices taken from the coats-of-arms. The work is heavy and stiff, and there is no attempt to indicate physiognomy or space.

From the same period comes another work, *The Tanners' Crucifixion*, now in the museum of the Church of St Sauveur in Bruges, and originally on the altar of the guild of tanners. Christ is shown on the Cross against a background of burnished gold strewn with leaves and stalks, between a group of his followers and a band of soldiers. The work is in the traditional Western style. Several of the figures have the charming elegance of fourteenth-century French art. But the artist has not even attempted to show his figures in a spatial setting, except for the two saints at either end, in such deep niches that the effect is one of corridors. There is a certain amount of harmony between the rather dull colours. Brown dominates the blues, reds and muted greens. The grey flesh-tints have brown shadows, with no shading. Noses, mouths and eyelids are drawn in with the brush. The pupils of the eyes are circles with dots in their centres, and hair consists of a few brush-strokes to represent curls on a neutral ground.

One can assume that there was a higher standard of painting in the eastern provinces of the old Low Countries where the Van Eycks were born. In fact the altarpiece of the Life of the Virgin and the portable altarpiece are evidence of this. Further proof is provided by *The Last Judgment*, which probably dates from the first quarter of the fifteenth century. It was acquired in 1927 by the Musées Royaux of Brussels, and loaned to the Diest Museum. For many hundreds of years it hung in the courtroom of the town hall at Diest, and it must have been painted especially for that room. For convenience we shall call the artist the Master of Diest, though he probably worked in the province of Limburg. In this painting there is a marked attempt at more realistic presentation of the dead rising from their tombs. Some of the gestures are perfectly natural, and there is a definite attempt at flesh contours. For these two reasons the work is almost on a par with Lochner's *Last Judgment*. On the other hand, there are several elements, such as the Gate of Heaven, painted in red lacquer on a gold ground; the hieratic figures of Christ with the Virgin Mary and St John the Baptist; and above all the central group of the Apostles (obviously borrowed from a fourteenth-century Flemish miniature of *The Descent of the Holy Spirit*), which show that the work is archaic and incapable of inspiring any innovation. The lack of space and depth are further indications of this.

Logically one cannot judge fourteenth-century Flemish painting from the few fragments which have survived quite fortuitously. Their comparative mediocrity could be explained if the best artists had emigrated. Only the lesser talents would then have remained behind, and Flanders in those days resembled the old peasant families whose most energetic, enterprising and intelligent sons went to make their fortune abroad, leaving the weaker ones at home to look after the ancestral acres. During the second half of the fourteenth and early fifteenth centuries the best Flemish artists were drawn to France, to the brilliant courts of the king and his brothers. They moved with disconcerting ease. Famous artists such as Jan Maelwel – known as Malouel in France – from the region of Zutphen, the three Limbourg brothers, Jacques Coene from Bruges, André Beauneveu from Valenciennes, Jacques de Hesdin, and several others, settled in Paris and in the residences of the Valois princes. The Van Eycks were probably also there at the beginning of the fifteenth century. All of these were among the great French miniaturists, who began the stylistic revival in painting.

But an event occurred which was radically to alter conditions for artists in Flanders. In 1415 the flower of the French nobility was cut down at the Battle of Agincourt. French patronage was toppled. Only Philippe le Bon, Duke of Burgundy, kept up the tradition. He spent a great deal of time in Flanders with his brilliant court, and set an example for artistic patronage.

Moreover, the Flemish towns were at the height of their prosperity at this time. In every town, and even in the countryside, the cloth which was woven was regarded as the best in the world. It was exported great distances. Bruges became one of the commercial centres of the world and, in addition to its cloth, numerous works of art were exported. The affluent towns frequently employed artists. Not only princes, but government officials, nobles, rich merchants, well-to-do citizens and guilds commissioned votive pictures, portraits and decorative pieces for their houses.

From 1420 until the end of the century, Flemish painters who left the country were few and far between. The more accomplished settled in the most prosperous towns. Large numbers of them came from Hainaut, Holland, Northern France and Germany. They settled down and adapted their styles to what was current at the time. From the evidence of guild registers, accounts, contracts and lawsuits there were, on an average, about one hundred artists working at any one time in Bruges, Ghent, Brussels and Tournai, and about fifty at Malines, Ypres, Louvain and Antwerp (where the artistic climate really only blossomed at the beginning of the sixteenth century).

Hand in hand with economic prosperity in fifteenth-century Flanders went an intellectual climate which was ideal for artistic development.

Together with the plastic arts, literature is the best mirror of a civilisation, and there were close ties between these two means of communication. However, contrary to the opinion of Émile Mâle, I have come to the conclusion – after extremely careful consideration of the evidence – that medieval painting and sculpture, at least in Flanders, were scarcely influenced by the drama which was so popular at the time. Art and literature developed side by side. The Flemish literature contemporary with the Van Eycks is extremely distinguished. Literature certainly created a climate in which painting could flourish. The military exploits of the chronicles, the legendary stories of the chivalrous romances, satirical tales such as the *Roman de Renard*, biblical stories, lives of the saints all provided themes not only for paintings and illumination, but also for the walls of palaces and the houses of the aristocracy – as indeed documentary sources indicate. These murals disappeared along with the buildings, or were severely damaged over the years. But in addition to the documentation, tracings, descriptions, and a few fragments have survived, giving us a good idea of what they were like.

But although there may have been parallel development in art and literature, there was no mutual interdependence. In both fields the accent was on sacred subjects. Monastic libraries had, in addition to theological and philosophical works in Latin, less esoteric works in the vernacular, such as lives of Christ, legends about the Virgin Mary and the saints, accounts of visions, collections of meditations and sermons and songs. Thanks to the activities of the Franciscans, the Dominicans and, in particular, the Brethren of the Common Life, this kind of literature reached all levels of fifteenth-century society. The Brethren of the Common Life were a typical product of the Low Countries, where they had several extremely active communities in the fifteenth century. They were the heirs to the great mystics of these parts, who had written in Flemish: Hadewych, Ruusbroec and Geert Groote. They were the counterparts of Thomas à Kempis. Their works became known through books, sermons, songs and mystery plays given in market squares. In fact a great deal has come down to us. In these works, as in the painting of the time, the religious episode is placed in a familiar setting with a wealth of detail. The tone is simple, sincere, and permeated with the ingenuousness proper to deep faith. In those days the masses lived in communion with God.

Literature and the visual arts propagated an ideal which was not echoed in the political and social realities, or the morals of the time. There is sufficient evidence in the surviving documents to show the unbridled luxury of the dukes of Burgundy and the violence and subterfuge they indulged in to establish and extend their authority. There is evidence, too, of the dissipation among the richer citizens and government officials. In any case, the majority of men have always been dominated by their desires, and the temper of this period did not particularly encourage self-denial, chastity, and the Christian

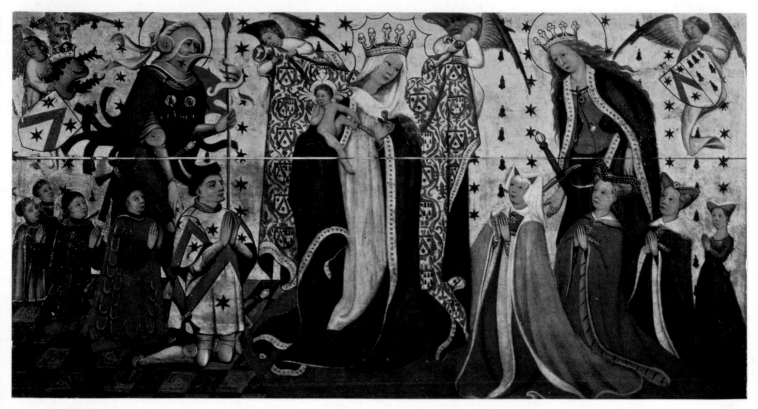

IV Early fifteenth-century Flemish Master: *The Virgin of the Donors Josse Brid and Yolande Belle*
Hôpital Belle, Ypres

virtues. Occasionally, terrible class hatred exploded. There were no hermetically sealed social divisions, but from time to time there was violent conflict between the exploiters and the exploited. Historians have recorded risings of workers and craftsmen against the more powerful; revolts against rulers, and the bloody repression of these revolts. In short, fifteenth-century man had all the vices and virtues which constitute the most stable element in humanity. All the same, the spiritual element tended to get the upper hand, by and large, and in so doing gave a particular flavour to this period, when a civilisation was in the process of being born. The deep faith gave the people of those days reality, a motive force and inspiration. It was the leaven of the mind. Medieval man had great weaknesses, but he redeemed himself through a clear recognition of evil.

In understanding any age, behaviour tells us far more than the economic situation. Is man really more concerned with where his next meal is coming from – as Karl Marx would have us believe – than anything else? Naturally material well-being is important for every individual, but is it really his basic motivation? Man's real concern is his happiness, his freedom, and his ultimate state. At the heart of all man's great enterprises has been a thirst for an ideal, come what may. In common with those who provided the money, the artists at the end of the Middle Ages were vitally concerned with everything related to spiritual matters of life and destiny. We have irrefutable evidence of this in the ideas and emotions which nurtured their art. Consequently economic factors had no direct influence on their basic artistic beliefs. They did, however, affect the scale and extent of their art. In the fifteenth

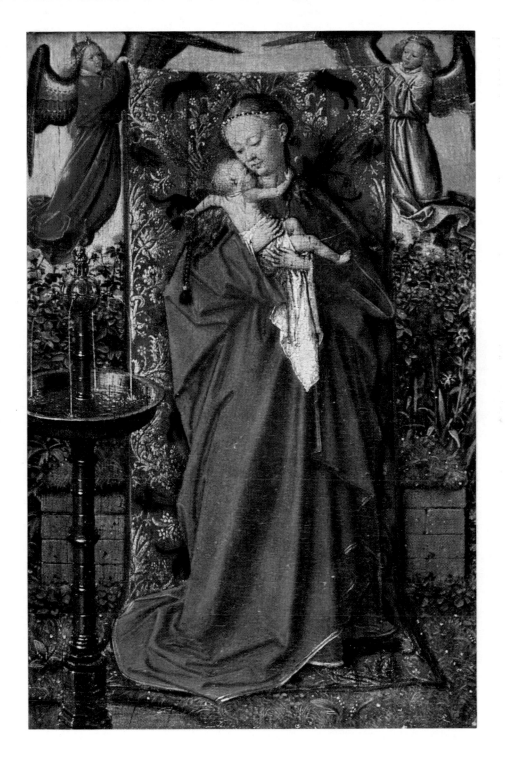

v Jan van Eyck: *The Virgin at the Fountain*
Musée Royal des Beaux-Arts, Antwerp

century, officials at the court of Burgundy, who had made their fortunes, successful tradesmen, and even corporations and guilds were greedy for richly coloured and beautifully painted pictures.

In these conditions, then, Flemish painting blossomed, and early in the fifteenth century the Van Eycks came on the scene. But they were not alone. Around them worked several other artists of

great talent – in particular the Master of the Annunciation of Aix-en-Provence, the Master of Flémalle and the young Roger van der Weyden.

The most important work by the Master of the Annunciation of Aix is the triptych of the Annunciation in the Church of the Madeleine at Aix. Its volets are split up: *Jeremiah* is in the Musées Royaux in Brussels, and *Isaiah* is in the Boymans-Van Beuningen Museum in Rotterdam. There is also a still-life which formed the upper part of the *Isaiah* volet, and which is now in the Stedelijk Museum in Amsterdam. The technique in these works is exceptional. I have studied them several times, and in particular on three occasions when they were temporarily re-assembled: at the Royal Academy in London, in 1927, the Louvre in 1929 and at the Petit Palais in Paris, in 1950. The intensity of the colour is remarkable. The vermilion of Jeremiah's robe and its complementary green on the lining of his cloak are of the same quality as the colours of the Van Eycks, which are, however, much brighter. The same is true of the deep green of Isaiah's garment, the golden yellow of the Virgin's cloak, and the red of the cape of the angel against the grey of the church. The colours are repeated in the still-life elements above the prophets, applied extremely evenly, and the more delicate colours are laid on so lightly that they hardly cover the white underneath.

But more important is the fact that here we are already aware of a feeling for space and light. The contours of the figures are no longer the only indications of space. There is a third dimension. There is air in the church; the niches in which the prophets stand are highly convincing (though unfortunately Isaiah's has been mutilated). The figure intercepts the light and casts a shadow – a shadow which is transparent, ethereal, and blurred at the edges by the light.

Obviously the Master of the Annunciation did not simply follow in his predecessor's footsteps. He used his eyes, and in so doing discovered new solutions to several problems. Unlike many other artists – even the Van Eycks – he did not treat the prophets as polychrome statues, but gave them flesh-tints which stand out against their clothing. In this way he brings them closer to us. The two still-life elements above the prophets consist mainly of books and writing materials. These objects are extremely lifelike – for example, the artist has given a leather strap just the right amount of heavy flexibility and he has not forgotten the light shadow it casts on the wall. The nails in the inner surface of the niche and the planks of the shelf seem to have been put there only for the artist's own pleasure in reproducing, with brush and paint, the shape and nature of the nails and the shadows cast by them.

Virtually only in the Flemish School do we find artists with such powers of observation and such application in handling relief. People have looked in vain elsewhere. Attempts have been made to identify the Master of the Annunciation as Jacques de Litemont, who worked first in Bourges, and then for King René of Anjou, who became extremely fond of Flemish painting when he was a prisoner of Philippe le Bon in Lille and Dijon from 1431 to 1437. The Sicilian artist Colantonio, painter to René of Anjou, has also been mentioned, as well as a Burgundian artist influenced by the Van Eycks, Konrad Witz, Klaus Sluter and Klaus van de Werve. Investigations were also made into the Provençal School. It seemed that the riddle was solved with the discovery of the will of Pierre Corpici, dated 9 December 1442, in which the sum of one hundred florins was left for an Annunciation altarpiece for an altar to the right of the choir in the Church of St Sauveur, from where it was apparently removed to the Church of the Madeleine in Aix-en-Provence (8).

But the evidence is not overwhelmingly convincing. The documentary facts must be related to the aesthetic content of the painting. The composition, choice of colours and style of painting of the picture all prove that the artist worked in Flanders for a long time at the same period as the Van Eycks. If it turns out that this is the Corpici altarpiece – and Corpici lived until at least 1449, if not longer – then one may assume that he bought it while on a trip to Bruges, then the cloth centre of the world. It is even more probable that he bought it in Aix-en-Provence from someone who had commissioned it from the Master of Flémalle, Robert Campin, who might have painted it after being sentenced to a

pilgrimage to St Gilles. This theory is set out in detail in my article in the *Gazette des Beaux-Arts*, Paris, 1954. Only the outside of the volets, with Christ appearing to Mary Magdalene, was painted by a Provençal artist. The technique is different. Not only is the painting on canvas glued to a cyprus- or walnut-wood base, but also the style is clearly Meridional. The feeling of the work is somewhat crude, and the colours subdued. Silhouettes are etched in and clothing is stylised. The painting itself is rather free and the brushwork is visible. The background, with its branches, leaves and flowerets, is reminiscent of the murals in the Papal Palace of Avignon.

☆

After these preliminary considerations, two observations must be made.

The historian, Henri Pirenne, maintained that the secret of the development of Belgium lay less in its own vitality than in the effect that its neighbours had upon it. In his opinion, no other nation was subjected so persistently and so fundamentally to the influence of the nations around it. If this is true from a political, economic, or even cultural point of view, it is not true artistically. Flemish art did indeed borrow many of its features from European tradition, and also assimilated several foreign painters. But the vital energy came from her own soil and her development is governed by internal needs. In the fifteenth century, Flemish art was rich enough in itself to be able to give generously to others.

Secondly, the development of Flemish art was not a process of continuous evolution or progressive improvement. There were ups and downs. We shall follow the peaks rather than the troughs, and linger over the creative geniuses who mark the turning points in the history of painting.

CHAPTER FOUR

THE VAN EYCKS BREATHE NEW LIFE
INTO PAINTING

THE MYSTIC LAMB

The flowering of Flemish painting begins with the Van Eycks' unanimously acclaimed masterpiece, *The Mystic Lamb*. In order to appreciate it properly one must see it in the chapel of the Church of St Bavon in Ghent for which it was intended. In the majestic silence of the architectural setting the inner meaning of the work is apparent. It is direct, intense, and convincing. At the same time the full visual beauty of the painting can be appreciated.

The meaning of *The Mystic Lamb* has been the object of countless discussions. Learned allusions to the Apocalypse, the Golden Legend, the Roman Breviary and contemporary religious literature have been detected. Consideration of the arguments – none of which is, in itself, totally convincing – brings one to the conclusion that simplest explanations usually turn out to be the best. Leaving controversy aside, the subject of the polyptych is, in my opinion, the very basis of the Christian faith – man's Redemption by the Son of God. The work was painted for the people, and the people were able to understand it.

Even for an unbeliever, this monumental theme implies relations between man and the supernatural, and therefore had to be painted in such a way as to capture people's imagination and raise them to the point at which faith takes on its fullest meaning. All the skill of the artist has been summoned up to depict the moment when, in the fullness of time, contented humanity, in beatific contemplation, gives thanks for its Redemption on an earth where all things have been made new. Vegetation from the North and South is shown side by side in a vast garden of paradise. Different groups of regenerated men from the four cardinal points of the compass give thanks and praise to the Redeemer who, by His Incarnation and Passion, made expiation for Original Sin. He is shown as the expiatory Lamb on the altar and as God in glory in the upper register. The altar of sacrifice is placed in the centre of the landscape, and the sacrifice is denoted by the blood of the Lamb flowing into the chalice. Its merits are symbolised by the fountain of sanctifying grace in the foreground. On the left, kneeling, are the Hebrew prophets, the Patriarchs and the men of good will who, in their various countries, and despite the fact that they knew nothing of Christianity, nevertheless obeyed the natural law and so by implication the divine law. On the opposite side are the Confessors who followed Christ's Church: apostles, popes, bishops, priests and believers. In the background, amidst myrtles, rosebushes and orange trees are two groups of blessed souls carrying palms. Men come from the left and women from the right. These are the martyrs who shed their blood as a witness of their faith in Christ.

There are other groups going towards the Lamb on the volets. On the left are the defenders of the faith: the Warriors of Christ and the Just Judges. On the right are the most devout believers: Holy Hermits and Pilgrims. This information is contained in the restored inscriptions on the frames.

In the upper register Christ in glory receives the homage and respect of mankind assembled in the lower register. On either side of Him are the two beings who collaborated most closely with Him in

in the work of Redemption: His mother, the Virgin Mary, and His predecessor, St John the Baptist. Angels join in the chorus of praise. At either end are Adam and Eve in attitudes of regret. They are there because their sin was the 'happy fault' which brought about man's Redemption.

The donors' portraits are on the exterior of the polyptych, along with St John the Evangelist and St John the Baptist, the patron saints of the Church, which was originally dedicated to St John, and then subsequently to St Bavon. The events foretelling the Redemption, and its initial step, are shown above. On one hand are the Hebrew prophets and pagan sibyls who foretold the Redemption, and on the other is the Incarnation of the Son of God, which happened the moment Mary accepted the mission entrusted to her by the Angel of the Annunciation on behalf of God – to become the mother of the Saviour.

The altarpiece therefore sets out the Church's essential teaching on the subject of the Redemption of the human race, including those who made it possible, its causes, prophecy about its origin and its consequences. It is quite possible that the artist received precise instructions – as was frequently the case at this time – from learned theologians, and that the theologians drew on several sources, most of which cannot now be identified (9).

Rather than spend time trying to trace the texts in question, it will be more profitable to look at the way in which the artist set about organising his picture. He wanted to impress people, and in his eyes the way to do it was not to lose himself – as previous artists had done – in archaic conventions which no longer had any meaning. He therefore had to find new and direct visual language for all the intellectual and supernatural concepts related to his subject matter. It was important to put this within the grasp of everyone, to give divine beings a convincingly real aspect and human beings the sort of serenity which would move the beholder. The dimensions of the work were fixed by the width of the altar, and all the various elements had to be assimilated in such a way that nothing detracted from the ultimate function, that of an altarpiece. This meant that the artist had to find a range of colours which was both distinctive and diverse, and yet at the same time perfectly matched, to suggest – in the upper register – celestial glory: red for Christ, blue for the Virgin Mary, green for St John and bronze for the angels. He also had to devise the various shades for the lower register, where the basic green of the foliage provides a single accompaniment to all the different tonal combinations.

The result is an unqualified success, mainly because of the artist's rare originality and his technical accomplishments. He shows us truth, grandeur and beauty. To the people of his time he offered a direct and meaningful vision of the splendour of a god, depicted as a mature man, wearing the robes and insignia of the highest civil and religious authority. In addition he has given definite personalities to simple human beings, who are present in considerable numbers in the painting, but each one of them has a little of the other-worldly serenity which goes with celestial happiness. Each element helps to elucidate the ideas and abstract qualities the work represents. In some passages the reproduction is so exact that one is almost tempted to say that it diminishes the spirituality of the work. Karel van Mander, in 1604, was full of admiration for the fact that it was possible to see which of the angels were sopranos, and which of them had lower voices. Possibly the unity of the painting is impaired by the fact that in his concern for immediacy, the artist has not been consistent in his handling of the lighting. In the room where the Annunciation takes place the light does not come from the same source as the light one can see through the window, outside. Another defect is the handling of perspective in the upper register. The area containing the angels is seen from another viewpoint when compared with the three main figures. But strict realism appears in the treatment of Adam and Eve, in apparent contradiction to the rest of the work. This is no more than apparent, however, for these figures are seen in exactly the same spirit as the upper and lower panels, and the features of Adam are no less spiritual than those of Christ.

A fairly recent hypothesis holds that Jan van Eyck assembled several of his brother's works, added some, and so made up the altarpiece. It has even been suggested that the work consists of two quite

VI Hubert and Jan van Eyck:
Judocus Veit
Detail from one of the volets of *The Mystic
Lamb*. Cathedral of St Bavon, Ghent

VII Hubert and Jan van Eyck:
Isabella Borluut
Detail from one of the volets of *The Mystic
Lamb*. Cathedral of St Bavon, Ghent

different altarpieces (10). Both these theories are invalidated by the unity of style and conception. The figures in the upper register are large because they were to be seen from a distance. Moreover, the basic principle of the composition – with the upper figures disproportionately larger than the rest – was already long established in the tympana of medieval cathedrals and in Gothic ivories, and continued into the Last Judgment as painted by Roger van der Weyden and Jan Memlinc.

One notable problem still unsolved is the respective part in this work played by each of the Van Eyck brothers.

The inscription on the lower edge of the frame of the volets is quite unequivocal:

> *Pictor Hubertus e eyck, maior quo nemo repertus*
> *Incepit. Pondus q[uod] Ioannes arte secundus*
> *...[f]ecit. Iudoci Vyd prece fretus.*
> *VersV seXta MaI Vos ColloCat aCta tVerI.*

This may be translated as follows: 'The painter Hubert van Eyck (whose reputation is unsurpassed by anyone) began the great work which Jan (who is second to him in art) finished, and he has been paid by Josse Vyd. Through this line the sixth day of May invites you to come and view the work.' (The last line is a chronogram which forms the date 1432). The inscription – whose authenticity has been unsuccessfully challenged – therefore states that Hubert began and painted most of the work, and that Jan completed it. The unity of the conception and composition and the even technique show that only one artist – Hubert – handled the major part of the execution, and that Jan's part was carried out in a spirit of profound respect for his older brother's creative genius and skill.

In spite of the inscription and unity of style, however, some people have expressed scepticism and feel that since Jan has a much more important place than Hubert in the history of painting, he should therefore be regarded as the one to whom *The Mystic Lamb* should be attributed. Jan is certainly regarded as an artist of great talent. He is mentioned several times in historical documents, and several works have survived which bear his signature or which can be attributed to him with absolute certainty.

Jan van Eyck is undoubtedly an excellent artist, but there is nothing in his output to suggest the force of creative genius. The one who was unquestionably gifted with genius – and a much greater genius – was the brother who conceived and, for the most part, painted *The Mystic Lamb*. He passed on his technique to his younger brother Jan, who admitted that he was his brother's inferior *(arte secundus)* as far as art was concerned. Moreover, tradition and sixteenth-century texts – whose importance has wrongly been minimised – hold Hubert to have been responsible for the work. Finally, the irrefutable evidence of the inscription on Hubert's tombstone bears out the truth. An artificial fog has been created by some writers, casting doubts on such authentic and specific evidence, even going so far as to maintain that Hubert van Eyck never existed. In support of this theory the old inscription on the painting was declared spurious – the result of rivalry between the people of Ghent and the people of Bruges in the sixteenth century. Its only purpose was to create a Hubert van Eyck to oppose the Jan van Eyck of Bruges.

There may have been political and economic rivalry between these two towns, but intellectual or artistic rivalry at this time had not even been considered. In any case, suppositions of this sort cannot stand up to the positive proof we have that the inscription was added in Jan van Eyck's workshop for the forthcoming inauguration of the altarpiece which took place on 6 May 1432. In the first place the date corresponds to the anniversary of the dedication of the church, and in the second, the inscription – whose authenticity has been doubted – is organically part of the layer of matter which covers the wood; a fact which has been revealed by scientific analysis (11). Thirdly, the Latin of the inscription is definitely medieval, and not that of the Humanist period, as it would be, had it been added later (12).

Finally – and this seems to settle absolutely the issue – there is no work signed by Jan van Eyck or at present attributed to him which has the breadth or the serenity of the brilliant mind behind *The Mystic Lamb*. Jan van Eyck was neither a thinker nor a poet, as was certainly the inspired creator of this wonderful altarpiece.

HUBERT VAN EYCK

Once his masterpiece has been examined, one naturally wishes to discover the rest of the master's work. But since the polyptych is the only work which bears his name, we are forced to proceed by making stylistic comparisons.

From innumerable works by the Flemish Primitives we have to pick out those clearly related to *The Mystic Lamb*. Then one must eliminate those by Jan van Eyck. Jan's style may be studied in a dozen signed works and in several others evidently by the same artist. The style is positive and precise. The works which, on the other hand, are close to *The Mystic Lamb*, with deep spiritual content, a strong poetic quality and less definite form are almost certainly by Hubert.

There are some such works in existence. First there are several lettrines, *bas de pages* and large miniatures from the Milan and Turin Hours, which are part of the *Très Belles Heures de Notre Dame*. The archives show that they were painted in 1404, in a Franco-Flemish workshop under the patronage of Duke Jean de Berry, in France, and that the section known as the Turin and Milan Hours was produced for William IV of Holland, between 1413 and 1417. The Turin Hours were destroyed in a fire in 1904. Not even photographs of them survive, only reproductions published by Count Paul Durrieu. The Milan Hours were in the collection of Prince Trivulzio, and from there they passed to the Turin library. A recent critic has wrongly seen the hand of a later artist in them. I have examined the manuscript, and whilst some of the miniatures have Jan van Eyck's objective style, others have that of Hubert.

So Hubert was a miniaturist – a fact confirmed in a letter from Naples, dated 20 March 1524, from Summonte to Marcantonio Michiel, in which he affirms that the Van Eycks started as miniaturists. A study of the miniatures is outside the scope of the present work, however, so we must confine ourselves to the paintings.

The most important work is *The Three Marys at the Sepulchre*, originally in the collection of Sir Francis Cook at Richmond, and now in the Boymans-Van Beuningen Museum in Rotterdam. The landscape in this picture is that of a dream world. In the light of dawn the three Holy Women – Mary Salome, Mary Cleophas and Mary Magdalene – go to the sepulchre where the soldiers are sleeping. From the stone which has been rolled away an angel announces the Resurrection. The painting is steeped in poetry. It comes from the meek attitudes of the women; the majestic quality of the angel; the strange setting; the first morning light which, in the background, catches the left-hand side of the towers and houses, and from the light coming from the right which bathes the angel and casts the shadow of the lid onto the sarcophagus. The poetry comes also from the intensity of the colour, whose richness and dense quality were only fully revealed in 1947, when several layers of varnish were removed. There are isolated areas of strong colour in the clothing of the Holy Women (dark green, ultramarine, vermilion – the same colours used for the principal figures in *The Mystic Lamb*); bright yellow for one of the

soldiers; and the browns in the rocks, the light greens in the grass and the dark greens in the foliage sustain these intense colours. Even the way in which the work is painted helps to create the idyllic atmosphere of the picture. The features of the Holy Women are treated delicately, the folds of the clothing are soft, the foliage round the angel is painted with exquisitely light brushstrokes. There is no such poetic sense in works signed by Jan van Eyck, except in *The Arnolfini Marriage*, where the poetry is of a different sort. Hubert's poetic sense comes across in the delicate touch of an artist painting from memory, painting what he sees in his mind's eye rather than avidly recording reality – as Jan van Eyck does. To see the contrast immediately one has only to compare the coat of mail of one of the soldiers in Hubert's painting with that of St George in *The Madonna with Canon van der Paele* by Jan van Eyck, and the rocks with those in *St Francis receiving the Stigmata*, again by Jan.

It is easy to compare and contrast *The Three Marys at the Sepulchre* and the lower register of *The Mystic Lamb*. The landscape is painted in a series of receding zones like the wings of a stage set. The light is diffuse and comes from various sources. The bushes and plants are painted with minute brushstrokes. There are also striking similarities of detail: contours painted with soft gradations of colour; impossible architectural units with overhanging storeys; reflections on the armour of the sleeping soldier in front of the tomb like those on the breastplate of one of the pages of the Warriors of Christ. Such similarities are adequate proof that the painting is by Hubert, and not Jan van Eyck – even less by an artist 'near to Petrus Christus', as has been suggested. As to the date, despite some attempts to date it after 1483, the style is completely against such dating.

Attempts have also been made to read a signature into the letters on the hem of a cloak, but this is wrong. The letters are Hebrew characters spelling out fragments of a biblical text. Others have seen the arms of Philippe de Comines in the bottom right-hand corner, inside the collar of the order of St Michael, to which he belonged. This would show that the work was painted for Philippe de Comines shortly before his possessions were confiscated in 1472. Certainly the picture could have belonged to him. At all events the coat-of-arms – which is inside the collar of the order of St James, and not St Michael – is obviously a later addition. While the painting was being cleaned a large fox was discovered in some of the bushes at a point where its presence was inexplicable. Possibly it is a survival from an earlier painting showing through. There are also some gilded rays in the bottom right-hand corner of the picture, going from left to right. One can assume from this that the support was once the outer portion of a large altarpiece.

The same style and creative force are evident in the diptych of *The Last Judgment* and *The Crucifixion*, which I have studied in the Hermitage at Leningrad and subsequently at the Metropolitan Museum in New York. The atmosphere of the work is that of a poetic breadth of vision, painted by someone who is inspired by a large crowd, likes to use several different colours with small, distinct applications of paint.

In *The Last Judgment* there is nothing particularly original in the handling of Christ and the saints in Heaven, but there is considerable inspiration in the portrayal of Death, with his bat's wings, driving the damned into the abyss of everlasting torment. This fertile imagination, which was hitherto unprecedented (apart from *Hell*, a miniature by one of the Limbourg brothers), has produced a very varied treatment of the damned, thrown as fodder to the voracious monsters of evil. The artist's technique was equal to his imaginative powers, and enabled him to bring off the effect of the falling figures.

The crowded, overlapping figures in *The Crucifixion* recall the groupings in *The Mystic Lamb*. There are also some echoes of *The Three Marys at the Sepulchre*. The use of colour has the diversity and richness of that of *The Mystic Lamb*, and there is a similar graduated use of reds, blues and greens which tone with each other.

Attribution of this work to Hubert van Eyck has much better foundation, since it is possibly the

work mentioned in the inventory of Jean de Berry of 1416: '*uns (sic) grand tableaux l'un de la Passion de Notre Seigneur et l'autre du Jugement*' (13) ('A[*sic*] large pictures, one of the Passion of Our Lord and the other of the Judgment'). Objections have been made on the grounds that the size of the painting can hardly warrant the description 'large', but the question is a relative one. At that time such a work would be large when compared with the other works one would expect to find in a connoisseur's study or private collection.

A work which is more serene, but from the same hand, is *The Virgin in a Church* in the Staatliche Museen in Berlin. White light comes through the door, but the light which comes through the windows takes on a bluish tint, because of the stained glass, and fills the rest of the church to the point of blurring a little the silhouette of the Virgin. The Virgin is noticeably disproportionate in relation to the architecture, but in fact the latter is simply intended as a setting. It is Burgundian in style, like that in the Requiem Mass miniature of the Milan Hours, also attributed to Hubert.

There is also a *Christ on the Cross* in the Staatliche Museen in Berlin, with Christ between the Virgin Mary and St John. Once more the landscape is akin to that of *The Mystic Lamb* as far as treatment and style are concerned. The handling of Christ and the faces of the Virgin and St John is almost Impressionist – so much so that one can only relate it to certain passages in the works of Hubert van Eyck.

Finally, there is a work which was still unknown a short while ago, until it came up for sale at Christie's in London on 2 July 1965. It is a head of Christ, painted on wood, of which the frame is an integral part of the picture which measures 32 × 23 cms, or 12½ × 9 ins. There is a copy in Berlin, without the angels. Christ is shown in profile, looking towards the left, surrounded by angels who part the clouds so as to reveal this apparition of the Saviour. The treatment of Christ's face, against its gold background, is hieratic. This particular iconography comes from an old medieval carved emerald which was held to be a true portrait of Christ. The deep spirituality inherent in this work is found at this period only in the works of Hubert van Eyck. In fact only Hubert van Eyck was capable of creating it and executing it. His rich touch is apparent in the angels' faces, his light handling of their hair; his capacity for feeling in Christ's left hand and the soft folds of His garment; his exquisite delicacy of touch in the jewelled cross and the inscription *Fili David miserere* embroidered on the edge of the garment.

There is a great temptation to include the little portrait of Jean sans Peur, in the Musée Royal in Antwerp, amongst Hubert van Eyck's works, but it is impossible to decide until the layers of varnish and overpaintings have been removed. But was there anyone else at this time able to convey such an expression of concentration on this face with its aquiline nose and heavy lip? Or such meaningful stylisation to the hands? Who else could have given such an amazingly lifelike quality to the silver embroidery at the cuffs, the coats-of-arms of the houses of Valois, Burgundy and Flanders? They are as stiff as gold thread and yet follow the movement of the fabric on which they are embroidered. The only point against attribution to Hubert van Eyck is the thick black line which isolates the face from the blue-green background, but it is highly probable that it is a later addition.

Traces of Hubert van Eyck's genius might well be evident in some old copies of some of his lost works, for example *Christ carrying the Cross* in the Budapest National Museum, and in two drawings: *The Adoration of the Magi* in the Kupferstichkabinett in Berlin (14), and *The Taking of Christ* in the British Museum.

It is scarcely possible in a work of this sort to deal with Hubert van Eyck's character on the level it deserves. From what has already been said, however, it is obvious that an artist with such marked individuality could not possibly be a purely legendary figure, as several people have maintained (15).

The authentic inscription on *The Mystic Lamb* mentions his name and underlines his distinction: *maior quo nemo repertus*. It also states that, having begun the work, he was unable to finish it, and that the altarpiece was unveiled in 1432. There are four references to the artist in the archives of Ghent

51

between 1424 and 1426. His patronymic (i.e. name derived from that of a father or ancestor) is mentioned once and the clerk wrote his Christian name in four different ways, a common occurrence at the time. We learn from these documents that the city magistrates went to look at a work they had commissioned from him; that they gave sums of money to his assistants; that the painter carried out work for one of the citizens; and that finally, in 1426, his heirs paid duty on furniture which had belonged to him. From this last piece of information one might assume that Hubert van Eyck died in Ghent in 1426.

We have no precise information about his origin. His name would suggest that he came from Maaseik. If this was the case, one can assume that he learned his calling in the Mosan area (i.e. the area around the River Meuse), in one of the artistic centres such as Maastricht, Liège or Cologne. We do not know where he worked before he settled in Ghent. There is a fairly well-established and accepted theory that he worked as an illuminator of manuscripts in one of the workshops of the Valois princes before the bloody battle of Agincourt which, after 1415, forced many Northern artists working in France at the time to go elsewhere. There are several very good reasons for believing that he worked with his brother Jan on the Turin and Milan Hours, between 1413 and 1417. In certain places their respective styles are distinguishable.

JAN VAN EYCK

To begin our study of Jan van Eyck, the following works are signed and generally dated, either on the panel itself or on the frame:

Prior to 1432 – *The Mystic Lamb:* finished in 1432
1432 – portrait of Tymotheos (?), National Gallery, London
1433 – *The Ince Hall Madonna,* National Gallery, Melbourne
1433 – *The Man with the Red Turban,* National Gallery, London
1434 – *The Arnolfini Marriage,* National Gallery, London
1436 – *The Virgin with Canon van der Paele,* Groeninghe Museum, Bruges
1437 – *The Virgin and Child,* Gemäldegalerie, Dresden
1437 – *St Barbara,* Musée Royal, Antwerp
1439 – *The Madonna at the Fountain,* Musée Royal, Antwerp
1439 – portrait of the artist's wife, Groeninghe Museum, Bruges.

On the basis of comparison, one can add other works whose style demands their inclusion.

By virtue of the dated works, attempts have been made to sketch out the development of the artist's style over a period of a dozen years or so. But it is more worthwhile to define the distinctive points of Jan van Eyck's style and the intrinsic worth of his output. If we examine the works, we become aware of the fact that Jan – who said himself that he was not as good as Hubert – to a large extent developed his older brother's technical resources. It was Hubert who made Jan aware of the pictorial possibilities in nature, and made him realise that a picture is a projection, in a single plane, of a specified space which contains a variety of objects. Jan was the keener observer, not of interior truth, but of objective reality. Moreover, he was a painstaking worker, almost fanatical in his dedication, and extraordinarily patient. He gave rein neither to dream nor imagination, but scrupulously recorded what he saw and

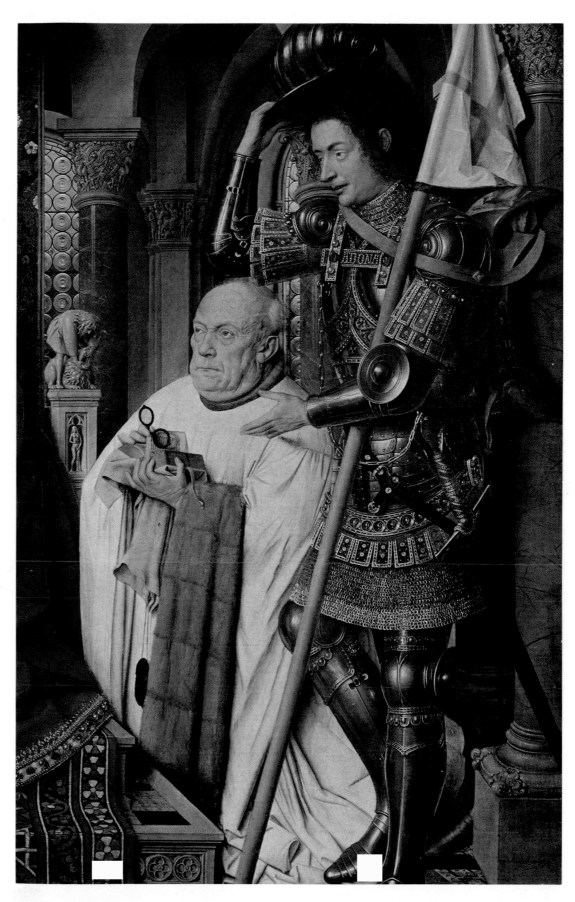

VIII Jan van Eyck: *Canon van der Paele* and *St George*
Detail from *The Madonna with Canon van der Paele*. Groeninghe Museum, Bruges

felt. He restricted the number of figures in his pictures, watching them when they were resting, so as to show them in a static position in a fixed light.

These characteristics are evident in signed and dated works between 1432 and 1439, and in an important series of works which may be attributed to him.

The very marked difference in temperament between Jan and Hubert is most striking in Jan's portraits, where psychology and realism are the keynotes. The great number of faces in *The Mystic Lamb* are well differentiated, but that still does not prevent their expressions having a decidedly fixed look about them – an obvious impersonal quality. The portraits by Jan van Eyck assert, express and faithfully reflect the individual personality of each sitter. He scrutinises the features engraved with the virtues and deep faults of the individual. Because he reproduces all visible details with a penetrating objectiveness, he reaches the real person behind them.

With Jan van Eyck, portraiture took a colossal leap forward. Until then people were content to paint profiles – very rarely three-quarters face – following an invariable pattern. The nose, mouth, chin and eyes were precisely drawn; the relief of the cheeks was shown by a slight contour. Jan van Eyck built up a face, not by drawing it in with a brush, but by the use of different shades of colour. He showed his sitter three-quarters face, turning it towards the source of the light, so that the most important features – eyes, nose, mouth and chin – were fully lit, and so that he could paint almost all the face clearly. The bust seems rather cramped in the frame. Sometimes it is compressed and proportionately too small for the head, as for example in the portrait of the artist's wife. Often the hands seem painfully added to the bust, and they barely rest on the edge of the frame, or whatever support the artist has provided.

The portrait of Cardinal Albergati in the Vienna Kunsthistorisches Museum is less accomplished, probably because the artist was unable to paint it with the cardinal present. When he was in Flanders in 1431, Jan van Eyck did a silverpoint drawing of the cardinal, from which he subsequently painted the portrait. The drawing, now in Dresden, is most expressive. It presents an analysis of a man gifted with a positive personality and able to master all his emotional impulses. The force of this character is no longer evident in the Vienna painting. The face is less expressive and has only a mere shadow of the diplomat's circumspection, which is so cleverly shown in the drawing. The red of the cardinal's cassock against the blue-green background brings the only lively note to the pinkish face.

But Jan van Eyck painted other portraits, with the sitter present, in which his gift for penetrating analysis is immediately visible. Take, for example, the portrait of Tymotheos (?) in the National Gallery in London; the portrait known as *The Man with a Pink* and the portrait of Baudouin de Lannoy, both in Berlin. In these portraits no line is visible. Curves, wrinkles and imperfections are all obtained by shading, and the masterly use of technique.

The portrait of Tymotheos (?) is remarkable for its vigorous handling of the features. They almost look as if they were carved out of stone. The hand is like a piece of sculpture, with thick impasto, and the wrinkles (rendered with two tones) seem like chisel marks. The flat nose, low brow and bright eyes of the learned young man are deeply etched in the pink flesh-tints, with the red of his garment below and the assertive green of his hat above.

The Man with a Pink is a thorough-going, even severe, analysis of a face. But it is above all a colour symphony in grey and brown. Only the bright red at the collar breaks the general tonality.

The general use of browns is even more pronounced in the portrait of Baudouin de Lannoy, a typical devoted and attentive courtier. There is a razor-sharp quality to the face. The skin, which seems tanned, is mounted like a stone between the brown clothing and fur hat, which fade into the neutral background.

Several writers have attempted to trace Jan van Eyck's artistic development. But as I have already pointed out, a great artist's style does not develop as if it were a constant process of improvement. It would therefore be foolhardy to draw up a list – as many art historians have done – based on this principle, which is always arbitrary. Jan van Eyck's style was directly affected by the aesthetic emotions

he experienced while painting. Of his portraits the least expressive and the least successful is that of Cardinal Albergati, dated 1431. But this inferior work comes after two excellent portraits, *The Man with a Pink*, painted before Jan left Holland in 1425 (the date is fixed because the sitter is wearing the collar of the order of St Anthony, founded by William IV, Count of Holland), and the portrait of Baudouin de Lannoy, who visited Jan when he was on a mission to the court of Portugal in 1428. From this point of view the portrait of Cardinal Albergati indicates a temporary eclipse of the artist's talent.

In 1433 Jan van Eyck signed and dated one of the best portraits of all time, his *Man with a Red Turban* in the National Gallery in London. This masterpiece of expression and technique shows the artist's subtlety. The turban highlights the clear, open face of an intelligent man who is sure of himself and who is capable of steering his ship through the reefs of a busy existence. The technique is amazing. The ox-blood red turban is knotted with great elegance, and the pink flesh-tint emerges from under it, softened with brown shadows. The veins at the temple are clearly shown. The face, turned three-quarters left, is lit from this side also, and yet the nose is shown in relief on the left hand side, with definite shadows, where one might have expected the light to have removed the shadows. It could be a self-portrait, because the man is looking straight at the spectator, and the panel is only marginally smaller than the next one to be discussed, and whose pair it could be. The thickness of the frame could have made up for the difference, which is only some three inches.

The portrait of Jan van Eyck's wife in the Groeninghe Museum in Bruges, was painted in the last year of the artist's life. We know that the sitter is his wife from the inscription on the frame: '*Co[n]iux m[eu]s Ioh[ann]es me c[om]plevit an[n]o 1439 17 iunii*'. There is a faithfulness to reality – one might almost say carelessness – that only a husband would have allowed himself. One suspects that she was a difficult woman, but probably an excellent housewife. Her thin lips hardly seem capable of a smile. The overall presentation and even the colours accentuate this impression. The dress is dark red, with narrow pleats, and hugs the bust. The white head-dress, with its starched frills, brings out the line of her face which broadens towards the brow. Nevertheless one is aware of a fault of observation. The bust is too restricted by the frame and the hands too small in relation to the head.

It is at this point that we shall look at a work already mentioned, but worth closer consideration. Signed and dated five years previously, in 1434, *The Arnolfini Marriage* is now in the National Gallery in London. It has been wrongly taken to be the artist and his wife. The woman bears absolutely no resemblance to the artist's wife, and the inscription '*Johannes de Eyck fuit hic*' should not be taken to mean 'this man was Jan van Eyck', but 'Jan van Eyck was here' (i.e. present). The man is Giovanni Arnolfini, an Italian merchant living in Bruges. It is mentioned in the inventory of the collection of Margaret of Austria, Governor of the Low Countries: '*ung grant tableau qu'on appelle Hernoul le fin avec sa femme, dedens une chambre … fait du painctre Iohannes*' ('a large painting they call Hernoul le fin [Arnolfini] with his wife in a room … made by the painter Jan'). The work was probably painted for the couple's marriage, at which the artist was present and which he wished to record. This would explain the inscription.

The painting is entirely successful. The gestures are restrained but expressive, the details of the room precise; the space inside it is increased by the reflection in the convex mirror; but above all the way in which the colours tone with each other, even more so since the work was cleaned. The claret-red in the man's clothes, the green of the woman's dress with blue in the sleeves, and the vermilion in the bed and its hangings all tone with the many shades of brown and give a warm, intimate feeling to the scene.

It is one of the rare occasions when Jan van Eyck went further than he had intended, and unconsciously created a powerful symbol of conjugal faithfulness. In order to understand this painting there is no need to look for complicated explanations of the individual symbols, as Dr Erwin Panofsky has attempted to do (16). The painting speaks for itself. Marcus van Vaernewyck of Ghent, writing in the

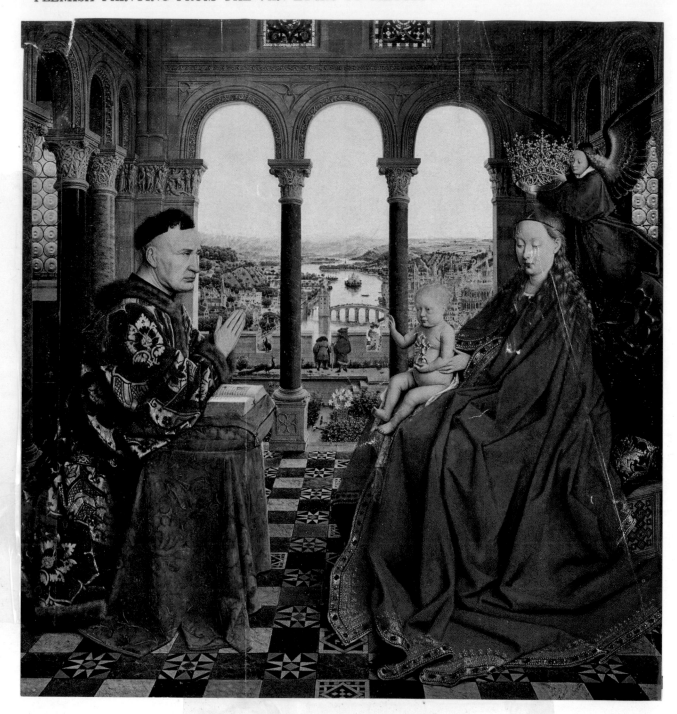

IX Jan van Eyck: *The Madonna with Chancellor Rolin*
Louvre, Paris

sixteenth century, had already emphasised the deep symbolism of the painting. He saw it in the collection of Mary of Hungary, who succeeded Margaret of Austria as Governor of the Low Countries, and described it as '*waerin dat geschildert was een trauwinghe van eenen man ende vrauwe, die van Fides ghetrauwd*

worden' ('where was painted the marriage of a man and a woman who were united by faithfulness') (17). *Fides* is not to be taken allegorically here, but as an abstract noun. Such a painting had never before been attempted, and it would be a long time before anyone attempted to imitate it. It is in fact a full-length double portrait in an interior in which the figures, setting, and colouring are perfectly combined. It is a milestone in the history of painting.

There is little point, after this, in spending much time on the small, religiously inspired works which Jan van Eyck painted for various chapels. Those showing the Virgin – for example *The Madonna at the Fountain* in Antwerp – are enlarged miniatures. They are highly coloured and well balanced, in fact excellent examples of painting, but they do little to enhance the artist's reputation. One does not feel that he was deeply inspired when he painted them. They have no feeling of transcendence or grandeur. They only confirm the conviction that the Virgin of *The Mystic Lamb* could not have been created by the same person.

One should not underestimate the smaller works. I have closely examined *St Francis receiving the Stigmata* in the J.G. Johnson Collection of the Philadelphia Museum, and I was amazed, not by the spirit or atmosphere of the work, but by the lifelike quality of the plants, the saint's brown habit and the dark grey habit of Brother Leo, the pink flesh-tints, the furrowed soles of the feet and the rendering of the rocks, much more solid than those by Hubert van Eyck in *The Three Marys at the Sepulchre*. The concern with truthfulness is so intense that the saint is scarcely the legendary St Francis of Assisi, but rather a young Flemish peasant.

We should, however, devote more attention to a group of large works which are very representative of Jan van Eyck's art – masterpieces in their own right – and so close in style to the signed works that one can safely attribute them to him.

The first is *The Madonna with Chancellor Rolin* in the Louvre. Judging from the age of the donor, of whom there are other portraits extant, this work could have been painted after Jan van Eyck had entered the service of the Duke of Burgundy in 1425. Nicolas Rolin had been master of the household since 3 December 1422. There is none of the greatness nor subtlety of Hubert van Eyck in this painting. It is entirely Jan. Everything in it is the work of an artist who restricts his aesthetic vision to outward appearances, and whose imagination does not rise above the level of everyday life. The Virgin and the donor are shown on equal footing, thus to indicate the Virgin's superiority, Jan van Eyck has had to employ the services of an angel to hold a crown over her head. Mary holds the Christ Child on her knee with all the simplicity of a good mother. There is as little true spirituality in her, however, as there is veneration in the face of the donor. The two figures have the same visual importance. The Virgin is paying a visit to the chancellor, who receives her in a room with a beautiful view over the town and its surrounding countryside.

For a long time I have taken this view to be of Liège. Some people say Geneva, others – such as A.C. Coppier, J. van der Haagen and E. van Nispen – have identified it as Maastricht. Andrieu and J.F. de Mély maintain that it is Lyons seen from the monastery of Ainay, with the Alps in the distance. Even Brussels has been suggested. In fact it is probably an imaginary city, made up from various elements of real places. The tower of Utrecht has certainly been included – as it was in *The Mystic Lamb*.

It is obvious that the artist had only one aim – to paint a beautiful picture which would please with its rich colours and marvellous finish. The red of the Virgin's cloak has been darkened by a thick, and relatively modern, oil glaze. It contrasts with the ultramarine of the prie-dieu, which has taken on a greenish cast because of the glaze, and the brown and gold brocade of the chancellor's garment. The figures are set against the black-and-white tiling of the floor and the browns of the walls. The impasto is fairly thick, so that the artist has been obliged to show demarcations on the faces.

In this work Jan van Eyck has obviously attempted to deal with the new problem of combining an interior with a landscape in depth. One cannot say that he has entirely succeeded in his adventurous

undertaking, however. The room is lit from the right, but this scarcely relates to the light outside, which only enters the room up to the capitals below the arches, and the pillars are dark brown against the sky. But as anxious as Jan van Eyck is to be objective, he is even more concerned with the overall harmony of colour. He takes the tonal range of the room onto the terrace and even into part of the landscape. But the mountains are painted in a different grey-blue light.

The landscape – which has rightly been praised by so many critics – is in fact a backcloth behind the arches. Nevertheless it is a delightful backcloth, inviting one to wander among the streets, bridges, waterfront, and past warehouses, houses, inns and churches. The eye is then led to the countryside, to the hills with their flocks of sheep and up to the snowy summits. It is a complete microcosm within a little space.

It is essentially the work of a miniaturist, who has nevertheless scanned the world avidly and has enjoyed recreating it in paint. He has assembled a vast quantity of details in the picture, but he has not succeeded in incorporating them properly into the composition. The building is out of proportion to the figures, and there is no connection between the fore-, middle and background. But fortunately, in spite of falling short of his self-imposed principles, and certain concessions to outdated ideas, Jan van Eyck maintains the unity of the work through his use of colour which, even in the large figures, for example, is still governed by the dark area of the room.

The Virgin and Child with SS. Barbara, Elizabeth (?) and a Donor in the Frick Collection in New York, is in the same manner. The Virgin, in a blue robe, stands in front of a beautiful red hanging. The colour of the hanging is in fact nearer to pink, which goes well with the grey in the clothing of the two saints, and gives the whole painting a more delicate feeling by comparison with other works. The bronze statue of Mars in the tower behind St Barbara provides an interesting iconographic detail.

A painting which is even more dazzling than *The Madonna with Chancellor Rolin* is *The Madonna with Canon van der Paele*, signed and dated 1436. Now that the layers of varnish and overpaintings have been removed, one can appreciate the full effect of the work in the Bruges Museum. One may regard it as the artist's masterpiece. It radiates truth and strength. The Virgin is a healthy young Flemish girl; the Christ Child looks lively and has an expressive, though not particularly pleasing face. St George is rather stiff because of his armour, but the cleaning in 1934 removed the retouches which made his smile seem like that of a simpleton. One also feels that gentle St Donatian is real, and of course Canon van der Paele himself, fond of good living and yet endowed with a fine mind; and finally the sculpture and carpets. The only features which give the work its more impressive side are the imposing composition – direct and symmetrical – contained in a Romanesque apse, and the broad colour passages which tone with the brown of the architectural setting. But it is difficult to keep one's eyes off the brocades, clothing, sculpture, the way hands and faces are painted, and especially the magnificent coat of mail worn by St George. One can pick out every link with its brown and yellow reflections, yet at the same time the feeling of a heavy and supple piece of armour is maintained. The figures and objects are immediately convincing as three dimensional forms.

Having lingered over this incomparable work, we can deal more briefly with three other paintings. *The Annunciation*, formerly in the Hermitage at Leningrad, and at present in the National Gallery of Washington, is one of the better works as far as composition is concerned, but lacks a feeling of richness because the colour is restricted to greys. *St Barbara* in Antwerp is, as has already been pointed out, a drawing done with the tip of the brush, and not a sketch for a painting. Finally there is a little-known work by Jan van Eyck, but one which is very instructive about his method of working. The painting in question is *The Madonna with Provost van Maelbeke (The Madonna of Maelbeke)*, at present in a private American collection. I studied it in Berlin in 1930 when it had been cleaned and the seventeenth-century overpainting removed, revealing its true quality. The colours are complementary – red for the Virgin and green in the donor's cape – and the flesh contours firm but delicate. The composition is

spacious and the general range of colours brighter, potentially indicating a new phase of Jan van Eyck's development. Unfortunately the promise remained unfulfilled. Jan van Eyck must have died before he could finish the picture. It was placed, incomplete, over the tomb of Nicolas van Maelbeke, twenty-ninth provost of the Collegiate Church of St Martin in Ypres. It is referred to in the Memorial of the Greyfriars at Ypres in 1445 as the work of Jan van Eyck (18). The sixteenth-century writers L. Guicciardini, L. de Heere and Marcus van Vaernewyck mention it. It was completed in the seventeenth century and another head painted over that of the donor. It was still attributed to Jan van Eyck until the eighteenth century, then it was discredited. The most important feature of the work, after it was cleaned, was its incomplete state. The inside of the volets has several passages barely sketched in grey and brown, and in one place the beginning of a flesh contour. In the central panel several parts lack only the finishing touches, in particular the vault, but the skin of the Virgin and the Christ Child are remarkably rich and supple. The background consists of Jan van Eyck's finest landscape, with a pink-roofed castle reflected in water. It is the same technique as in the miniature of *The Baptism of Christ* by Hubert van Eyck in the Milan Hours. In it Jan van Eyck's art reaches its maturity.

He did not precisely set out to find the abstract in reality, hidden as it is under material form, nor the inner soul behind the outward appearance, but nevertheless in this picture he approaches a world of pure poetry. Consideration of *The Madonna with Provost van Maelbeke*, so powerful a painting, must surely make short work of the platitude that the Flemish Primitives hardly idealised nature, and that their successors owed this improvement to the Italian Renaissance. Jan van Eyck was essentially a realist, but in this work he rejected trivial and useless detail. There is magnificent formal balance without resort to classical formulae, and without any of the sterile conventions to which it unfortunately gave birth.

Nevertheless, as great as Jan van Eyck was, he lacked the breadth of vision and frequently the quivering sensitivity of his brother. One is inclined to wonder how he became so famous so soon and eclipsed his older brother. He probably owed this more than anything else to his rapid social ascent. Whilst Hubert doubtless worked, modestly at first, in the illuminators' workshops in France and Holland, then in Ghent, Jan became an official painter, with a title, attached to the most famous and brilliant prince of the day – the 'Great Duke of the West'. He travelled abroad and was known throughout Western Europe. He has never been forgotten by the art world, and even today more attention is devoted to him than to Hubert. The large number of documents relating to him, particularly in the Burgundian archives, has enabled the progress of his career to be traced. Moreover, a dozen or more works which he signed and dated himself facilitate the definition of his style and the attribution of of other works. One can even try to trace his development. The details of his life are comparatively well known – at least from the moment he appeared in history at the court of Holland.

There are several indications that Jan, like Hubert, came from Maaseik. First there is his name. Then his native language, from his motto *Als ixh xan* (As I can), and by the colour annotations on the preparatory sketch for the portrait of Cardinal Albergati, which contain several words peculiar to the dialect of Limburg, such as *ich, nase, blewachtich, augen,* and *bleicachtich*. Moreover his daughter retired to a nunnery in Maaseik, and he himself made a donation to one of the town's institutions. Finally there is a document of Philippe le Bon, dating from 1435/6, relating to the artist, under the name of Johannes van Tricht (Maestricht, near Maeseyck).

One may assume that Jan learnt his trade from his older brother, Hubert, and that he followed him to the court of one of the Valois princes, then to that of William IV, Count of Bavaria and Holland, at The Hague, where he assisted with the illumination of the Turin and Milan Hours. The accounts of the court at the Hague reveal that three payments were made to Jan van Eyck for unspecified paintings between 27 September 1422 and 15 February 1425. Each time the name is given as Jan the Painter. We can be sure that it is Jan van Eyck because of an entry dated 19 May 1425 in the register of the general account book of Philippe le Bon, Duke of Burgundy, where he is referred to as ' *Jehan de Heick*,

jadis pointre et varlet de chambre de feu monseigneur le duc Jehan de Bayvière ('Jan van Eyck, formerly painter and valet de chambre to the late lord John, Duke of Bavaria').

John of Bavaria, Prince-bishop of Liège, succeeded Count Wiliam IV of Holland in 1417, and died on 5 January 1425. In the same entry from 19 May 1425, Jan van Eyck was received into the service of Philippe le Bon who, '*tant pour l'abilité et souffisance que par la relacion de plusieurs de ses gens il avoit oy et mesmes savoit et cognoissoit*' ('as much for the skill and capability as by the accounts of several of his people he had heard and even knew and understood'), awarded him the title of '*pointre et varlet de chambre*' with a pension of one hundred pounds annually.

Philippe le Bon had a high regard for him. Already in 1425 he awarded him an extra twenty pounds to cover his removal expenses from Bruges to Lille. The painter remained in the duke's service while he was at Lille from 1425 to 1428, and during the period of his residence at Bruges, to the end of his life. The Burgundian court archives show that on several occasions his employer entrusted him with 'certain distant secret voyages' in 1426, 1427, 1428 and 1436. The 1428 voyage involved some well-known events. A delegation was sent to ask, on behalf of Philippe le Bon, the hand of the Infanta Isabella of Portugal. Jan van Eyck, a member of the delegation, was to paint two portraits of the princess, one to be sent by sea and the other by land. The delegation returned via Tournai, and Jan van Eyck was ceremonially welcomed on 23 March 1428 by the dignitaries of the city, and also by the artists, amongst whom were Roger van der Weyden and Jacques Daret. He had previously been received there on 18 October 1427. In 1433 the duke visited him at Bruges, and in 1434 was represented by a proxy godparent at the baptism of one of Jan van Eyck's children, to whom he gave a present of silver cups. In addition, he increased the painter's pension that year to 350 pounds annually. At the beginning of 1435, the treasury, in an attempt to economise, suspended payment of court pensions. But on 12 March the duke wrote to the treasury, commanding them to pay his painter's pension without delay. He had written a similar letter on a previous occasion, on 3 March 1427, so that the pension would be paid promptly.

In Bruges Jan van Eyck also worked for himself. In 1432 the city fathers went to his workshop to look at a picture he was busy painting, and in 1435 the artist painted six polychrome statues for the façade of the town hall. At that time great artists were not too proud to do work that was more in the realm of craftsmanship than pure art.

In 1441 he received the last payment of his pension at St John's tide (in May). His death is entered as 9 July 1441 in the obituary book of the Church of St Donatien at Bruges. He was buried initially in the churchyard, but later in the church itself at the instigation of his brother Lambert.

THE VAN EYCKS' CONTRIBUTION

It would be an exaggeration to say that Flemish painting began with the Van Eycks. In the way that the art of Phidias, bursting in on the world in the fifth century BC, was the end product of the ceaseless efforts of hundreds of obscure artists, so the art of the Van Eycks rose out of the laborious experiments of the Franco-Flemish painters of the second half of the fourteenth century. One has only to look at the large number of excellent miniatures to see this. Moreover, contemporary painting shows exactly how stimulating the appearance of the Van Eycks was.

27 Hubert van Eyck: *Head of Christ*
Arthur L. Erlanger Collection, New York

28 Hubert van Eyck: *Head of Christ*
Detail from 27. Arthur L. Erlanger Collection, New York

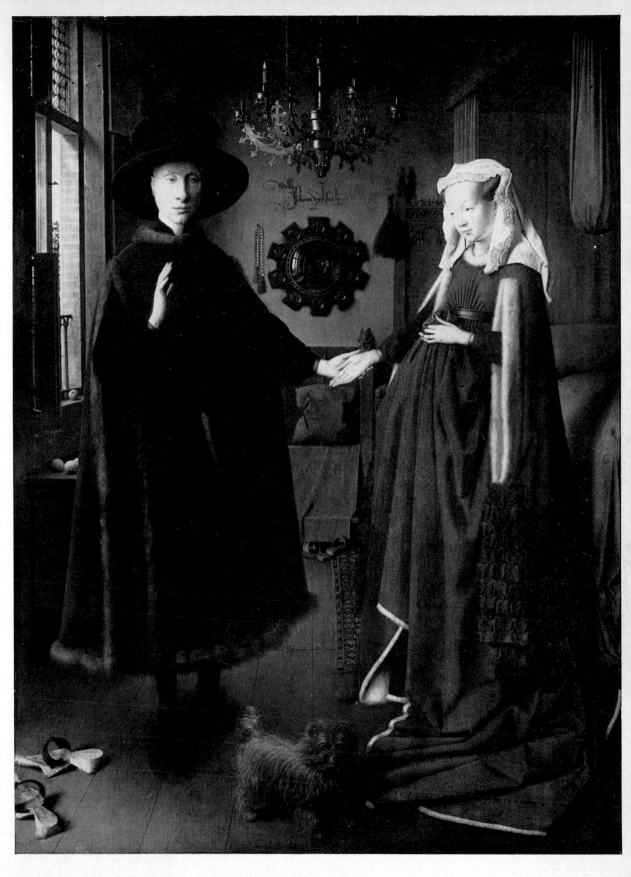

31 Jan van Eyck: *The Arnolfini Marriage*
See colour plate III (p. 25). National Gallery, London

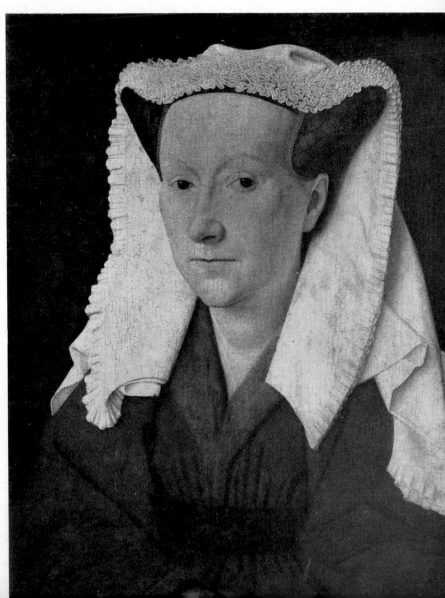

32 Jan van Eyck: *The Man with the Red Turban*
See colour plate II (p. 6). National Gallery, London

33 Jan van Eyck: portrait of the artist's wife.
Groeninghe Museum, Bruges

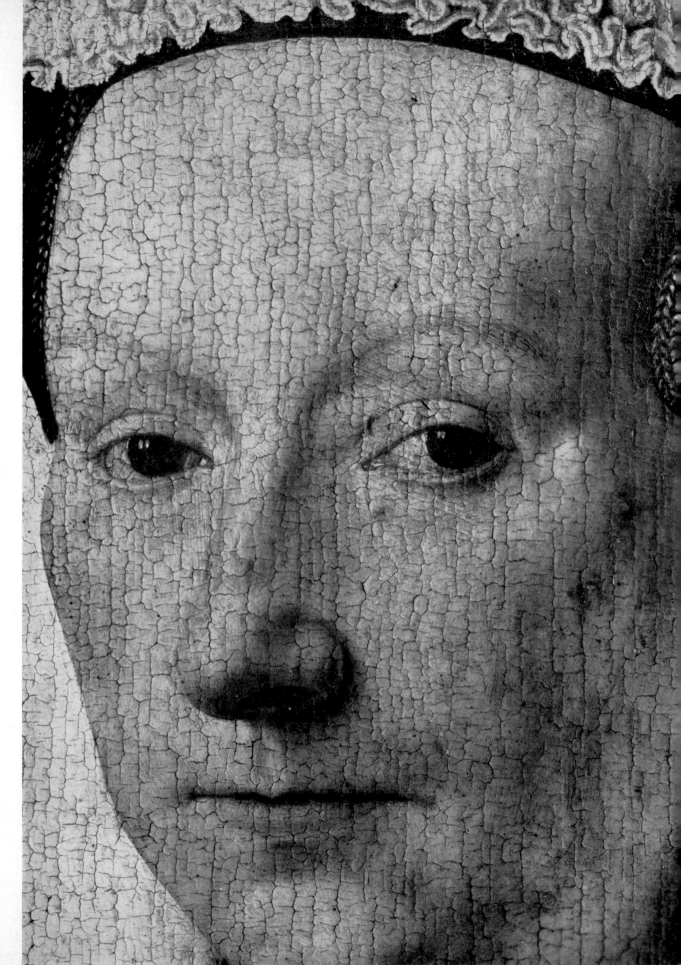

34 Jan van Eyck: portrait of the
artist's wife. Detail of 33.
Groeninghe Museum, Bruges

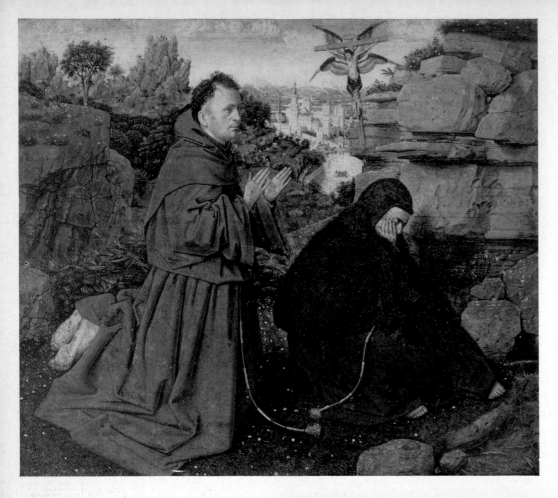

35 Jan van Eyck: *St Francis receiving the Stigmata*
J.G. Johnson Collection, Philadelphia Museum

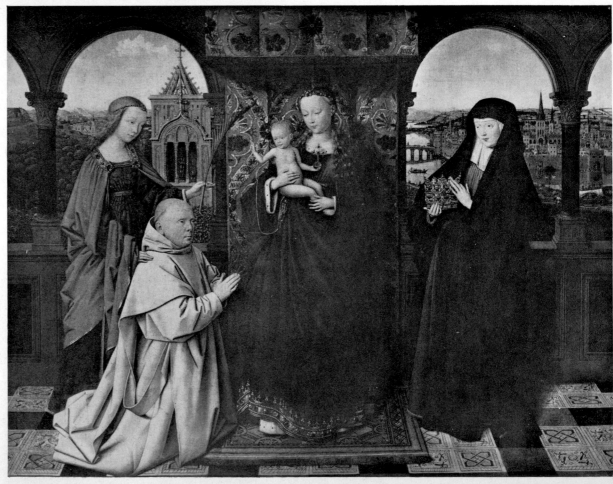

36 Jan van Eyck:
The Madonna with a Carthusian
Baronne G. de Rothschild Collection, Paris

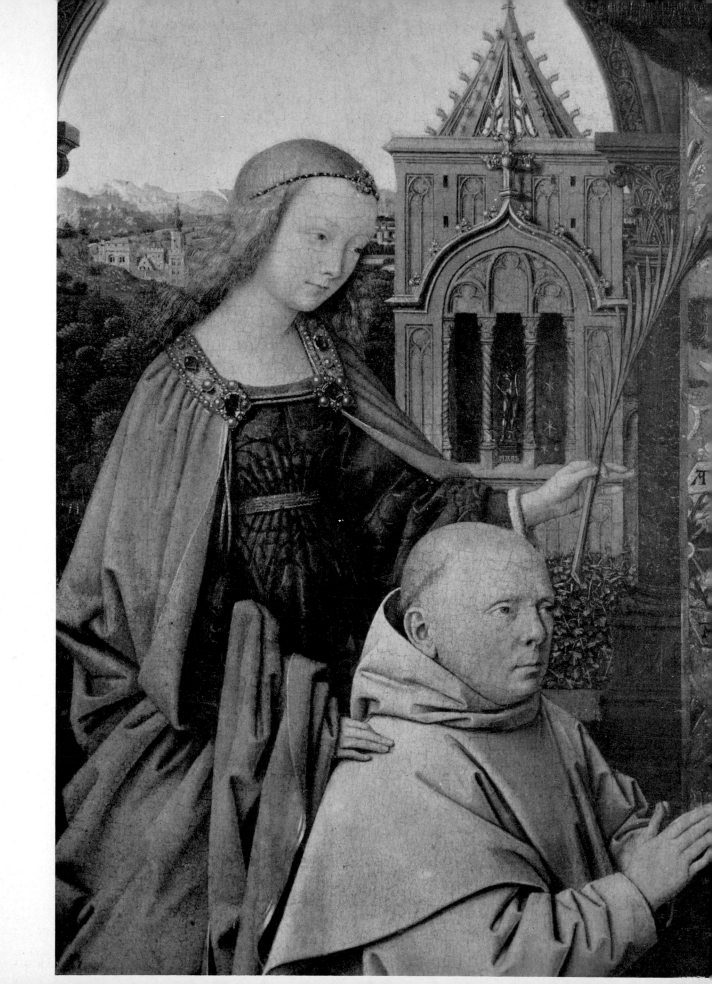

37 Jan van Eyck:
The Madonna with a Carthusian
Detail of 36. Baronne G. de
Rothschild Collection, Paris

38 Jan van Eyck: *The Madonna with Chancellor Rolin*
Detail showing central landscape from colour plate
IX (p. 56). Louvre, Paris

Their influence was as important in the purely technical field as it was in that of artistic vision.

Hubert, and then Jan, were far ahead of both their predecessors and successors for the space of a century. They brought a major improvement to technique. They did not invent oil painting, which had long been known, but in addition to using egg they introduced a new means of making the colours stand out, making them more flexible, and grading – by intermediary tones – the passages from light to shadow so as to accentuate contours, volume and space. Anxious to increase the effect of the colour, they carefully controlled the intensity and resonance between tones. The sum of their work represented a fund of knowledge for the painters who came after them. Pictorial art entered an important new phase with the Van Eycks.

They broke as much new ground as far as artistic conception was concerned. In both Byzantine and Roman art, figures were always treated hieratically, with impassive faces and wooden attitudes, emphasised by sharp contours and the absence of any true relief. Colour played a purely decorative role, and the play of light was of minimal importance. There was no attempt to bring the idea or feeling suggested by the subject matter nearer to the spectator. Gothic painting attempted to make figures more lifelike, accentuating contours and movement. There was even an attempt at indicating the third dimension. Even so, the works of Giotto and Duccio seem to be born of reason rather than visual impression. Of course they do portray, in their abstract way, an emotion or an idea, but do they really have volume and weight? If one touched them, would they respond or give assurance of their solidity? Do they give an impression of space? They are really like graphic signs, lifeless images placed in a permanent and clear vacuum. The artists who followed Giotto and Duccio in Italy used principles which were already established; ready-made formulae; and they were concerned above all with perfection of line.

In the North, especially in France, the concern was with stylistic elegance, purely ornamental effects, and beautiful, sophisticated colour. The fourteenth-century miniaturists' ideal – even the most reputable of them – was nothing more than elegance of form and subtle use of colour. The last miniaturists of the century worked in the centres established by the four princes of the house of Valois: Philippe of Burgundy, Louis of Anjou, Jean de Berry and Charles v. Here there was obvious concern for new ideas and increased realism. The famous *Très Riches Heures du Duc Jean de Berry,* now at Chantilly, have an accurate view of Bourges and some details of landscape which are significant from this point of view. For example there is a difference in colouring between the hay that has just been cut and that which is dry. One also sees in these miniatures one or two touches which are decidedly bold when considered in relation to the prevailing aesthetic temperament of their day, and a scene of Hell, in particular, looks forward to Bosch. But although these miniatures are far in advance of the panel painting being produced at the same time in Flanders and France, they are nothing more than the first tentative notes of the magnificent music of the Van Eycks.

With the Van Eycks, painting underwent a metamorphosis and took on life. It left its hitherto almost exclusive supports – wall, glass and parchment – for portable panels. The decorative rigidity disappeared. Pictorial art abandoned its traditional static quality and became mobile. Even the practice of surrounding everything with a hard outline disappeared. Colour assumed its proper place – the most important. Painting became truly pictorial. Through carefully considered tones, it now indicated all the different shades that objects can take on in the atmosphere, and through this the fluttering, changing quality of light.

There were many consequences of this new way of seeing things. First of all in the treatment of contours. In Italy at this time artists were still adding black to individual colours to produce shadows – rather on the lines of drawing technique – but the Van Eycks achieved the effect by a subtle shading towards a darker tone – but of the same colour. There was no use of lines, only extremely delicate shading.

Still using this delicate shading, the Van Eycks achieved perfect aerial perspective – much more important than linear perspective, which was discovered by the Italians in the fifteenth century. They arrived at it by stages, successive improvements being made by virtually scientific researches by several generations of painters. Flemish artists never became completely adept at linear perspective, which should involve gradual reduction of dimensions. They used the almost theatrical convention of a series of scenic units placed one behind the other at regular intervals.

But the Van Eycks' great discovery in atmospheric painting was of major importance. They observed and understood how, in nature, colour variation depends on what objects are made of and how much they reflect light. They saw how things lose the brightness of their colour the further away they are. They had the necessary talents and technique to bring to painting an essential element – space – which until then had no place there. It is most illuminating to compare the paintings by Jan van Eyck in the National Gallery in London, with those by more recent Italians such as Verrocchio's *Tobias and the Angel* or Botticelli's *Madonna and Angels*. One sees how much better Jan van Eyck is in this respect. Naturally the Van Eycks have the benefit of an accomplished technique and sumptuous colour. But their greatest legacy was their shading of colour, through which they show the weight and thickness of objects, their texture, and their place in the ambiance of the picture. This new way of seeing things considerably enriched painting and carried it into modern times.

Through their discovery of the technique of shading they translated their artistic vision into comprehensible forms. Doubtless man was aware of nature and his relationship to the universe well before the Van Eycks, as Greek thought and the science of the Arabs clearly show. But there was nothing speculative about the knowledge of the Van Eycks. It is precisely what modern man is constantly looking for, ever attempting to extend his domination over the tangible universe. The Van Eycks analysed the elements of nature. They isolated the essence and the external form of things, and considered them in relation to the three dimensions. They realised the inter-relationship between objects. They saw how everything combined in the universe and what man's place is in it. They put it all back together in their minds and interpreted it in colour on a flat piece of wood. Three generations before Piero della Francesca and Verrocchio they understood the strange connection between colour and light in painting reality on a flat surface. The day will come when the exaggerated admiration for Italian art will subside and then the true perspectives of artistic development will be established. When that happens, the Flemish Primitives will take their proper place alongside the Italian Primitives, on the same level.

Of course one must admit that the treatment of the human body as seen by the Flemish Primitives has none of the charming elegance it has in contemporary Italian painting, at that time unequalled in a feeling for the overall conception of a moving figure. By the same token the composition in some of the Van Eycks' works is simply symmetrical, or a heaping up of elements.

Contrary to the present belief, the Van Eycks did not push Western painting towards a realistic conception. The tendency had been present in Western art generally since the end of the Middle Ages, whilst in the Far East painting was developing in a completely idealistic way. After the discovery of descriptive writing in China, painting took over to convey what the poet-painter was unable to say in words. Thought and emotion are the chief constituents of Chinese painting; shape and colour are only used to give expression to the ideal world. This approach is still very much in evidence in the work of the Van Eycks, but their new way of seeing and reproducing objects and the technical improvements they introduced increased the importance given to forms and their representation. One could say that they are nearer to the Renaissance than those Flemish artists who, a century later, took great pains to copy the Italian Renaissance. After all, the essential feature of the Renaissance was the discovery of man, his environment, space and the universe, and this the Van Eycks portrayed in their paintings. Although their work is a superb flowering of medieval art, their way of seeing things puts them on the threshold of modern times. In them one sees the artistic vision which was to develop over the course of

the centuries, and also the seeds of all the various movements: figure painting, historical subjects, the portrait, landscape, seascape, the nude, genre painting, and still-life. Not until the present day would anything entirely new be added, in realms of art whose very existence was hitherto unsuspected.

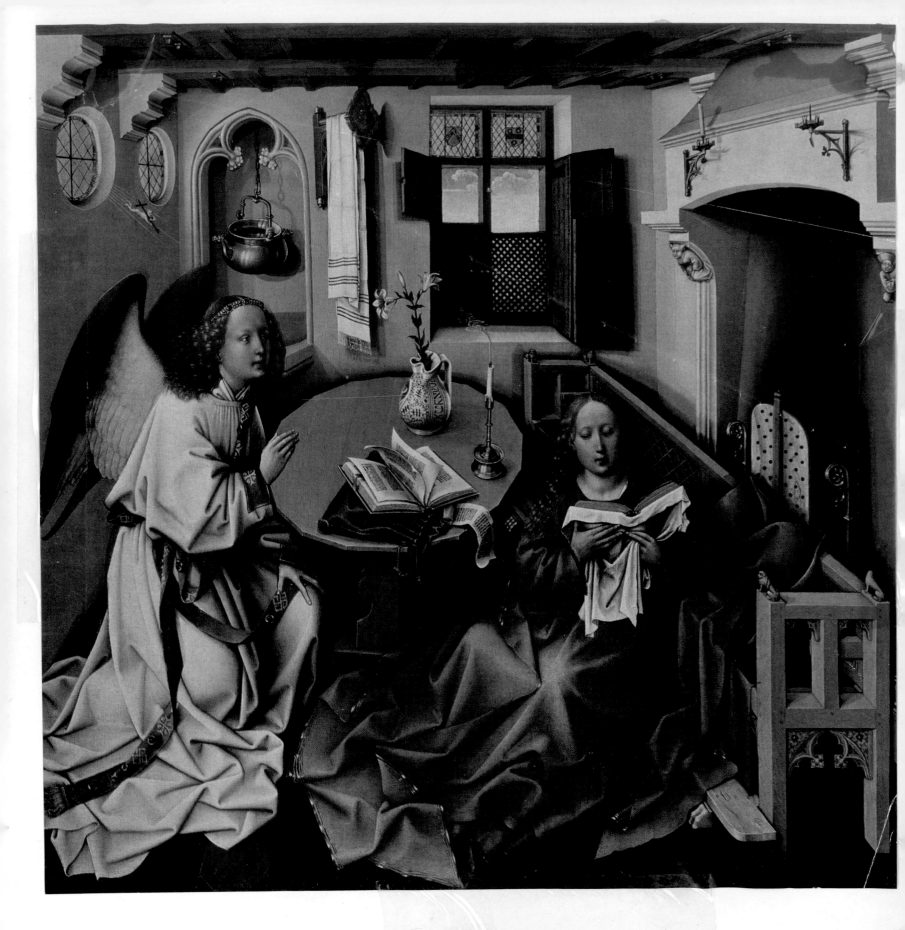

CHAPTER FIVE

A CONTEMPORARY RIVAL OF THE VAN EYCKS: THE MASTER OF FLÉMALLE

As I have already pointed out, it would be a mistake to imagine that the Van Eycks were isolated artists. They had some accomplished predecessors and some notable contemporaries, of whom the Master of Flémalle was the most important.

The paintings attributed to the Master of Flémalle are close in style to those of the Van Eycks, but differ in a less idealised approach, more precise forms and more brilliant colours. The anonymous artist was given his name because three of his most important works were supposed to have come from the Abbey of Flémalle. In fact there was no such place. The core of his work consists of four paintings in the Städelsches Kunstinstitut in Frankfurt: *The Virgin, St Veronica, The Trinity* and a fragment of a *Crucifixion*.

These four works are obviously by the same artist. They contain some medieval elements, and yet at the same time there is a strong preoccupation with conveying the material nature of things. Specifically medieval features are the monumental figures, inspired by sculpture, and the way in which detail with a purely decorative function is liberally introduced. On the other hand, there is a much more modern feeling about the relief, which is almost tangible. But where use of colour is concerned, the Master of Flémalle learnt nothing from the way Van Eycks relate one colour to another, nor from the subtle gradations which they use to link objects to each other, and so bring them into the general atmosphere of a picture. He sees objects individually and paints them as they occur to him. Naturally he puts them in specific parts of the painting, but each one assumes as much importance as the next. He places as much emphasis on an article of clothing as on a face; he paints a vase with as much care as a hand; a landscape in the background is painted with as much concern as a principal figure. Each object has an outline which isolates it from its context and emphasises its nature. Hands painted by the Master of Flémalle are less fleshy than those of the Van Eycks, and reveal solid bone structure. His visual matter is dense, and he uses the thinnest of impasto for the contours. His very individual colour sense often heightens the heroic character of his figures. In the Frankfurt *Virgin*, the white of the dress and cloak turns to milky blue in the shadows, and the radiant figure stands out against the pink background emblazoned with gold chimaeras. The blue of the Christ Child's robe is the only vivid moment in this impressive painting.

There is one particular point of technique visible in *The Nativity* and *The Marriage of the Virgin* (which will be discussed later), and that is the delicate white impasto on the facial features, and the way in which the lighter passages on the folds of the cloak are painted, with tiny parallel strokes. Similar strokes, added before the paint was completely dry, are also visible in the Frankfurt *St Veronica* in the highlights of the saint's voluminous red dress. In the same way the saint stands out against the white, gold and grey of the background fabric.

The Frankfurt *Trinity* is a *grisaille* of imitation sculpture, so much so that the edge of Christ's garment

73

is half a centimeter or some three-eighths of an inch deep. The artist has not attempted to think in terms of a fabric, but of real stone, and he executes this effect more cleverly than in the two saints John on the volets of *The Mystic Lamb*. The most striking feature of the fragment of *The Crucifixion* at Frankfurt is the way in which the contours of the body of the crucified thief are extremely soft, whereas the features of the two bystanders are emphasised by the addition of definite lines.

The degree of insistent severity (*hostinato rigore*, as Leonardo da Vinci wrote on one of the drawings at Windsor Castle) with which forms are treated does not prevent the artist from expressing the emotion which he feels when he contemplates his subject. He shows respect for the nobility of his image of the Virgin, muted pain in St Veronica holding her veil with the sad face of the Saviour, and pity in God the Father presenting His murdered Son to mankind.

All these characteristics can be seen in several other works whose style is clearly related to that of the Frankfurt paintings. Most notable is *The Nativity* at Dijon. In spite of its small size, the work shows more concern with the decorative effect than with the subject itself. The artist deliberately fills the entire painting with shapes and colours, which he attempts to harmonise, but without conspicuous success. There is a certain amount of harmony – and not only in the musical sense – provided by the three angels in the sky who sing *Gloria in Excelsis Deo*. The three large areas of colour of their robes support the decorative harmony of the picture. The red, green and blue are exactly the same basic colours used for the three main characters in *The Mystic Lamb*, and they reappear in the main group here. St Joseph's cloak is crimson, picked out with faint white brushstrokes, and his cape is sky blue; the tunic of the midwife who is standing is pale blue and, towards the hem, a beautiful vermilion edged with green. The colour softens in the yellow bodice of the kneeling midwife and in the creamy white of the Virgin's dress with its soft blue shadows. White dominates, as in the Frankfurt paintings. It is most vivid in the Virgin's dress, the women's hair and the sky. The picture has recently been cleaned, and the colours are altogether brighter than in the work of the Van Eycks. They are perfectly in keeping with the sincerity of the artist's conception of his subject. The cleaning has also brought up the idyllic landscape, which is handled in a completely different way from that of *The Mystic Lamb*. The details are placed against a clear, luminous sky in which the sun is like gold leaf. Some things are entirely true to life, such as the willows, half of which are pollard and half still have all their leafless branches. But the plausibility of the entire work is undermined by its lack of unity – a unity which the Van Eycks had already achieved elsewhere. The handling of the landscape is perfect, but it is not linked to the rest of the picture by any delicate gradation of tone. It suddenly emerges behind a hill painted the same colour all over, and it bears no relation to the hill itself. The artist has not the feeling for space which the works of the Van Eycks had at the same time. All the same, one must admit that his treatment of landscape is far in advance – both in accuracy and objectivity – of that of the miniaturists who directly preceded him.

The artist's feelings are often reflected in the sincerity of his composition and his clear-cut forms. One sees this particularly in *The Annunciation* in the Cloisters at the New York Metropolitan Museum. The work came from the famous Belgian family of Mérode, and a simpler version, less carefully painted, is in the Musées Royaux in Brussels (19). One can see that the Master of Flémalle has thought about the subject a great deal; that he has steeped himself in the meaning of it. The first light of dawn enters the little room where the Virgin has spent the night in prayer. The candle on the table has just been put out and is still smoking. An angel has appeared and has told the young woman his disturbing news: through her, God will be born. The painting has all the atmosphere which surrounds a great event, hence the restrained gestures, the clarity of the light and the sober use of colour. Through the unpretentious décor – a contemporary room full of familiar objects – the action and the emotions become real for us. Although he is portraying the most solemn moment in the Redemption of mankind, when God became man, the artist insists on natural simplicity. He even shows us on the right volet, in an adjacent room, the carpenter Joseph peacefully employed making mousetraps. One of them rests on the

work-bench, another on the shutter, which is open to reveal the market place of a town. In this triptych the artist is at pains to show the volume and texture of objects with a much sharper perception than that of the Van Eycks. He has deliberately included several of them to conceal the shortcomings of his perspective, as if to fill the vacuum of his space. One sees how much better – through graded tonalities – the Van Eycks conveyed the intimacy of a room in, for example, *The Birth of St John the Baptist* in the Turin and Milan Hours.

Despite its small dimensions, *The Madonna in Glory* at Aix-en-Provence retains the impressive quality of the Frankfurt works. It has also the same technique and general brightness. One notices particularly the Virgin's blue cloak, the vermilion throne, the mauve of St Augustine's cape and the red of St Peter's cloak. One also notices the light impasto on the facial features and the tiny white brushstrokes on the lighter parts of the clothing.

This seems to be the least successful of the Master of Flémalle's output, however. Some people are even inclined to classify it as one of his earliest works, but an earlier painting is surely *The Deposition* in the Seilern Collection in London. This painting was discovered in a London sale in 1944 and one clearly sees, in addition to several of the artist's characteristics, a direct relationship to the international style current at the beginning of the fifteenth century. The subject matter is seen almost as through the eyes of a miniaturist. There is no organisation of the figures and absolutely no sense of space. The lack of perspective and the gold background give the impression of one of the small funerary monuments produced by the School of Tournai, and of which many survive in museums and churches.

In *The Virgin and Child before a Firescreen* of the Salting Bequest in the National Gallery in London, the solidity of the shapes is even more accentuated – as in the Frankfurt *Virgin* and *St Veronica*, and the artist's realistic approach is particularly evident in the heavy folds of the dress, the firm contours of the flesh – picked out in black – and in the wicker screen, which also acts as a halo for the Mother of God, in front of the fireplace.

The Master of Flémalle can portray reality with unflinching fidelity, but he scarcely manages to create space. Attention has been drawn to this already, but *The Marriage of the Virgin* in the Prado is another example. The two architectural units have no real depth, they are completely unrelated to each other, and out of proportion to the figures. The artist fails to see man in direct relation to his environment. The grouping of the figures is boldly dynamic, but there is neither overall unity nor any attempt at geometric construction. Fingers and certain other shapes – such as that of St Joseph in the Temple, on the left – have a hard outline, and yet the colours shade off at the contours, and even the impasto, heightened with white, was done before the paint was dry, so that it is absorbed to some extent by the adjacent colours.

Handling of space improves in two volets of the triptych in the Prado – *The Donor Van Werle with St John the Baptist and St Barbara* – where the convex mirror doubles the spaces in its reflection. Here the artist has obviously tried to stick as close as possible to reality. He has included numerous shadows, as in the New York *Annunciation*. A statuette, a candle, a vase and a bottle each cast two different shadows, showing that the light comes from two different sources. In the Prado *Marriage of the Virgin* the statuettes cast three different shadows. These two volets are the only dated works of the Master of Flémalle, and have the late date of 1438. By this time he must have had the opportunity of seeing works by the Van Eycks, and in particular *The Arnolfini Marriage* by Jan van Eyck, which contains the model for the convex mirror reflecting the part of the room not visible in the rest of the painting.

In the Master of Flémalle's portraits the clarity of shapes so characteristic of his style is even more evident than in his anecdotal paintings. He uses paint with a more even consistency than the Van Eycks, so that the flesh is more solid and at the same time more supple than that of Jan van Eyck. He even goes so far as to show each individual hair of a young man's beard, with minute brushstrokes in several directions. In this context the Berlin *Man with a Double Chin; or Portrait of a Fat Man* is a remarkable

XI The Master of Flémalle: *The Nativity*
Detail of the landscape from 51 (p. 83) Musée des Beaux-Arts, Dijon

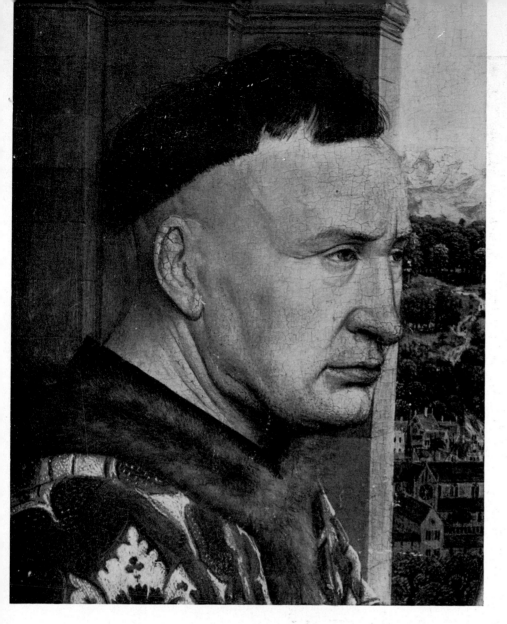

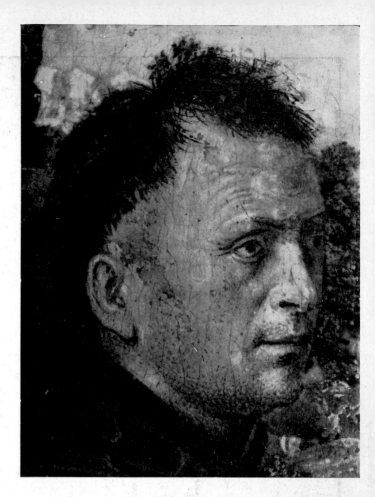

39 Jan van Eyck: *The Madonna with Chancellor Rolin*
Detail showing Chancellor Rolin's head. Louvre, Paris

40 and 40a Jan van Eyck: *St Francis receiving the Stigmata*
Details of 35 (p. 66) showing the head of St Francis and a section
of the rocks in the upper right-hand corner of the picture.
J.G. Johnson Collection, Philadelphia Museum

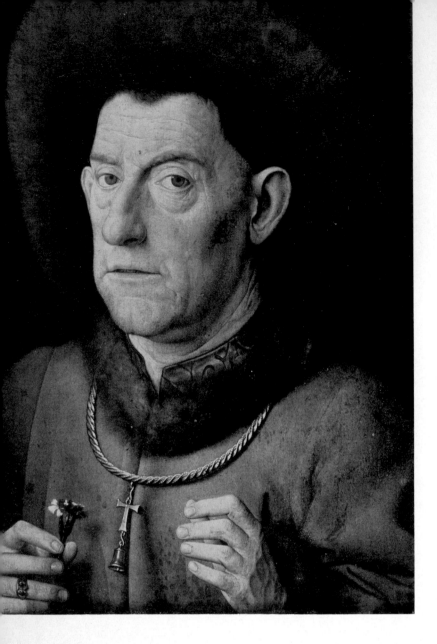

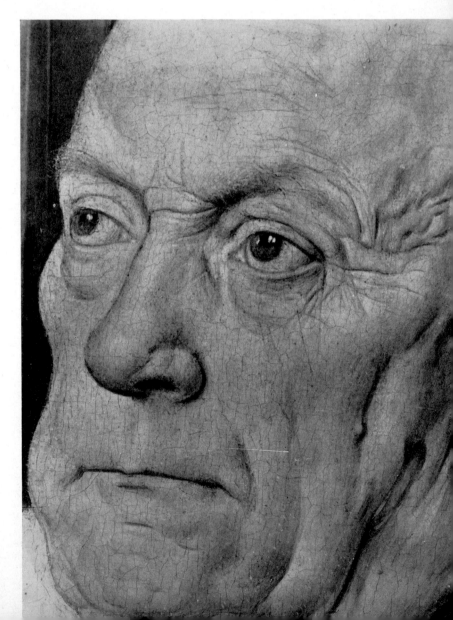

42 Jan van Eyck: *The Madonna with Canon van der Paele*
Detail showing Canon van der Paele's head from
colour plate VIII (p. 53). Groeninghe Museum, Bruges

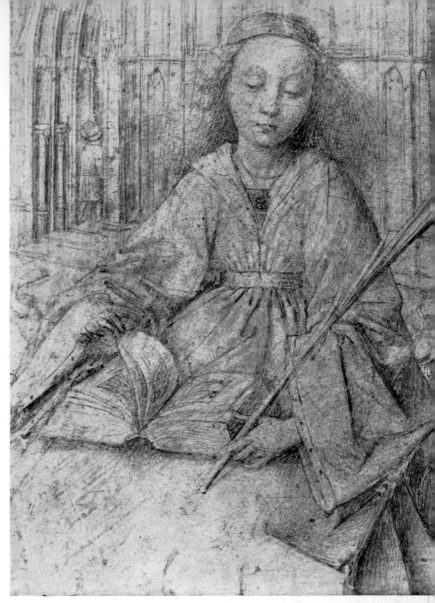

43 Jan van Eyck: *St Barbara*
Detail. Musée Royal des Beaux-Arts, Antwerp

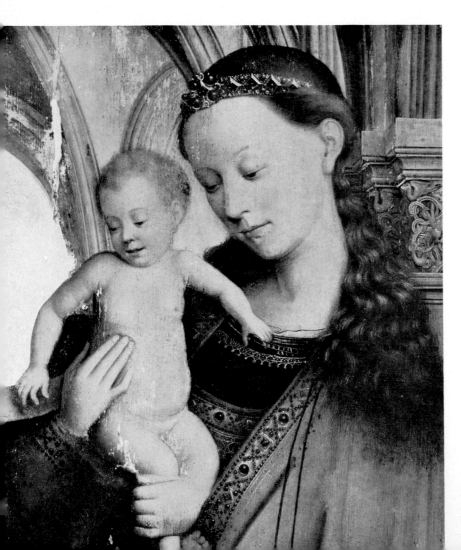

44 Jan van Eyck: *The Madonna with Provost van Maelbeke*
Detail showing the Virgin and Child. This photograph
was taken after the painting was cleaned, but before res-
toration. Private collection, New York

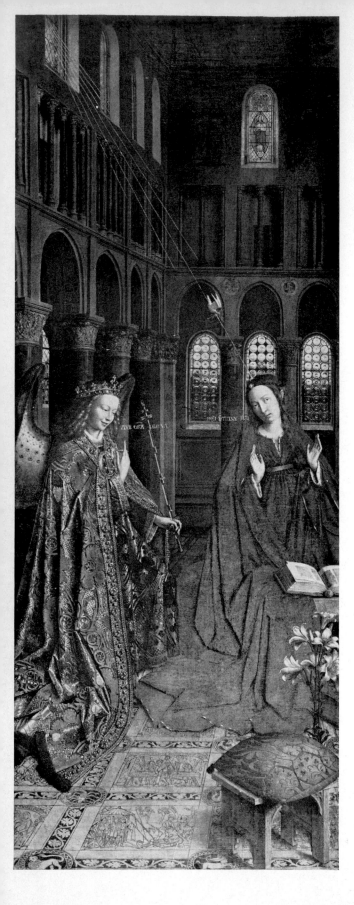

46 Jan van Eyck: *The Virgin and Child in a Church*
Gemäldegalerie, Dresden

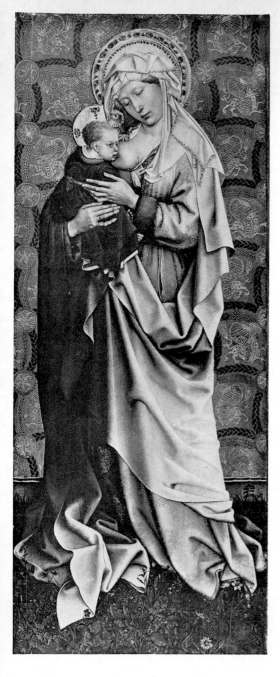

47 The Master of Flémalle: *Virgin and Child*
Städelsches Kunstinstitut, Frankfurt

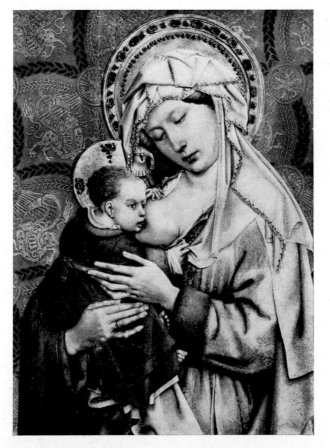

48 The Master of Flémalle: *Virgin and Child*
Detail of 47. Städelsches Kunstinstitut, Frankfurt

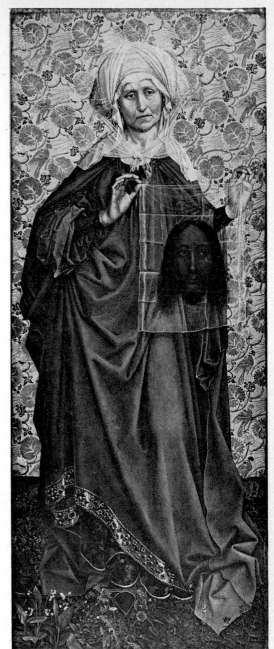

49 The Master of Flémalle: *St Veronica*
Städelsches Kunstinstitut, Frankfurt

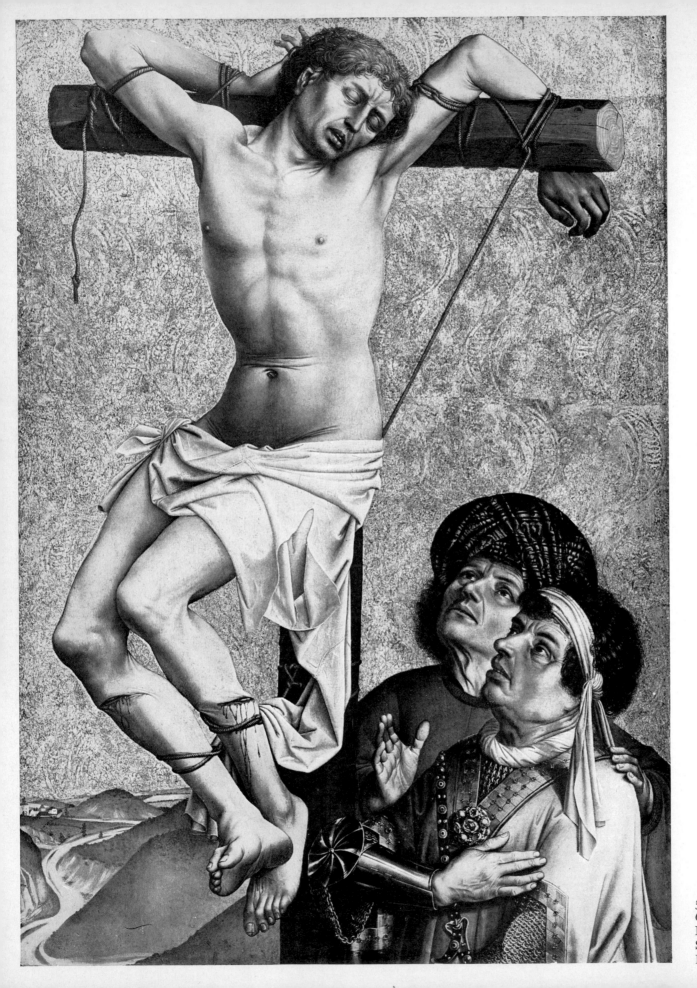

50 The Master of Flémalle:
Crucifixion (fragmentary)
Detail showing thief on cross.
Städelsches Kunstinstitut,
Frankfurt

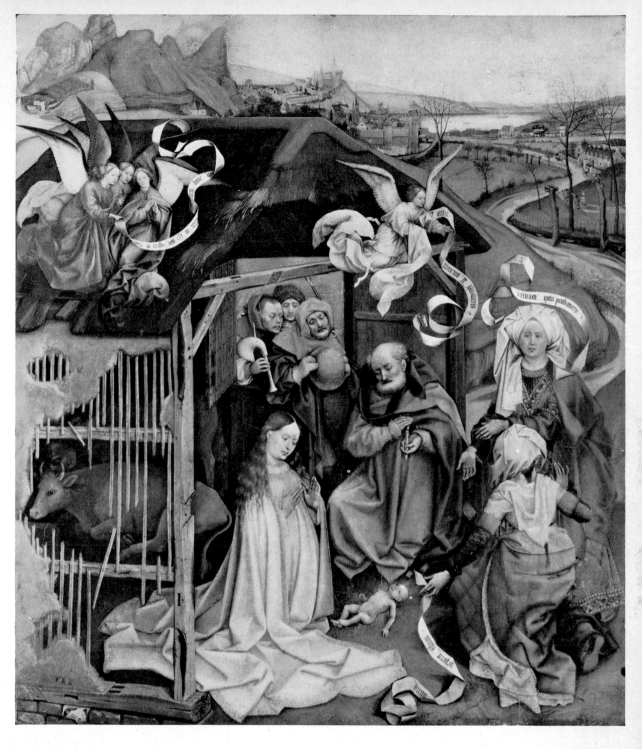

51 The Master of Flémalle: *The Nativity*
A detail of the landscape is shown in colour plate xi (p. 76). Musée des Beaux-
Arts, Dijon

52 The Master of Flémalle: *The Nativity*
Detail showing the heads of the shepherds from 51 (previous page). Musée des Beaux-Arts, Dijon

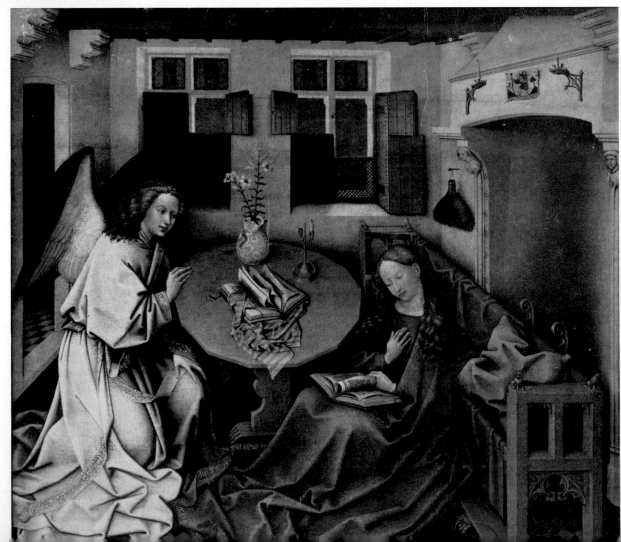

53 The Master of Flémalle:
The Annunciation (central panel).
For another version, see colour plate x
(p. 72). Musées Royaux des Beaux-Arts,
Brussels

piece of work. If it really is by the Master of Flémalle – and the fact is by no means certain – one must admit that he has surpassed the Van Eycks. Just as remarkable is the recently discovered portrait of a young man in the Katz Collection at Dieren. It is by the same artist as the Berlin portrait, but it is superior in its approach to reality, its richness of tonality, and its choice of a light ground, which neither Jan van Eyck nor Roger van der Weyden used.

☆

Who, therefore, was the Master of Flémalle? Attention has been drawn to his sculptural qualities, and therefore connections with sculptors have been sought. Burgundian art, and in particular the work of Klaus Sluter, has been considered, especially since M.J. Duverger showed that Sluter worked in Brussels before settling in Dijon (20). But the Master of Flémalle's form is generally less powerful than that of Sluter. In fact he has more in common with the School of Tournai. There were many skilled sculptors working in Tournai when the Master of Flémalle was a youth, and they carried on a tradition three hundred years old. Attention has already been drawn to similarities between their work and certain works of the Master of Flémalle.

Roger van der Weyden was born at Tournai, and some scholars (21) see his hand, as a youth, in the output of the Master of Flémalle. The arguments are not convincing. Similarities in faces, hands, noses and eyes have been pointed out, but that proves nothing. It is well known that artists borrowed such features from each other quite openly. The really important thing is to distinguish the artist's true personality, his soul, his style and his idiosyncracies – in fact his own particular way of seeing and painting. When looked at from this point of view, the paintings attributed to the Master of Flémalle are quite different from those authentically attributed to Roger van der Weyden. The former have a constant preoccupation with reality, the latter a marked tendency to idealisation. A similar divergence of aims is evident in the use of colour. Colour is one of the major factors in any consideration of painting. The Master of Flémalle's style is more applied, the colours more distinct, and he makes frequent use of impasto. Roger van der Weyden is the opposite. Of course, a certain heaviness could be regarded as normal in his earlier works, but there we are dealing with such fundamentally personal characteristics that they remain constant throughout the whole of an artist's career.

In establishing the identity of the Master of Flémalle, one is obliged to turn to the person of Robert Campin – as Dr H. Beenken has done in exhaustive fashion – and as indeed have most interested scholars.

Not one signed or authenticated work by Campin survives. The murals discovered in the Church of St Brice at Tournai, where he worked, are surely not by him, and in any case they are only fragmentary. But some of the documentary evidence available about him would seem to permit attribution of the works assigned to the anonymous Master of Flémalle (22).

Robert Campin was born at Valenciennes in 1375 and enrolled as a master at Tournai as of 1406, which makes him a contemporary of the Van Eycks. Roger van der Weyden and Jacques Daret became two of his apprentices, the first in June 1426, the second in 1427. Campin is mentioned several times at Tournai with the title of master, until his death in 1444. He was invited to design robes for the magistrates, paint banners and statues and give his opinion on various artistic matters. Like Jan van Eyck, he was not averse to carrying out interior decoration. He was known at Tournai as a painter of *platte peinture*, meaning a painter on panels. The dean of the guild of artists of Ghent apprenticed his son, Jan

de Stoevere, to Campin in 1415. Stoevere became an artist at Ghent, and is known for his *Life of the Virgin* and *Last Supper*. We also know that Robert Campin was to make '*le patron de la vie et passion du dit Monseigneur saint Pierre, pour monstrer icelui à plusieurs Maistres, pour en marchander et trouver le meilleur marchiet que faire se porra, et en avoir eu son advis et conseil*' ('the pattern of the life and passion of the said Lord St Peter, show it to several masters, to sell it and find the best possible market, and to have had his advice and counsel') (23).

CHAPTER SIX

THE ADVENT OF DISTINCTION:
THE ART OF ROGER VAN DER WEYDEN

In his day, Roger van der Weyden was almost as famous as Jan van Eyck, whom he survived by some twenty years. There are in fact similarities between the two, but then there are also similarities between Van der Weyden and the Master of Flémalle – so much so, in fact, that some people have been inclined to attribute the latter's output to Van der Weyden's early period. The question could be debated *ad infinitum* if one were to accept doubtful attributions. Many books and articles have been devoted to Roger van der Weyden, and in them some hundred paintings of widely differing style are attributed to him. Hence the difficulty in defining his typical style. Not one work signed by him has survived, so in order to have a clear idea of his style one must make a careful study of the few works which can be definitely attributed to him on the strength of relevant documents.

One of the first such works is the Miraflores Altarpiece in the Berlin Museum, where it is known as the Altarpiece of the Virgin. There are three panels of equal size: *The Nativity*, a *Pietà*, and *Christ appearing to the Virgin Mary*. The altarpiece was acquired from the charterhouse of Miraflores, near Burgos in Spain. According to Antonio Ponz' *Viaje de España*, published in 1783 (24) – at a time when Roger van der Weyden was virtually forgotten – a local tradition attributed the work to a Flemish artist called Rogel. Ponz goes on to say that, *segun se cuenta* (according to tradition), the painting was given to the monastery in 1445 by King Juan II of Castille, to whom it had been given by Pope Martin V. Since Martin V died in 1431, the altarpiece must have been painted before that date. Some scholars doubt the truth of all this, because Van der Weyden was only enrolled as a master painter in 1432, and they therefore feel that he could not have painted the work before then. In any case, they think that the work is unworthy of Van der Weyden. In reply to the first objection, Van der Weyden spent a long time in Robert Campin's workshop – much longer than the usual term of apprenticeship, and he could quite well have painted a work for himself before obtaining his mastership. Strict as the rules of the guild of artists were, they were not always strictly observed. This must have been the case in a workshop such as that of Campin, who was never one to worry about rules and regulations. But there is no answer to the charge that the work is very inferior to the best paintings attributed to Roger van der Weyden. Compare it to the work next to it in Berlin, the Altarpiece of St John the Baptist, which has the same dimensions but is beautifully painted with bright, glowing colours. One is immediately struck by the general heaviness, and even more by the dark colours, of the Miraflores Altarpiece. The Virgin's robe in the *Pietà* is dark red; so is the cloak of St Joseph, with blue in his hood, and the same colours appear in the flanking panels. The angels in the upper register are painted entirely in monochrome – two in blue and one in mauve.

There is an identical copy of the work still in existence, though now dispersed. Two panels, *The Nativity* and the *Pietà*, have been removed from the royal chapel in Granada and are now in the museum there, and the third is in the Metropolitan Museum in New York. Should one therefore regard the Miraflores Altarpiece as a copy by a less competent artist? One can safely accept the local tradition, and

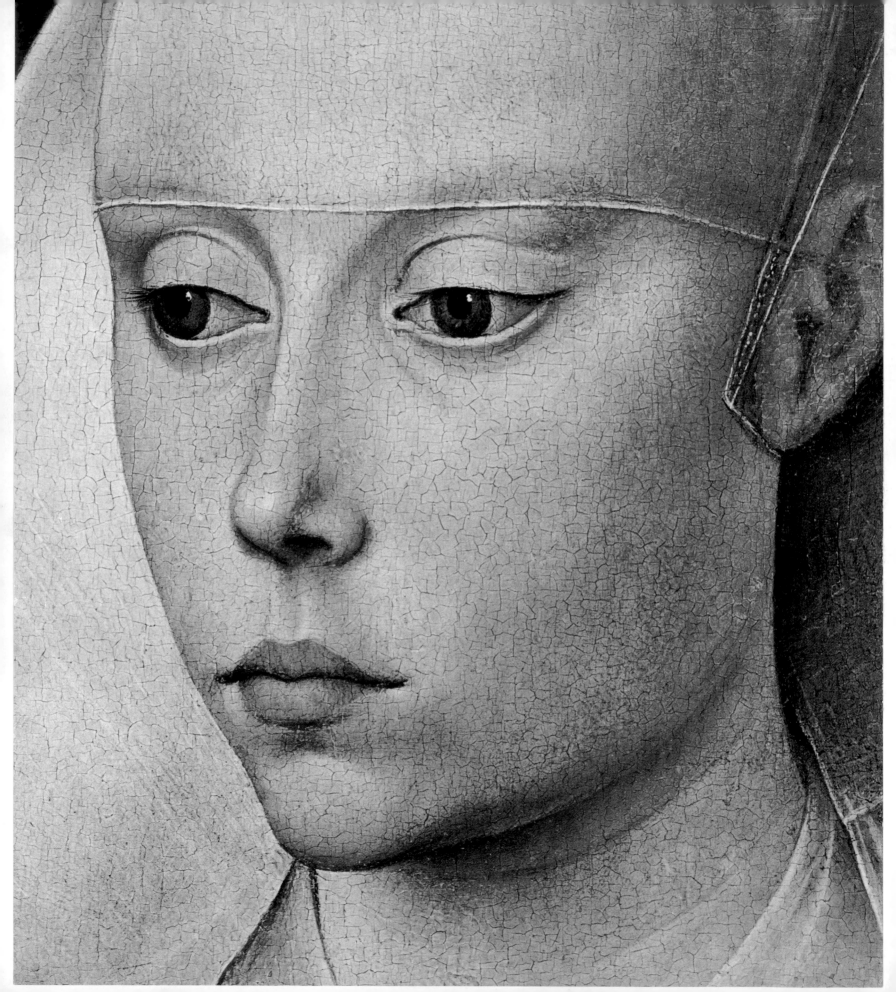

assume that the Berlin Altarpiece was painted by Van der Weyden before 1431, and that the other one is a later version by the same artist, painted when he had decided – as we shall see – to lighten his general range of colours. The Miraflores Altarpiece thus takes on historical significance. It is the earliest work by Roger van der Weyden which we can date.

There are many details in it which recall the Master of Flémalle, in whose workshop Van der Weyden could have painted it. The shapes are precise, and the technique somewhat hard; moreover the colours, such as mauve, and those chosen for St Joseph – red cloak and blue hood – are those used in the Master of Flémalle's *Nativity.*

A second picture which may be attributed to Roger van der Weyden – this time without reservation – is *The Descent from the Cross,* originally in the Escorial and now in the Prado in Madrid. Karel van Mander, the late sixteenth-century Flemish historiographer, mentions a *Descent from the Cross* in his book on artists – *Het Schilderboeck* – published in 1604, by one Roger of Brussels, in the Church of Notre Dame-hors-les-Murs at Louvain (25). His brief description corresponds with the painting in the Prado, apart from details. Van Mander frequently makes such mistakes, however. He also says that the painting was sent to the King of Spain, and in fact a similar work is mentioned under the name of 'Rugier' in the inventory of the collection of Philip II in 1574. The name Roger also appears on an engraving based on the work, made by Cornelius Cort in 1563, and signed Roger. Finally, there still exists, in the Church of St Pierre at Louvain, a small copy known as the Edelheer Triptych. A contemporary inscription gives the date of 1443. At the end of the sixteenth century the historian Molanus of Louvain mentions this copy as being the work of *Magister Rogerius* (26). Molanus was only interested in the subject matter as Van der Weyden had painted it, and was not particularly concerned about its authenticity.

From all of this, the well-authenticated *Descent from the Cross* in the Prado is generally regarded as Van der Weyden's most important work. There are two main reasons. In the first place, for a long time it was the only work which could be attributed to him through precise documentation. Secondly, it appeals directly to the onlooker, and its controlled, direct composition easily registers on one's consciousness. All the same, it is not the artist's masterpiece. He may well have been following Jan van Eyck's example and livened up the colour. Or he may well have been influenced by the Master of Flémalle and showed more concern for the inner life than for the outward aspect of things. At the same time, he succumbs to the Master of Flémalle's tendency to sculptural forms and wide variety of colour. The whole atmosphere of the work seems to be very much under the influence of the master sculptors who were so active in Louvain. In fact it almost seems like a polychrome high relief on a neutral ground. Possibly Roger van der Weyden was consciously attempting to paint the equivalent of one of the carved altarpieces which were so commonly produced by the School of Tournai. It must also be pointed out that although the artist has made a very laudable attempt at conveying the feelings of the characters, he is nevertheless a long way from reaching full expression of his own personality in this field.

In attempting to date the work one can determine the point before which it must have been painted. The copy in the Church of St Pierre in Louvain was restored in 1859 by Étienne le Roy. In the areas which he did not repaint one notices that the contours are very heavy, the shapes lack clarity, and the colour lacks vigour. The outside of the right volet has a contemporary inscription: '*Dese tafel heeft veree[r]t, he[re]n Wille[m] Edelhee[r] en Alyt syn werdinne int iaer ons he[re] MCCCC en[de] XLIII*' ('This picture was given by Lord Willem Edelheer and Alyt his wife in the year of Our Lord 1443'). Willem Edelheer was master of the crossbowmen, whose guild possessed *The Descent from the Cross* now in the Prado, but formerly in the little Church of Notre Dame-hors-les-Murs at Louvain. The donor probably wished for a smaller copy of the work to be placed over his tomb in St Pierre. The wish was carried out in 1443, four years after his death. From this one can prove that Van der Weyden's *Descent from the Cross* had been painted by 1439, the year Willem Edelheer died.

The third picture which can legitimately be included in the Van der Weyden catalogue is the portrait of Lionello d'Este, which went with the Friedsam Collection to the Metropolitan Museum in New York. An entry in the archives of Ferrara records that on 13 December 1450, '*M. Rugiero depinter in Bruga*' was paid twenty golden ducats for '*certe depincture delo illustrissimo olim nostro S[ignore] che lui faceva fare a Belfiori*' ('a certain painting of our late most illustrious lord which he commissioned him to do at Belfiori') (27). At that time the lordship of Belfiori belonged to Lionello d'Este. The subject of the portrait may be identified by comparison with medals and with another portrait painted by Pisanello in the Morelli Collection at Bergamo. Therefore the portrait is not that of Meliaduse d'Este, as has been maintained (28). It must have been painted when Van der Weyden was in Italy in 1450. The very light use of colour seems even lighter because of the beautiful creamy background, and the stylisation of the hands verges on exaggeration.

A fourth painting, *Christ on the Cross with the Virgin and St John*, removed from the Escorial to the Prado in Madrid, is authenticated by a specific document. In the list of pictures given by Philip II to the Escorial in 1574, it is mentioned as being 'by the hand of Roger' and from the charterhouse of Brussels. '*Una tabla grande, en que está pintadó Cristo nuostro Señor en la cruz, con Nuestra Señora y San Juan, de mano de Maestro Rugier; que está el Bosque de Segovia; que tiene trece pies de alto y ocho de ancho; estaba en la cartuja de Bruselas*' (29). ('A large painting, depicting Christ Our Lord on the cross, with Our Lady and St John, by the hand of Master Rugier; Segovia wood; thirteen feet high and eight feet wide; formerly in the charterhouse at Brussels'). The first monks of the charterhouse at Brussels, from which this painting came (*la cartuja de Bruselas*), were from the charterhouse at Hérinnes, where one of Van der Weyden's sons was a monk. The artist made donations of money and paintings to the charterhouse of Brussels (30), built on its hill at Scheut, between 1450 and 1466. He must therefore have painted the work towards the end of his life.

M.J. Friedländer said that the work was in bad condition, and that it was therefore difficult to assess. It has in fact been restored several times, and I was able to see it in the Prado while it was being cleaned. It is 325 cms high and 192 cms wide (10 ft 8 ins × 6 ft 3 ins), and is Van der Weyden's largest picture. It is a priceless work. Christ's emaciated body, in shades of yellow and brown, stands out against a vermilion cloth whose broad, accentuated folds emphasise the verticality of the painting. The Virgin and St John are dressed in grey, with white highlights and touches of black in the shadows. The major interest lies in its freshness, the lightness of the colours and the softness of the contours. There is still evidence of a somewhat sculptural approach, but nevertheless Van der Weyden uses a light palette.

Christ on the Cross with the Virgin and St John in the Johnson Collection of the Philadelphia Museum, whose style is directly related to the preceding picture, is the fifth work which can be attributed through documentation.

Jean Robert, of the Abbey of St Aubert at Cambrai, records a commission given to Roger van der Weyden:

'*le XVI de juing, lan LV, je Jehan abbé marchanday à maistre Rogier de la Pasture, maistre ouvrier de paincture de Bruxelles, de faire I tableau de V piez en quarrure à II huysseoires, de telle devise que l'ouvrage le monstre. Se furent les devises faittes à plusieurs fois, et ossi il fist ledit tableau de VI pieds et demi de hault et de V piez de large pour le bien de l'œuvre lequel tabliau fut parfait à la Trinité lan LIX, se cousta en principal IIIIXX ridders d'or de XLIIIs. IIIId. la pièce, monnoye de Cambray, dont il fut tous payez du nostre à plusieurs fois*' (31).

('On the 16th June, in the year 55 [1455], I Jean the abbot commissioned master Roger van der Weyden, master painter of Brussels, to make a painting five feet square in two parts [2 doors] with such subjects as the work shows. These were subjects made several times before, and also he made the said picture six-and-a-half feet high and five feet long for the good of the work, which painting was completed on Trinity [Sunday] in the year 59 [1459], and cost in principal twenty-four

gold ridders of 43s. 4d. each in Cambrai currency, all of which was paid to him by us several times [in several instalments]').

A connection has long been recognised between this reference and another painting in the Prado, the Calvary Triptych, which had always been known as the Cambrai Altarpiece. Some people have been reluctant to agree, however, since they found thirteen subjects in the centre of the work instead of eleven. But they overlook the fact that '*II huysseoires*' does not mean 'eleven histories' but 'two doors *(huis)* or panels'. The Prado work is of course a triptych. M.E.P. Richardson's suggestion (32) that the work in the Johnson Collection could be the one ordered for Cambrai seems to be correct. It is clearly a work consisting of two *huysseoires* capable of being folded back on top of each other or, when opened out, forming a single picture. The unity is sufficiently obvious from the fact that the Virgin's dress on one of the panels is continued on the other. The dimensions more or less correspond to those mentioned in the text from the Abbey of St Aubert at Cambrai. Six and-a-half *pieds* by five gives roughly 211 × 162 cms (6 ft 11 ins × 5 ft 4 ins). When the Johnson diptych is open it measures 180 × 184 cms (5 ft 11 ins × 6 ft), which could be correct if we bear in mind the fact that in those days the frame was included in the dimensions, whereas today we only take the actual painted surface.

The work was delivered in 1459, and it serves – along with the Prado *Christ on the Cross with the Virgin and St John* – as a yardstick for Roger van der Weyden's last paintings. It is a muted, expressive work. Some critics, who have only seen reproductions, consider it a purely decorative work. It has recently been cleaned, and the fabric behind Christ, which had been painted over with black, is now pure vermilion. The upper part of the Cross, previously barely discernible, now appears against a gilded background. The delicate faces of the Virgin and St John are once more pink, and the grey and blue clothing has taken on body. This is surely one of the artist's best works, because of its light colouring, its simple shapes, and controlled expressions.

Here, then, are five works which can be attributed to Van der Weyden with documentary support. Although different in style, it is obvious that they are the product of the same mind. By comparing and contrasting, it will be possible to attribute others. But since we have so few dates it is not possible to attempt to plot the development of the artist's style. Some scholars have ventured to make an extremely detailed classification of the works, almost year by year, based on whatever progress they thought they could detect. These subjective opinions have finally become accepted as established fact. In this way the evolution of Van der Weyden's style was determined, and every newly discovered work was henceforth destined to have a definite place in the classification.

This sort of system – as I have already pointed out – is potentially dangerous because it goes from the lesser to the better works. Both psychology and experience show how wrong this method is. The artist is a man, and all human endeavour is subject to fluctuations. These may be of a spiritual nature or governed by time and place – or occasionally by purely technical factors. Van der Weyden changed his point of view and even his way of working, depending on whether he had to paint a large work or a small one.

An examination of the works most definitely attributed to the artist, however, reveals three broad divisions in his artistic career. First came the period when he was in direct contact with the works of the Master of Flémalle and Jan van Eyck. At this time he concentrated on the material nature of forms, using dark shades of colour, but also absorbing them into the general atmosphere of a composition (the Miraflores Altarpiece, before 1431; *The Descent from the Cross*, before 1439). Then came his visit to Italy, during which he lost none of his Northern personality but went for more direct form and more reasoned composition (the portrait of Lionello d'Este, 1450). Finally there are the last fifteen years of his life when he produced the two great masterpieces, the Madrid *Crucifixion* (between 1450 and 1464) and the Philadelphia *Crucifixion* (delivered in 1459).

54 The Master of Flémalle: *The Madonna in Glory*
Musée Granet, Aix-en-Provence

55 The Master of Flémalle: *The Crucifixion*
Staatliche Museen, Berlin

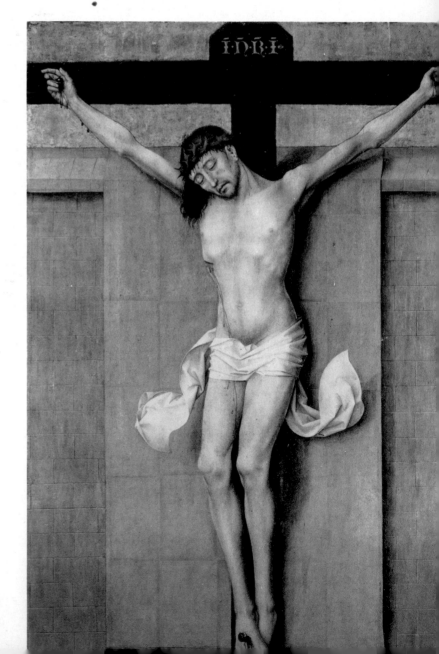

56 Roger van der Weyden: Detail showing the
Virgin and St John, left-hand wing of a diptych.
J.G. Johnson Collection, Philadelphia Museum

57 Roger van der Weyden: Detail showing the Crucifix,
right-hand wing of a diptych. J.G. Johnson Collection,
Philadelphia Museum

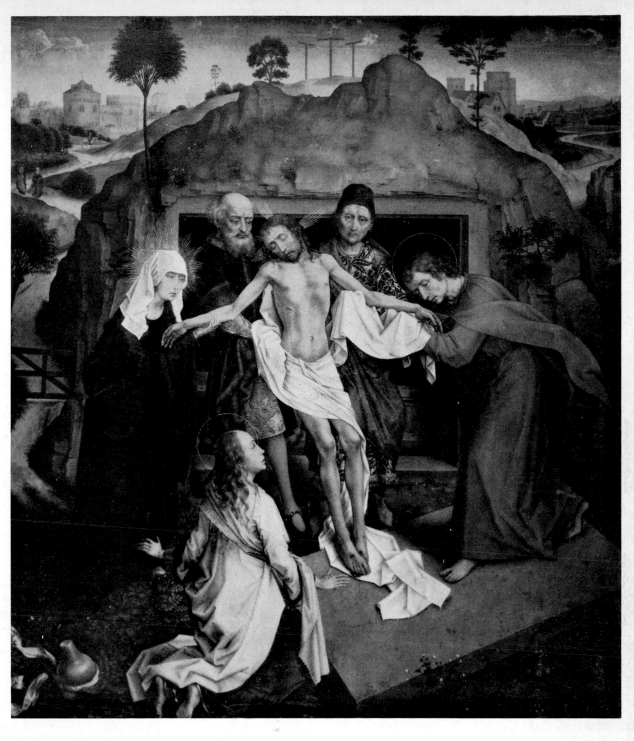

58 Roger van der Weyden: *The Entombment of Christ*
Uffizi, Florence

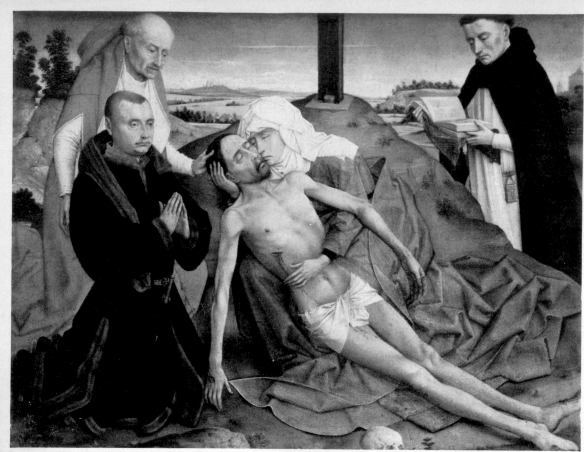

59 Roger van der Weyden: *Pietà*
Collection of the Comte de Paris, London

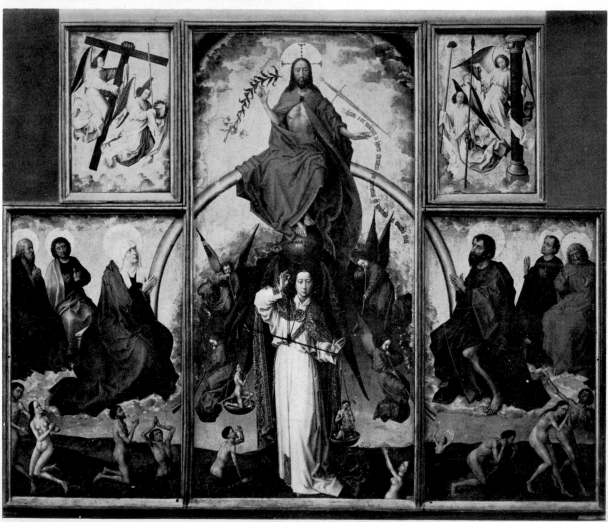

60 Roger van der Weyden:
The Last Judgment
Museum of the Hôtel Dieu, Beaune

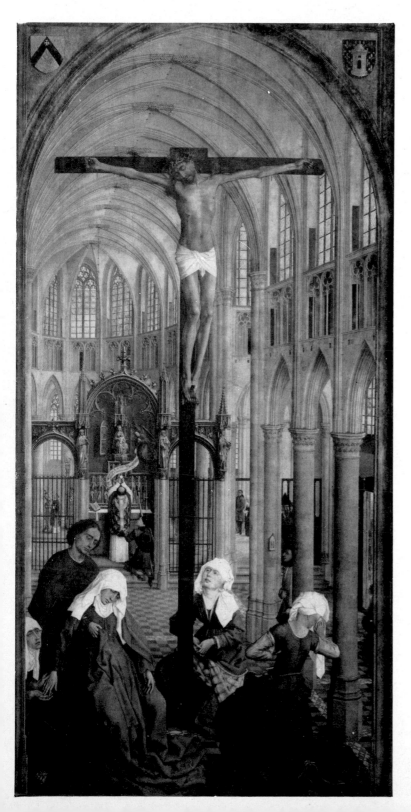

61 Roger van der Weyden: the Altarpiece of the Seven Sacraments. Detail showing Baptism, Confirmation and Confession. Musée Royal des Beaux-Arts, Antwerp

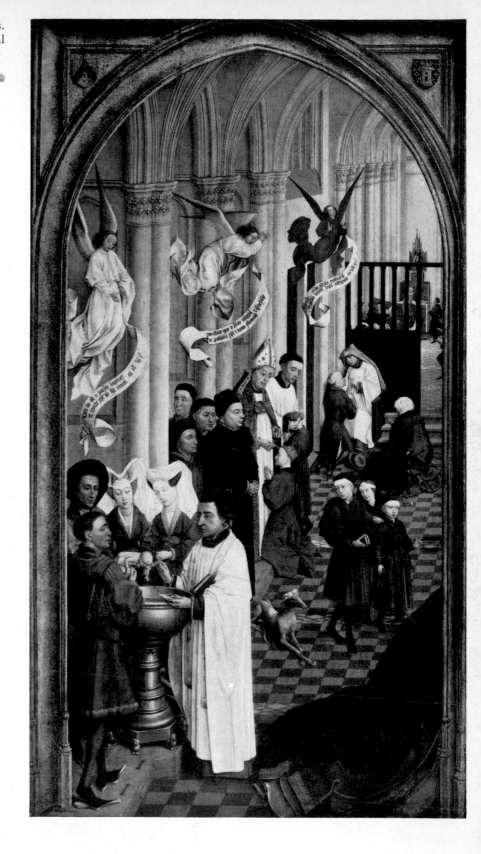

62 Roger van der Weyden: the Altarpiece of the Seven Sacraments. Detail showing the Crucifixion and the Eucharist. Musée Royal des Beaux-Arts, Antwerp

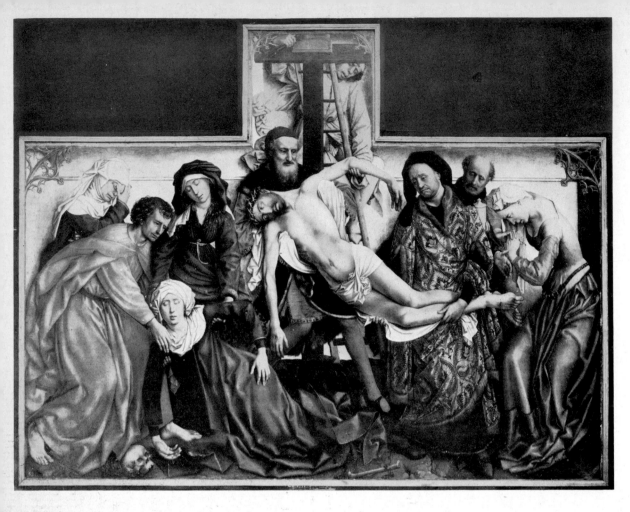

63 Roger van der Weyden: *The Descent from the Cross*
Prado, Madrid

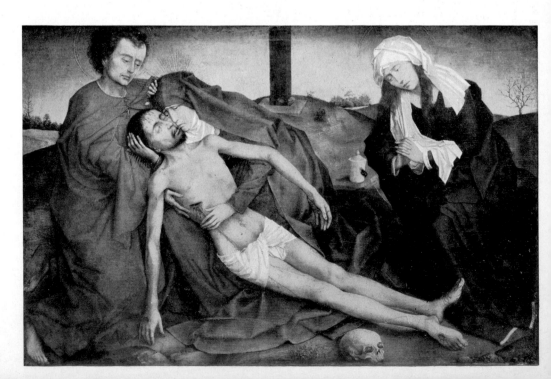

64 Roger van der Weyden: *Pietà*
Musées Royaux des Beaux-Arts, Brussels

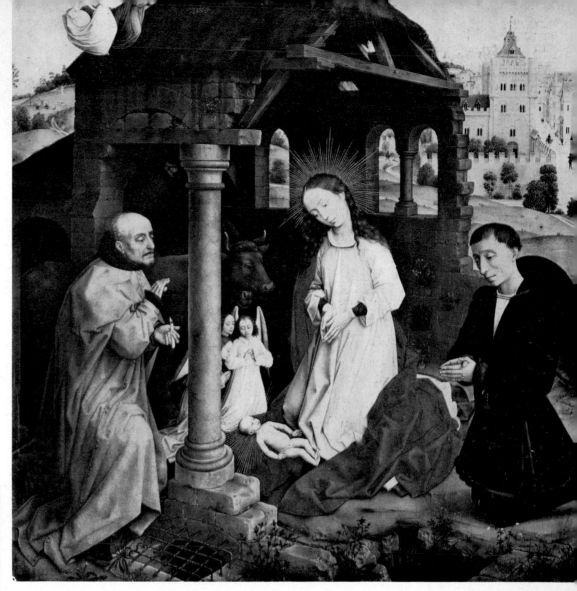

65 Roger van der Weyden : the Bladelin Altarpiece. Detail showing the Nativity on the central panel. For landscape detail, see colour plate XIII on p. 92. Staatliche Museen, Berlin

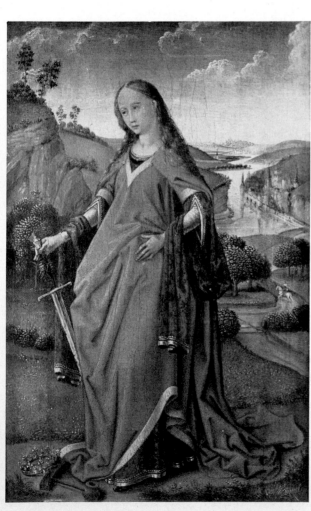

66 Roger van der Weyden : *St Catherine*
Kunsthistorisches Museum, Vienna

67 Roger van der Weyden:
St Luke painting the Portrait of the Virgin
Museum of Fine Arts, Boston

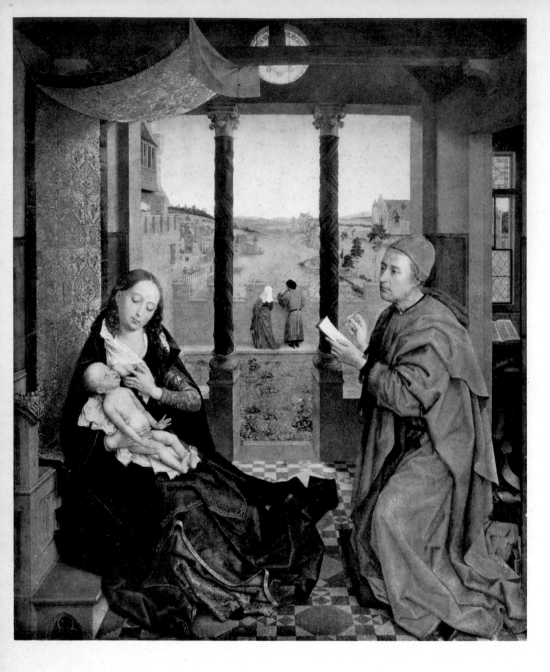

68 Roger van der Weyden: portrait of a woman.
Staatliche Museen, Berlin

Without following the chronology too closely, we can introduce into this framework several other first-rate works whose style and technique have similarities to one or other of the five documented works. We must be quite ruthless in ignoring any painting which does not bear the stamp of the artist's personality, otherwise we shall not be able to arrive at a clear conception of his essential style.

Taking the first two works mentioned (the Miraflores Altarpiece and the Prado *Descent from the Cross*), we see that *The Annunciation* in the Louvre is from the same period. It is the central panel of a triptych whose volets (*The Donor* and *The Visitation*) are in the Galleria Sabauda in Turin. Some aspects recall the precision of the Master of Flémalle, for example the diagonally placed bench, the reflections of the ewer, or the shadow cast by a wall bracket. Others, such as the feeling of space, are more reminiscent of Jan van Eyck. But the overall feeling is rather that of Roger van der Weyden, already expressing his individuality. His elegant silhouettes and his gentle, intimate approach are evident here. Nevertheless the picture is far from being a masterpiece. The shapes have no real volume, and the large zones of even colour betray too much concern for the purely decorative aspect.

A much more interesting work is *The Adoration of the Magi* in the Munich Pinakothek, which can also be included in this group. It is also placed towards the end of the artist's career. One very reputable authority bases his conclusion on the fact that Memlinc, who copied the work, could only have done so when, in his opinion, he was in Van der Weyden's workshop round about 1460. Another fact which should be taken into account is that the Church of St Columba in Cologne, from which the altarpiece came, was enlarged as of 1456. There is little point in stressing how inconclusive these arguments are. Memlinc could perfectly easily have worked from a drawing. As to the second point, Goddert von den Wasservass, who was the donor and burgomaster of Cologne from 1437 to 1462, could have acquired the work before the chapel in which he wished to be buried was even built. One does not find here the breadth of vision nor the simplicity of form and colour evident in the last two authenticated works by Van der Weyden. The colours are still intense, as in *The Descent from the Cross*, dating from before 1439 – particularly the red of the cloak, the violet of the dress and the lacquered dark red in the sleeves of the kneeling king. The wide variety of colours makes one think that the work was painted not long after *The Descent from the Cross*, when Van der Weyden began to discard the influence of the Master of Flémalle in favour of that of the Van Eycks, or even during his stay in Tournai before 1435.

Alongside *The Descent from the Cross* and *The Adoration of the Magi* one may put the two versions of *St Luke painting the Portrait of the Virgin* – one in the Boston Museum of Fine Arts and the other in the Munich Pinakothek. There is the same approach to form, identical colouring, and borrowing (for the composition) from Jan van Eyck's *Madonna with Chancellor Rolin*. The Munich version is a pair to *The Adoration of the Magi* and has the same quality of style and technique. I saw the Boston version before and after cleaning, and the red and blue of saint and Virgin respectively do not have the same rich quality as the red and blue in the Munich painting. Van der Weyden's individual shades of colour are already evident in the Munich work. The lighter reds in the saint's garments are almost pink, as are the highlights of his claret-coloured hat. Similarly the Virgin's dark violet robe has bluish patches where it catches the light. The Munich work is also much closer to Jan van Eyck's style than the Boston version. One should bear in mind that when Roger van der Weyden was working as Robert Campin's assistant at Tournai, Jan van Eyck was living in Lille from 1426 to 1428. He was ceremonially received by the Tournai guild of artists on 27 October 1427, and he returned on 23 March 1428. The two artists both worked for the Burgundian court. But although Roger van der Weyden can be said to have absorbed something of Jan van Eyck's style, he was far from being one of his disciples, as some old Italian scholars maintained. Bartolomeo Facio talks of '*Rogerius Gallicus, Joannis discipulus*', and Giovanni Santi mentions '*il gran Joannes, el discepol Ruggero*'. But of course one always has to be wary when old chroniclers talk about foreign artists.

There was an excellent opportunity to compare the Boston and Munich works when they were side

by side in the Flemish Primitives Exhibition at Bruges in 1960. Several critics think that the Boston work is the original and that the Munich version (which unfortunately has an old layer of bitumen over it), is a copy. In those days artists thought of themselves as artisans, and if a patron liked a particular work, they would make copies of it. In the event I believe the Boston work to be a copy of this sort from a later date, because the paint is more evenly applied and the colours are lighter and fresher.

The influence of the Van Eycks as far as colour is concerned is also evident in the Braque Triptych now in the Louvre, which may date from 1451, since the donor, Jean Braque of Tournai, died on 25 June 1452. His coat-of-arms is on the back of one of the panels. Only shortly before 1451, he married Catherine of Brabant, whose coat-of-arms is also on the back of one of the panels. The colouring of Christ, the Virgin, St John the Evangelist and St John the Baptist recalls the Van Eycks and the hieratic treatment visible in *The Mystic Lamb*. The colours are perhaps a little darker, with the heavier shadows verging on black, but the landscape is light. Despite his meticulousness, Van der Weyden does not succeed in integrating the figures. Only Mary Magdalene, on the right volet, fits into the light colouring of the landscape. She is painted entirely in light, delicate shades, with soft contours and transparent shadows.

The influence of the Van Eycks is again much in evidence in *The Last Judgment* in the hospital at Beaune in Burgundy. This work can unhesitatingly be attributed to Van der Weyden. The colours used for the principal figures – Christ, the saints around Him, St Michael, and those raised from the dead – are intense. The upper part of the sky is dark blue, and against it is set the vermilion of the Saviour's cloak; the violet robes of the four angels; several bright colours in the robes of the apostles; red in St Michael's cloak with its green lining; and the brown tints of those raised from the dead. The gold ground behind St Michael is not a concession to the archaic: its function is to mark the centre of the work. Originally it was situated above an altar at the end of the great ward of the hospital, where Mass was celebrated for the patients. The lighting at that point is particularly poor.

This huge polyptych (560 cms or 18 ft 4 ins when opened out) has scarcely any elements which can be traced to the Master of Flémalle, except possibly the sharply defined faces. The colour, however, still looks to the Van Eycks, but already it is tending towards the clarity which characterises Van der Weyden's mature works. The same is true of the elegance of form which Van der Weyden was to develop more and more.

There is no similarity of composition between the two subjects as seen by Roger van der Weyden and Hubert van Eyck. Here Van der Weyden owes more to medieval iconography and, like his medieval counterparts, is concerned with the pathos of the moment when the Supreme Judge, coming out of Heaven with those who took part in the Redemption of mankind, will pronounce the irrevocable word which will separate the just from the damned. Following the tradition of sculptors in medieval cathedrals, Van der Weyden has exaggerated the size of the celestial beings in relation to human beings. But he has given an old formula a new, acceptable idiom, without diminishing the feeling of grandeur at which he was aiming. This is why he does not fill his Hell with hideous, hairy devils, as do so many contemporary representations of the scene (33).

Vain attempts have been made at dating what is an important work. It must have been commissioned for the hospital where it still hangs, by the Chancellor of the Duchy of Burgundy, Nicolas Rolin, who appears on it as a donor. The hospital was founded by Rolin in 1443, and the painting could have been commissioned as of then. There are grounds for thinking that the altarpiece was finished before 1452, for St Antony the Hermit is depicted in it as patron saint of the sick, but on 1 January 1452 he was replaced as such at Beaune by St John the Baptist.

The Entombment of Christ in the Uffizi and *The Virgin with Saints* in the Städelsches Kunstinstitut in Frankfurt, should be classified with the portrait of Lionello d'Este, although the two styles do not have exactly the same characteristics. The portrait was probably painted in Italy in 1450. In fact the first

two works mentioned in this paragraph show an adaptation to the Italian style of composition. *The Entombment* is inspired by a work of Fra Angelico, and for the second painting there are several precedents in Florentine art. This policy of borrowing elements from other painters – though not very closely – shows that Van der Weyden was at pains to please his Italian clients. In any case the borrowings are entirely limited to composition, and did not influence the artist's subsequent production in any way. They tell us little about his style, and the technique is the same as that in the works unquestionably painted when he was in the Low Countries. *The Entombment of Christ* was, moreover, painted before 1450, since the learned Italian Cyriaco d'Ancona states that he saw it in July 1449 at Lionello d'Este's residence at Belfiori, near Ferrara. The technique is somewhat cursory, almost awkward, with impasto in the flesh-tints. The painting is covered with a layer of brown varnish which mutes the richness of the colour, though in fact there is much in common tonally with the Munich *Adoration of the Magi*. The red and blue in St John and the Virgin are sustained by the areas of green around them. Heavy colours also appear in the bronze of the old man on the right, the deep violet of the old man on the left, and the opaque brown at the mouth of the sepulchre. In fact the overall atmosphere has little in common with the portrait of Lionello d'Este, which leads one to suppose that *The Entombment* was commissioned in Brussels and painted before 1450. *The Virgin with Saints*, on the other hand, is generally much lighter, and would therefore seem to have been painted in Italy (34).

At the end of the artist's painting career, that is from 1450 to 1464, came the Prado *Crucifixion* and the Johnson *Crucifixion* in Philadelphia, as we have already seen. One can place various works by Van der Weyden with these two paintings.

First is the Altarpiece of the Seven Sacraments in the Musée Royal of Antwerp, which has the coats-of-arms of the bishopric of Tournai and Jean Chevrot, bishop from 1445 to 1460. Critics have tried in vain to disprove the attribution to Roger van der Weyden, but the general clarity of the work, the ease and elegance with which the figures are handled, and the subtle gradation of the shades of colour all suggest it to be one of the artist's last works. It is difficult to date, however (35).

The Bladelin Altarpiece in the Staatliche Museen in Berlin, also seems to date from this period. It comes from the church at Middelburg, near Bruges, a little town founded by Pierre Bladelin, Treasurer-general of the Duchy of Burgundy, and built between 1446 and 1450. The donor probably commissioned the work for this very church, after 1450. The limpid, relaxed style would seem to confirm this dating. It is not very complicated. The space is handled well and the figures relate well to each other. The colours are bright, but tone into the general lightness of the work.

Probably from the same period are the three *Pietàs*, of similar composition and almost equal quality. One is in the Prado, the second in Berlin and the third in the National Gallery in London, but previously in the Earl of Powis' Collection. The first two are painted with glowing colour. There is a translucent blue sky with large white clouds. St John's robe is very pale blue, and his cloak light green. The Virgin's clothing is claret-red verging on mauve, with a soft carmine in the donor's gown. The ground is light brown and the flat landscape brown, turning to grey. The paint is thick, but takes on the appearance of delicate porcelain. The technique is perfect. The same can be said of the London *Pietà*. Here, then, we have three versions of the same work by the same artist. There is no question of an original and copies.

To this group also belong two panels which I take to be the volets of an altarpiece – probably carved – which was originally in the St Hubert chapel, inaugurated in 1439, of the Cathedral of St Michel in Brussels. Writers in both the seventeenth and eighteenth centuries refer to it (36). One of the volets, in the National Gallery in London, depicts *The Translation of the Mortal Remains of St Hubert*. The other, *St Hubert designated Bishop of Liège* (also known as *Pope Sergius' Dream*), is at present part of the estate of Baroness von Pannwitz in New York. Because the composition of these two works is somewhat empty and the technique too meticulous, some critics have been inclined to contest the attribution to Van der Weyden.

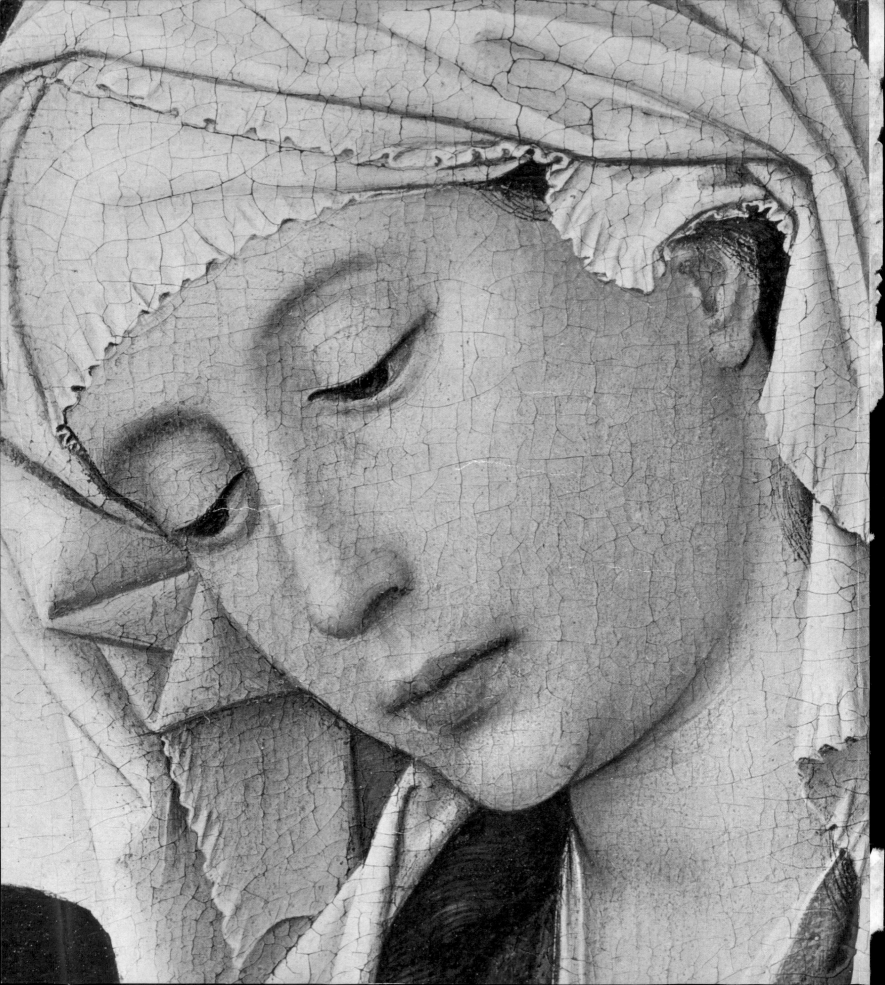

Another work in which the characteristics of the last years of the artist's life are apparent is *The Annunciation* in the Metropolitan Museum in New York. It is a large volet of a lost work. It shows that Van der Weyden was deeply concerned with refinement of both form and colour. The angel is not restricted to the rather unsatisfactory triangle traditional for a kneeling figure, and the red in the Virgin's dress is brightened with light carmine.

In the last ten years of his life, Roger van der Weyden painted several portraits which confirm the evidence of a remarkably sensitive mind at work. The portrait of Philippe de Croy in the Musée Royal of Antwerp, dates from this period. It must have been painted in 1459 or 1460, when the sitter, identifiable by his coat-of-arms on the back, was lord of Sempy, which is also mentioned on the back. At first sight the work would appear to date from an earlier period because the colour seems dark and flat. But it is covered with several layers of cracked and dirty varnish, and one has to look hard to see that the colour is in fact as fresh as that revealed by the cleaning of the portrait of Laurent Froimont (?) in the Musées Royaux in Brussels. This painting is the pair to *The Virgin and Child* in the Caen Museum, which is another reason for placing it in this group. The Virgin shows the delicacy which is the hallmark of the last works of Roger van der Weyden. The objection that the face of the Virgin in this painting is similar to the one in *St Luke painting the Portrait of the Virgin* is of no interest. Van der Weyden continued to use neither 'patterns' nor drawings, as some maintain, but living faces which he carried in his memory.

☆

How, then, do we define Roger van der Weyden's essential style? And first of all, how important is he?

One must admit that he never achieved Hubert van Eyck's breadth of vision. He only sees things on the grand scale when he restricts his composition to a few imposing figures, such as *Christ on the Cross with the Virgin and St John* in the Prado and the Johnson Collection of Philadelphia. He is much less at home with large groupings, and his best in this field is in *The Adoration of the Magi* in Munich, where all the elements relate well to one another, but where the overall effect is not particularly impressive. He does not really understand the way in which planes in imaginary space are related as far as colour is concerned. He has difficulty in putting man into the atmosphere, in relating him to his environment, and establishing his relationship with the surrounding universe. His vision lacks breadth. In his *Last Judgment* – a subject which calls for the grand manner – although the altarpiece itself is large, his approach is rather pedestrian. It scarcely goes any further than a medieval mural or the tiered sculpture on the tympanum of a Gothic cathedral. Then there is the obvious disproportion between the celestial and terrestrial figures – a direct legacy of the Middle Ages from which even Hubert van Eyck in *The Mystic Lamb* was unable to free himself completely. But Van der Weyden could have gained the necessary inspiration from another of Hubert van Eyck's works, the little diptych of *The Last Judgment* and *The Crucifixion*. Here he could have found an idea for an altogether broader approach. But the figures in the Beaune polyptych are small, and even the main figures are not really imposing. They are too much like enlarged miniatures.

Several points of similarity with the Van Eycks have been mentioned in passing, but one should be wary of placing too much emphasis on subject matter and individual shapes and objects at a time when artists had no scruples about copying from each other. What is really important in establishing the influence of one artist over another, is imitation in the use of colour and basic technique. Sometimes Van der Weyden uses intense colours in the same shades as the Van Eycks, but he does not manage to achieve the Van Eycks' overall harmony. The dark shades in the clothing do not harmonise with the interiors, architecture and landscapes around them. One only has to compare Van der Weyden's

105

Opposite:
XIV Roger van der Weyden: *St Mary Magdalene reading*
Enlarged detail two and-a-half times actual size. National Gallery, London

Descent from the Cross in the Prado with Jan van Eyck's *Madonna with Chancellor Rolin* in the Louvre – both painted at more or less the same time. Bearing in mind the very different atmosphere in each painting – quiet sensitivity in the first and impassible realism in the second – let us consider the actual technique. Both artists want richness of colour, and at this point in his development Roger van der Weyden, like Jan van Eyck, uses rich colours across the entire surface. But he fails to create a setting, a unit of space, an atmosphere surrounding his people, and it is in this that Jan van Eyck excelled. Van der Weyden learnt nothing practical about figuration from the examples around him, neither initially in Tournai and Flanders, nor from the Master of Flémalle. He was not concerned about clear formal presentation in a suitable setting. He knew perfectly well how to paint figures, but they lack solidity. This is especially true of the Prado *Descent from the Cross*. The figures stand out in relief against a slightly concave neutral ground which forms a shallow niche – an effect he could have seen in the altarpieces and little funerary monuments produced in Tournai in his day. He does not see his figures in terms of a picture. The space in which they move never becomes real. Even when he sets his figures against a landscape, as in the Braque Triptych in the Louvre, the light which floods the scene does not affect the way the figures are presented. With the exception of Mary Magdalene, the heads and shoulders stand out with firm, brown flesh-tints, highlighted in coppery tones, against a landscape which is little more than a backdrop. In the same way, if he chooses an interior as the setting for a picture, then it seems placed behind the figures like scenery. It never surrounds them. One sees it in *The Adoration of the Magi* in Munich, *The Entombment* in Florence, and even in the Antwerp *Seven Sacraments*, although this picture would seem to date from the artist's maturity. In it a church interior forms the background to a large *Crucifixion*. The church probably symbolises the Roman Catholic Church, which administers grace through the sacraments. But the setting does not envelope the *Crucifixion*, and the charming scenes which represent the administration of the sacraments spill out of the chapels because the artist was unable to insert them adequately.

Obviously Roger van der Weyden was more concerned with other innovations: the expression of his inner world.

Van der Weyden was a poet who lived his dream fiercely and painted under the influence of the feelings inspired by his subject. In an attempt to let the onlookers share them with him, he expressed his feelings in the faces of his characters, and in their attitudes and gestures – and even in his use of colour. It is a mistake to call the Prado *Descent from the Cross* dramatic in the theatrical sense. What really touches us in this work is the pathos, the emotional intensity which emanates from each individual. There is the same atmosphere in the small *Pietà* in the Musées Royaux in Brussels. His mother, the beloved disciple and the repentant sinner stand around the waxy, bloodless body of Christ. The heavy forms have no consistency, no solidity, and are badly grouped geometrically – all of which proves that the artist is concerned with expressiveness rather than objectivity. Mary Magdalene is crushed with grief. The Virgin has wept until she has no more tears left and her eyelids are swollen. St John has great difficulty in holding back his tears. The gestures are restrained and respectful. The intense colours are perfectly matched and contribute enormously to the expression of emotion. The blue of the Virgin's cloak and the purplish-blue of her dress, the dark red of St John's cloak and the brown and green of Mary Magdalene's clothing are all colours in a minor key, accompanied by the equally plaintive effect of the yellow and orange sunset. This unusual use of colour has led critics to think – wrongly – that it is not one of Van der Weyden's authentic works. As we have already seen, there are three similar works, the Prado *Pietà* and the two other versions in Berlin and London. All three have a fairly generous application of paint, with a light tonal range, and were probably painted in the artist's maturity. The Brussels *Pietà*, on the other hand, seems to date from the time when Van der Weyden was under the influence of Jan van Eyck.

We can see therefore that at the time when Flemish painters generally were having great difficulty

in producing lifelike faces, Van der Weyden was the first to be able to convey grief in painting. Before any of his contemporaries, he could show moral anguish or pain long endured in silence, with his firm yet delicate brushwork. He conveys pathos through the wringing of hands, the contraction of a muscle at the corner of a mouth or with eyes no longer able to weep. He does not use exaggerated attitudes or extravagant gestures. Van der Weyden is a master at rendering intense emotion by very subtle means, and this is evident in all his work, from the Miraflores Altarpiece right through to his last paintings. His *Nativity* scenes are full of restrained tenderness – as in the Bladelin Altarpiece – and an *Annunciation* such as that in the Metropolitan Museum in New York, captures completely the curious emotion of that dialogue between God's messenger and the chosen Virgin. When he paints Mary Magdalene, as in the Braque Altarpiece in the Louvre, he almost casts a spell over us.

Roger van der Weyden's aesthetic interests, directed as they are to the achievement of distinction in his painting, spring from this reserve and intimacy. He takes immense care with his elegant figures, and devotes a great deal of energy to the folds and pleats of their clothing. The overall effect is not always perfect, but the individual parts are excellent. His contribution in this field was enormous. His quality of refinement came at a most opportune moment, when most of the artists of the Low Countries – following the example of Jan van Eyck and the Master of Flémalle – were much more concerned with objectiveness than refined sensibilities.

This was the chief feature of Roger van der Weyden's style, and it became apparent very early in his works. It is evident in his approach to his subject; his simple, balanced composition; his graceful forms – sometimes a little too mannered in their attitudes; his discreet contours and, finally, his lighter colours. It is evident in the Munich *Adoration of the Magi,* and it is this quality – not the bright colours of the clothing – which gives the picture its sense of mystery. The magi (who do not represent the three great dukes of Burgundy who ruled Flanders, as has been suggested) bring the strange and distant Orient with its occult sciences, astrology and legendary riches to the dilapidated stable to worship the Child-God.

This inherent distinction is also evident in Van der Weyden's portraits, in the line of a silhouette or the contours of faces and hands. In a portrait such as that of Lionello d'Este, the artist's subtle mind is evident in the dignity of the expression, the formal rhythm and the interplay of the tapering fingers, which have wrongly been described as badly painted. This is yet another example of Van der Weyden's sensitivity. The colour is restricted to light shades which go well with the creamy background and enhance the overall effect, which is one of great subtlety. The atmosphere is quite different from Jan van Eyck's very positive portraits or the solid, concrete portraits of the Master of Flémalle (37).

This spirituality is better expressed in the portraits which are similar in style to the works painted after 1450. It appears, for example, in the portrait of Isabella of Portugal in the John D. Rockefeller Jr Collection in New York, where it corresponds admirably to the sensitivity of the unfortunate princess, and in the presumed portrait of Laurent Froimont in the Musées Royaux in Brussels. The sitter is given this name because there is a representation of St Lawrence on the back, with the word 'Froimont'. He seems to be a gentle, intelligent man, an affable courtier and probably an extremely distinguished one. The artist suggests all this by the way he has painted him, with fresh flesh-tints, regular features, restful hands – the most splendid pair of hands in the whole of the fifteenth century – and his greyish clothing. But above all the artist has expressed his own personality here.

There is similar delicacy in the portrait of a young woman in the National Gallery in Washington, which is a better work than the painting in the same vein in the National Gallery in London. The idealism is evident in the tension in the face, the expression of the eyes, and above all in the way in which the colour is married to the graceful shape: grey shading in the pleats of the white coif, soft shadows in the pink face and purplish-blue in the clothing, which harmonises beautifully with the brown background.

xv Roger van der Weyden: portrait of Philippe le Beau.
Groeninghe Museum, Bruges

69 Roger van der Weyden: portrait of Lionello d'Este.
M. Friedsam Collection, Metropolitan Museum, New York

70 Roger van der Weyden: portrait of Laurent Froimont (?)
Musées Royaux des Beaux-Arts, Brussels

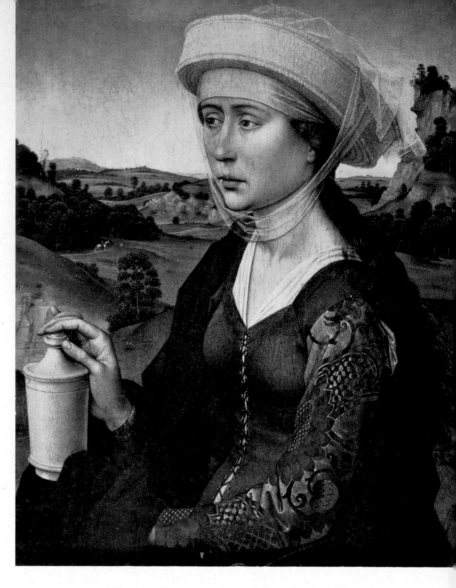

71 Roger van der Weyden: the Braque Triptych.
Detail from the right volet showing St Mary Magdalene.
Louvre, Paris

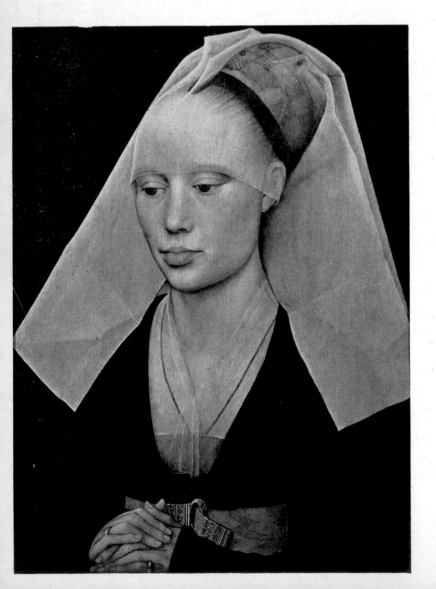

72 Roger van der Weyden: portrait of a woman.
Enlarged detail shown in colour plate XII (p. 88).
National Gallery, London

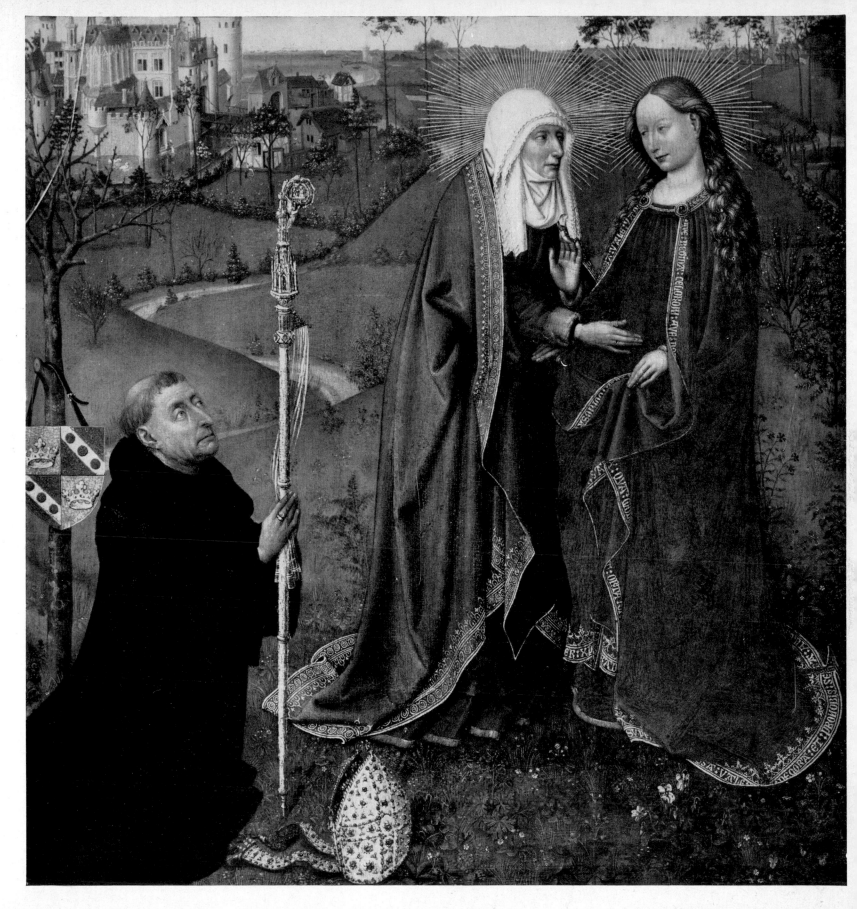

73 Jacques Daret: *The Visitation*
Staatliche Museen, Berlin

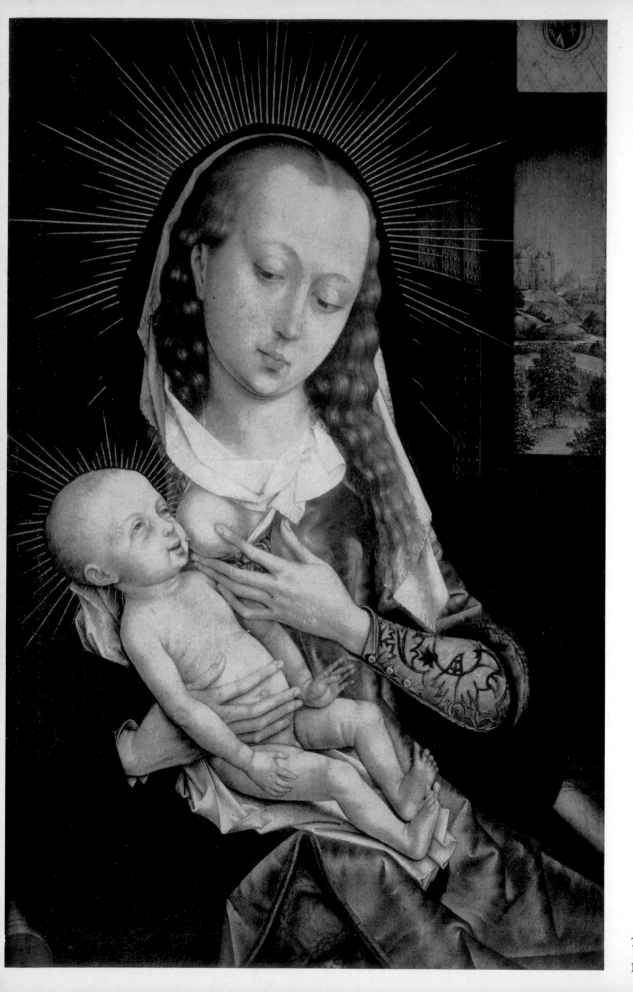

74 Follower of Roger van der Weyden:
Virgin and Child
Musées Royaux des Beaux-Arts, Brussels

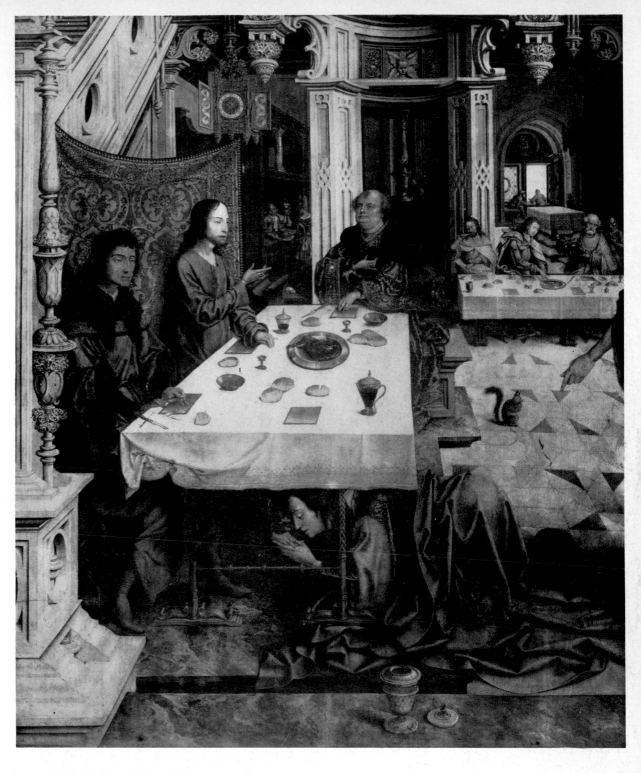

75 Master of the Abbey of Dillighem: the Dillighem Triptych.
Detail of central panel showing Jesus in the house of Simon the Pharisee. Musées
Royaux des Beaux-Arts, Brussels

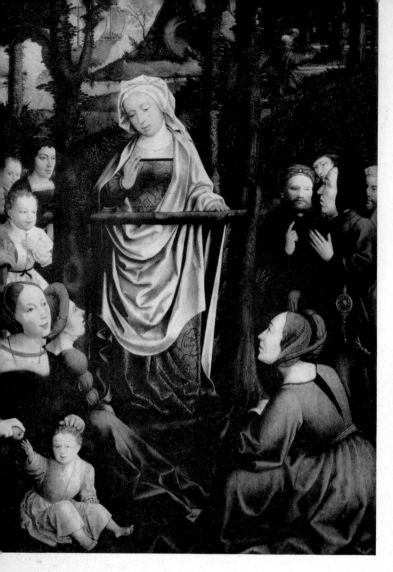

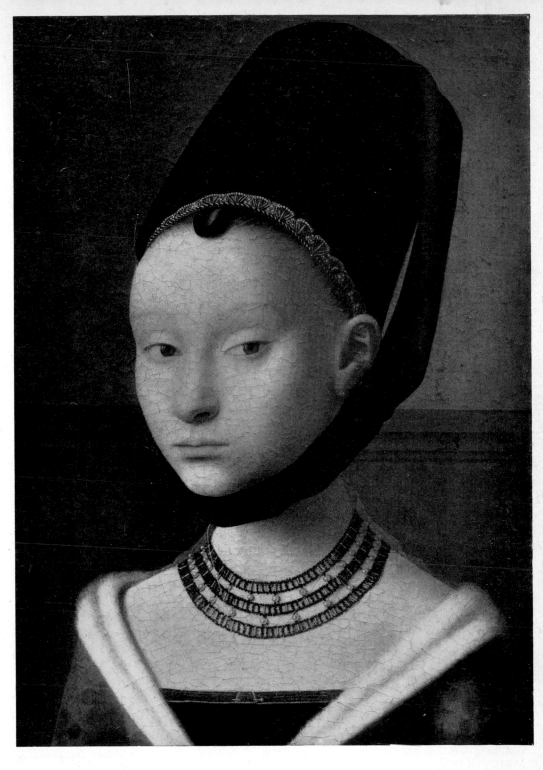

78 Petrus Christus: portrait of a young woman.
Enlarged detail in colour plate XVII (p 135) Staatliche Museen, Berlin

79 Petrus Christus: *The Madonna with a Carthusian*
Staatliche Museen, Berlin

80 Petrus Christus: portrait of Denis the Carthusian.
Staatliche Museen, Berlin

The same refined elegance is apparent in the portrait of a woman in Berlin, where the onlooker immediately feels sympathy with the sitter. It has been claimed that here, for the first time, an artist has dared to depict the sitter looking directly at the onlooker, since Van der Weyden was painting his wife. But Masaccio had already tried to bring off this effect, and so had the Master of Flémalle (or another artist prior to Van der Weyden) in *The Man with a Double Chin* in Berlin.

But Van der Weyden's real innovation in portraiture was the graphic, pictorial quality he introduced. Unlike Jan van Eyck, he did not worry about a careful rendering of every facial detail. Nor was he concerned – as was the Master of Flémalle – with solidity and volume, thickly applied paint and facial contours. Roger van der Weyden slowly and deliberately reproduced, in paint, the mental image which he had formed of his sitter. He was economical with colours, and shaded them perfectly in the flesh-tints, and even in the clothing, which Jan van Eyck tended to neglect in his portraits.

This concern for spirituality eventually became a form of obsession for the artist. At the same time it was also the means by which he fulfilled himself, at the end of his career, and marked him out from the other great artists of his time.

The Descent from the Cross still betrays signs of a tendency to the formal realism then in fashion; but by the time Van der Weyden painted the nudes in *The Last Judgment*, form had dissociated itself from matter and escaped from it. In the Bladelin Altarpiece in Berlin, the style of which is similar to that of the Beaune polyptych, the donor is kneeling humbly, head bowed and eyes lowered. It is interesting to compare this attitude with that of Jan van Eyck's Chancellor Rolin, who is face to face with the Virgin and looks at her without compunction.

Everything is sublimated in the two great works of Roger van der Weyden's last years, the two versions of *The Crucifixion* in Madrid and Philadelphia. The artist has left out Calvary, and we only see the dying Christ alone with the Virgin and St John. Christ's body would seem, at first glance, to be similar to that of the Vienna *Crucifixion*, but on closer inspection we see that the silhouette is firmer and the contours broader. The loin-cloth no longer flutters in the wind and the figures of the Virgin and St John in the Madrid picture have a sculptural quality reminiscent of the statues in the triforium of the Church of St Pierre in Louvain, probably carved from drawings by Van der Weyden. The tension in the bodies and the generous folds of drapery help to increase the feeling of reserve and deep grief. The last works are full of peace, serenity and extraordinary grandeur.

The distinctive quality of the works painted in the last fifteen years of the artist's life is shown primarily in his preference for lighter colours. In the Bladelin Altarpiece in Berlin, there are still several bright passages of red, green or blue, but in the St John Altarpiece, also in Berlin, and stylistically similar to the two versions of *The Crucifixion*, one immediately notices the overall lightness of colour. There are several works by Van der Weyden in Berlin, and this one stands out for this very reason. Grey predominates in the architectural setting, but the reds and blues are not particularly intense, and highlights are rendered with small touches of white. In addition there are some new light colours: yellow in the executioner's hose and delicate mauves in St Joachim's cloak and Salome's garment.

As we have just pointed out, it is through these various details that Van der Weyden preserves his art from falling into the sort of realism into which a clumsy imitation of Jan van Eyck and the Master of Flémalle might have led. But these factors also helped to create a kind of abruptness of form which, in his imitators, degenerated into sterile formulae, particularly in the numerous interpretations of the Virgin and Child.

No other Flemish artist could equal Roger van der Weyden in depicting the Virgin. His portraits of her are almost perfect realisations of the ideal of grace and purity coupled with maternal tenderness. In this kind of figuration, which is full of nobility, one is aware of the way in which the artist avoided unmitigated realism, and to what extent he pursued stylised form. But therein lay the danger to which the artist exposed himself. One feels that his Madonnas, with their curving brows, almond-shaped eyes,

117

long, thin noses, delicate mouths or charming, pouting lower lips and long, slender hands with distinguished-looking fingers have all the artist's tenderness and feeling. Nevertheless this distinction verges on elegance, and as a result a hint of affectation sometimes tinges the creative impulse. Such treatment can easily become routine, with the subtle danger of staleness and borrowing from oneself. The greatest artists run this risk at some point in their career, and in some of his Virgins, Roger van der Weyden seems to have indulged in pastiches of his own work.

☆

Roger van der Weyden's basic biography is as follows. He came from Tournai, as several documents indicate, and there he was known as Roger de la Pasture. When he lived in Brussels he was known as Roger van der Weyden, which is a Flemish translation of the French. As guardian of his niece, the daughter of his '*Sœur-germaine*' (his own or full sister) Jeanne, he had a power of attorney drawn up at Brussels, in 1440, for the sale of a house at Tournai. The same house is mentioned in an earlier document, dated 1426, at Tournai, and reference is also made to Henri de la Pasture and Agnes Watrelos, the parents of Jeanne and Roger. There is also a letter which was sent in 1463 by the Duchess of Milan to '*Magister Rugiero de Tornay pictori in Brussels*'. Finally there is the weighty evidence provided by the register of the Tournai guild of artists, with Van der Weyden's entry as master and the mention '*natif de Tournai*', and the accounts of the guild of St Luke at Tournai for the year 1463/4. Here the expenses in connection with his funeral service are recorded: '*Item payet pour les chandelles qui furent mises devant saint Luc, à cauze du service Maistre Rogier de la Pasture, natyf de cheste ville de Tournay le quel demoiroit à Brousselles, pour ce ... 4 gros*' ('Item, paid for the candles which were placed before St Luke, for the service of Master Rogier de la Pasture, born in this town of Tournai, who lived in Brussels, for this ... 4 gros').

There are two pieces of documentation for his birth, but they do not agree. In one, dated 21 October 1435, he is said to be thirty-five years old. In the other, dated 15 March 1441, he is stated as being forty-three. Nevertheless one can assume that he was born around 1400.

There are two references to Van der Weyden in the Tournai archives which seem to contradict one another, and which have been the subject of much debate. One deals with the apprenticing of a '*Rogelet de le Pasture*' to Robert Campin on 5 March 1427. The other relates to the official welcome by the city fathers of Tournai for a 'Master' Roger de le Pasture on 17 November 1426. It seems strange that an artist should be given the title of Master when he was only an apprentice, and critics have therefore concluded that there were two artists of the same name at Tournai, one called Rogelet and the other Roger.

The difference in the Christian names is more apparent than real. It was the custom in Tournai, as in Bruges and elsewhere in Flanders, that when an apprentice was enrolled, his Christian name was given in its diminutive form. What was less usual was the fact that in this case the apprentice should be so old. If he was born round about 1400, he must have been about twenty-six years old on 5 March 1427 (38), when he was enrolled. But there is a possible explanation. First of all, at Tournai as elsewhere, the trades limited the number of apprentices to any one master. Consequently boys would go and work in an artist's workshop without being officially enrolled as apprentices, and if they were well paid they would stay there for a considerable time and only have themselves enrolled as apprentices when they were thinking of setting up on their own account. At Tournai the regulations required that before a person could be received as a master he must first have been registered as an apprentice for four years. If a person wanted to work for himself, he must also have had four years' apprenticeship. We know from the archives that

in 1427 Roger van der Weyden was married and his son Cornelius was born. This, then, is why he had himself enrolled officially as apprentice in 1427. Furthermore his fellow apprentice, Jacques Daret, did the same thing. He had been an assistant to Robert Campin for more than nine years when, on 17 April 1427, he had himself enrolled as apprentice and became master in 1432.

How then can an apprentice have been given the title of Master in the same year that his official apprenticeship began, and be ceremonially received by the city fathers, who made him a present of eight *lots* of wine?

First of all one must bear in mind that the title of Master was not used to indicate a degree of seniority in the guild hierarchy. It also had an honorary use at the time, as a mark of respect. Maurice Houtart, who has made an intensive study of the Tournai archives, has shown that the title of Master in the town was not restricted to those who held an official mastership of a guild, but was used rather generally of any distinguished person: well-known artists, writers, clerics and schoolmasters. It would be wrong, on the other hand, to think that the title was given to all artists as soon as they were enrolled as masters in their trade. Of the 104 masters enrolled during the fifteenth century in the register of painters at Tournai, only six were honoured with the title in official documents. One must also bear in mind that the clerks used the title somewhat indiscriminately. In the account of the wine for Roger van der Weyden there is a certain '*Maitre Gilles Rac, tailleur d'images*' ('Master Gilles Rac, carver of images'), whereas when Jan van Eyck was received ceremonially at Tournai, he is simply mentioned as '*Johannes, peintre*'. One should not be surprised therefore to see the title of master used for the 'apprentice' Roger de le Pasture in 1427. He had certainly already given manifest proof of his abilities, and the clerk wanted to show his deference.

There are some political factors which better explain the situation. In 1425 serious unrest broke out among the populace of Tournai. Many people left the city. When order was re-established in 1427, the exiled townsfolk returned. The city fathers welcomed them back and offered them a glass of wine as a sign of appeasement. Roger was treated in the same way as those who returned. The eight *lots* of wine were not all for him, however. They represent the amount consumed on this occasion. The fact that there was less wine for the reception of Jan van Eyck simply shows that there were fewer guests or that they were more abstemious.

This shows that a study of customs and events can often throw light on references which, when taken in isolation, might seem contradictory. There is absolutely no reason to suppose the simultaneous existence of two painters called De le Pasture, one Rogelet and the other Roger; one of no account and the other highly talented; one an apprentice who never became a master and the other a master who had never been an apprentice (39).

On the 1st August 1432, Roger de le Pasture was finally enrolled as a master in the register of the Tournai guild of artists. In the same year *The Mystic Lamb* was unveiled in Ghent. By this time Hubert van Eyck was dead, and Jan van Eyck was working in Bruges partly for the Duke of Burgundy and partly for himself. Van der Weyden was an excellent artist, and he soon found a career opening up for him. He lived in Brussels from 21 October 1435. This information comes from a document already mentioned concerning an annuity '*Maistre Roger de le Pasture peintre, fil de feu Henry, demeurant en la ville de Bruxelles ... éagié de trente cinq ans*' ('Master Roger de le Pasture painter, son of the late Henry, living in the town of Brussels ... thirty-five years old').

He soon became official municipal painter. We know this from a resolution of the Brussels city council, dated 2 May 1436, not to appoint another municipal painter after the death of Roger van der Weyden. We also learn something of his activities from various other archives. He painted four large pictures for the town hall – doubtless murals – with two scenes from the Legend of Trajan and two from that of Herckenbald. These works are mentioned several times, but were destroyed when the French bombarded the city in 1695. Some critics say that these paintings were the models for a set of tapestries

now in Berne, but they do not correspond to the description given by Calvete de Estrella in his *Felicissimo Viaje del Rei Felipe*, published in Antwerp in 1552.

Bartolomeo Facio, in his *De viris illustribus* of 1457 (but not published until 1745 in Florence), maintains that '*Rogerius Gallicus*' took a trip to Italy in 1450. There are in fact records of payments made in his favour by the Court of Ferrara (40). Roger van der Weyden died in Brussels on 16 June 1464.

JACQUES DARET

The proliferation of works relating to the Flemish Primitives has created an immense amount of confusion, and the uninitiated are tempted to accept as gospel truth the latest theory that is convincingly presented. There is also another danger, namely that too much importance is given to an artist about whom there is a great deal of documentation, but whose authenticated works are nothing more than mediocre.

Such is the case of Jacques Daret. He is mentioned as a pupil of Robert Campin, to whom he was apprenticed on 12 April 1427, at the same time as Roger van der Weyden. He was enrolled as a master in 1432 by the Tournai guild of artists. In 1434, 1441 and 1452 he carried out various commissions for the Abbey of St Vaast at Arras. In 1454 he worked with four of his assistants on the decorations in Lille for the famous Banquet of the Vow of the Pheasant. In 1468 he worked on the decorations at Bruges, as did Hugo van der Goes, for the marriage of Charles le Téméraire to Margaret of York. After this his name is no longer found in the archives. Certainly he was highly thought of at the time (41).

He was even believed to have been the Master of Flémalle at one time, and major works were attributed to him, until the altarpiece was discovered which Jean du Clercq, Abbot of St Vaast, commissioned from him.

The archives of Arras have records of payments for the colouring of a sculpted altarpiece and the painting of the volets, with a mention of the subjects; above, across the whole width, was *The Annunciation*, and below *The Visitation, The Nativity, The Adoration of the Magi* and *The Circumcision*. All but the first of these pictures have been identified. *The Visitation* and *The Adoration of the Magi* are in Berlin; *The Nativity* is in the Metropolitan Museum in New York, and *The Circumcision* is at present in the Petit Palais in Paris, where it is called *The Presentation in the Temple*. All four panels have the same dimensions and are identical in style, and one of them depicts the Abbot du Clercq and also has his coat-of-arms. Similar to these pictures is *The Adoration of the Magi* in the Metropolitan Museum in New York.

On examination these works show a considerable lack of invention. The composition of *The Visitation* is almost identical to that of Roger van der Weyden's picture in Lützschena. Charles de Tolnay has suggested that the two artists used the same model. I think it more likely that the more feeble imitated the more inspired artist. Furthermore, the composition of *The Nativity* is a simplified version of the Master of Flémalle's painting in Dijon.

By and large Jacques Daret places his figures in the foreground of his pictures in a way which is calm, even almost ingenuous. There is no evidence of the strong, organic unity one finds in the Master of Flémalle, with whom he studied. His figures are squat, except for those in *The Visitation*, which is an imitation of a work by Roger van der Weyden. Jacques Daret's figures are put in front of a backdrop. They lack volume and only seem to occupy a two-dimensional space. Their expression – whether it be

in their attitudes or their features – is insignificant and feeble. The technique is heavy, and even when the artist concentrates on the material nature of objects, such as jewellery, embroidery or bony hands, using impasto, he does not manage to give them real consistency. Daret drew little profit from either his master or his brilliant fellow student. He is decidedly a lesser artist.

ROGER VAN DER WEYDEN'S CONTEMPORARIES AND SUCCESSORS

In the interests of current historiography we have been obliged to spend some time on the work of Jacques Daret. We must also consider the many unimaginative artists who imitated the style of Roger van der Weyden. No other contemporary Flemish artist had a comparable influence. Of course the works of the Van Eycks and the Master of Flémalle were admired by every artist. But such painting, by its very richness and variety, discouraged followers. They only assimilated fragments. Van der Weyden's style was admired for its graceful figuration. It was more simple, more accessible, full of easily understood concepts which his imitators rapidly codified into sterile realism. In Germany, the Master of the Life of the Virgin, Herlin, and many others, found inspiration in his works. Even Schöngauer was influenced by him. In Spain, too, he had his imitators. In Italy, Zanetto Bugatto, portrait painter to the Sforza family, was the first to copy Van der Weyden. He was sent to his workshop in 1460 to study the 'Flemish manner' and it was probably there that he painted the Sforza Altarpiece in the Musées Royaux in Brussels. Subsequent imitators were Cosimo Tura, Francesco del Cossa and Ercole de Roberti of the School of Ferrara, from 1448 to 1451 (42). Piero della Francesca, who lived at the court of the Este family at Ferrara, doubtless met Van der Weyden there during his stay in 1450. It would be unwise, however, to attach too much importance to such contacts. An artist may perfectly well be moved by a particularly beautiful work painted by another artist, and even borrow elements without necessarily intending to imitate him. But one thing is certain, namely that Van der Weyden painted the portrait of Lionello d'Este at Ferrara, in pale colours on a pale ground, and that Piero della Francesca subsequently introduced the idea into his own works.

The art historian must organise the numerous Flemish followers of Van der Weyden into groups based on similarities of style. The immediate followers were: the Master of the Marriage of the Virgin, the Master of the Legend of St Catherine, the Master of the Legend of St Joseph, the Master of the Altarpiece of the Redemption, the Master of the Embroidered Foliage, and the Master of the View of St Gudule. Then came the second generation, which continued into the sixteenth century: the Master of the Altarpiece of the Abbey of Afflighem, the Master of the Legend of Mary Magdalene, the Master of the Multiplication of the Loaves, and the Master of the Abbey of Dillighem.

The question of attribution is a maze into which I do not intend to wander. The purpose of this book is to follow the development of Flemish painting, so we can linger only on the peaks of its prolific output. Even so, the practice of making daring attributions, too frequently indulged in by scholars, simply confounds the less enlightened. Art history has nothing to gain from allocating a work to an artist about whose output we know nothing, or a work for whom we have no artist. Where is the sense in manipulating what has survived from the past in the misguided hope of wringing from it facts which it certainly does not contain? It is much better to continue to use provisional names than attribute anonymous works definitely to artists whose existence is known only from documents. The recent creation of the

output of Vranck van der Stockt (or Vrancke van der Stoct, according to one of the ways of spelling his name discovered in the archives) is a typical example of hypothetical attribution. Several pictures have been associated with this name, and he is already spoken of in catalogues and periodicals as an artist whose output is perfectly well known. The truth is that we have nothing more than a collection of suppositions. The archives do in fact tell us something of the life of Vranck van der Stockt, but so far they have not led us to discover a single example of his paintings. His contemporaries certainly held him in a certain amount of esteem, since he was offered the post of official artist to the municipality of Brussels – **a** post previously held by Roger van der Weyden. From that fact it has been deduced that he must have been a follower of Van der Weyden – in fact the best of his successors – and therefore responsible for a number of good works bearing obvious traces of his influence. But is there an artistic law which ordains that an artist must be obliged to imitate the person whose post he succeeds to?

It is tempting to linger over such works as *The Virgin and Child*, no. 650 in the Musées Royaux in Brussels. In the technique, at least, of this painting the artist achieves the perfection of a Van der Weyden. Only the master's intensity of expression is lacking; otherwise it would be of the same quality as some of his best works. In fact the artist is simply an extremely careful, but highly talented, imitator.

Another follower, but a less careful one when it comes to form, is the Master of the Marriage of the Virgin, who takes his name from the painting of the subject in the Church of Notre Dame in Antwerp. The overall composition is borrowed from a work on the same theme in the Prado, attributed to the Master of Flémalle. On the other hand, the form and colours are inspired by Van der Weyden. The heavy application could not be his, however.

Some artists, while attempting to copy Van der Weyden's forms, have occasionally succeeded in bringing a personal note into their works. There is the Master of the Embroidered Foliage, for example, the Master of the Legend of St Barbara, and in particular the Master of the Legend of Mary Magdalene. The basic work of this last artist is the dispersed triptych of *The Legend of Mary Magdalene*. When one sees the works which critics group together with the triptych, one sees that the artist was initially a follower of Roger van der Weyden – particularly his pictures of the Virgin and Child – and then of Bernard van Orley. He became a portrait painter to the court of Margaret of Austria. He could best be identified with Pieter van Coninxloo, of Brussels, not with a descendant of Vranck van der Stockt, for whom we have no work which we can definitely attribute.

The Master of the Abbey of Dillighem painted – at the rather late date of 1537 – the beautiful triptych of *The Legend of Mary Magdalene* in the Musées Royaux in Brussels, and also *The Calling of St Matthew* in Windsor Castle, which has been attributed to an anonymous artist from Antwerp but which, after close examination, can be unequivocally attributed to him. This artist has considerable personality and is obviously touched by Renaissance anxiety, love of logic and love of decoration. But long after the others, he remained faithful to certain figurative elements and the technique he inherited from Roger van der Weyden.

☆

To these various anonymous artists, whom scholars constantly attempt to identify, may be added some whose names we do know, and for whom we have authenticated works.

First there is Goswyn van der Weyden, Roger's grandson. He was born in about 1465 in Brussels, and settled in Antwerp, where he painted, in 1505, a series of panels of *The Legend of St Dymphne*, at present in the collection of Baron J. van der Elst in France. The only similarity of style between Goswyn and Roger is the clarity of the composition and its presentation, and the incisive

xvi Goswyn van der Weyden: detail from the Colibrant
Family Altarpiece showing *The Marriage of the Virgin*.
Church of St Gommaire, Lierre

figuration. However, Goswyn also has much in common with the Antwerp Mannerists, with their love of the picturesque and garish colours.

At the end of the fifteenth and beginning of the sixteenth centuries, another distant successor of Roger van der Weyden, Colijn de Coter, was active in Brussels. Since his life and work is relatively well documented, there was a tendency to regard him as more important than his talent merits. There are three signed works, and others may be added to them. He is rather a late successor, and uses fashionable elements rather clumsily.

There was also Cornelius van Coninxloo, working in Brussels in the first half of the sixteenth century. Despite a rather disconcerting mannerism which he brought into his settings, he lacks imagination. Jan van Coninxloo, another artist, can only be regarded as deliberately archaic. He practised an outdated style and was unable to get on to the same wavelength as his contemporaries.

81 Petrus Christus: Head of a Man (detail from the *Pietà*, 83, p. 127).
Musées Royaux des Beaux-Arts, Brussels

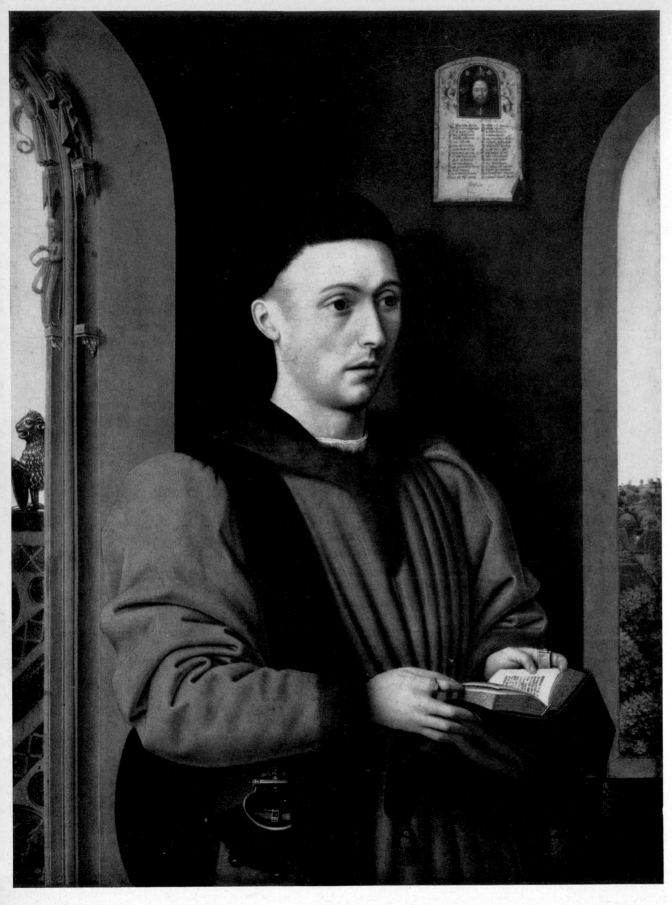

82 Petrus Christus: portrait of a young man.
National Gallery, London

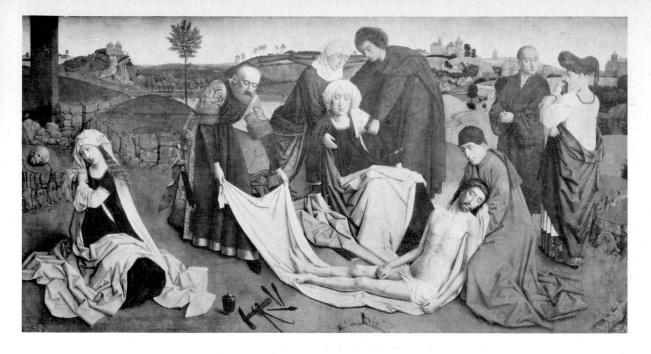

83 Petrus Christus: *Pietà*
Musées Royaux des Beaux-Arts, Brussels

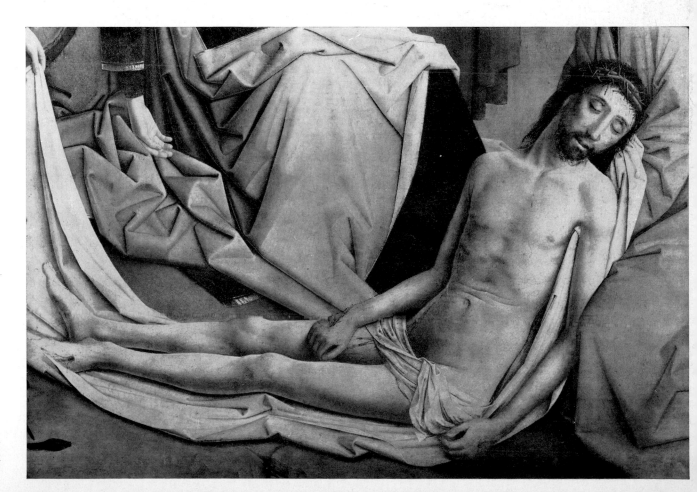

84 Petrus Christus: *Pietà*
Detail of 83. Musées Royaux
des Beaux-Arts, Brussels

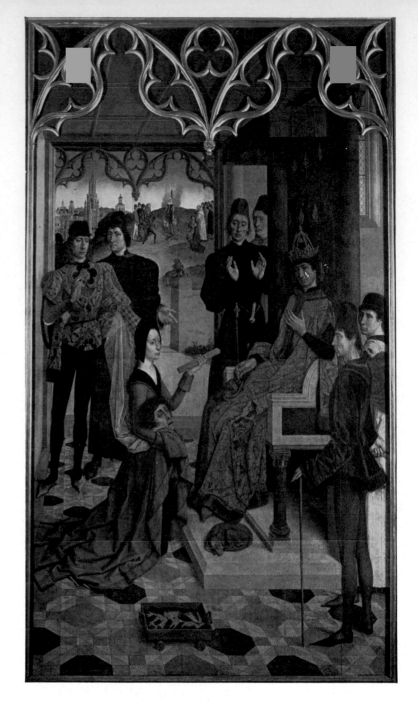

85 Dieric Bouts: *The Justice of Emperor Otto III*
Panel showing the execution of the innocent vassal.
Detail in colour plate XXIII (p. 153).
Musées Royaux des Beaux-Arts, Brussels

86 Dieric Bouts: *The Justice of Emperor Otto III*
Panel showing the ordeal by fire. Detail in
colour plate XXII (p. 152)
Musées Royaux des Beaux-Arts, Brussels

87 Dieric Bouts: *The Last Supper*
Detail of 90 (p. 130) showing head of bystander at right.
Church of St Pierre, Louvain

88 Dieric Bouts: *The Martyrdom of St Hippolytus*
Right volet showing the judges.
Cathedral of St Sauveur, Bruges

89 Dieric Bouts: *The Martyrdom of St Hippolytus*
Central compartment of a triptych
Cathedral of St Sauveur, Bruges

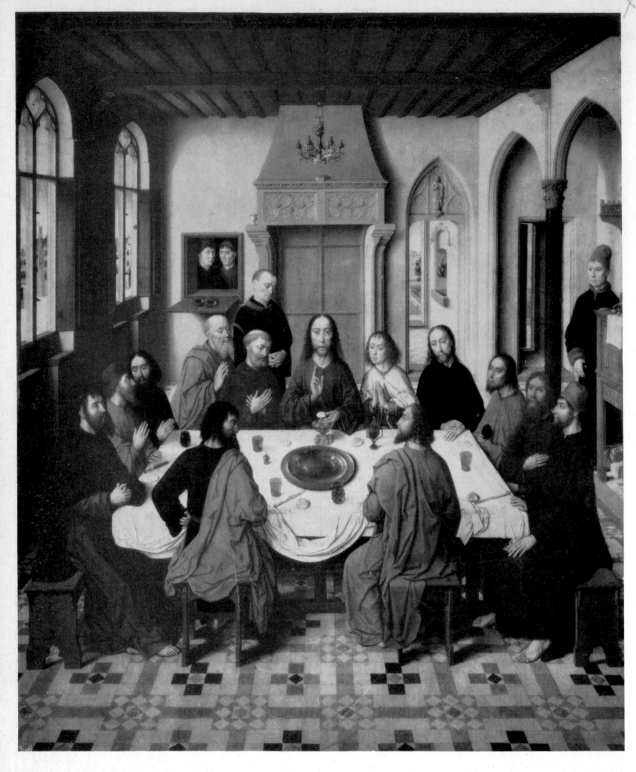

90 Dieric Bouts: *The Last Supper*
Church of St Pierre, Louvain

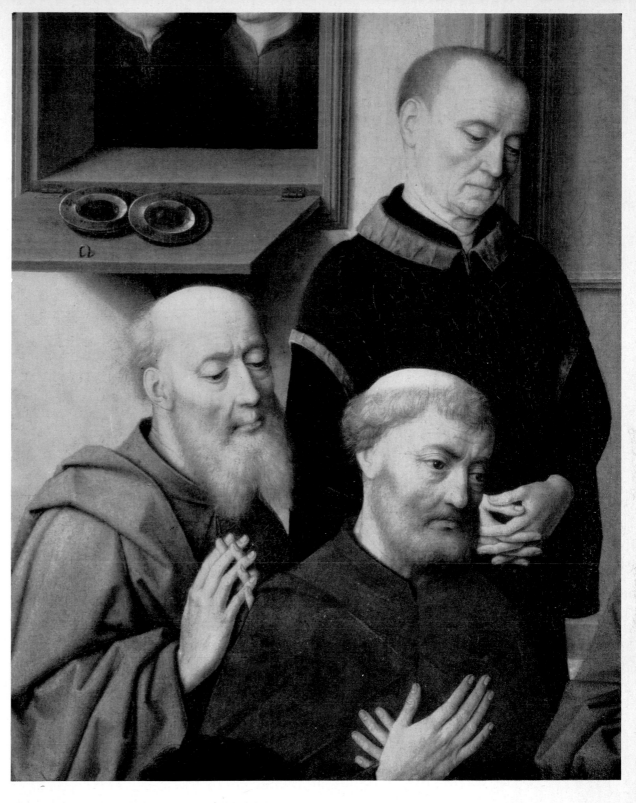

91 Dieric Bouts. *The Last Supper*
Detail of 90 opposite, showing the three heads to the right of Christ.
Church of St Pierre, Louvain.

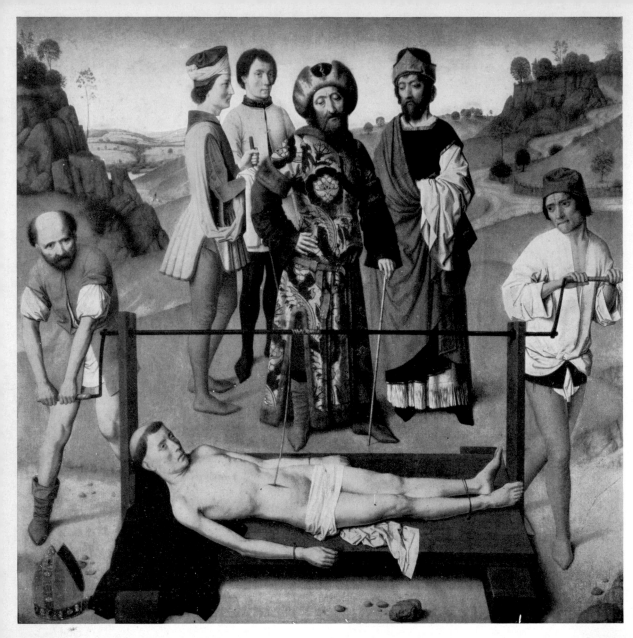

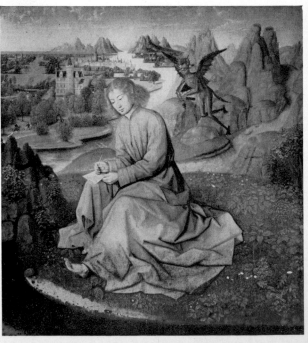

THE DEVELOPMENT OF THE FLEMISH STYLE WITH PETRUS CHRISTUS AND DIERIC BOUTS

PETRUS CHRISTUS

With Petrus Christus we return to Bruges in the period immediately after the death of Jan van Eyck. Christus is often held to have been either the pupil or the successor of Van Eyck, and he is even supposed to have inherited his workshop. Details have been found in Christus' works which also figure in some of Van Eyck's paintings – for example, wall-hangings, carpets, a convex mirror. There is no point in dwelling on this. As we have already pointed out several times, at this period artists borrowed freely from each other when they saw details they liked.

Although Petrus Christus follows Jan van Eyck chronologically, his art could scarcely be more different. It is high time this fact was emphasised.

One only has to study seven works, all of which are signed, and six of which are dated. They are as follows: portrait of Edward Grymeston, from the collection of the Earl of Verulam of Corambury, at present on loan to the National Gallery in London, 1446; portrait of a Carthusian in the Jules S. Bache Collection in the Metropolitan Museum of New York, 1446; *The Legend of St Eloi*, Robert Lehman Collection in the Metropolitan Museum of New York, 1449; *The Annunciation*, *The Nativity* and *The Last Judgment*, Berlin, 1452; *The Virgin with St Jerome and St Francis*, Städelsches Kunstinstitut in Frankfurt, 1457; *Head of Christ*, R. Timken Collection in New York, no date; *Virgin and Child*, Thyssen Collection in Lugano, 1449.

These seven paintings are not all among the masterpieces of Christus, but they must serve as a basis from which to define the characteristics of his style.

One of the first characteristics is the solidity with which he manages to endow his objects. Jan van Eyck was meticulous right down to the smallest details and, like his brother Hubert, created unity of atmosphere and setting. Petrus Christus tries to give the illusion of a much more solid and tangible reality. In fact he takes this preoccupation to such lengths that he paints the heads in his portraits and religious works as if he had mentally turned them beforehand out of wood. They are spheres, and it looks as if he had stuck the ears on afterwards, and placed them too far back. Then he renders volume with large brown shadows which verge on the opaque.

A second characteristic is the pronounced emphasis of the contours. The artist hardly worries about shading. The placing of passages of bright colour is carefully thought out, but the shading is wrong. This is particularly obvious in *The Legend of St Eloi*.

The Virgin and Child in Lugano, the portrait of Edward Grymeston in the National Gallery in London, and the portrait of a Carthusian in New York all have these intense colours. In fact the last of these three is a very interesting exercise in colour. The light flesh-tints and clothing closely match the brown

in the beard, and the whole is set against a dark background which, on the right, turns to a shade of crimson. It was probably the brightness of his colour that was responsible for the artist's fame in his own lifetime.

One presumes that *The Legend of St Eloi* in New York was commissioned from Christus by the gold-smiths of Antwerp – St Eloi being their patron saint. The treatment is original, and the realism genuine. The artist has depicted the saint as a fifteenth-century goldsmith. We see him in his shop determining the price of a ring inset with rubies, which the man and woman wish to buy. The red of the goldsmith's hat and garment contrast in their simplicity with the sumptuous gold brocade of the young woman's dress and the iridescent green of the man's clothing. The artist has taken great pleasure in rendering the various objects entirely by his technical skill. He has chosen perfect shades of colour for the bright-ness of the coral, the intense yellow of the amber and the pure, limpid quality of the rock crystal. He uses reflections cleverly to indicate the hardness of metal, and shadows cast by objects to indicate distan-ces. In this he is following the example of his predecessors. But he particularly stresses the solid nature of objects and their individual colour, and here he shows himself even more objective than his predecessors.

In attempting to define exactly the difference between Petrus Christus and Jan van Eyck, there is nothing more illuminating than a comparison between *The Legend of St Eloi* and *The Arnolfini Marriage*. Both show a couple in a room, but whereas Jan van Eyck gives a secular subject an almost religious feeling, Petrus Christus takes an ostensibly religious subject and makes it devoid of any spiritual elevation. It is simply a picture of a couple in a shop. The man has his arm round the young woman's shoulder without paying any attention to the presence of a third party. The lighting is diffuse and cold. The atmosphere is one of banality, of everyday familiarity. It has much less mystery than the Van Eyck painting, and as such is already a genre painting.

Christus' great concern with colour is also evident – sometimes more so – in some of the unsigned works which can be attributed to him because of their closeness in style to the signed works. In *The Nativity* in the National Gallery in Washington, the large black passage of the Virgin's dress is an admirable foil to the heavy red of St Joseph's cloak. The splendid portrait of a girl in Berlin (which James Weale wrongly took to be the pair to the portrait of Edward Grymeston) recalls the paintings of Vermeer, with its fresh flesh-tints, blue dress and black headdress, but above all the mother-of-pearl quality of the work as a whole. The same pictorial qualities are present in the portrait of a young man in the National Gallery in London.

As far as composition goes, Christus is rather eclectic. He borrowed several purely formal details from other artists, and sometimes even an entire composition. His *Last Judgment* in the Berlin diptych is manifestly influenced by Hubert van Eyck's *Last Judgment* in New York. *The Nativity* – also part of the Berlin diptych – is influenced by that of the Master of Flémalle in Dijon. *The Virgin and Child with a Carthusian* in Berlin, which one may unhesitatingly attribute to Christus on stylistic grounds, is simply a reduction of Jan van Eyck's painting on the same theme. It is not difficult to show extremely close similarities of form between Christus and Roger van der Weyden. Yet again Christus has turned to good advantage some of the technical assets of his contemporary, Dieric Bouts. But it would be wrong to regard him as a direct follower of any one of these artists, because Christus always adapted the elements he borrowed in his own particular way. In fact when really inspired, he is capable of works which reveal a very definite personality and which made a valuable contribution to the development of style in Flemish painting.

Unashamed borrower that he was, Christus produced one of the most remarkable works of his time, the *Pietà* in the Musées Royaux in Brussels. The work has a classic quality which sums up all the various attributes of the signed works. A *Pietà* is a representation of the sorrow of the Virgin at the death of her Son. In this work she holds the centre of the picture. St John and one of the Holy Women hold her up in her crippling mental anguish. In front of the closely knit group, and given cohesion by it, is the

XVII Petrus Christus: portrait of a young woman
See also 78 (p. 115) Enlarged detail twice actual size. Staatliche Museen, Berlin

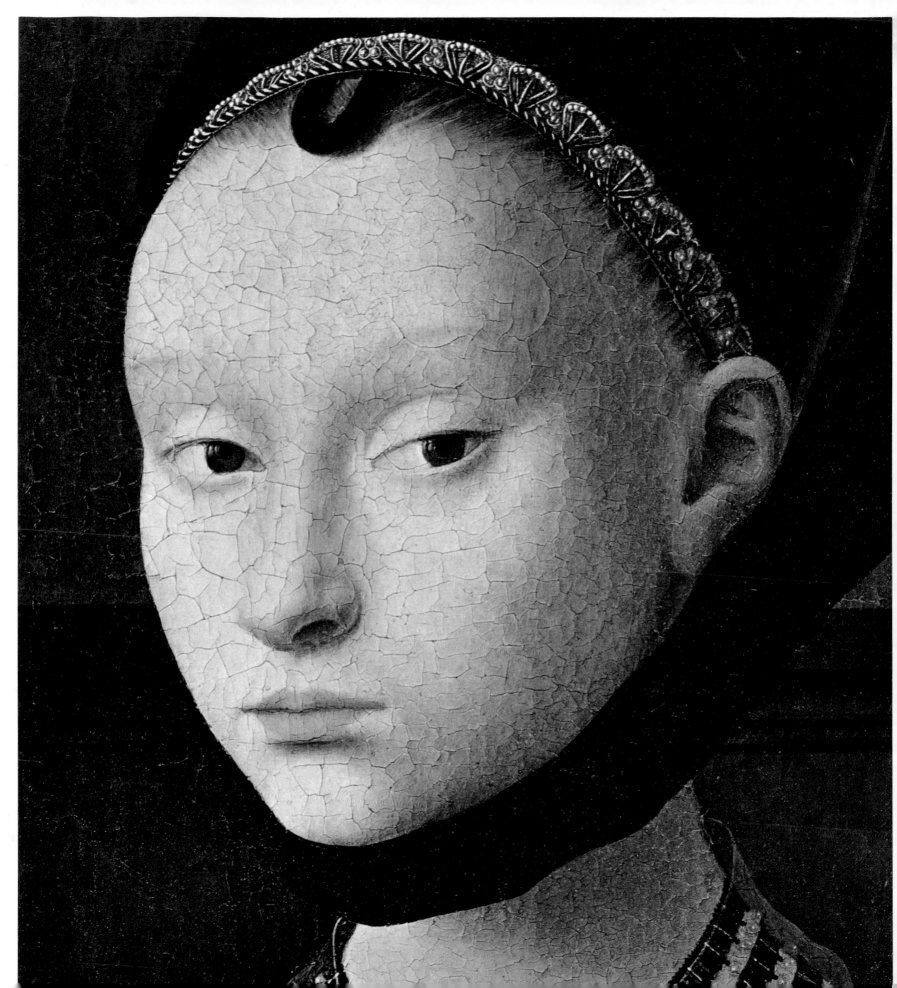

lighter zone of Christ's bloodless body, lengthened by the shroud and the two male figures. The curve thus produced in the foreground is a triumph of originality in composition. At one end of the picture is Mary Magdalene, and at the other, two onlookers – the two forms balancing each other. But whereas there are two figures on the right, there is only one, that of Mary Magdalene, on the left. With her full cloak and its many folds, she makes a perfect isosceles triangle. Although the composition is symmetrical, it is diversified, and is supported by a huge landscape whose rhythm and subtle colours harmonise superbly with those of the figures. The contours of the landscape are rather similar to those in the central panel of *The Mystic Lamb*, but there is a greater sense of unity in Christus' landscape.

This *Pietà* is undoubtedly the work of a major artist. Those who attribute it to Dieric Bouts are wrong. There are certainly similarities to Bouts, but the conception is very different. Hulin de Loo used the fact that several of the characters have short hair in support of his argument. But Christus could have done this deliberately, in order to emphasise the shape of the heads, which was one of his particular interests. One can see this very well by looking at the Virgin in the *Pietà*, copied from the Virgin in Van der Weyden's *Descent from the Cross* in the Prado. Van der Weyden uses different shades of colour in the face to emphasise the Virgin's grief. The numerous folds of her veil are like a stream of tears round her face. Christus simplifies the form, has fewer folds in the veil and keeps it flat to emphasise the shape of the head itself. But in his attempt to make too faithful a copy of St John he retains the curly hair, and as a result the saint becomes a rather insignificant figure, with none of the imposing qualities of the other figures in the picture.

We see in the *Pietà* a good example of the sort of colour Christus was capable of producing. It is a long way from the pale tints of Roger van der Weyden's works. Some of the colours here are only found in works by Christus – such as the claret-red which appears in almost all his pictures. The *Pietà* is not signed by him, but one may certainly attribute it to him. Whatever one might think about the treatment of the forms, one only has to compare the lively greens in the landscape here with those in the landscape of his *Last Judgment* in Berlin, which is signed, and the glowing green tints in the trees which show from which direction the light comes, with comparable passages in *The Nativity* of the same diptych.

A simplified version of the *Pietà* – in fact an earlier version – is in the Metropolitan Museum in New York, but the colouring is darker. The shadows in the flesh-tints turn to black; the blue in the Virgin's dress has greenish tints, and St John's cloak is a dull red. But the vermilion of Mary Magdalene's dress and her blue cloak lined with coppery green are particular features of Christus' colour.

There is another *Pietà*, small in size, acquired by the Louvre from the collection of Mme Schloss in Paris, but it is a weaker work and not directly related to the Brussels and New York versions.

The Dormition of the Virgin, which has recently gone to the San Diego Museum and which I saw when it was on sale in New York in 1939, dates from the artist's mature period. All the characteristics of his style are apparent, particularly the lively colours, and the way in which he solves the problem of spatial composition.

☆

Petrus Christus is mentioned for the first time in the archives on 6 July 1444. He was at this time described as a citizen of Bruges, but a native of Baerle, which is the name of two villages, one in northern Brabant and one near Ghent. Could he have been a pupil of Jan van Eyck? One cannot be certain. Van Eyck had been dead three years when Christus was enrolled as a citizen, and there is nothing to prove that he had settled in Bruges before 1444. In 1462 Christus and his wife were enrolled in the guild

of Notre Dame de l'Arbre sec. In 1463 the city paid him for a painting of the Tree of Jesse. The signed paintings date from 1446 to 1457, and the last payment mentioned in the archives is in the year 1467-8, for the restoration of a picture. He is mentioned in 1471 as dean of the guild of artists, and he died in 1472.

In short, Christus' activity at Bruges spans the gap from the death of Jan van Eyck to the advent of Jan Memlinc. He is more, however, than simply a link between the two.

DIERIC BOUTS

Fifteenth-century Flemish art owed its vitality to the contributions of highly individual artists who maintained the tradition, but at the same time expressed their own personalities and broke new ground technically.

Immediately after Jan van Eyck, and for some years simultaneously with Roger van der Weyden and Petrus Christus, but in a different artistic centre – Louvain – Dieric Bouts was active from 1458 to 1475. His particular contribution brought a new and rather unusual flavour to Flemish art.

Bouts has sometimes been assigned to the School of Haarlem, and sometimes to that of Roger van der Weyden. At any rate he came from Haarlem, in the north of the old Low Countries – according to Karel van Mander who saw an inscription underneath a picture by Bouts in Louvain. Van Mander also adds that tradition has it that there was an important school of painting in Haarlem. No one has yet been able to give conclusive evidence for the existence of such a school. On the other hand, to include Bouts with the Brussels artists would be to presuppose that he left Haarlem and went to Brussels specifically to be within striking distance of Van der Weyden, or that he was actually one of his pupils. None of this, however, has been proved. The theory rests entirely on a certain number of formal similarities between the two artists.

Rather than considering what points there may or may not be in common with Van der Weyden, it is more interesting to see how Dieric Bouts asserted his own personality in the face of the great popularity which Van der Weyden enjoyed at the time.

The only absolutely authenticated works by Bouts show signs of an accomplished style. It would be hazardous to assume from these works that he had a youthful style which later matured. I would not therefore attribute to him the Granada altarpiece of *The Descent from the Cross*, repeated in the Valencia triptych and four panels in the Prado: *The Annunciation, The Nativity, The Visitation* and *The Adoration of the Magi,* which recall Van der Weyden. Did he paint them in close proximity to the master? This still would not prove that he was his pupil. He could have settled in Brabant at the outset of his career and had the foresight to see that it would be sensible to introduce into his works some of the elements preferred there. But one should not over-emphasise this. Bouts' use of light tonalities has nothing at all in common with that of Roger van der Weyden at the close of his career. In Bouts' work the light is more harsh, picking out the colours in faces and clothing, whereas Van der Weyden's overall tonalities are darker, even when the figures are in front of a landscape.

We can only discover Bouts' real style – and his originality – in the properly authenticated works. We know of no signed work, but several may be attributed to him with certainty on the strength of contemporary documents. These are: the large triptych of *The Last Supper* and *The Martyrdom of St Erasmus,* both in the Church of St Pierre, Louvain, and *The Justice of Emperor Otto III* in the Musées Royaux in Brussels.

Concerning *The Last Supper*, we know that in 1464 two professors of theology from the University of Louvain, Jan Vaernacker and Gillis Bailluiwel, gave the artist iconographic specifications for the picture. They chose as the prefigurations of the Eucharist – which was to appear on the central panel – the meeting between Abraham and Melchisedek, the gathering of the manna in the wilderness, Elijah being fed in the wilderness, and the Passover. The contract for the work has survived, dated 1464, and the completed triptych was delivered to the church in 1468. The receipt for payment, in the artist's own hand, is written on a page of the account book of the guild of the Blessed Sacrament (43).

There is a curious feeling of something held back in the faces and attitudes of the characters. If Van Mander was right, this could be due to the artist's Northern origin, coming as he did from Holland. In the fifteenth century the northern Low Countries had not been exposed to the rigidity of Protestantism, and the difference in character and customs between North and South was not as pronounced as it is today. All the same, history and literature show that already at this time the North differed from the South in its rigorous thought and austere way of life. The countryside was less fertile and the towns less prosperous. This could then explain to a certain extent the geometrical composition of Dieric Bouts, the stiffness of his figures, his reserved, even closed features.

In *The Last Supper* the religious feeling is restricted to asceticism. The uncompromising cube of the setting affects all the components: grouping, figures and tonalities. The characters – apparently seen from an elevated viewpoint – are shown in rigid attitudes and are symmetrically distributed around the the light zone of the supper table. The colours are quite well balanced, and the combination of these factors, rather than the expressions on the faces, gives the institution of the Eucharist the special sense of the sacred and the solemn emotion combined with something of human gravity. There is no hint of emotion or misplaced poeticism, only the moving splendour of the unfathomable mystery taking place before the eyes of the chosen. The carefully handled setting, and also the addition of some secondary characters, throws into relief the severity of the style with which the subject is handled. The word rigid has been used to describe it, but one is tempted to say cold, for in spite of the deep blues, reds and greens in the garments, the general effect of the colour is cold when compared with the Van Eycks, who matched their colours better, and related them more successfully to an atmosphere that had greater reality and human feeling. A comparison with the original of *The Mystic Lamb* – a black-and-white reproduction would not be adequate – would show how much more restrained Bouts is. There is a similar gap between the mystical writings of the Brabançon Jan van Ruusbroec and the Dutchman Geert Groote and the Brethren of the Common Life.

The volets of *The Last Supper* have more humanity in them, although there is still rigidity of form. But it seems that here the artist's imagination ranged more freely. In the Old Testament scenes there is a certain amount of fantasy in the handling of events, accentuating of faces, varying of the dress, and treatment of the landscapes, so that they are much livelier.

From a technical point of view Bouts' rendering of distance by reduction of colour is less successful than that of either Van der Weyden or the Van Eycks. The 'wings' are too pronounced. But the sky is generally beautifully lit, which makes up for a great deal. The pure clarity is emphasised by the slender trees which stand out in silhouette.

There is even more restraint evident in the two large panels of *The Justice of Emperor Otto III* in the Musées Royaux in Brussels. The work is authenticated by documents, and was probably painted towards the end of Bouts' life, for he died leaving one panel unfinished. The work was intended for the council chamber and courtroom of Louvain town hall. The artist received the commission in 1468, but the panels did not arrive until 1470 (44). The unusual rectangular format (nearly twice as tall as they are wide) forced the artist to elongate the figures – he generally made them rather squat – as a result of which they seem stiff and angular. The painting has a decorative quality, and the tonal range is more neutral than that of *The Last Supper*. The overall effect is of a tapestry.

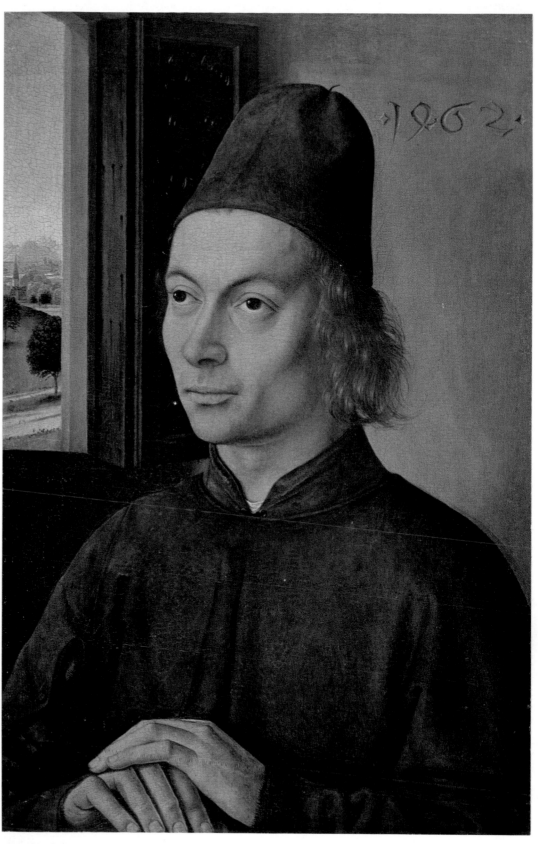

xVIII Dieric Bouts: portrait of a man.
National Gallery, London

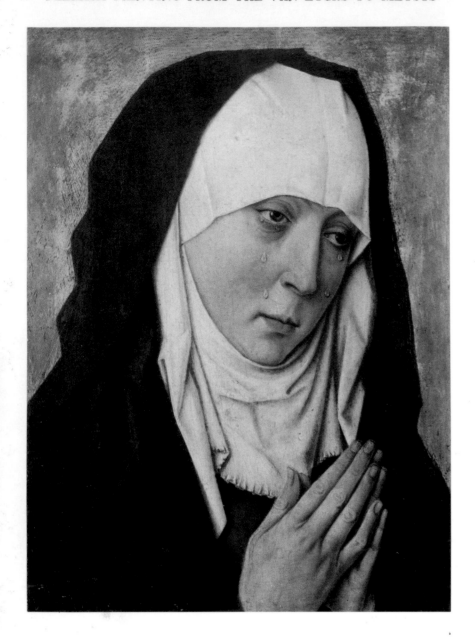

xix Dieric Bouts: *The Virgin of the Sorrows*
Private collection

The two main works concerned with Justice must have reminded judges of the danger of not considering their judgments adequately. They tell the story of a wrong judgment and its eventual redress. The story is taken from *Pantheon*, a history of the world compiled shortly before 1185 by Gode-froid, Bishop of Viterbo. It was then reproduced in the fifteenth century in an anonymous compilation published in Hesse. One of the vassals of the Emperor Otto was condemned to death by the emperor on the strength of accusations made by the empress. In fact, the empress had made advances to the man and had been rejected. The first panel shows the emperor on the palace walls watching the unfortunate man going to his death. The victim tells his wife to establish his innocence. In the foreground we see him being beheaded and his wife receiving the bloody head. In the second panel the widow claims redress from the emperor and demands that the empress stand trial. The wife offers to submit to the judgment of God by taking hold of a red-hot piece of iron. The ordeal goes in her favour and there is no

140

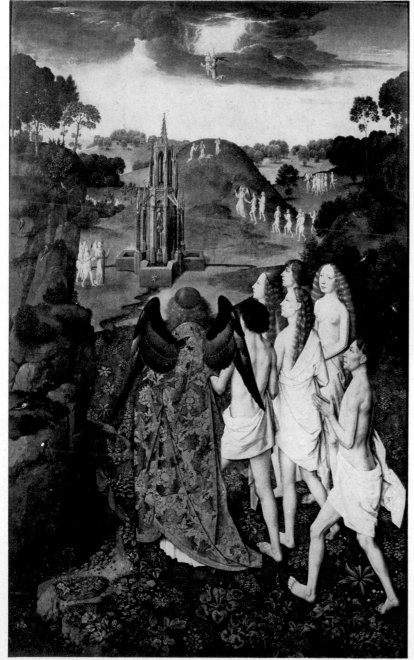

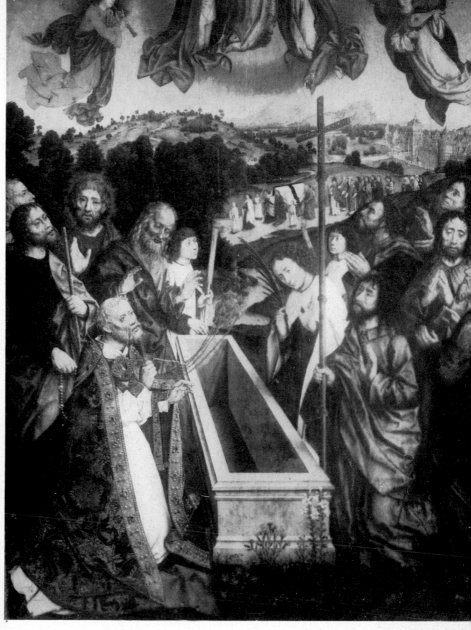

94 Aelbrecht Bouts: *The Assumption of the Virgin*
Musées Royaux des Beaux-Arts, Brussels

95 Dieric Bouts: *The Last Judgment*
Left volet showing Heaven.
Musée des Beaux-Arts, Lille

96 Hugo van der Goes:
The Adoration of the Magi
Staatliche Museen, Berlin

97 Hugo van der Goes:
The Adoration of the Shepherds
(Portinari Altarpiece)
Uffizi, Florence

98 Hugo van der Goes:
detail of 97 opposite,
showing the Shepherds.
Uffizi, Florence

99 Hugo van der Goes: *The Adoration of the Shepherds*
Left volet showing Tommaso Portinari and his sons with
their patron saints. For detail see colour plate XXIV (p. 156)
Uffizi, Florence

100 Hugo van der Goes: *The Adoration of the Shepherds*
Right volet showing Tommaso Portinari's wife and daughter
with their patron saints.
Uffizi, Florence

161 Hugo van der Goes: *The Dormition of the Virgin*
For details see colour plates XXV and XXVI (pp 160 and 161).
Groeninghe Museum, Bruges

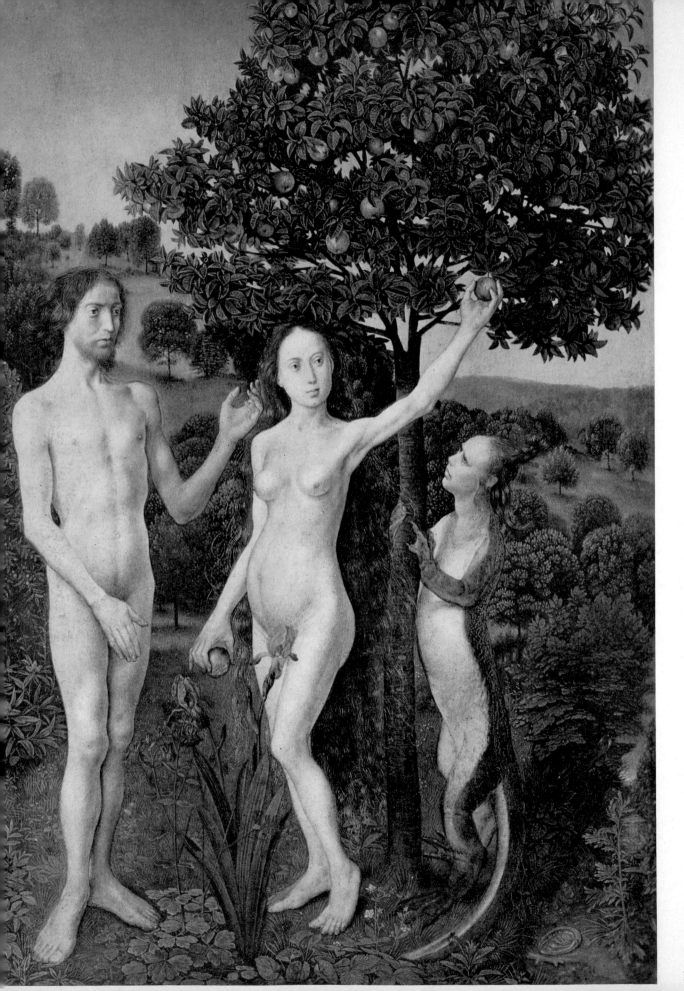

102 Hugo van der Goes:
The Fall of Man
Kunsthistorisches Museum, Vienna

103 Hugo van der Goes: *A Donor with St John the Baptist*
Walters Art Gallery, Baltimore

104 Hugo van der Goes: portrait of a man.
Metropolitan Museum, New York

105 Hugo van der Goes: *The Virgin, St Anne and a Donor*
Musées Royaux des Beaux-Arts, Brussels

106 Hugo van der Goes: *The Virgin, St Anne and a Donor*
Detail of 105 showing the Virgin and Child.
Musées Royaux des Beaux-Arts, Brussels

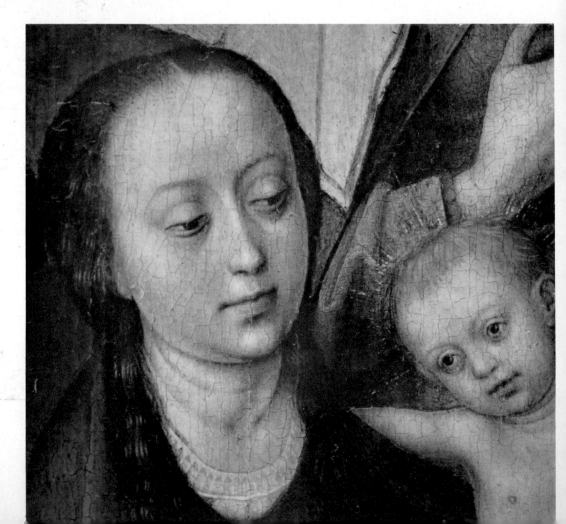

sign of a burn. The truth is now apparent to all. The empress is to be burnt alive, and in the background we see the event taking place.

Molanus, a historian and theologian living in Louvain in the sixteenth century, alludes to two works by Bouts as being in the chapel of the Blessed Sacrament in the Church of St Pierre in the city. One is *The Last Supper* already dealt with, and the second is probably *The Martyrdom of St Erasmus*, still in the same place. There is a repainted inscription on the frame with the name and an incorrect transcription of the date (an Arabic 4 occurs before a Roman C, which must be read as 4 times C [100]), indicating that the work is by Dieric Bouts and was painted in 1468.

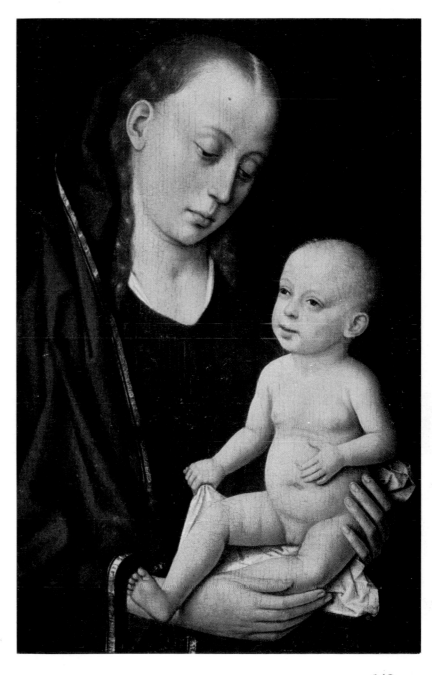

xx Dieric Bouts: *Virgin and Child*
Private collection

XXI Dieric Bouts: *The Martyrdom of St Erasmus*
Detail of the left volet of 92 (p. 132) showing
St Jerome. Church of St Pierre, Louvain

This is probably not Bouts' most important work, but it is certainly his most artistic. One finds in it his calm lucidity, his attempt to avoid the brutal reality of the execution and show the saint's moral courage as he bears his torture with calm heroism. The torture is atrocious. An incision has been made in his abdomen so that his entrails can be wound round a sort of winch. He is stoical in his suffering. There is no distortion round his mouth or contortion visible in his muscles. He accepts the pain silently, out of love of God, and he glimpses his heavenly reward. Even the executioners play their part without hatred or remorse, whilst the judge and the three onlookers watch the execution with the indifference of compulsory witnesses. The calm treatment of the figures is helped by the composition. There is a large arc from the head of one executioner through the saint's body and up to the other executioner's head. Within this arc is the compact square of the onlookers. All the figures look solid, and they fill their portion of the space adequately. There is a curiously geometrical feeling about the alternating vertical and horizontal zones in the groupings, but it fits perfectly into the shape of the picture. It is

150

the most radiant work in fifteenth-century Flemish painting, despite the heavy colouring of some of the clothing. The rendering of the various zones of the landscape is beautifully managed, and the standing figures are caught in its clear light. In this work Dieric Bouts already achieves the *al fresco* quality which Piero della Francesca was to use, and for which he is wrongly given the credit. The two onlookers on the left would not have been out of place in a work by Piero. The volets of *The Martyrdom of St Erasmus*, with St Jerome and St Bernard, have the same qualities.

☆

The archives also mention a 'little' picture of *The Last Judgment* which was painted by Dieric Bouts for Louvain town hall at the same time as *The Justice of Emperor Otto III*. We do not know whether or not Bouts carried out the commission, but M.J. Friedländer has put forward the extremely plausible theory that the volets of this 'little' picture – which need not necessarily be very small, since the terms of reference are the extremely tall panels of *The Justice of Emperor Otto III* – could well be *Heaven* in the Lille Museum and *Hell* in the Louvre. The style is the same as that of *The Last Supper* and *The Martyrdom of St Erasmus*. In *Heaven*, the blessed receding into the background towards the Fountain of Life show a fine example of *al fresco* composition. In *Hell* – darkened by opaque varnishes – the rendering of the damned emerging convulsively from the ground is excellent; so also are the demons piling them up in a rocky gorge. Bouts' imagination and technical resources have brought off some magnificent effects in portraying the forces of evil. The monsters with their grey highlights and phosphorescent eyes are more expressive than those painted later by Bosch.

After examining the documented works, we shall consider the main works which may be attributed to Bouts on stylistic grounds.

First of all there is *The Martyrdom of St Hippolytus*, in the St Sauveur Museum, Bruges, which may confidently be attributed to Bouts except for the left volet. This volet, which is unanimously seen as the work of Hugo van der Goes, has the portraits of the donors, Hippolyte Berthoz and Elisabeth de Keverwyck, of Bruges. It is possible, of course, that the donors commissioned one artist to paint the centre of the work and another the portraits on the volets. But this is not in line with normal practice at the time, nor would it seem a valid suggestion for a small work such as this. It seems more likely that Bouts died before it was finished, and that Van der Goes was called in to paint the second volet. We know, after all, that when Bouts died, Van der Goes decided how much was due to his colleague's widow for the paintings which remained unfinished at the time.

The same person painted *The Martyrdom of St Erasmus* and *The Martyrdom of St Hippolytus*. There are the same reserved attitudes, similar delicacy in the tonal values, equal intensity of colours, and the same brightness. In the second picture there is, however, a more solid approach to contours in the figures and a certain number of errors in the proportions. Bouts was not quite able to meet the demands of his composition and was unable to save enough space on his little panel to carry it through to the end. He was therefore forced – rather clumsily – to reduce the size of the horses tearing the saint apart.

There are several works similar in style in the Munich Pinakothek: for example, *The Taking of Jesus, The Resurrection* and *St John the Evangelist*. The browns characteristic of the artist are evident, so is his beautiful slate blue, the erect figures and, most of all, the reserved expressions. But *The Adoration of the Magi* is a little masterpiece of much greater importance. For some incomprehensible reason the triptych was first of all attributed to Dieric Bouts the Younger, of whom we know virtually nothing – except that he was an artist – then to an anonymous Flemish master. And yet the wonderful technique

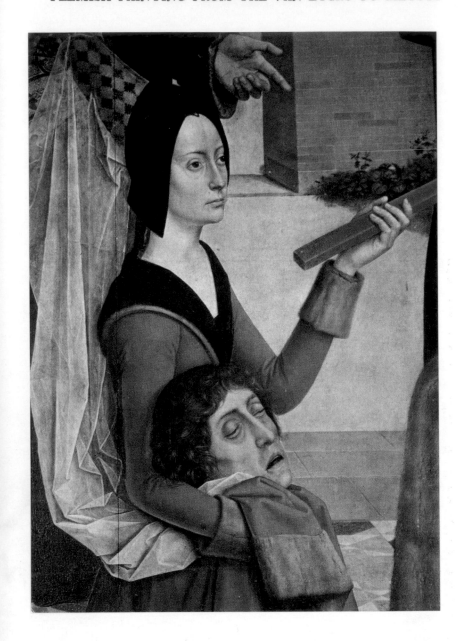

xxii Dieric Bouts: *The Justice of Emperor Otto III*
Detail of 86 (p. 128) showing the ordeal by fire.
Musées Royaux des Beaux-Arts, Brussels

and strong colour is the very essence of Dieric Bouts himself, and shows him at the height of his powers.

The same characteristics are found in the portrait of a man in the National Gallery in London. It bears the date 1462, and is therefore the first of Bouts' paintings which we can place chronologically. We shall probably never know with certainty, even by a process of deduction, which were his previous works.

Bouts was an excellent portrait painter, and it is in his portraits that his tight, Northern temperament is most clearly seen. He approaches his sitter as a living reality, and brings with him the resources of his technique so as to portray his direct vision. He achieves obvious successes. Even in some of his compositional paintings – such as *The Last Supper*, for example – some of the characters have the feel of portraits. But in a true portrait, when the artist isolates his sitter against a plain background, he gets even closer to the character he is studying. He records the solidity of the cranium, the skin stretched over

the bone, the fixed look and the individual physical characteristics. In this genre his approach is similar to that of Jan van Eyck. He lights the side of the face which is turned in towards the background. He models the essential features with extremely finely graded tints and with subtle and delicate highlights. The best portrait which can be attributed by stylistic comparison with the figures in his authenticated works is possibly the portrait of a man in the Metropolitan Museum of New York, and formerly in the Oppenheim and Eltman collections.

The biographical details about Dieric Bouts (there are several variations on his Christian name) are few. It seems that he was born round about 1400 or 1410. Probably he began his career in Haarlem. Karel van Mander said that he was born there and speaks of the house he lived in. We know nothing definite about the early works, nor do we know anything about the school of painting which was supposed to have flourished there at this time. The great Dutch painters Aelbrecht van Ouwaeter and Geergten tot Sint Jan did not begin their careers until 1465 and 1490 respectively. Their styles are very

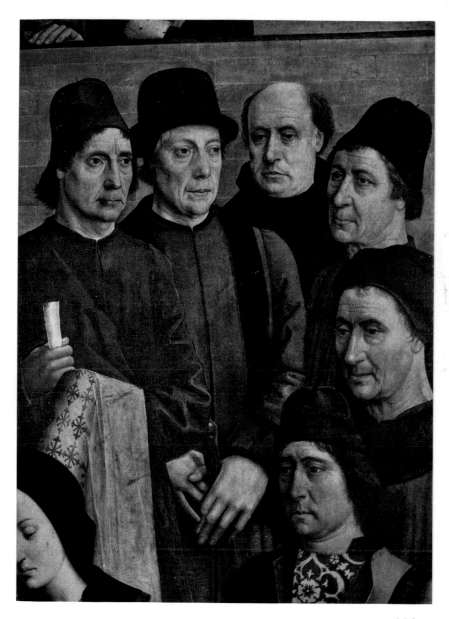

xxiii Dieric Bouts: *The Justice of Emperor Otto III* Detail of 85 (p. 128) showing the heads of the onlookers. Musées Royaux des Beaux-Arts, Brussels

153

individual, and we cannot deduce anything from their works – nor from the works of Dieric Bouts – about painting in Haarlem before 1460.

The first documentary reference to Bouts is at Louvain in 1447-8; it relates to his marriage to a young girl from the town, Catherine van der Bruggen. Possibly he only arrived in Brabant a short time before this date, as M.J.Friedländer has suggested (45). In that case, he had probably worked elsewhere, and only arrived in Louvain when he had finished his apprenticeship and acquired his mastership. On the other hand, he might have come to Brabant much sooner, attracted by the reputation of Roger van der Weyden, as Hulin de Loo has suggested (46). In support of this theory reference is made to a view of Brussels in a *Crucifixion* in Berlin, a work which is attributed to Bouts. Is this one piece of evidence sufficient to establish that the painter spent some time in Brussels early in his career? Even if the work is to be attributed to him, he could perfectly well have made a sketch while he was on a visit, and used it later. Besides, it is fairly normal that an established artist, who settled in Louvain somewhat late in his career, should feel the need to assimilate something of the style of Roger van der Weyden – the most famous artist in the whole of Brabant at the time. Van der Weyden had also worked in Louvain, where he painted the angels on the ceiling of the Church of St Pierre.

From 1448 to 1457 there is no documentary record of Dieric Bouts. Hulin de Loo has suggested that the artist returned to Haarlem for these nine years. In support he points to the influence which Bouts subsequently had on the School of Haarlem. There is no foundation for this whatsoever. Aelbrecht van Ouwaeter need not necessarily have been taught directly by Bouts, he need only have studied his works. The same goes for Geertgen tot Sint Jan.

But what is the point in inventing ingenious theories in order to explain the lack of documentary evidence about Dieric Bouts? It is quite possible that he simply worked quietly at Louvain for some years in relative obscurity. His name reappears in the archives of Louvain in September 1457, then in 1462 he painted a picture on which Karel van Mander read the inscription: '*Peint à Louvain par Dieric qui naquit à Haarlem*' ('Painted in Louvain by Dieric who was born in Haarlem'). From this time on, references become numerous and continue until his death in 1475.

DIERIC BOUTS' CIRCLE

There is little point in lingering over the followers of Dieric Bouts who carried on his style of painting in Brabant. He was directly imitated by some artists, and one of them made a version of his *Jesus in the House of Simon the Pharisee* in Berlin, and this second version – in which the composition is reversed – is now in the Musées Royaux in Brussels. It would be a mistake not to accept this copy for what it is, however. It has a great deal of vigour and the colour is very refined. Some critics have suggested that the picture is by Bouts' eldest son, but this is only a theory.

There is very little precise information about the works of Dieric Bouts the Younger, or about his career. He came of age in 1473, married in 1476, and died somewhere between 28 December 1490 and 2 May 1491. He is mentioned as '*pictor imaginum*'. That is all we know about him, which makes any attribution to him a very hazardous business.

On a basis of analysis of style with Dieric Bouts the Elder, some critics have identified his son as the Master of the Tiburtine Sibyl, so called from *The Apparition of the Sibyl to Emperor Augustus* in the Städelsches Kunstinstitut in Frankfurt. The style of the work is similar to that of Dieric Bouts the

Elder, but the manner of painting is heavier. Other works associated with the son are: *Standing Virgin* in the former Böhler Collection in Munich; *Seated Virgin* in the Stephenson Clarke Collection at Haywards Heath, England – of which there is another version, dated 1494, at Leitmeritz in Bohemia. Similarly critics attribute to him the *Pietà* in the Prague Museum, which is closely inspired by Petrus Christus' *Pietà*, and *St Luke painting the Portrait of the Virgin* in Lord Penrhyn's Collection, copied from Van der Weyden.

There is certain documentary evidence relating to Aelbrecht Bouts, Dieric's second son, but nothing specific about his output. He had not come of age when his father died, and in 1476 he was still a minor. He is mentioned as a '*peintre de figure*' in 1479. He married in 1481, and again in 1490. In 1515 he worked on an *image* in the chapel of the guild of the Blessed Sacrament in the Church of St Pierre, Louvain, and in 1518 on the restoration of a *Crucifixion* in the aldermen's hall of Louvain town hall. He died in 1549.

According to certain critics, Aelbrecht Bouts painted several works which bore no artistic relation to each other, but in which his father's style was evident in a watered-down form. There is only one work which may be attributed to him with any certainty, and that is *The Funeral of the Virgin and the Assumption*, in the Musées Royaux in Brussels, along with a second version, also in Brussels. Evidence comes from Molanus, the sixteenth-century historiographer, who has a relevant passage and a punning coat-of-arms which could possibly be that of Bouts, but most of all from texts which have recently been reinterpreted (48). But the severe style of the great Dieric Bouts has by this time become rather insipid. There is nothing left of his structures, his confident technique or his strong colour. What we can see is the work of a third-rate artist. The same is true of another work – with the same coat-of-arms – an *Annunciation* in the Munich Pinakothek. There is no life in the work and the colour is flat. Yet critics have attempted to attribute several works, some of them good, to this artist simply because they are in the style of Dieric Bouts. Several versions of *The Crowning with Thorns* and *Our Lady of the Sorrows* have been attributed to Aelbrecht Bouts. They have much in common with the style of Dieric Bouts, but all one can say is that they were painted by an artist who, although he followed Bouts fairly closely, was far from his equal in every respect.

THE DARING ART OF HUGO VAN DER GOES AND JOSSE VAN WASSENHOVE

HUGO VAN DER GOES' PREDECESSORS AND CONTEMPORARIES

Jan van Eyck had been dead for twenty-five years, Roger van der Weyden had recently died, and Petrus Christus and Dieric Bouts were almost at the end of their careers when Hugo van der Goes, enrolled as a master in 1467, made his appearance and then rapidly outclassed the numerous disciples of Roger van der Weyden.

The archives of Ghent, where Van der Goes first made his mark, give the names of several artists and a number of specifically described paintings which seem to have been extremely popular. Unfortunately we are unable to associate these names now with surviving pictures.

One of the most important artists in Ghent was Nebuchadnezzar or Nabur Martins. He is first mentioned in 1427-8, enrolled as master in 1435, and it is possible to follow his career until 1457. The archives mention several of his paintings and decorative works, but it is impossible to point to any work with certainty and say that it is his. There is a mural of *The Nativity* in Ghent dating from 1448 in the former chapel of the Grande Boucherie, which has been attributed to him, but without proof (49). The mural was discovered in 1855, but has been so heavily restored that it is no longer possible to give any opinion of its original artistic value. It is typical of what was being produced at Tournai at this time, particularly by the Master of Flémalle and Jacques Daret.

Daniel de Rycke, enrolled as master in 1440, also had quite a following in Ghent. Several of his works are mentioned in the archives, but none of them has been identified.

A third artist, Livinius van Laethem, master in 1454, is mentioned as a famous painter at the beginning of the sixteenth century by Jan Lemaire des Belges, court poet to Margaret of Austria. When he was employed by Philippe le Bon, Van Laethem had a quarrel with the guild of artists of Ghent, who finally expelled him. He had himself enrolled in Antwerp in 1462, then set up in Brussels. In 1468 he was summoned to Bruges to help provide the *entremets* (sweet course) for the wedding breakfast of Charles le Téméraire and Margaret of York. Afterwards he returned to Antwerp, where he lived until the beginning of 1493. Apart from some miniatures, we have nothing which can be attributed to him with certainty.

There were several artists in Ghent at the same time who had full and active careers. Gheerrolf van der Moortele and Clarenbaut van Uytvelde are two of them, but their works are unknown today.

XXIV Hugo van der Goes: *The Adoration of the Shepherds*
Detail of 99 (p. 144) showing the heads of the sons of Tommaso Portinari.
Uffizi, Florence

HUGO VAN DER GOES

Of the painters from Ghent mentioned so far, only Hugo van der Goes is in the category of the great masters. We can see how famous he was in his own lifetime from the rapidity with which he became a juryman, and then dean of the guild of artists, and from the important commissions he received from civic authorities and princes. Dürer, Van Mander, De Heere, Sanderus and even Descamps have helped to maintain his reputation, but unfortunately not one signed work has survived.

The only one of his works authenticated by documentation is the great Portinari Altarpiece, *The Adoration of the Shepherds*, in the Uffizi in Florence. Vasari, in the first edition of his *Lives* in 1550, and Guicciardini in 1567, mention it as his work. Though rather late, we can accept these references as accurate. By comparison with three portraits of him by Memlinc, Tommaso Portinari has been identified on one of the volets of the triptych. We know, moreover, that it was Tommaso Portinari who gave the triptych to the Church of Santa Maria Novella in Florence, where it remained for several centuries. Portinari was the Medici agent in Bruges. Some critics have tried to fix an approximate date for the painting from the fact only the three oldest Portinari children, born between 1471 and 1474, appear on the volets. This would place it towards the end of Van der Goes' activity. It was certainly in Florence before 1485, because in that year Ghirlandaio finished his *Adoration of the Shepherds*, in which the shepherds are inspired by those in Van der Goes' painting.

The Portinari Altarpiece is Van der Goes' major work, and the most striking aspect of it is the monumental figures, which are most unusual for Flemish painting at that time, when small size often spoilt the scope of pictures. The size envisaged (the central panel alone is 249 × 300 cms – 8 ft 1 in. × 9 ft 10 ins) demanded a work on the grand scale. Van der Goes' previous experience in decoration, mentioned in the archives but unfortunately now untraceable, would have stood him in good stead.

He would have known how to accommodate to various shapes and sizes of panel by relating his forms proportionately to the surface area. In the central section the figures of the Virgin and St Joseph, broadly developed, with beautiful colour passages, set the key of the scene. Artists had previously placed the shepherds a little way off, as if they were secondary characters. They showed them looking on timidly from a distance, or through a window or a hole in the roof. Van der Goes makes the shepherds important figures. Their compact group is rich with movement and colour. The traditional stable is replaced by the ruins of a palace, which solidly underpin the whole composition. The spaces are cleverly filled with angels, animals, a vase of flowers or a bale of straw – but without the excessive quantity of objects one sometimes finds in the Master of Flémalle. There is a clear space for the Holy Child, who rests on the ground in a pool of light and amidst a respectful silence.

This is a strangely daring work for its time, and it avoids the flat feeling of a single plane which one finds in the three great pictures of Roger van der Weyden. Van der Goes' composition has depth and solidity, with strongly opposed figures and dark tonal values on the left and light ones on the right. The shepherds are very slightly set back. The treatment of the angels is extremely varied, and they are more or less everywhere in the picture. Some are kneeling in the foreground to left and right, some complete the grouping in the background and others float in the air. One of the last group shows marvellous contrast in lighting, particularly in the floating garment, which is already Baroque in feeling. In the background there is a house with the letters P NSC MV on the door, and a shield with a harp on it, which could be an allusion to David, from whom both the Virgin and St Joseph were descended. On the right a landscape is seen intermittently, with the angel announcing the birth of Jesus to the shepherds. The lightness of the landscape echoes the light around the Christ Child. The colour is a powerful component of the picture: St Joseph's massive form is painted crimson, and the Virgin a deep ultramarine blue. The shepherds are given a variety of browns.

The same goes for the large figures of the patron saints on the inside of the volets. St Thomas (painted in light red, dark red and green) and St Antony the Hermit on one side; Mary Magdalene and St Margaret (a beautiful vermilion) on the other. The saints are shown as superior beings against a calm, noble landscape. Not until the sixteenth century, with Dürer's apostles and the works of some Italian Renaissance artists, were there to be comparable figures of such stature. Nowhere in the triptych does the artist's splendid vision flag. It even continues on the outside of the volets, where there is a *grisaille Annunciation* with a Virgin of supreme dignity. The beautiful angel with lowered head and raised hand assumes a majestic quality unequalled in fifteenth-century Flemish painting.

Hugo van der Goes was a formidable and original artist whose style was sensitive and direct. The fundamental element in his works is the monumental quality mentioned above, and the second characteristic is undoubtedly his truthfulness. His frank approach, without emphasis or circumlocutions, but warm and vibrant, has direct and wide appeal. In spite of their noble quality, the Virgin and St Joseph are of the common people; they have the hands of a working-class couple. The angels, too, seem more human than divine. As for the shepherds, they are manifestly true to life; rustic characters moulded by the most primitive form of country life. Of course they are transfigured as they worship the Christ, but their rugged faces and heavy, roughly-formed bodies make them admirably suited for their parts. The popular element bursts into Flemish art with Van der Goes, and yet at the same time it avoids any hint of vulgarity.

Alongside this *Adoration of the Shepherds*, which is so accessible in its human simplicity, Roger van der Weyden's *Adoration of the Magi* has the air of a visit to a princely court where the people look on with curiosity, even respect, but to which they feel foreign.

Finally one must note the wonderful finish to the painting. Van der Goes spent his formative period in Ghent, and shows himself to be a remote disciple of the Van Eycks. He is doubtless the subject of the story told by a late fifteenth-century German traveller, the doctor Hieronymus Münzer (Monetarius). Münzer tells how the people of Ghent talked about a great painter who so despaired of ever achieving the perfection of *The Mystic Lamb* that he fell into a deep depression and blackest melancholy (50). Despite a certain amount of affinity with the Van Eycks, Hugo van der Goes never reaches the sublimity of thought, nor the rich blend of colour ard the all-pervading smoothness of *The Mystic Lamb*. His approach is more decorative and his tonal range less rich. In *The Adoration of the Shepherds* there are several splendid passages: the blue of the Virgin's dress; the red of St Joseph's clothing; the brown and gold brocade of the angels' copes and dalmatics. On the other hand, the flesh-tints are generally either dark or chalky; the ground and the buildings dull, and the landscape colouring discreet to the point of timidity. The work's pictorial qualities lie in the tonal delicacy and the sureness of touch, through which the material nature of objects – their volume, density and situation in spacc – is rcndcrcd. Van dcr Gocs has a surprising ability to render straw, the texture of a flower, the hardness of a pot or the suppleness of hair. His feeling for contour is also remarkable. He has a very personal way of suggesting both the solidity and the elasticity of flesh entirely by grey shading. In common with all Flemish artists at the time, he paints slowly and with a great amount of application. Nevertheless at times he relaxes, doubtless because of the exceptionally large size of the painting. The Virgin's hair has a freedom of brushwork rare for those days. Van der Goes treats hands analytically, with marvellous technique, whereas those of the Van Eycks had been massive, and they were generally schematic in the works of Van der Weyden and Memlinc. With Van der Goes the contour is all important. In his portraits, Van der Weyden paints splendid hands with pronounced bone structure, muscles, and even veins. With Van der Goes the features are clearly marked under a supple layer of flesh. His hands are always remarkably individual. St Joseph, for example, has sturdy hands that are hardened by work. The shepherds' hands are rough and gnarled. The Virgin's hands are slightly swollen with rheumatism.

This analysis gives us a sufficient number of stylistic elements with which to consider other works

which may be attributed to Van der Goes – always bearing in mind, of course, the variations one can expect to find in a painter who was so much of an innovator.

The monumental quality and individualistic style are apparent in two panels from an organ case in the Palace of Holyrood House in Edinburgh. One shows James III of Scotland and his son, with St Andrew, patron saint of Scotland; and the other James III's wife, Margaret of Denmark, and her daughter, with St Canute or Knud, patron saint of Denmark. The figures of the two patron saints belong to the same artistic family as those on the volets of *The Adoration of the Shepherds* (the Portinari Altarpiece). The portraits are less successful. One could even say that the heads are bad, except for the prince, whose hands have the same shape as those of the Virgin in the Portinari Altarpiece, and the daughter of the donor's wife. Hugo van der Goes did not see all his sitters for the Edinburgh portraits, and a Scottish artist probably completed them. This would seem to be confirmed by the fact that St Andrew's right hand seems emaciated. Originally it was intended that he should hold the crown of Scotland, and one assumes that Van der Goes left a blank space so that a local artist could finish the work more accurately by painting in the crown and the hand. On the back of one of these panels is a portrait of Canon Edward Bonkil, the donor, who is identifiable by his coat-of-arms. At the time of the marriage of Charles le Téméraire to Margaret of York, Bonkil was in Flanders, possibly even with the young prince, whose portrait is so striking. One may assume that Bonkil commissioned the panels when he was in Flanders. Van der Goes has painted a very good portrait of him. There is one point of particular interest, which is that the face is not lit from the side, as in the works of Jan van Eyck, nor from the front, as with Van der Weyden, but slightly from above, which gives completely new contours.

There is a portrait similar in style to those on the volets of the Portinari Altarpiece in Florence – a donor with his patron saint, now in the Walters Art Gallery in Baltimore. It is a fragment of a large volet of an altarpiece. Recent cleaning has removed part of the saint's beard, and the firm contour is now visible. The donor's head is seen in three-quarters profile, but the light does not fall full on the face. It touches a temple, a cheek and the nose, and the other features are handled in half-tints. This represents yet another innovation in the art of portraiture. In the light of this portrait, one is rather

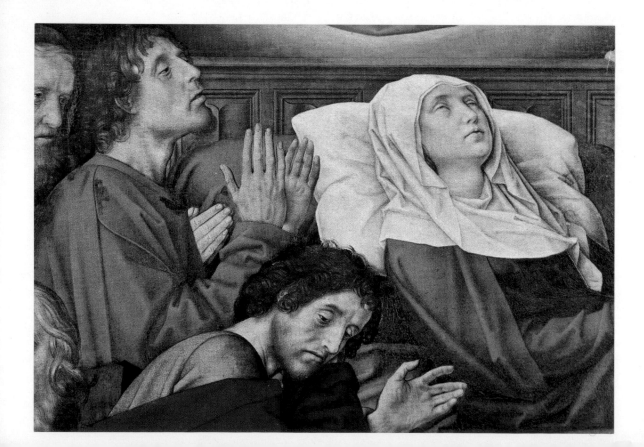

xxv Hugo van der Goes:
The Dormition of the Virgin
Detail of 101 (p. 145).
Groeninghe Museum, Bruges

XXVI Hugo van der Goes:
The Dormition of the Virgin
Detail of 101 (p. 145).
Groeninghe Museum, Bruges

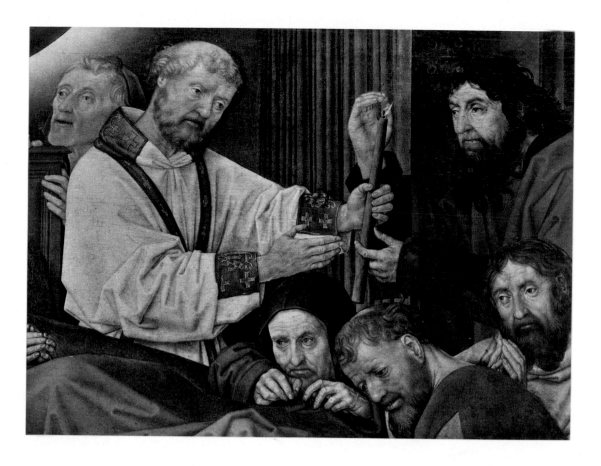

dubious about the current attribution to Van der Goes of a portrait of a man in the Metropolitan Museum of New York, which has in any case lost some of its colour.

By stylistic comparison with the Portinari Altarpiece in Florence one may attribute other important works to Van der Goes. No one doubts the attribution of *The Adoration of the Magi,* formerly in the Monastery of Monforte de Lemos in Galicia (Spain), and now in Berlin. The figurations would confound critics who attribute mainly by a comparison of types. The Virgin here is very different from the one in the Portinari Altarpiece, and the Christ Child – lively and pert, but tender – is not like any of the other representations we have seen so far. The presentation is on a grander scale, with a great many movements. Nevertheless, one recognises in the Berlin work Van der Goes' very personal style. He was an artist on his own, gifted with a remarkable faculty for innovation, which involved not only variety of form, but also of colour. The colours here are firmer and there is more variety than in the Portinari Altarpiece. The magi's garments are strong red, firm brown and bright green respectively. St Joseph's clothing is deep claret-red, and the Virgin's a beautiful pure blue. The tints in the landscape combine with these rich colours to make the Berlin picture even more sumptuous than the one in Florence. The upper part, which originally terminated in an arc, has been cut off. There is a copy extant in which one can see the whole of the angel now cut off at the waist in the original.

There is also in Berlin an *Adoration of the Shepherds* which is close in spirit and style to the Florence picture but even more spacious by the addition of a prophet at either end, pulling back curtains. This recalls the mystery plays, in which the Nativity was preceded by a prophecy about the incarnation of the Messiah. The shape of the panel has made the presentation of the scene more intimate. The use of

161

colour is as vigorous as in the Florence triptych, and is dominated by three basic shades: blue for the Virgin, vermilion for St Joseph and, in the two figures of the prophets, scarlet and brownish-red contrasting with the complementary green of the curtains. These strong colours are softened with, for for example, white in the blue of the Virgin, purple in the vermilion of St Joseph and all over lighter secondary tints.

There are also some smaller pictures which are similar in style to the Portinari Altarpiece, but the colours are brighter, the technique more concentrated and the impasto heavy. Because of these differences it has been wrongly imagined that they must be early works, but they were dictated simply by the the smaller format.

The most important of the smaller works is *The Adoration of the Shepherds* in the Earl of Pembroke's Collection at Wilton House. All the characteristics of the artist's style are there, particularly the dark flesh-tints. The main colours are more distinct: deep ultramarine for the Virgin, bright vermilion for St Joseph and intense green for the shepherd on the left. As he often does elsewhere, Van der Goes has added violet, grey and brown of differing intensity. All the artist's personality seems to be concentrated in these small works. The composition becomes more dense and almost symmetrical.

A work similar in conception is *The Virgin with St Anne and a Donor* in the Musées Royaux in Brussels. The contours are pronounced and the general feeling is one of exquisite gentleness. The balanced composition clearly indicates the artist's desire to enclose it within a triangular outline. This has been taken by some to indicate an early work, but one sees in this picture every bit of the greatness, maturity of spirit and sureness of touch visible in the works claimed to be of the late period. What we see here is complete; there is no future promise, no hint of a further development.

There is a painting of the Virgin in Brussels – which radiographs show to be only a heavily restored ruin of the original – and others in the Johnson Collection in the Philadelphia Museum and the Städelsches Kunstinstitut in Frankfurt (of which there are copies in Kassel and in Richmond in Middlesex, England). These are all vastly superior to the endless Virgins painted by Van der Goes' contemporaries in a progressively weaker imitation of Roger van der Weyden.

One little work is worthy of special mention. It is the diptych of *The Fall of Man* with a *Pietà* in the Vienna Kunsthistorisches Museum. Here the small format has once again resulted in the artist achieving a brilliant and marvellously painted picture. The contours and colouring are typical of the person who painted the Portinari Altarpiece. The figures of Adam and Eve are so noble and so fresh, and the flesh-tints have a slightly dark cast. Highlights in the shadows emphasise the contours. One also sees Van der Goes' precision in the wooded landscape. The overall effect is of a transposition of reality to a spiritual plane. How eloquent and persuasive a picture this must have been for people, showing how man's life of happiness was abruptly shattered by the evil spirit! Everything here is new and wonderfully expressive. The Tempter is shown as a sort of lizard with a yellow and violet stomach and a female head. Eve is a moving figure with her candour and grace. Adam's attitude shows man's moral vulnerability. There are two specific points about the *Pietà*, where unfortunately the Virgin's dress shows that the pigment used for the blue was not sufficiently purified. First, some of the female heads and headdresses recall those of Roger van der Weyden. Secondly, the main figures are distributed in pairs – in two parallel oblique lines. Again, critics have been tempted to assume that the echoes of Van der Weyden and the geometrical composition point to an early date in the artist's career, but in *The Dormition of the Virgin*, which really does not seem to be an early work, the feeling for geometrical composition is just as pronounced.

And in fact *The Dormition of the Virgin*, in the Bruges Museum, appears to be the work of an accomplished artist, who has a deep knowledge of composition. There is a beautiful contrast between the clear, calm apparition of Christ calling His mother to Heaven and the conflicting rhythms of the group of apostles. The work has a geometrical base, at the centre of which is the rectangular bed around which

the apostles are grouped, two at the foot and the others above. This skilful composition is accompanied by a wide choice of colours. The bed-cover forms a large passage of light and dark blue with other bright passages around it. In the lower part of the picture there is an olive green in the cloak of the apostle seated on the left; red lightening to pink in the cloak of the first apostle on the right; a deep green in the cloak of the second apostle on the right, with several other shades here and there. At the top are blues and clear reds in Christ's clothing, against the yellow of the sunburst behind Him. The grief displayed by the apostles – which is only natural, since in the Virgin they were losing their last living link with the Master – is intimate and deep. But the way in which it is expressed is too uniform. The apostles' faces are worthy of an artist awaiting the final vision. All the faces show signs of unspeakable anguish and stunned confusion, which the artist has painted with really pitiful truthfulness. We know that for the last two or three years of his life, Van der Goes suffered from nervous depression, morbid melancholy, nervous breakdowns and even attacks of madness. This picture may be a foretaste of the sickness into which he eventually fell. The work also has an idiosyncrasy which is almost as good as a signature – the artist's very personal way of painting hands.

For some people, the colour of *The Dormition of the Virgin* is almost an enigma. The unusually raw tones with dominant greens and cold blues are surprising. Some critics have maintained that injudicious cleaning must have affected the original tonal qualities by the removal of glazes – as if the artists of the time painted in successive transparent layers. All that was removed was in fact the varnish. The work has been cleaned of the brown varnish and reveals the brightness of the original colour applied with egg. All that now needs to be done is to give the picture a new coat of varnish, so that the whole surface area will be as it was originally. The cold tints were intended by the artist. In fact the same effect is evident in *The Virgin and Child* in the Städelsches Kunstinstitut in Frankfurt.

☆

Despite Hugo van der Goes' eminence, little is known about him. No one knows where he was born, although it was suggested by the historiographer Opmeer at the beginning of the seventeenth century that he came from Goes, a small town in Zeeland. That is only a theory, however. His Christian name appears in archives as Huyghe. Later the Latin form of Hugo was introduced. Although he maintained that he knew very little about the Flemish Primitives, Van Mander says that Van der Goes was a pupil of Jan van Eyck, which would imply that he first worked in Bruges. Vasari and Guicciardini would have one suppose that he came from Antwerp, since they call him Hugo d'Anversa. It is just as likely that he was born in Ghent, where the name Van der Goes was not uncommon at the time. A document in the Louvain archives mentions him as being a native of Ghent: '*geboren van de stad van Ghendt*' (51).

At all events, we meet him for the first time in Ghent. He was enrolled as master in the guild of artists in 1467 (52). The artist Josse van Wassenhove and the paint-seller Daniel van Lovendeghem introduced him and were his guarantors for the mastership (53). This shows the connections that existed between Van der Goes and Wassenhove.

A year later Van der Goes collaborated – along with the best artists in the region – on the decorations for the marriage of Charles le Téméraire with Margaret of York in Bruges. Messengers were sent to artists far beyond the boundaries of Flanders, to Bois-le-Duc ('sHertogenbosch) in the north, Amiens in the south and Tirlemont in the east. Van der Goes' salary was less than that paid to Jacques Daret, Vrancke van der Stockt and Daniel de Rycke.

In 1469 he was entrusted with the most important part of the decorations for the *Joyeuse Entrée* of the princes into Ghent. In the very same year he was made a juryman of the guild of artists. On several occasions he was guarantor for newly admitted members. He carried out further decorative

commissions in Ghent in 1470, 1472, 1473 and 1474. He was dean of the guild in 1474-5. Then, abruptly, the archives make no further mention of him. We know that he entered the Augustinian Abbey of Roode Kloster, near Brussels, as a lay brother, and he was there when he was summoned to Louvain in 1479-80 to give expert opinion on the pictures commissioned from Dieric Bouts, and to assess the amount due to the artist's heirs for the works unfinished at his death (54).

Gaspard Ofhuys, a monk at Roode Kloster, wrote an historical account of the abbey in which he included all he knew about Van der Goes, with whom he had served his novitiate (55). He tells us that the artist went in about 1476 to Roode Kloster, where his half-brother Nicolas was already an oblate. Five or six years after his arrival, in about 1481, he went to Cologne with other religious from the abbey. It was on the return journey that he showed the first outward signs of mental illness and fell into a deep depression. The prior tried to cure him with music. In his lucid moments Van der Goes was friendly and quite humble. He continued to receive visits, among them some very distinguished people, such as the future Emperor Maximilian, who dined with him. His colleagues looked after him with devotion, while the unfortunate artist continued to paint. Ofhuys tells us that he was obsessed with all the pictures he still wanted to paint, and lamented the fact that it would take him at least another nine years to finish what he had undertaken. He died at Roode Kloster in 1482.

☆

One should not be surprised that Hugo van der Goes had no true followers. His powerful genius must have discouraged would-be imitators. Furthermore, he only worked in Ghent for some eight years before retiring to Roode Kloster. There are no names of pupils mentioned in the archives. In the years which followed his enrolment as master, several artists belonging to the guild in Ghent received important commissions, for example, Willem de Bake, Jan van der Maele, Matthieu van Rooden. Did they work with Van der Goes? It is impossible to say, for we do not know any of their works. It is nevertheless probable that he taught his nephew, Cornelius van der Goes, the son of Jan. Cornelius acquired his mastership in Ghent on 17 December 1481. In 1494 he received two payments for paintings, and in 1497 he was to paint a *Last Judgment*. But since it has been impossible to authenticate any one of his works, any artistic connection with Hugo van der Goes remains hypothetical.

There is not enough space to devote to the many direct or partial copies of his works. They were painted by artists of no personality who litter the paths of art history. Even painters of orginal talent such as Memlinc and David brought echoes of Van der Goes' works into their pictures, altering them to a greater or lesser degree, depending on their understanding and mood. And even in Florence, in 1485, Ghirlandaio drew inspiration from the Portinari Altarpiece, which he was able to study on the spot; proof of the interest the better artists had in Hugo van der Goes' works.

JOSSE VAN WASSENHOVE

Josse van Wassenhove was a friend of Hugo van der Goes, though some years his senior. It is even possible that Van der Goes served as his pupil. Nevertheless, Van Wassenhove was not such a good artist. He left Ghent and settled in Italy, undertaking a great deal of work at Urbino, where he was called Giusto de Guanto, and he was known for a long time as Justus of Ghent.

His chief work, and one which is well documented in the archives of Urbino, is *The Last Supper* (also known as *The Communion of the Apostles*), in the Urbino Museum (Galleria Nazionale delle Marche). Instead of giving the traditional Flemish iconography of this event, the artist shows Christ giving communion to the kneeling apostles. This was quite a daring innovation, but nevertheless shows his desire to adapt his talent to Italian art. Fra Angelico had already treated the subject in this way in two surviving works, a fresco in a cell at S. Marco, and a little painting in the Accademia in Florence. There was a third example by Fra Angelico in the chapel of the Blessed Sacrament in the Vatican, but it is now lost. Van Wassenhove could also have seen this work, for a document of the time tells us that he left Ghent to go to Rome.

But Van Wassenhove took his innovation further than did Fra Angelico. All the apostles have left the table and are kneeling in front of the Master, in the same way that the faithful come to the priest distributing the Eucharist. The setting is not the Upper Room but the apse of a church – a liturgical setting, in fact. There are no dishes or plates on the white cloth, only the chalice and one or two other objects. This bareness recalls the ritual simplicity of the Holy Table. An angel acts as Jesus' server and others float over the gathering. The work takes on a symbolic significance. The spaciousness of Italian art is apparent in some of the figures – for example, that of Jesus isolated in the middle, moving towards St Peter. At an equal distance on the other side is another apostle, and the composition is given its basic strength by the symmetry of these three figures in the foreground. At the same time, the artist retains his national characteristics. The apostles show their faith openly. Intense concentration and veneration are evident in their attitudes and expressions.

The style is very Flemish. I once described it as somewhat dull, but that was before it was cleaned in 1931. Since then it has been possible to appreciate the strong colours, such as the clear blue in St Peter's cloak and the ox-blood red of his cloak, the green on his sleeves and, alongside this, gentle shades such as the pale pink of the apostle in the middle ground near the table, and the greyish-blue of Jesus' robe. Characteristic also is the way in which the paint is evenly applied, the way the hands are emphasised, with the accent on their consistency, and the way in which the hair is painted as an area of colour with additional fine brushstrokes superimposed (56). Obviously the artist has not painted from life, using local models. He has remembered details from Van der Goes, and one sees here the roughness of Van der Goes' facial types. His apostles are clearly related to those in *The Dormition of the Virgin*. M.J. Friedländer believes that Josse van Wassenhove was Hugo van der Goes' *anregere* or animator. Or was Wassenhove led on by his clever friend? Or were they both pupils of the same master? All one can safely say is that they had a similar approach aesthetically, and even when they were separated they worked in identical ways. The method of painting hands is very similar, but other details differ. For example, most of Wassenhove's heads tend to be small with the back of the skull scarcely developed.

There are various figures in the background of the picture, among them Federico di Montefeltro, Duke of Urbino. There are several extant portraits of him, all showing the same characteristic profile with his damaged nose. He is accompanied by two courtiers, and one can see a nurse in the background carrying his heir, Guidobaldo. The child's mother, Battista Sforza, died shortly after giving birth to him. The duke appears to be explaining the scene to a richly dressed man with a large beard, which was rather unusual at that time in the West. Possibly it is Caterino Zeno, a Venetian appointed by the Shah of Persia – at that time at war with the Turks – to obtain help from the Italian rulers. All the same, the portrait is not painted from life. There is an astonishing likeness to the judge in Dieric Bouts' *Martyrdom of St Erasmus* – the hat, beard and position of the head are the same. Did Josse van Wassenhove remember the character, or did he make a sketch of it? Zeno visited the Duke of Urbino in 1474. Flattered at being approached, he probably asked the artist to add a portrait of the ambassador to the picture, no doubt after Zeno had left Urbino. The work was painted between 1473 and 1475. The brotherhood of the Holy Cross of the Church of Corpus Dominici, who commissioned it, had been

collecting together the money since 1465. The duke also gave a substantial sum. The archives mention a first payment to Giusto da Guanto in 1473, then two more in 1474 and 1475.

Why did the Duke of Urbino choose Josse van Wassenhove, when he had on hand Piero della Francesca, Giovanni Santi or Melozzo da Forlì? Possibly he was influenced by the reputation Flemish artists had carved out for themselves in Italy and wanted to appropriate Wassenhove to his court as he passed through on his way to Rome. Be that as it may, although this painting is moving, it is inferior to works by the Van Eycks, Van der Weyden and Van der Goes.

The old Florentine historian, Vespasiano da Bisticci, who was in contact with Federico di Montefeltro, relates that the duke was having the palace decorated and summoned an artist from Flanders. He commissioned the artist to paint his portrait and, for the walls of his library, imaginary portraits of poets, philosophers and doctors of the Church (57). Twenty-eight of these portraits are known today. Half are in the Louvre, and the other half were formerly in the possession of Prince Barberini in Rome, but were transferred in 1934 to the Ducal Palace at Urbino.

There has been a certain amount of controversy about the attribution of these portraits. Some critics think that they are partly the work of Melozzo da Forlì and Giovanni Santi, who also had a hand in the interior decoration of the palace. Others attribute them to the Castalan artist Pedro Berruguete. But the most ingenious explanations cannot overcome the difference in style between these portraits and the styles of the various artists mentioned. I have studied them closely and believe I can recognise Josse van Wassenhove's style. There is a different approach by comparison with similar works by him, but this is the result of the conception of the series: several small portraits were to be placed in two rows, one above the other. But the choice of colour, the way in which the impasto is applied – particularly for the precious stones – the visual approach and the tendency to individualisation all indicate the hand of a Flemish artist. The composition often follows current Italian aesthetic principles, however. The dull colour of the faces and the hands, which are so expressive, with the thumb spread out and the palm open, reappear in *The Last Supper* by Josse van Wassenhove.

The hand of the same artist is evident in two portraits of Duke Federico di Montefeltro, one of which was in the Barberini Collection in Rome and then handed over to the state in 1934. It has an imposing quality, despite the small size of the work, and shows the duke with his son at the age of two or three. Federico, wearing armour, is seated at a desk, reading. On the desk is his ducal cap, bestowed on him on 21 August 1474. The picture cannot therefore have been painted any earlier than this. The background is neutral and the touch firm. The colour is particularly strong in the armour and crimson and gold brocade. Again, the colour is Flemish, whereas the form is adapted to the Italian manner. The second portrait of the duke is in Windsor Castle. When I saw it, it was nothing more than a ruin, overpainted and covered with thick varnish. One could imagine some solid reds and greens in the clothing. The duke and his son, with some courtiers, are shown listening to a lesson from a tutor (58).

M.J. Friedländer has cleverly defended the theory that Van Wassenhove also painted the seven liberal arts – the trivium and quadrivium – which also came from the Ducal Palace of Urbino, where they were probably in the second room of the library, the *studiolo*. Three of the seven have been lost; two – *Astronomy* and *Logic* – were in the Berlin Museum but were destroyed in World War II; the last two – *Music* and *Rhetoric* – are in the National Gallery in London. Following the opinion of A. Schmarsov, others see in them a purely Italian conception and attribute them to Melozzo da Forlì. But it is not impossible that Josse van Wassenhove, always an eclectic artist, should finally become so impregnated with the spirit of the Italian Renaissance that he should paint like Italians round about 1480. Only technique can provide the solution, and the technique seems to be Flemish.

A study of *The Last Supper* has also shown Josse van Wassenhove to have painted a beautiful picture in the Church of St Bavon in Ghent, a work previously attributed to an artist from Ghent – Gerard van der Meire, whom Van Mander mentions in a different context. The similarity between the figures

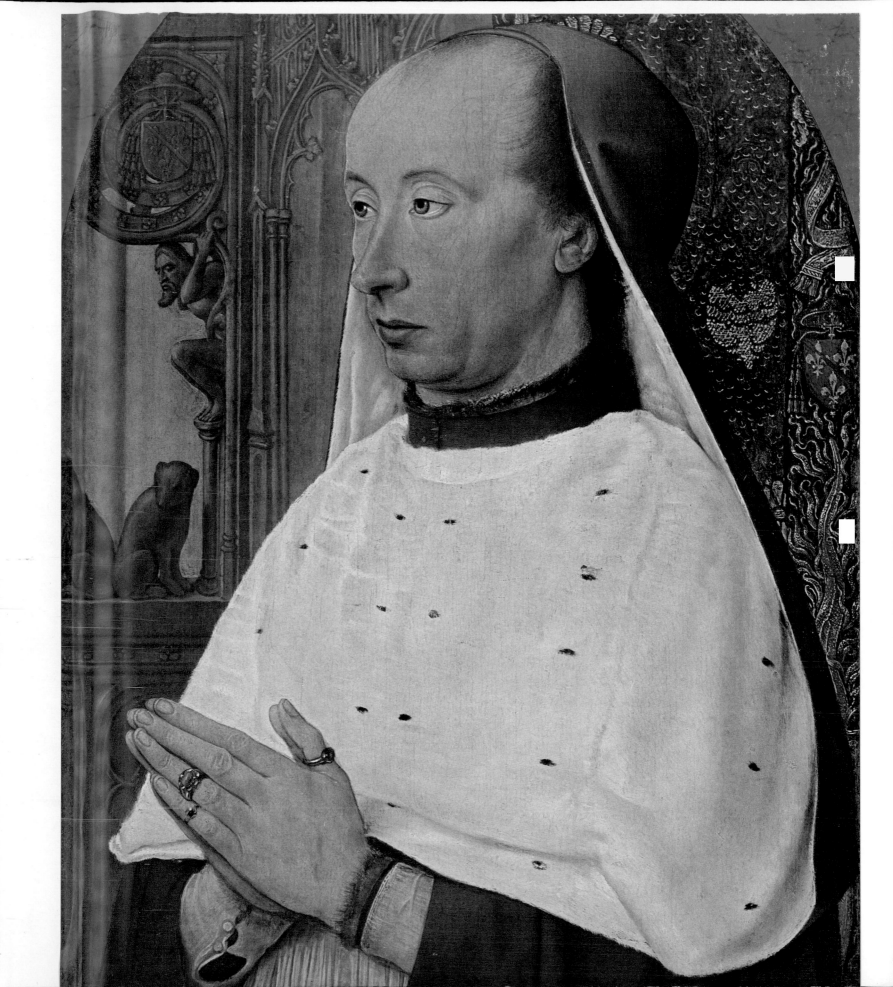

His chief work is the altarpiece now in the sacristy of the Cathedral of Moulins. Others close to it are: *The Nativity* in the Musée Rolin at Autun; a portrait of the Dauphin Charles in the Louvre since 1945; *St Maurice and a Donor* in the Glasgow Gallery; *The Annunciation* in the Chicago Art Institute, and *The Virgin and Child* in the Musées Royaux in Brussels. Certain features of the paintings seem to be echoes of Van der Goes. There is the same objective vision, the extreme care in rendering textures and consistencies, the concentration on the pictorial rather than the linear effect, the pale flesh-tints and the knotted hands. All of which would seem to indicate that if the Master of Moulins was not actually of Flemish origin, then at least he studied in Van der Goes' circle. A more definite piece of evidence is provided by the fact that the landscape in *St Maurice and a Donor* is only a simplified version of that by Petrus Christus in his Brussels *Pietà*.

As for the Master of St Giles, his forms are similar to those of Van der Goes, but the subtle harmony of his golden colours puts him outside the Flemish world and fairly and squarely in the mainstream of French painting.

ANONYMOUS MASTERS AND GERARD HORENBOUT

Other artists with a considerable amount of talent followed Van der Goes' style more closely. Chief was the Khanenko Master, so called from his *Adoration of the Magi* in the old Khanenko Collection in Kiev. This is far superior to the work of an anonymous artist from Antwerp, who also painted an *Adoration of the Magi* in the Musée Royal in Antwerp (no. 208). In this painting the artist has slavishly copied the grouping used by Van der Goes in the Montforte Altarpiece in Berlin. The Khanenko Master was more individualistic, though at the same time he drew inspiration from some of Van der Goes' figures, frank presentation and deep, graded colours. His personality shows in *The Virgin and Child* in the Stuttgart Museum; in several versions of *The Virgin in an Apsidal Chapel*, for which the original idea possibly came from the Master of Flémalle; and in *The Sibyl with the Emperor Augustus* in the Bearsted Collection in Upton House, England, and formerly in the W. Samuel Collection in London. M.J. Friedländer would attribute this last work to Van der Goes himself. If this is correct, then we must assume that the work was unfinished, and that the Khanenko Master only completed it. We know from the monk Ofhuys that Van der Goes was dismayed by the fact that he had so many pictures to finish, and that nine years would not have been sufficient to do so.

Another artist close to Van der Goes is the Bruges Master of 1499. He is called this because of a diptych in the Musée Royal in Antwerp, dated 1499, showing on one side *The Virgin in a Church* (copied from a work by Hubert van Eyck in Berlin), and on the other Christian de Hondt, Abbot of Dunes from 1496 to 1509. The execution is meticulous, the rendering exact and the colours rich. The paintings on the reverse are the work of a later artist. Similar qualities are evident in his *Coronation of the Virgin* in Buckingham Palace in London, and it is possible that this is related to a lost work of Van der Goes. *The Family* (or *Kinship*) *of St Anne* in Ghent may be attributed to the same artist. A quite different artist, also known as the Bruges Master of 1499, painted a triptych of *The Martyrdom of St Andrew* in the parish church of S. Lorenzo della Costa, and catalogued as no. 36 in the 1946 exhibition of old Ligurian art at Genoa. There are echoes of Van der Goes in the form and composition, and it could well be by Francisco Henriques, painted before he left for Portugal – as suggested by Reynaldo dos Santos – where he founded a school of painting.

A less important successor was the Master of St Sauveur, who painted a *Crucifixion* in the Musée St Sauveur in Brussels; one in the Städelsches Kunstinstitut in Frankfurt, and a third in Turin.

Finally, Hugo van der Goes had considerable influence on the excellent and prolific school of miniaturists which flourished in Ghent and Bruges in the late fifteenth and early sixteenth centuries. The explanation lies partly in the fact that one of the more important miniaturists, Alexander Bening of Ghent, was probably connected with Van der Goes, because he married a Catherine van der Goes, also of Ghent, and one assumes that Hugo was guarantor for him when he was enrolled as master. His son, Simon Bening, became a famous illuminator, and established himself in Bruges early in the sixteenth century. Along with many others, he produced several works inspired by the forms and composition of Van der Goes. Meanwhile, many second-rate artists continued to follow the style of Van der Weyden, and were immune to the improvements made by Van der Goes, whose talent must have discouraged the more mediocre painters.

Another famous illuminator at this time was Gerard Horenbout of Ghent. At the present time a somewhat confused account is being built up around him, and several pictures have been attributed to him. We scarcely know anything of his life or work. In the Ghent registers his enrolment as master is dated 27 August 1487. Rather late in his career he was attached to the court of Margaret of Austria, Governor of the Low Countries. Between 1516 and 1522 he received several payments for miniatures and paintings, in particular for a portrait of Christian II of Denmark. There is no further mention of him in Flemish documents after 1522. According to Karel van Mander he went to the court of Henry VIII of England, and Sir Lionel Cust maintains that he died there in 1540.

Marcantonio Michiel mentions Girardo di Guant as one of the three illuminators of the Grimani Breviary. Guicciardini speaks of him as '*Ghirardo excellentissimo nell'alluminare*' ('Gerard, most excellent in illumination'); Van Mander praises him and describes two volets of a carved altarpiece for the Abbey of St Bavon, on which were painted *The Flagellation* and *The Descent from the Cross*. He also mentions a *Crowning with Thorns* with a *Virgin and Child surrounded with Angels* on the reverse. Only the Grimani Breviary is known today, and critics feel that they can distinguish Horenbout's work in it from that of his colleagues. By connecting an account of a book of hours, for which the artist was paid by Margaret of Austria in 1521, with the Sforza Book of Hours in the British Museum, G. Hulin de Loo succeeded in attributing it to Horenbout. By an elaborate process of deduction – based only on corroboration of time and place – Hulin de Loo has also attributed two volets, portraits of donors, to Horenbout. He persuaded the Ghent Museum to buy them in 1932. They are rather mediocre, and although the artist copies Van der Goes' style, at a distance he makes it heavy, both in technique and colour. As things are at present it would be hazardous to use these pictures to 'construct' the artist's output. Even more so, since there is also in the Ghent Museum a St Anne Altarpiece in which one of the characters has the inscription '*Gerardus*' on the edge of his cloak, which could be the artist's signature. However, the style of this work is quite different from that of the portraits of donors. If we wish to know more about this artist's style, then a start should be made with a closer study of his miniatures.

107 Josse van Wassenhove: *The Last Supper*
Gallerie Nazionale delle Marche, Urbino

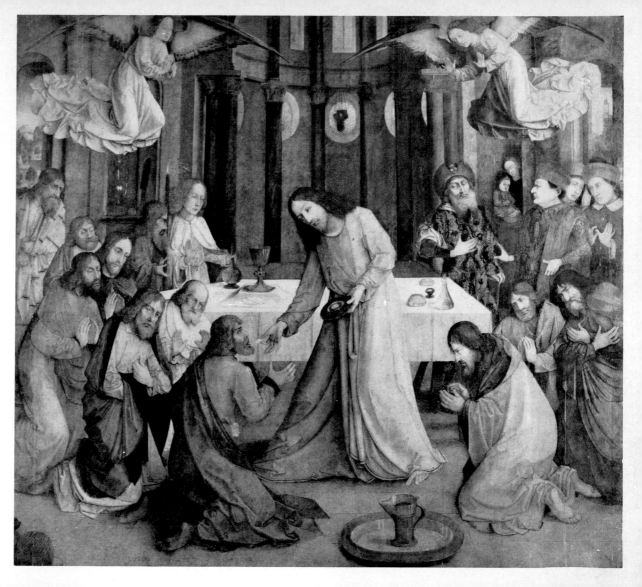

107 Josse van Wassenhove: *The Last Supper*
Gallerie Nazionale delle Marche, Urbino

108 Josse van Wassenhove: *Cicero*
Gallerie Nazionale delle Marche,
Urbino

109 Josse van Wassenhove:
King Solomon
Gallerie Nazionale delle Marche,
Urbino

110 Josse van Wassenhove: *St Augustine*
Louvre, Paris

Top right:
111 Josse van Wassenhove: *The Crucifixion*
(central panel of a triptych).
Cathedral of St Bavon, Ghent

112 Josse van Wassenhove: *The Adoration of the Magi*
Detail showing one of the kings.
Metropolitan Museum, New York

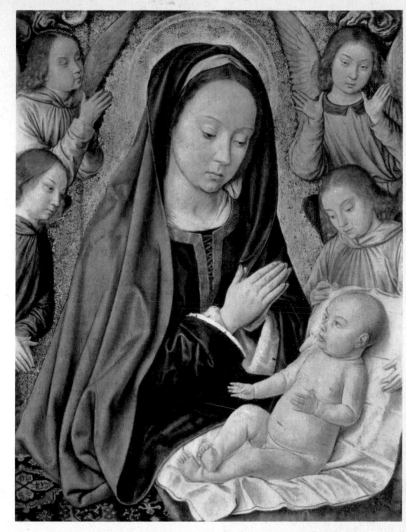

113 Josse van Wassenhove: *The Crucifixion*
Detail showing a woman drinking purified water.
Cathedral of St Bavon, Ghent

Top right:
114 Master of Moulins: *Virgin and Child*
Musées Royaux des Beaux-Arts, Brussels

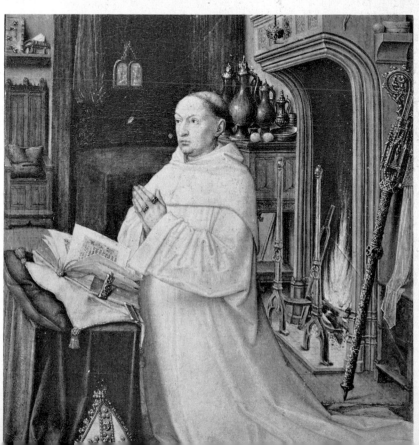

115 Bruges Master of 1499:
portrait of Christian d'Hondt,
thirtieth Abbot of Dunes (detail).
Musée Royal des Beaux-Arts, Antwerp

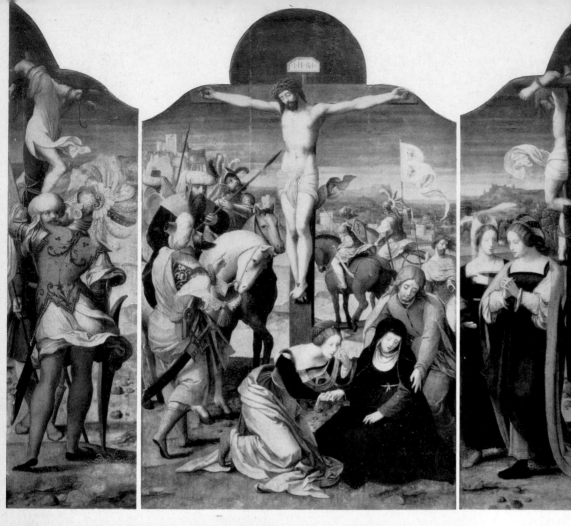

The Crucifixion (triptych).
Galleria Sabauda, Turin

Bottom left:
117 Jan Memlinc:
*The Virgin and Child worshipped by Angels
and Donors*
National Gallery, London

118 Jan Memlinc: *Virgin and Child*
Art Institute, Chicago

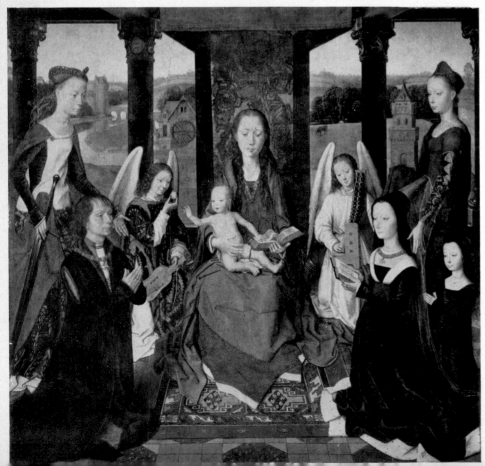

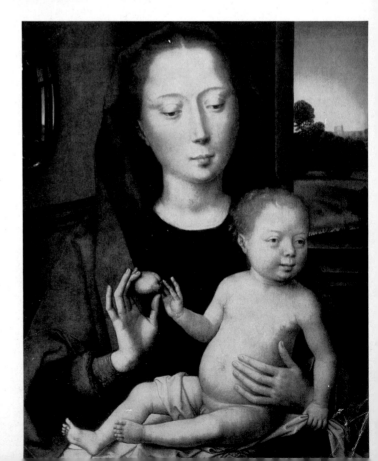

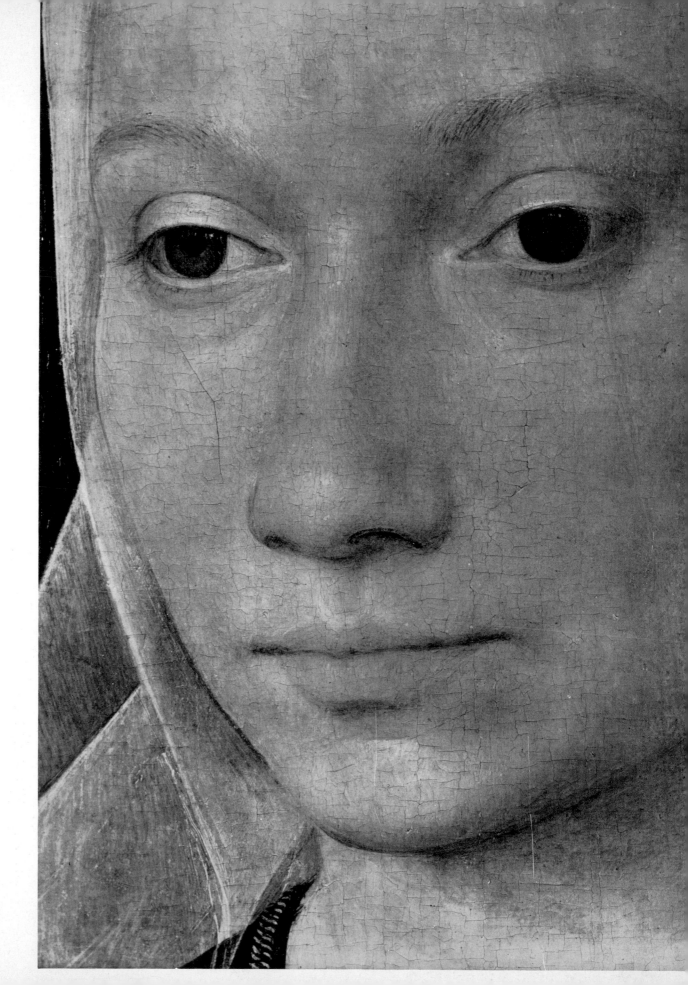

119 Jan Memlinc:
portrait of a woman, known as
The Sibyl of Sambetta (detail).
Hôpital St Jean, Bruges

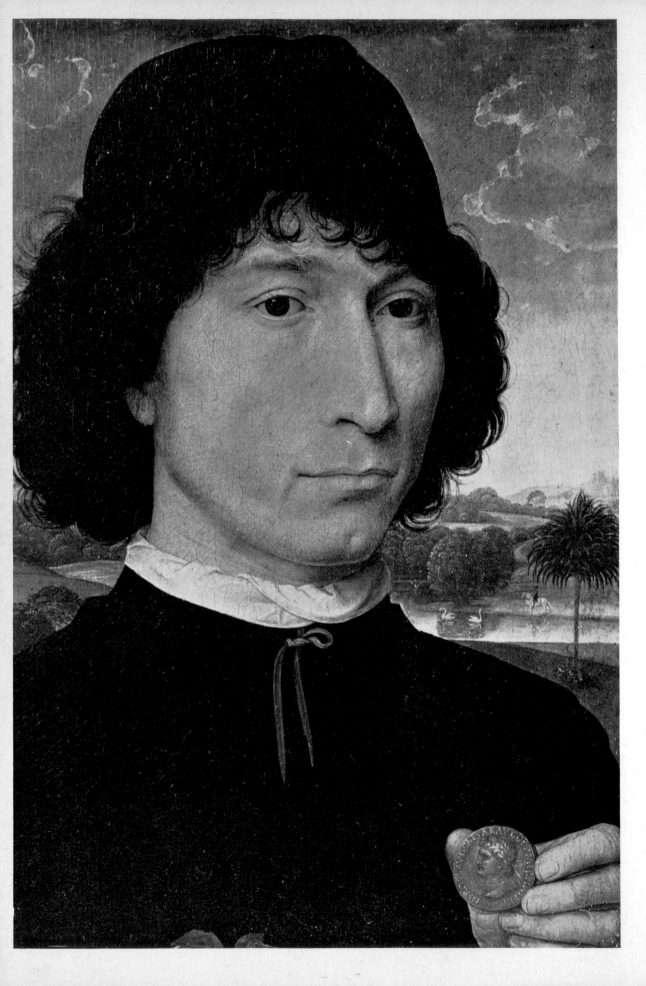

120 Jan Memlinc:
The Man with the Medal
Musée Royal des Beaux-Arts, Antwerp

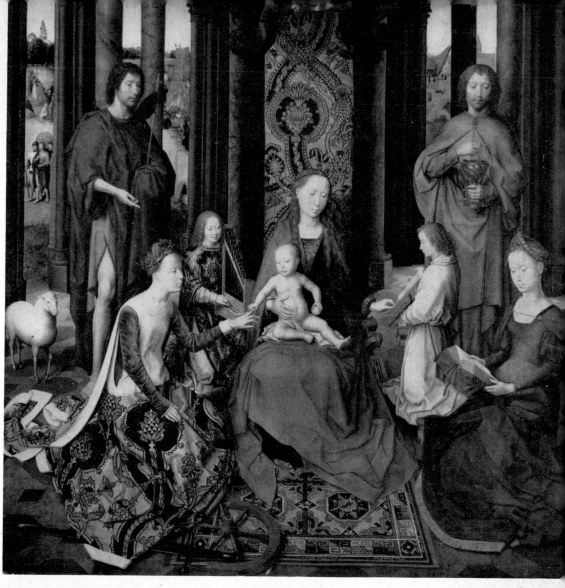

121 Jan Memlinc:
The Virgin and Child worshipped by Saints and Angels
Hôpital St Jean, Bruges

122 Jan Memlinc: *St Maurus,
St Christopher and St Giles*
Detail of 125 (p. 189) showing
St Giles.
Groeninghe Museum, Bruges

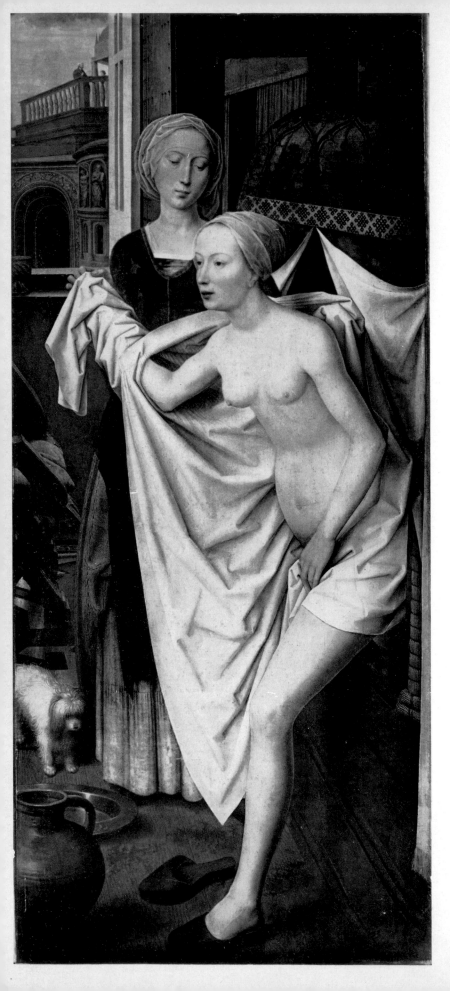

123 Jan Memlinc: *Bathsheba stepping out of her Bath*
Staatsgalerie, Stuttgart

124 Jan Memlinc: *The Martyrdom of St Ursula.*
Panel from the reliquary of St Ursula. See also
colour plate XXVIII (p. 182).
Hôpital St Jean, Bruges

INSIPIDITY IN THE ART
OF JAN MEMLINC

The Flemish Primitives are sufficiently highly thought of nowadays for us to stop overestimating them. Since Jan Memlinc was the first of them to be relatively well known, there has been a tendency to exaggerate his reputation. In addition, he was surrounded by the touching legend about his arrival in Bruges and the atmosphere which floods his works, in the old hospital of St John, where a sort of medieval enchantment lingers on.

Tradition has it that one evening the nuns of the hospital found a exhausted soldier on the doorstep. They took him in and looked after him for several months. So as to give him something with which to occupy his convalescence, the nuns procured him materials for drawing and painting. First of all he painted devotional pictures, and then, since his work pleased people, he was encouraged to continue. The nuns had him decorate the reliquary of their saint, Ursula, and then commissioned him to paint a picture for the high altar. As a token of his gratitude, Memlinc introduced the chief nursing sisters and various lay brothers into the volets of the picture. For centuries the paintings have been reverently kept in the same place. It is a touching story, but we shall see that the documents reveal a rather different Memlinc.

Memlinc's work, too, is rather different from what modern legend has made of it. After the magnificent Van Eycks, the vigorous Master of Flémalle, the emotional and elegant Van der Weyden, the contemplative Bouts and the sharp Van der Goes, comes the gentle Memlinc, and Flemish art goes into a decline. There is not a hint in Memlinc's art of the robust temperament of the people. Endowed with a great deal of talent, Memlinc often exceeds the average amongst the hundreds of painters of his day, but 'often' is the operative word, because from a purely pictorial point of view his works are so unequal that the fact must be pointed out. Many of them are worthwhile because the colour is closely allied to the forms, but the majority are generally insipid and the technique lacks conviction. These shortcomings would be excusable in an artist who was looking for new forms of expression, whose imagination was brilliant or who was capable of expressing deep feeling. But Memlinc is often little more than a creator of pretty pictures whose insipidity is sometimes almost sickening.

Nevertheless he has two great qualities – calm reserve and smoothness – which are evident in the majority of his signed works or those authenticated by documents.

The serenity of the approach is the very first thing which strikes one when looking at his indisputably accepted works; *The Virgin with Saints* and *The Adoration of the Magi,* both of which have been in the St John Hospital at Bruges since they were finished.

The Virgin with Saints – which has wrongly been called *The Mystical Marriage of St Catherine of Alexandria* (the mystical marriage is only a secondary detail) – has a repainted inscription on the frame *Opus Johannis Memlinc Anno 1479.* It was painted for the high altar of the hospital church, built between 1473

181

XXVIII Jan Memlinc:
Panel from the reliquary of
St Ursula, the arrival of
St Ursula in Rome.
Hôpital St Jean, Bruges

and 1476. One assumes that it was begun shortly before 1475, for Anthonis Seghers, one of the donors included in the painting, died in that year.

In this work he developed an idea which he had experimented with shortly before 1468, in the Donne Triptych in the National Gallery in London.

In the Bruges triptych the general grouping, the figures and the solid, balanced colour all show in an exemplary fashion the reserve which is Memlinc's finest quality. The forms are fixed clearly and symmetrically. The figure of the Virgin occupies an isosceles triangle, around which two saints and two angels form a semi-circle and balance each other. The different attitudes avoid monotony. On the right St Barbara is reading, and on the left St Catherine is holding out the fourth finger of her left hand to the Infant Christ, who is putting on it the wedding ring of the mystic union. This links the figure of the saint naturally to the central motif. The static figures of St John the Baptist and St John the Evangelist, in the middle ground, give the calm, clear composition a straightforwardness which is further accentuated by the pronounced verticals of the carpet, the hangings, the pillars of the throne and the columns, between which a landscape is visible. The work is a fine example of clarity in conception, yet lacks the breadth which is often so striking in the Van Eycks or Van der Goes. The logic is too evident, at the expense of genius. The characters seem unreal, they are frail and lack vital force. They scarcely seem to present enough volume to fill the space. The pattern which they form in the geometrical setting has the makings of a supple movement, but it is excessively slow.

Memlinc's reserve is even more pronounced in his treatment of the donors and their patron on the outside of the volets. Here the artist has brought off a compromise between portraits which are relatively true to life and idealisation intended to suggest eternal happiness. On the one hand the portraits share in the abstraction through their calm and almost other-worldly features and attitudes. On the other, the saints, without haloes, have a human quality from the fact that they are placed in open niches and their shadows suggest the solidity of their bodies.

However, the restraint in the forms and the way they are arranged does not hold good for the colour. Bearing in mind the place for which the triptych was intended – over the high altar – Memlinc was primarily concerned with the decorative effect. He has increased the number of different colours used and brightened them to the point where they begin to clash. The vermilion, carmine and claret-reds, blues and violets do not always go together. The variety of colours in the brocades – gold and blue, gold and green, gold and violet – is exaggerated. The vermilion of the Virgin's dress seems hard against the blue of her cloak; the olive green of St Barbara's dress clashes violently with the crimson of St Catherine's sleeves. Greens and reds are common in the better Flemish Primitives, but here the tones are scarcely matched. The contrasts are too strong, particularly in the right volet, where the bottom is so different from the upper part, which glows with a bright red.

All the same, Memlinc gives us full measure in this work. The triptych is a dignified *santa conversazione* and bears comparison with many Italian compositions of a similar nature. In this work everything that is clear and pure in Memlinc's approach blossoms out, but at the same time the limits of his knowledge also reveal themselves.

The Adoration of the Magi, in the hospital at Bruges, prompts the same remarks. The work is also authenticated by an inscription on the lower edge of the frame. It is the original inscription. The fur of the kneeling king passes over the gold of the frame and we can see the white preparation under the date – 1479 – which is the same as the previous picture. Here, however, the reserve becomes sterility and reveals the lack of invention. The composition is taken from Roger van der Weyden's painting in Munich, but is simplified to the point of purely geometrical staidness. In Van der Weyden's picture the splendid figure of the Moorish king worships with an expansive movement of the body. In Memlinc's picture the figure is seen three-quarters on, in expressive calm. Such simplifications can clarify a work, but they impoverish it considerably. Further examples of this are to be found: the fact that there is no

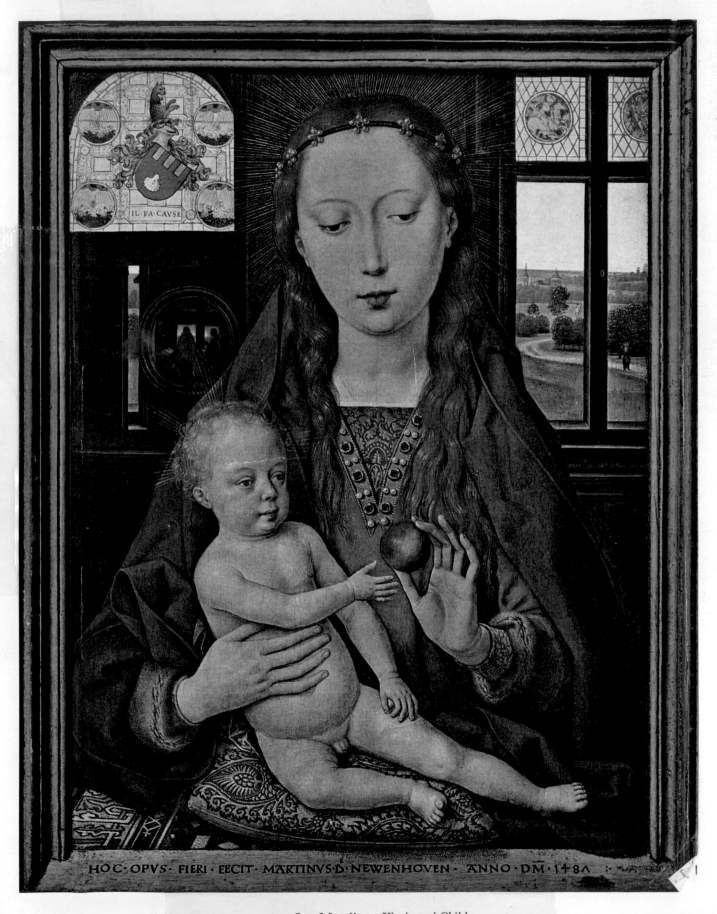

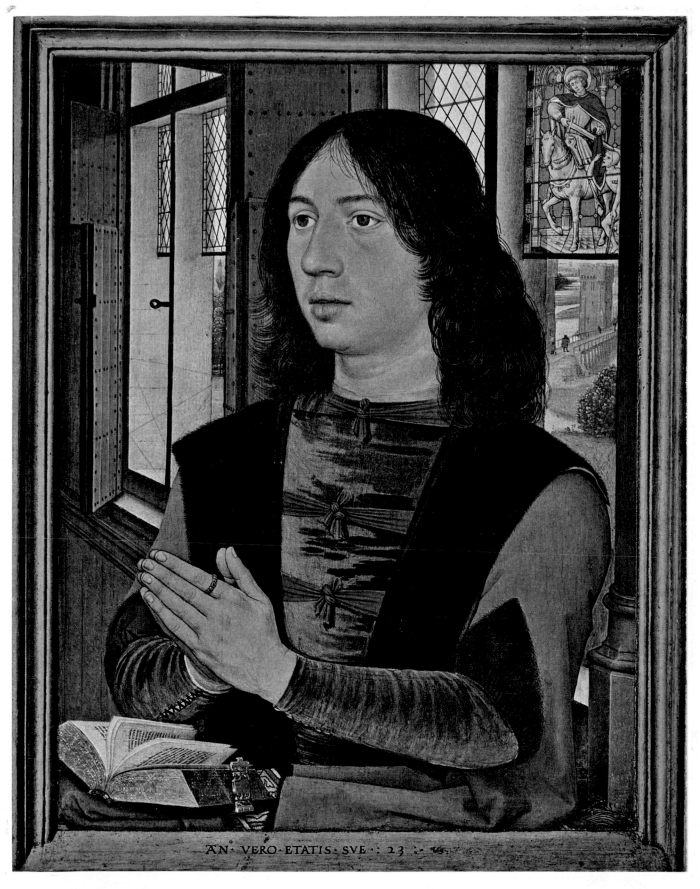

AN° VERO·ETATIS·SVE·:·23·:·

xxx Jan Memline: portrait of Martin van Nieuwenhove, right-hand panel of
a diptych. Hôpital St Jean, Bruges

connecting link between the figures in the foreground and those in the middle ground; and the stable is like scenery added to the background. The same goes for *The Nativity* on one of the volets, for which the composition was taken from Van der Weyden's Bladelin Altarpiece.

This triptych is smaller and the colour harmonises more successfully with the dignified figures. The dark blue of the Virgin's dress and cloak – although it has turned rather grey because of the chalk content of the pigment – forms a solid centre for the strong colours around it: the vermilion heightened with carmine in the king on the left; the light vermilion of St Joseph's garment; the claret-red with purplish shadows in the king kneeling on the right; the brownish tones of the background architecture.

The work is a small masterpiece. Its exterior and its painted frame, which has remained intact, both make it even more precious. There is another version, on a larger scale, in the Prado. For those critics who see Memlinc as a disciple of Van der Weyden, the Prado version would have been painted ten years before the Bruges altarpiece, because the figures in it seem nearer to those of Van der Weyden. But Memlinc could have turned later to the master so much in favour at the time.

The various works which may be attributed to Memlinc by comparing them stylistically with the two main works in the Bruges hospital all have the essential element of Flemish Primitive painting: the gift of rendering serene contemplation. His works capture extremely well the atmosphere of life in Bruges at the end of the Middle Ages when the town was gently sinking into sleep.

As soon as he abandons this serenity, Memlinc easily loses himself in confusion. He is not very successful at the great themes. *The Last Judgment* in Danzig – a work which dates from 1467 and has the the best characteristics of his art – contains numerous figures, but he only manages to achieve unity by copying from his predecessors. In his Lübeck *Crucifixion*, dating from 1491, but destroyed in World War II, and rightly attributed to him, he embarked on a composition which was visibly beyond his capabilities. Despite some successful groupings – for example the soldiers drawing lots for Christ's garment – and some excellent passages of great technical ability, the onlooker is constantly distracted by the very medieval concern of the artist to tell his story at great length, to the detriment of the concentration. Nevertheless there are two works in this style which have rightly been attributed to him, and in which he manages to integrate the whole composition in a very personal way. One is *The Passion of Our Lord* in Turin, and the other *The Life of the Virgin* in Munich, which was given in 1480, shortly before Easter, by Pieter Bultynck for the altar of the tanners in the Church of Notre Dame in Bruges. In order to tell his story more easily, the artist has divided it into little chapters – in both paintings – putting each scene into a little cell, and all the cells together form an imaginary city. This sort of treatment gives visual, but not organic, unity. Possibly the artist was inspired by the religious plays of the day, where the action took place in several places simultaneously in front of the spectators (62).

In fact, Memlinc is only really successful with isolated, static figures. His innate reserve finally finds a suitable medium, and from this point of view, *St Maurus, St Christopher and St Giles* in the Groeninghe Museum, Bruges, is very important. The work is rightly attributed to the artist, and the date of 1484 has not been restored, as some people have maintained. This calm portrayal of three large figures against a slightly flat landscape has genuine intrinsic grandeur. The forms have a majestic stateliness, and the movement is smooth, even in St Christopher's cloak and the Christ Child's garment, which billow out in an imaginary breeze. Here and there a certain amount of solidity is apparent in the black monastic habits which are beautifully linked to the foreground by the extraordinary dark water. In the middle, the strong vermilion of St Christopher's cloak – strengthened with carmine in the depths of the folds – glows between the brown rocks and tones with the blue in his garment and that of the Christ Child. Like three short, high-pitched notes, the three yellow areas of facing on St Christopher's garment give relief to the overall harmony. The light flesh-tints and the pure pink of the horizon reflected in the water soften it. A delicate white and blue sky gives a surprising, quite unreal light, which is neither dawn nor daylight, nor yet twilight. Unfortunately this beautiful light does not envelop the characters, who seem

rather to have been painted in a studio. Yet again Memlinc, unlike Petrus Christus, has failed to learn from the Van Eycks. The unity of vision is impaired. The figures are seen from below while the landscape, which is simply a backdrop behind them, is seen from above. All the same, the artist has managed to match his colours to his serene conception, especially in the left volet, where the claret-red clothing of the donor tones with the strong black clothing of St William of Maleval, his patron saint, and also with the green of the landscape.

At first sight the movement in the figure of St Christopher would seem to reflect some of the unrest which the beginning of the sixteenth century was to bring to people. And yet if one looks at his St George painted at the same time (and not in 1504, as Weale maintains), on the outside of the volets, one sees that, in spite of the vigorous movement of the scarf, there is controlled balance in this figure. It is achieved through the contrast between the two ends of the scarf and the stiffness of the armoured figure which counterbalances the movement of the dragon. The lance, which cuts the composition diagonally, and joins the two figures, contributes a great deal to the balance. It was painted quickly, in broad brush-strokes in *grisaille*, and yet there is no evidence of any real dynamism. Even here Memlinc's habitual reserve had not abandoned him.

Once again, it is in the smaller works that Memlinc's reserve is best expressed, and in particular in a well-authenticated picture dating from 1487: *The Virgin and Child* in the hospital at Bruges. The composition makes an isosceles triangle which suggests repose. The features, seen full-face and lit directly, are indicated by very discreet shadows. The purity of this peaceful, rather abstracted face, is underlined with delicate shading, by the gentle waves of the hair, the even folds of the cloak and the softness of the hands of both the Virgin and the Christ Child. One or two details show how little Memlinc cared about the truth of his vision: the mirror, inspired by Jan van Eyck in the *Arnolfini Marriage*, and Petrus Christus in *The Legend of St Eloi* is not convex, and the light from the windows in the background does not affect the faces.

It is hardly necessary to stress the second essential characteristic of Memlinc's art, for it is the smoothness which constitutes both his charm and his weakness. One only has to glance at his works to see that no one could equal him in conveying the feeling of a soul in meditation rather than in actual contemplation, of a soul often absorbed in prayer, but never lost in ecstasy. His Virgins and saints take us into a world in which everything is bathed in the relaxing warmth of a fine summer evening. Except for Fra Angelico – the saint who painted as he prayed – no one understood better than Memlinc the gentle radiance of virginal purity, the enchantment of the soul released from the flesh to reach out to its spiritual perfection. However little one looks at his best paintings of the Virgin and Child, one feels the spell working, and one breathes the delicate scent. Here Memlinc is very close to the language of Roger van der Weyden. The faces of his Virgins have the same contour, his saints have the same upright bearing. But his forms lack the concrete reality which rid them of their look of being part of a naïve dream.

The most important of his many Virgins is *The Madonna with Two Angels* in the National Gallery in Washington, rightly attributed on comparison of style. The picture captivates at first sight because of its technique and its richness of colour and content. The grouping is regular, the tonal qualities are balanced. The dark blue of the Virgin's dress and the vermilion and carmine of her cloak go with the vermilion of the dalmatic of the angel on the left and with the light colours in the landscape – all of which comes from the artist's intrinsic smoothness.

Memlinc was a foreigner assimilated by Flanders, and yet he was more successful than any native artist at translating in pictorial terms late Flemish medieval religious poetry. His magical charm comes from his artistic conception, strictly speaking, from his even shapes, his soft contours and his shading, and also from the calm movement of his gestures. Even when Memlinc paints a portrait, this expression is dominant. He only sees men at peace. The faces of his sitters never reveal the anxiety of an internal

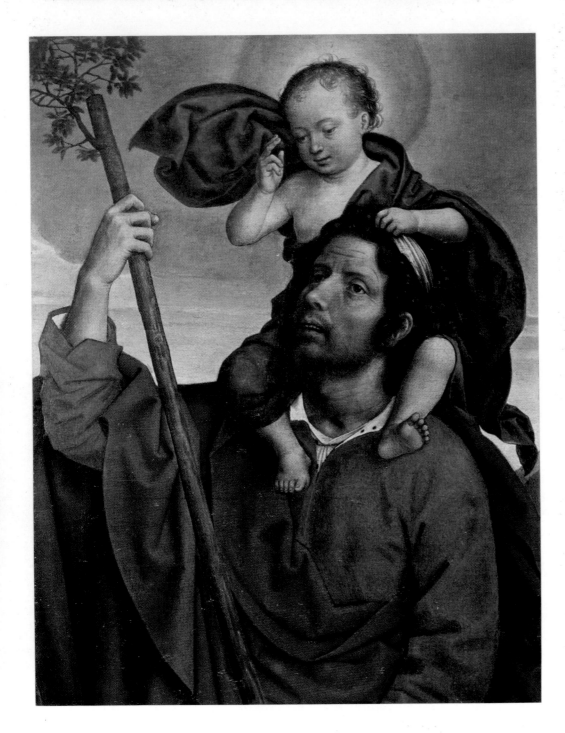

xxxi Jan Memlinc:
St Maurus, St Christopher and St Giles
Detail from 125 opposite.
Groeninghe Museum, Bruges

struggle. The portrait of Guillaume Moreel in the Musées Royaux in Brussels, justifiably attributed to Memlinc, has all the characteristics of Memlinc as a portrait painter. The profile has a fairly solid feel about it, but the very gentle contour gives the sitter an almost ingenuous look, and yet history shows him to have been a hard, authoritarian leader who had no qualms about nipping rebellion in the bud. Memlinc has made him look like a calm, peaceful monk. The same is true of the portrait of Martin van

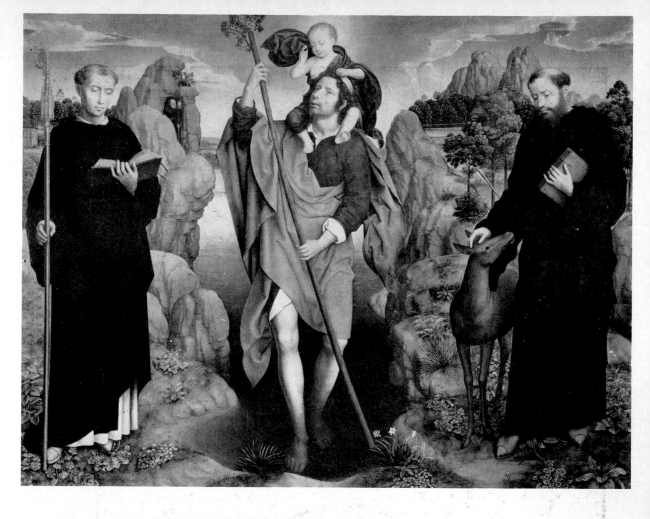

125 Jan Memlinc:
St Maurus, St Christopher and St Giles
For details see also 122 (p. 179) and
colour plate opposite.
Groeninghe Museum, Bruges

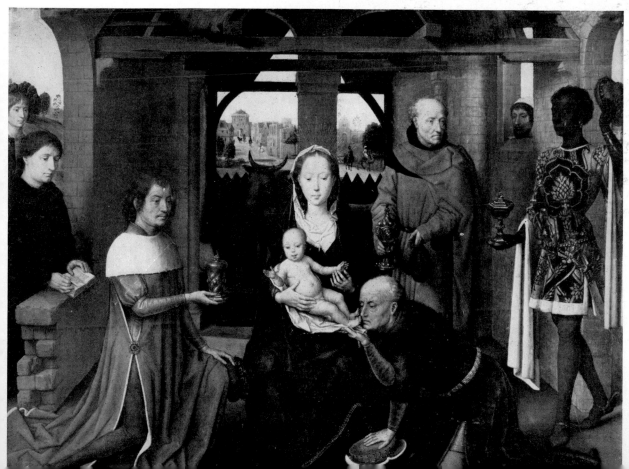

126 Jan Memlinc:
The Adoration of the Magi
(central panel of a triptych). For the
reverse of the volets, see colour plate
XXXIII on p. 200.
Hôpital St Jean, Bruges

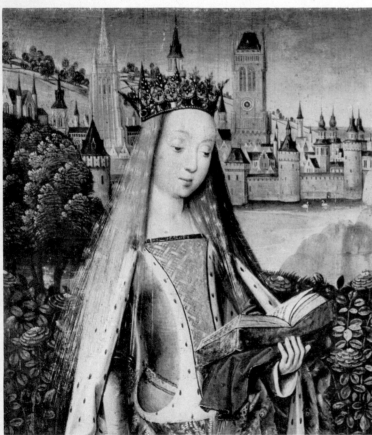

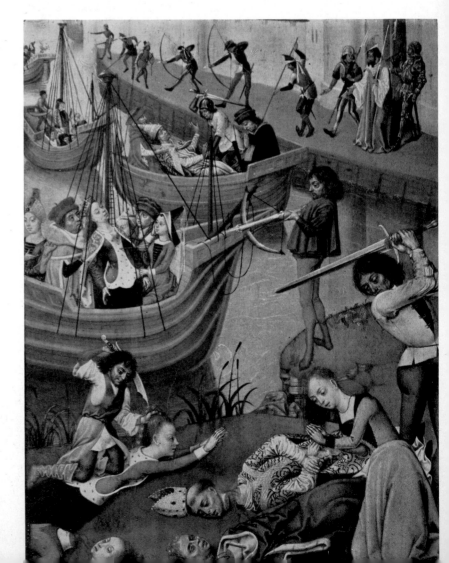

127 Master of the St Lucy Legend: *The Legend of St Lucy*
Church of St Jacques, Brussels

128 Master of the St Lucy Legend: *St Catherine* (detail).
J.G. Johnson Collection, Philadelphia Museum

129 Master of the St Ursula Legend: *The Legend of St Ursula*
Detail showing the martyrdom of the saint.
Convent of the Sœurs Noires, Bruges

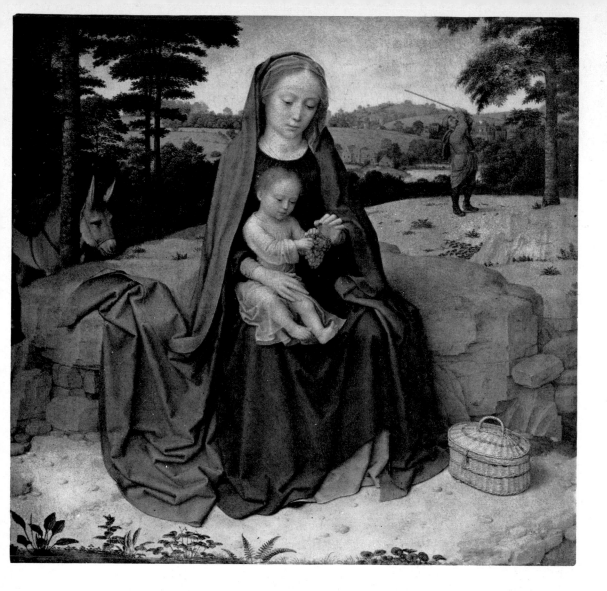

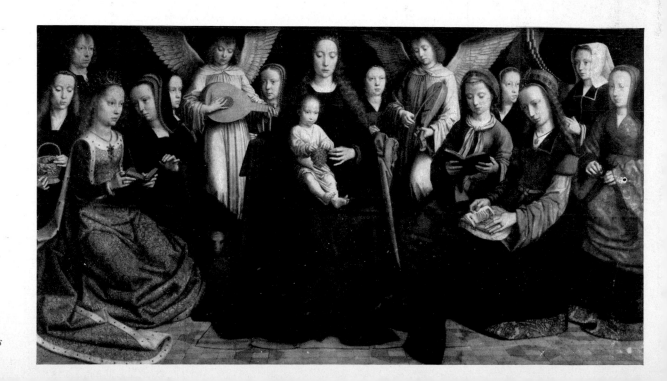

130 Gerard David:
The Rest on the Flight into Egypt
A.W. Mellon Collection, National Gallery,
Washington

131 Gerard David: *Virgo inter Virgines*
Musée des Beaux-Arts, Rouen

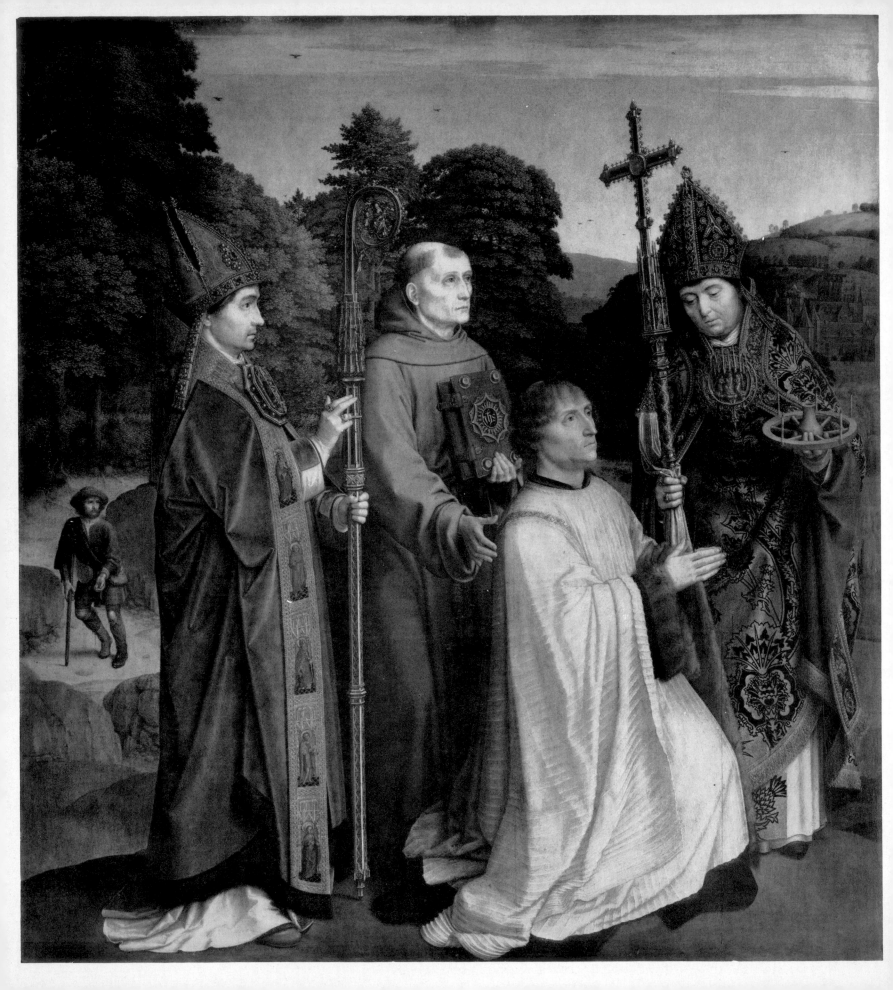

133 Gerard David: *The Crucifixion*
Left volet showing the Virgin and Christ's followers.
Musée Royal des Beaux-Arts, Antwerp

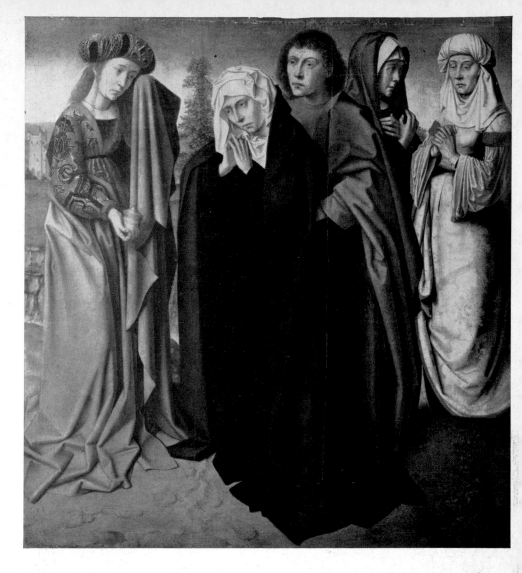

Opposite:
132 Gerard David:
Canon Bernardinus de Salviatis and Three Saints
National Gallery, London

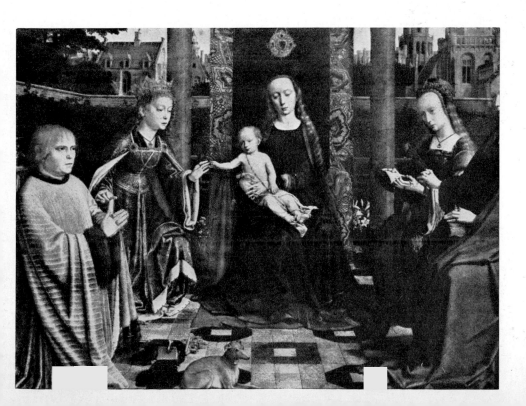

134 Gerard David:
The Virgin and Child with Saints and a Donor
National Gallery, London

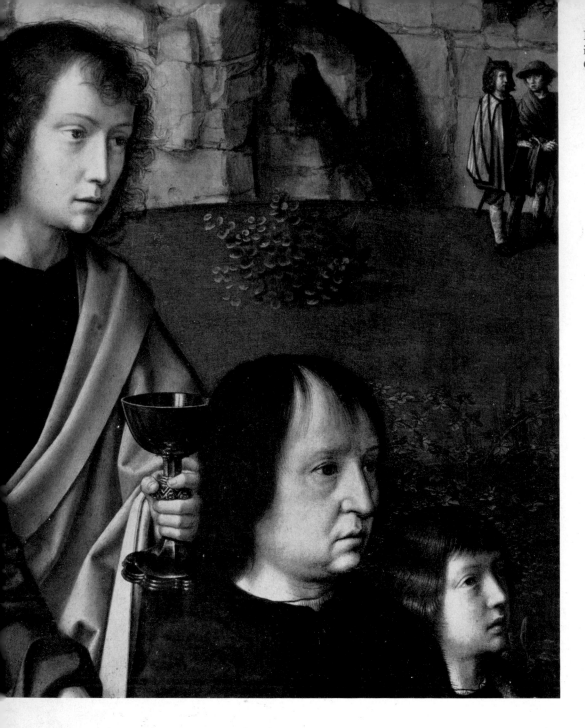

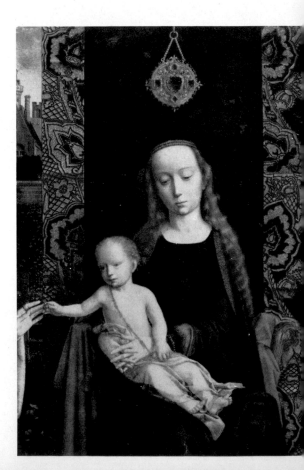

135 Gerard David: *The Baptism of Christ*
Detail of the interior of the left volet show-
ing the donor and St John the Evangelist.
Groeninghe Museum, Bruges

136 Gerard David: *The Virgin and Child*
Detail of 134 (p. 193) National Gallery, London

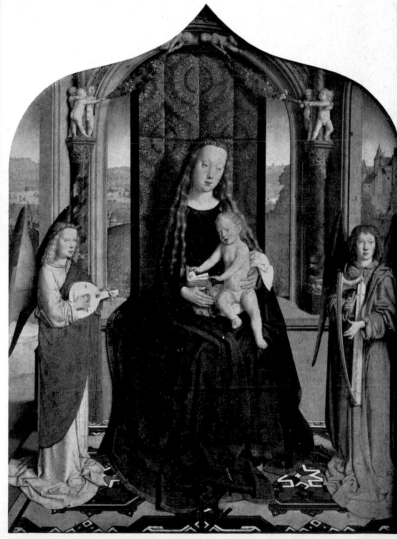

138 Gerard David: *The Virgin and Child with Angels playing Musical Instruments*
(central panel of a triptych). Louvre, Paris

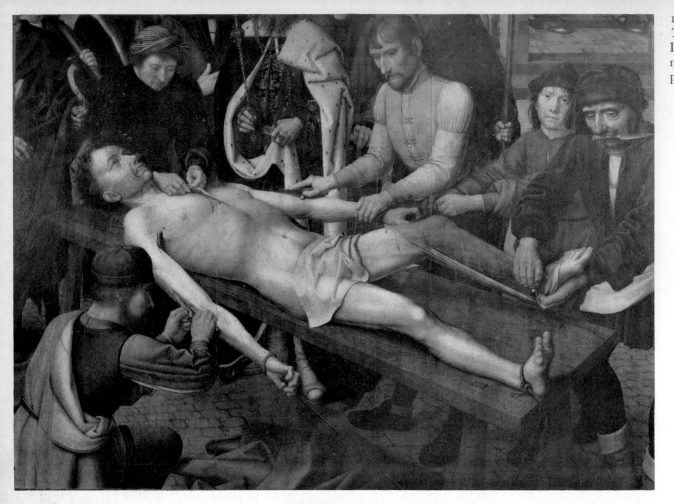

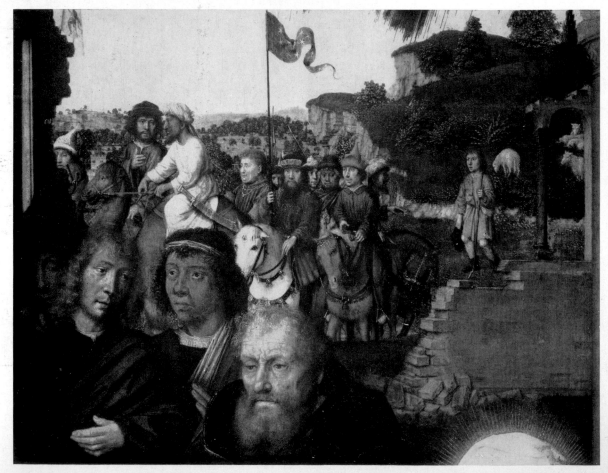

140 Gerard David:
The Adoration of the Magi (detail).
Musées Royaux des Beaux-Arts, Brussels

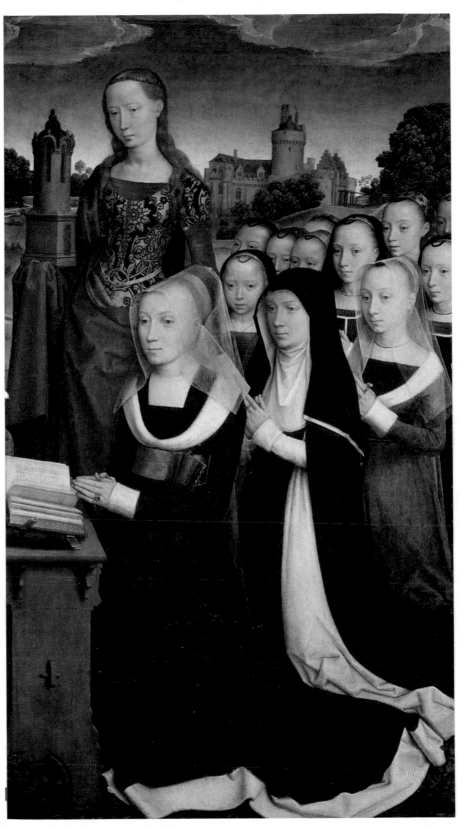

XXXII Jan Memlinc: *St Maurus, St Christopher and St Giles*
Left volet of the triptych showing Barbara van Vlaenderbergh
and her daughters with St Barbara.
Groeninghe Museum, Bruges

Nieuwenhove, burgomaster of Bruges in the hospital there, which is a pair to *The Virgin and Child*. Instead of active intelligence, the artist has given the sitter an air of benevolence, and of being wrapped in a blissful dream. It was probably this capacity for transposition – so flattering to the sitter – which brought the artist several commissions for portraits of rich citizens and merchants. Many have doubtless been lost over the centuries, but some thirty or more have survived.

One only – a solidly made portrait – shows evidence of a marked personality; it is the man with the medallion in the Musée Royal in Antwerp, a work unanimously attributed to Memlinc. Attempts have been made to identify the sitter as one of the Italian medalists working in Flanders – Niccolò Spinelli or Giovanni di Candida. It is more probable that the man was simply a numismatist.

Here, as in several other portraits, the artist has made a discreet innovation in opening up the background and adding a landscape. However, it is merely a backdrop. The light from it does not envelop the sitter's head, which is lit as it would be in the studio.

In his female portraits in particular, Memlinc painted with all the smoothness which was one of his greatest assets. His masterpiece in this field is the portrait known as *The Sibyl of Sambetta*, in the hospital at Bruges, dated 1480. The atmosphere and technique are directly related to the signed works. The face has extremely soft contours and is painted against a green background. The nose hardly has any relief against the pale skin, where a touch of pink lightens the cheeks and lips. The lower eyelids are shown with a light line and direct shading. Once again, the touch is so delicate that the work becomes almost abstract. Some critics have taken it to be the second daughter of Guillaume Moreel, but it is surely his wife, Barbara van Vlaenderbergh, who appears on two other occasions in Memlinc's works. The features are so impersonal here, however, that in the sixteenth century it was turned into a portrait of the Sibyl of Sambetta by covering the green background with black and adding the sibyl's name and her prophecy.

Memlinc's reserve and smoothness finally become so habitual in his work that these qualities seem to be easy to achieve. He slips into them almost like an affectation. Beside the work of his contemporaries Hugo van der Goes and Gerard David, Memlinc's figures, with their lack of solidity, conjure up a world whose inhabitants seem to doze. Memlinc very rarely expresses inner tension, powerful feelings, or a genuine emotional impulse. His work gives the impression of a gentle, static lake.

How then can one attempt to introduce a precise pattern of evolution into such a uniform style, even if one takes the known dates of some of the works as milestones?

Some critics place at the beginning of Memlinc's career those works in which echoes of Van der Weyden are to be seen, and for this reason they also believe that Memlinc was his pupil. Vasari and Guicciardini already said as much. And with a certain amount of skill, supporting evidence has been produced from a document which mentioned a work in the collection of Margaret of Austria, the centre of which was painted by Van der Weyden and the volets by Memlinc. Others, notably G. Hulin de Loo, attempted to show that three of Memlinc's works were even painted in Van der Weyden's workshop (63).

Such suppositions are fraught with danger. Would it not be better to avoid such subtle debates? The work belonging to Margaret of Austria could perfectly well have been an altar painting to which she added volets by Memlinc. Are similarities of figuration adequate proof that Memlinc worked in Van der Weyden's workshop? One cannot deny that certain details are borrowed, even certain colours, and not only at the start of Memlinc's career, but also in quite late works. Memlinc also took elements from Dieric Bouts and Van der Goes. This can be explained as lack of imagination on Memlinc's part, and also by the stability of his subject-matter and of his presentation. Only particularly inventive artists – such as Van der Goes – managed to overcome this.

It would in any case be inaccurate to say that Memlinc's best works were the product of his maturity. Some written documents oblige us to put the Reliquary of St Ursula in his maturity. But apart from

The Death of St Ursula, the general standard of composition is poor and the technique rather heavy. In fact, in the attempted chronology of his works, one deduction leads to another, without sufficient circumspection. We see an example of this in *The Virgin with a Donor and St Antony* in the Liechtenstein Collection at Vaduz, with the date 1472. For one scholar this picture is a point of departure in his analysis of style in Memlinc's Virgins. The same scholar offers no convincing arguments in support of his attribution. In any case, the picture is in such a bad state that it is almost impossible to study it satisfactorily.

If ever an artist was appreciably true to himself throughout the whole of his career it was Jan Memlinc – apart, of course, from the ups and downs implicit in any human enterprise. One can therefore only look at his work in its entirety.

When Memlinc arrived in Bruges the memory of the Van Eycks was still very much alive there. Many of their pictures were there, and so were those of one of Jan van Eyck's talented followers, Petrus Christus, who was painting until 1472. And yet Memlinc's colour is rarely like that of the Van Eycks, and he took up none of their technique. He merely assimilated the general trends of Flemish painting at that time, and in particular those of Roger van der Weyden. But he usually did so without concerted effort or obstinate patience. Memlinc did not advance the art of painting by devising new forms or improving technique. His own technique is uneven; sometimes it is careful, sometimes slack. The faces of his Virgins are oval, with convex brows, small mouths and the figurative elegance of those by Roger van der Weyden. In the rendering they have more in common with those of Dieric Bouts, though Memlinc adds an insipid affectation. To appreciate this one only has to compare Memlinc's *Annunciation* in the Metropolitan Museum in New York, with that of Roger van der Weyden; or better still, a beautiful Virgin attributable to Memlinc in the Art Institute of Chicago, with two attributable to Roger van der Weyden. In the last two works by Van der Weyden, the style is terse and noble, drawing its effect mainly from the silhouette against the red drapery, but also from the nose and lips. None of this is visible in Memlinc's works. The face is more soft, linked to a grey background of sea and landscape. Seen full face, she recalls a model who is rather too sweet.

Several works show that Memlinc was obliged to sketch in the outlines before he began to paint. In *The Virgin with Saints* in Bruges, he even continued sketching while he was painting. He used parallel strokes in some of the shadows and small, light strokes to position the highlights on the red and blue garments.

With the exception of the four large figures on the reverse of the volets of the Lübeck *Crucifixion* and those on the triptych of *St Maurus, St Christopher and St Giles,* Memlinc always worked slowly, with the precision of a miniaturist. It comes as no surprise, therefore, to learn that he inspired the master illuminators who immediately followed him in Bruges – in particular those responsible for the Grimani Breviary and, even in Ghent, the *Hortulus animae.*

To give Memlinc his proper place among fifteenth-century Flemish Primitives, one must acknowledge that he provided a very attractive melody in what was a magnificent concert. This explains his success in his own day, both at home and abroad, through the important foreign merchants who came to Bruges. And of course it also explains the charming spell he still exerts over the public today. But one must face the fact that, with Memlinc, Flemish art lost some of its masculine vigour, its beautiful plastic quality and its illusion of reality which it had possessed up to this time.

☆

Although German scholars have insisted on calling him Hans Memling (a form related to Memlingen or Mömlingen which was taken to be his birthplace), the artist's name is definitely Jan Memlinc. In the Bruges archives his Christian name is given as Johannes and Jan, and his surname is given in

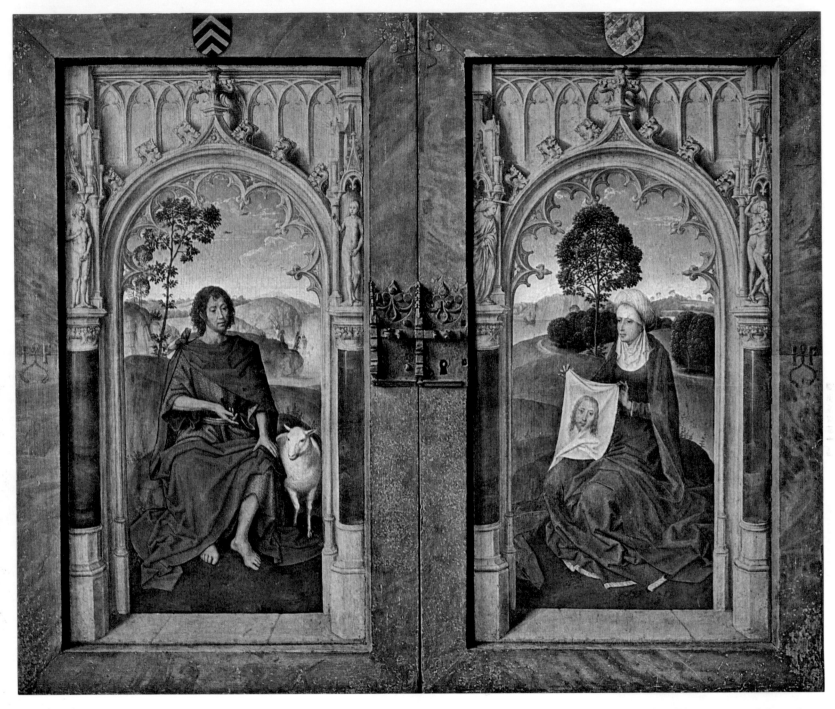

XXXIII Jan Memlinc: *St John the Baptist* and *St Veronica*. The reverse of the volets of
The Adoration of the Magi (see 126, p. 189). Hôpital St Jean, Bruges

141 Adriaen Isenbrandt:
St Mary Magdalene
National Gallery, London

142 Adriaen Isenbrandt: *The Seven Sorrows of the Virgin*
Church of Notre Dame, Bruges

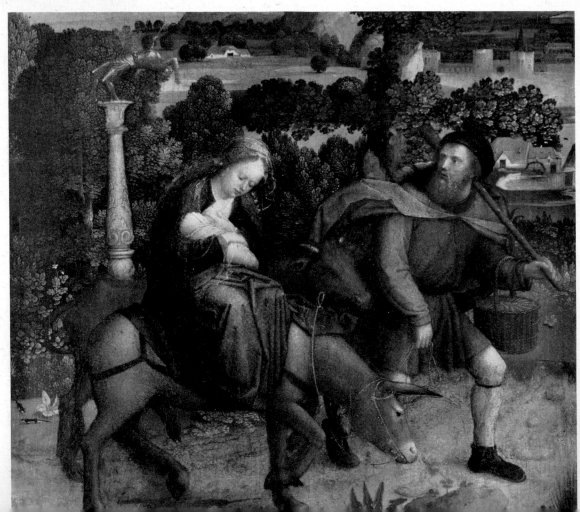

143 Adriaen Isenbrandt:
The Seven Sorrows of the Virgin
Detail showing the Flight into Egypt.
Church of Notre Dame, Bruges

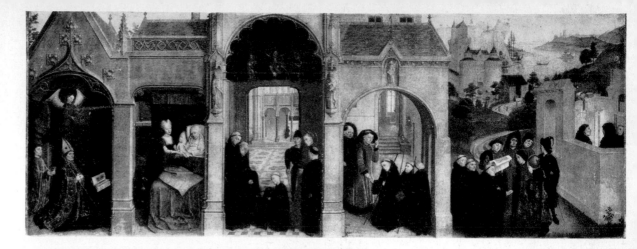

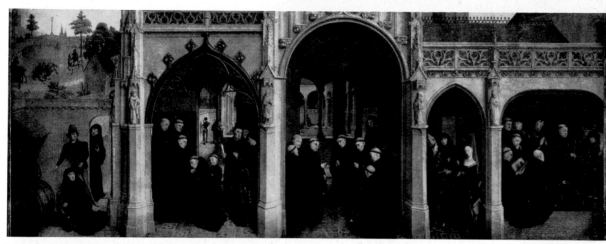

144 and 145 Simon Marmion:
scenes from the life of St Bertin.
Staatliche Museen, Berlin

146 Jan Provost:
Virgin and Child
Walters Art Museum,
Baltimore

147 Jan Provost:
The Martyrdom of St Catherine
Musée Royal des Beaux-Arts,
Antwerp

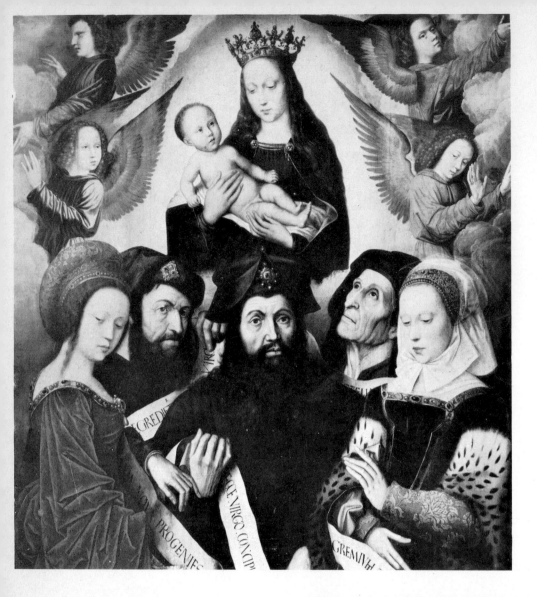

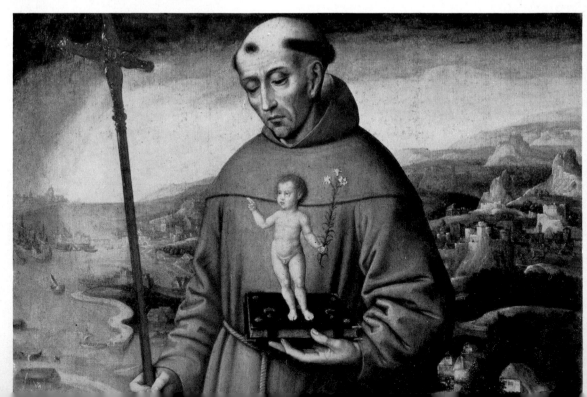

149 Ambrosius Benson: *St Antony of Padua*
Musées Royaux des Beaux-Arts, Brussels

fourteen different ways, most frequently Memlinc, but never Memling. It was long maintained that his name indicated that he came from Memlingen or Mömlingen-lez-Mayence. M. René Parmentier, keeper of the Bruges communal archives, has discovered a mention in the register of the citizens of Bruges, on 30 January 1465, of Jan Mimmelinghe, son of Hermann from 'Zalingenstat', which probably means Selingenstadt on the Main, near Frankfurt. The artist's family name would lead one to think that his paternal ancestors originally came from Mömlingen.

This, then, is where the artist's factual life story begins. Anything prior to 1465 is hypothetical, even pure fantasy. Some critics have even attempted to give the date of his birth, basing their deductions on the assumed ages of characters in his paintings at windows or behind a pillar, which they have taken to be self-portraits – as if these characters might not have been purely imaginary, or friends, assistants and servants. Or again, bearing in mind the particular serenity of his Virgins, it has been claimed that Memlinc could only have studied in Cologne – as if this characteristic could not be explained simply as a personal inclination of the artist. From the details taken from Van der Weyden it has been assumed that Memlinc spent some time in his workshop before he set up in Bruges. It has already been pointed out several times how common such borrowing was at the time. In any case, Memlinc adapted what he took, and this complicates the issue. From deductions made from historical characters which have been recognised in *The Virgin with Angels, Saints and Donors*, in the National Gallery in London (64), it has been established that the work dates from the early years of his activity in Bruges, and not from 1468. But the style of this picture proves that the artist had completely assimilated Flemish technique by then. If Memlinc studied in Germany, there is little doubt that this work would have betrayed some extraneous elements, but none is visible.

We do not know when Memlinc arrived in Bruges. Perhaps he was taken there by his father, Hermann, who is mentioned in the register of enrolment of citizens of Bruges. It is likely that Memlinc was in Bruges an early age, and that he studied there.

Historical documents give an astonishing detail for those who imagine that an artist's physical appearance bears some relation to his painting. People have envisaged the painter of so many calm and reserved works as some sort of ascetic. But Marcantonio Michiel, in his *Notizie d'opera di disegno*, says that he saw a self-portrait of Memlinc in the house of Cardinal Grimani in Venice in 1521. He describes the face as fat and ruddy (*grasso che attramente e rubicondo*). If this is correct, then there was nothing of the starved dreamer about Memlinc, as people have imagined.

Documents at Bruges show that he led the life of a well-to-do citizen. By 1466 he already had his own house, and in 1480 he bought another, built of stone, which was a real luxury for those days. At the death of his wife, various effects were shared amongst Memlinc and his three children. Finally, in 1480, he is mentioned as one of the 247 most wealthy citizens of Bruges who each loaned twenty *escalins* to the corporation for its war effort. His works date from 1472 to 1491. The archives also say that he was buried in Bruges on 11 August, 1494.

AFTER MEMLINC: THE MASTER OF THE ST LUCY LEGEND

Memlinc lacked energy – his style was essentially gentle and smooth, and he had many rather feeble imitators. We know the names of some of his pupils. In 1479, Annekin Verharneman, and in 1483, Passchier or Pasquier van der Mersch were enrolled with him (65). We also know that in 1499, his son

Jan, who must have studied in his father's workshop, painted a portrait of Agnes Adornes (66). Even during Memlinc's lifetime there were many artists at Bruges and Ghent who consciously adopted his style to express their serenity and their dreams, with smooth forms and delicate colours. Some of their works are grouped under the names of the borrowings, among the followers of Memlinc.

The most personal of these anonymous artists is the Master of the St Lucy Legend. His 'type' picture is *Three Episodes from the Life of St Lucy*, dated 1480, in the Church of St Jacques at Bruges. His style recalls that of Memlinc, and sometimes Van der Goes. His forms are generally stiff, with many verticals. His colours are relatively sober, and the technique somewhat heavy. He has the habit of rendering light on hair with a few clear, parallel strokes, as does Van der Goes, in *The Adoration of the Shepherds*.

The same stylistic characteristics are apparent in *The Virgin among the Virgins (Virgo inter virgines)* in the Musées Royaux in Brussels. In 1489 this work was installed over the altar of the Brotherhood of the Three Holy Virgins in Bruges. The colours here are duller than in the 'type' picture. There is another painting on the same theme and of similar composition in the Detroit Institute of Art, which should be attributed to the same artist, not because of the similarities of certain figures, but because of the identical style. The tonal values are darker in this work.

Doubtless by the same artist is *The Legend of St George* in the Kestner Museum in Hanover, in which the colour is better than in any work attributed to him, and *St Catherine* in the Johnson Collection in the Philadelphia Museum. There is a beautiful view of Bruges in the background of this work, and one can see the campanile without its octagonal third storey, which was not added until 1482. The work therefore dates from before 1482. In the same collection is a fine portrait of a man (no. 327), painted in the same style, but wrongly attributed to the Master of the Life of St Ursula.

THE MASTER OF THE LIFE OF ST URSULA

The artist is known by this name because of two panels, each with four scenes from the life of St Ursula, acquired by the Groeninghe Museum in Bruges. He must have worked at the same time as Memlinc. There is an attractive naïvety in his unfolding of the story, and he outdoes Memlinc in the freshness of his colour, which is sometimes daring. Some of the silhouettes on these panels are drawn in with a black line – a feature rarely found in Flemish painting. Many paintings have been attributed to this artist, but for the most part they have nothing at all to do with the style of the 'type' panels just mentioned.

The style of these artists – in common with that of Memlinc – shows a feeling of weariness, reflecting what was happening in the world around them at the time. The great Burgundian period was drawing to a close; the energetic pulse which it had given Flanders began to slow down. Philippe le Bon, the Grand Duke of the West, died in 1467. Ten years later his son, Charles le Téméraire, was killed at the Battle of Nancy. His death marked the end of the splendour which Philippe de Comines expressed in this way: '*Il me semble que pour lors les terres du duc de Bourgogne se pouvaient mieux dire de promission que nul autres seigneureries qui fussent sur terre*' (67) ('It seems to me that at that time the lands of the Duke of Burgundy could better call themselves the Promised Land than any other lands [lordships] on earth').

It is simplifying matters too much to attribute the rapid decline of Bruges to the silting-up of the River Swin, which had allowed foreign ships access to the ports of Sluis and Damme. The real cause of the decline seems to have been psychological rather than economic. Too much concerted effort had finally

exhausted old Flanders. The softness and comfort of prosperity put to sleep the energies and aesthetic aspirations which had always been shared by rich people and commoners alike. The exacting discipline of taste, which artists also imposed on themselves of their own accord, began to be of less consequence. Artists no longer worried about devising new forms or introducing technical improvements. If they produced a great deal they thought themselves adequately rewarded when they achieved popular success, without any obligation to make any extra expenditure of energy. Gradually they discarded the vigorous composition, the stretching of the whole being to the creative task. The powerful art of the Van Eycks was on the point of being lost.

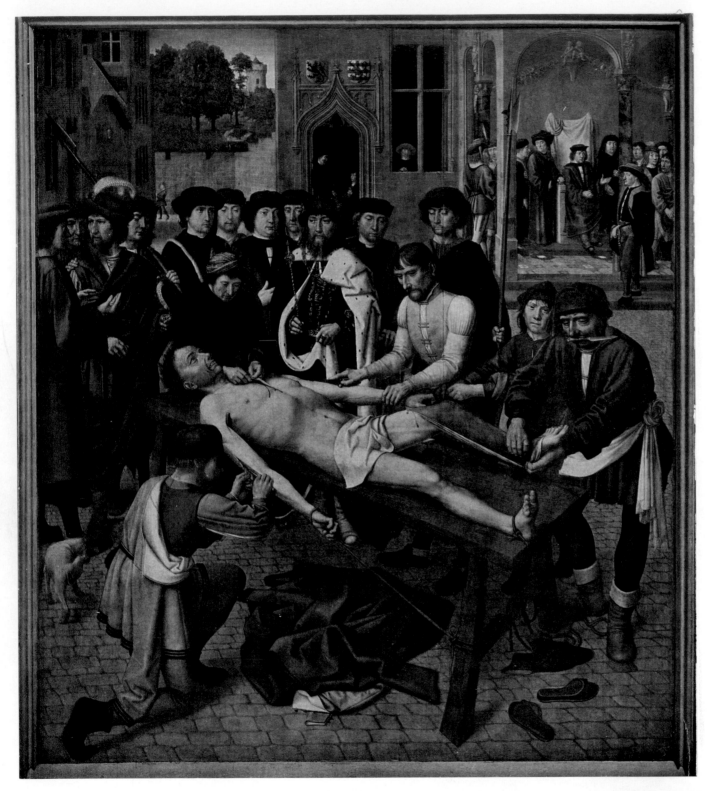

xxxiv Gerard David: *The Story of Sisamnes*
Panel showing the flaying of Sisamnes.
Groeninghe Museum, Bruges

CHAPTER TEN

THE LAST GLORY OF BRUGES :
GERARD DAVID

But once again a star appeared in the firmament: Gerard David. With him Flemish painting was temporarily rescued from an early decline. In every generation, throughout the fifteenth century, Flemish art had had the good fortune to find an artist of originality who was able to infuse new blood into it. For some years Gerard David halted the decline of painting in Bruges and produced several works which remain the glory of the city.

He began his career in Bruges in 1484, nineteen years after Memlinc. For nine years they worked simultaneously, and David continued until 1523. One can say, therefore, that he heard the bells of the Renaissance – without listening to them, however.

Among his undisputed works we must first look at the great diptych in the Bruges Museum, *The Story of Sisamnes*. The municipal accounts of Bruges show that in 1491 the aldermen paid the artist for a painting to hang in their hall (they also acted as judges), and between 2 September 1498 and 2 September 1499 they paid him the last instalment for a large picture for the same hall. The references are probably to two panels of a single diptych depicting *The Story of Sisamnes*, and one of them is dated 1498.

A quarter of a century earlier, Dieric Bouts had been commissioned to paint *The Justice of Emperor Otto III* for the courtroom at Louvain, also in the form of a diptych, which would serve as a warning to judges. In its turn, Bruges also wanted a work which would duly condemn corruption. Shortly before this, Pierre Lanchals, burgomaster and president of the tribunal, had been accused of this very crime. Probably the magistrates who followed him commissioned a diptych from Gerard David for the courtroom to remind themselves of the danger to which a corrupt judge exposes himself.

The subject matter comes from Herodotus v, 21 or Valerius Maximus vi, 3. In the first panel King Cambyses bursts into Sisamnes' house with his retinue. The king makes a series of accusations which he enumerates on his fingers. Drops of perspiration stand out on the judge's brow; he is about to rise from his seat, and he foresees his punishment. One does not know whether he is going to protest or attempt to escape. But already the executioner has taken him by the arm, to the satisfaction of those present. The explanation of the scene is in the background. The judge let himself be corrupted by accepting – on his own doorstep – a purse which a defendant slipped into his hand. In the second panel we see the terrible punishment. Sisamnes is flayed by impassive executioners. He is gritting his teeth, but his torture hardly moves the onlookers. So that the judge's son, who will succeed him, will never forget that a magistrate's first virtue should be integrity, his father's skin is spread out over his chair in the background.

Instead of using four different panels, David has adopted the medieval method of portraying two successive scenes simultaneously on each of the two volets. In this way he has condensed his story, giving more space to the principal scenes, and relegating to a less prominent position those which seem of secondary importance.

If one were looking for indications of a new spirit in this work, one would find them less in the introduction of vaguely Italian decorative elements – such as medallions like antique cameos, or the cupids bearing garlands of fruit – than in the method of grouping the crowd in the praetorium in a clearly delimited space and in serried ranks where verticals dominate. The strength of the colour and the sureness of touch are in keeping with the subject.

A second painting which is absolutely authentic is *The Virgin among the Virgins (Virgo inter Virgines)* in the Rouen Museum. In 1509 it went to the convent of the Carmelites of Zion in Bruges. An inventory of the convent, drawn up in 1537, relates that the picture was painted and presented by David (68). A seventeenth-century description runs: '*In ecclesia videre est famosissimam picturam summi altaris B. Virginis inter Virgines, quam Gerardus David celeberrimus pictor posuit anno 1509*' (69) ('In the church is to be seen the most famous picture on the high altar of the Blessed Virgin among the virgins, which Gerard David, the most distinguished painter, gave in the year 1509').

In the fifteenth century it was common in Flemish and Italian painting to represent a group of saints on the same panel. The figures were generally shown side by side. It was unusual for a Flemish artist to base his grouping on geometrical forms. David devised his own solution. Instead of a backdrop he used a neutral background. His figures in the foreground themselves create the space by their volume and shape. The lighting, and the bright colours, give this group diversity and the appearance of life, which is better than relying on positioning and gestures. The work is a powerful, solid composition of forms and colours, and to appreciate it fully one must follow the detail attentively. In the centre the extremely dark blue of the Virgin's dress and cloak creates a large, solid zone, relieved by the red cloth over the seat. The albs of the angels, with bluish shadows, discreetly isolate the Virgin from the other figures. The colour zones balance each other. First, on the right, is the orange-brown of St Godelva, and knotted round her neck is the linen with which she was strangled. Next is the green dress and violet sleeves of St Barbara, identifiable by the tower delicately worked into her crown. On the extreme right is the deep crimson red of St Lucy holding her eyes between her fingers. Above her the artist has painted his daughter at about the age of twenty, and not his wife – Cornelia Cnoop – as has been stated. On the other side, on the left of the angel with a lute, is St Agnes in dark green, with the lamb at her feet, and the light red – almost pink – of St Catherine's dress, which is made even lighter by the yellow embroidery. She is identifiable by the wheels in her crown. Finally, on the far left, St Dorothy is in blue, carrying the basket of flowers which is her attribute. Of the other saints, the one carrying a tooth in a pair of pincers would seem to be St Apollonia. The artist has included members of his family, and also himself on the far left-hand side of the picture, which he gave to the convent.

The strong, sustained colours are thickly applied, and the contours are soft. The colouring and technique are in perfect harmony with the spirituality and dignity evident in the smallest detail. For example, the eyes of the saints are half-closed; two light strokes show the edges of the lids. This feature was soon taken up by other artists, in particular the Master of Frankfurt.

These two entirely authentic works are fundamental, because in them David's style is revealed. It is the style born of a mind which is both thoughtful and positive: profound, collected, sometimes a little dreamy, and yet the artist likes to express himself in forms which are very close to reality. He strikes a fine balance between abstraction and tangible truth. David was a born artist, and his work has qualities which are much more solid than those of Memlinc. It is more brilliant, and at the same time more subtle. It comes, above all, from a surer touch, and the handling of the contours is almost that of a virtuoso.

There is another masterpiece, *The Baptism of Christ* in the Bruges Museum, which can be attributed to David because of its identical style, and chronologically it falls between the first two works mentioned, which were painted at an interval of ten years. The date of *The Baptism of Christ* has been ingeniously fixed through the presence, on the volets, of portraits of the two wives of the donor, Jean de Trompes.

His first wife, Elisabeth van der Meersch, died on 11 March 1502, so one assumes that the centre of the triptych and the interior of the volets were painted before this date. His second wife, Madeleine Cordier, painted on the reverse of the volets, died in 1510. This means that the portrait must have been painted before that date, but since the date of the second marriage is not known, one cannot be more precise. In any case, the style confirms that this is a work of the artist's maturity. It has deep feeling, and is the most successfully conceived and painted work we know by David.

The light is slowly fading as Jesus arrives at the edge of a wood where John the Baptist is preaching. He points out the Master. In the foreground Jesus has come to the river and humbly asked for baptism. He has taken off His clothes and left them in the care of an angel. The Baptist pours the cleansing water. His attitude, gestures and expression have a fine, respectful reserve. Christ receives His baptism with majestic dignity, and His pensive look indicates the vastness of the mission He has undertaken: the Redemption of humanity. The conception of the picture is very simple and the blend of colour skilful. It is full of the mystery of the sacramental rite; Jesus' body is bathed in a gentle light. The surface of the water around His legs shimmers with glittering spangles. In the undergrowth the daylight is weaker. This work shows the strong personality of an artist who responds powerfully to the possibilities of his subject matter and can use his technical accomplishments to express his feelings.

Here David almost achieves perfection. He uses the paint fairly thickly and renders relief gently, with light brown shadows which are almost transparent. Aerial perspective is suggested by subtly shading off the brightness of the colours. The flesh-tints are a soft pink, and rich colours are used for the clothing. There is a glossy finish to the work as a whole. This is one of the summits of Flemish Primitive art. It is full of spirituality and fervour.

There is an innovation in the landscape. The undergrowth with its mysterious light and the precision of the foliage is a rare achievement. The same clarity is seen in the two panels in the Rijksmuseum in Amsterdam, which are the reverse sides of the volets of a *Nativity* in the Bache Collection in the Metropolitan Museum of New York. These are the oldest pure landscapes in Flemish painting.

There has been a tendency to assign some of David's works to earlier or later dates – in relation to the three works discussed above – on the grounds of a less developed style or because of a more supple and more assured style. One cannot be dogmatic about this. Artists have moments of weakness as well as moments of greatness.

However, one can group various works together with *The Story of Sisamnes* on the grounds of economy in composition, a slightly heavy touch, and rather deep colours. First of these is *The Adoration of the Magi* in the Musées Royaux in Brussels, in which the composition is monumental; then come other less accomplished pictures in which the artist has still not found himself – as we see from the hesitations in the choice of colour, which is either too crude or too dull. Although they already have the specific characteristics of David's art, these works show that the artist is still doing his best to assimilate the essence of the Flemish tradition. He borrows from it composition, grouping, colour, and even technical effects, either from the Van Eycks, Van der Weyden or Van der Goes, but rarely from Memlinc. Specific examples are: *The Crucifixion* in the Thyssen Collection in Lugano, which is inspired by Jan van Eyck; *The Crucifixion* in the Bernes Collection in Philadelphia, inspired by Roger van der Weyden; *The Adoration of the Shepherds* in the Munich Pinakothek, in the style of Van der Goes, which has a curiously schematic quality with dull colours, and which one would be inclined to leave out of the David catalogue, were it not for the presence of his style in some of the large figures.

In *The Crucifixion* in the National Gallery in London, his individuality is more apparent. The volets of this work – *The Jews* and *Christ's Friends* – are in the Musée Royal in Antwerp. The Cross cuts diagonally across the picture, and the body of Christ is daringly foreshortened. The executioners are as natural as those in *The Story of Sisamnes*. On the volets, the heads of the men on horseback are no higher than those of the pedestrians, and the static figures are closely grouped, as also in *The Story of Sisamnes*.

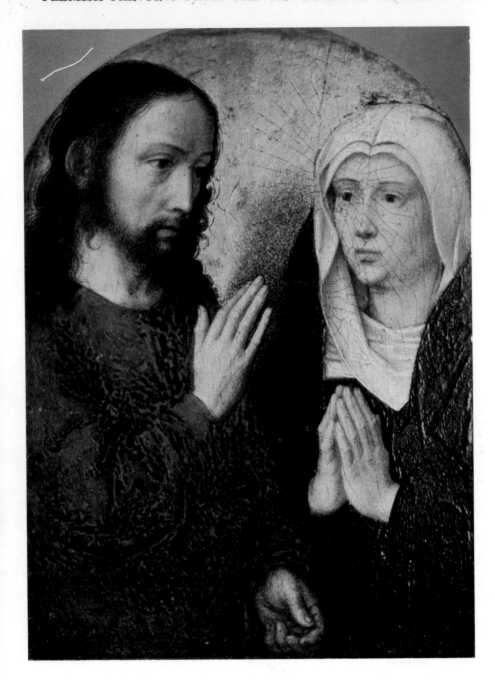

xxxv Gerard David:
Jesus taking Leave of His Mother
Staatssammlung, Munich

There is another important work which could well relate directly to *The Story of Sisamnes*, and that is *The Marriage at Cana* in the Louvre. The work is less relaxed than the Rouen *Virgo inter Virgines*. The grouping is compact; the figures placed closely together; there is little feeling of space; there are a number of verticals, and a wide variety of intense colours with very little shading. The contours in the flesh-tints are heavy and, in an unusual way, the main part of several of the faces is covered with a grey shadow. Often the brushwork is visible. This picture could have been painted shortly after 1503, the year in which Jean de Sedano, who is shown wearing the robe of the Brotherhood of the Holy

150 Ambrosius Benson: portrait of a man.
J.G. Johnson Collection, Philadelphia Museum

151 Quentin Metsys: *The Virgin with the Cherries*
E.W. Edwards Collection, Cincinnati

153 Quentin Metsys: the St Anne Altarpiece.
Exterior of left volet showing the refusal of the
offering of Joachim and St Anne.
Musées Royaux des Beaux-Arts, Brussels

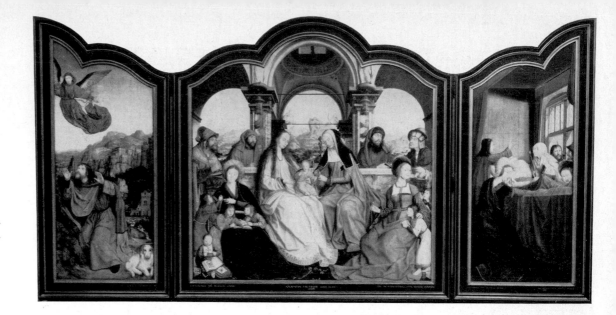

Bottom left:
155 Quentin Metsys: the St Anne Altarpiece.
Detail of central panel showing the Christ Child.
Musées Royaux des Beaux-Arts, Brussels

Bottom right:
156 Quentin Metsys: the St Anne Altarpiece.
Detail of central panel showing St John the
Baptist as a child.
Musées Royaux des Beaux-Arts, Brussels

154 Quentin Metsys: the St Anne Altarpiece open.
See colour plate XXXVII on p. 224, and 152, 153, 155 and 156.
Musées Royaux des Beaux-Arts, Brussels

157 Quentin Metsys: the *Pietà* Altarpiece. Detail of the right volet – the ordeal by boiling oil – showing the head of one of the executioners
Musée Royal des Beaux-Arts, Antwerp

Blood, was made a member. There is the same reserve, the same controlled emotion, but not the same effect of light nor the spatial sense of *The Baptism of Christ*, which would date from before 1502.

Jean de Sedano also appears – at a slightly younger age – in *The Virgin enthroned*, in the Louvre. This picture may be from an early date, though there is nothing in the style to warrant regarding it as a youthful work.

Similar in style to *The Baptism of Christ* is a volet in the National Gallery in London, showing *Canon Bernardinus de Salviatis and Three Saints*. There is the same spatial sense with the same glowing colours. The historical facts vouch for the work. The volet comes from an altarpiece erected early in the sixteenth century in the chapel of St John the Baptist and St Mary Magdalene in the Church of St Donatien at Bruges, at the instigation of Canon Richard van der Capelle in memory of his friend, Bernardinus de Salviatis, the son of a Florentine merchant who had settled in Bruges.

There are other works which relate to *The Baptism of Christ*, in which one feels the calm of a soul absorbed in contemplation. Forms are treated in a more serene way, the colours are clearer, and the general amount of light increased. It is apparent in several exquisite versions of *The Rest on the Flight into Egypt*, the best of which is in the Bache Collection in the Metropolitan Museum of New York, where the tonal range harmonises with the pinkish flesh-tint of the Virgin. It is also apparent in the several versions of *The Virgin and Child with a Porridge Bowl*. The best of these is in the collection of Baroness von Mannwitz at Heemstede. A branch from a cherry tree here replaces the spoon held by the Christ Child in other versions.

There is a *Virgin and Child with Saints and Donors* in the National Gallery in London, which provides more information about the art of Gerard David (70). Attempts have been made to date the work from the donor's coat-of-arms on the dog's collar. James Weale identified it as the arms of Richard de Visch, canon of St Donatien in Bruges, who died in 1511. The St Antony Chapel was inaugurated – according to a rather late document – in 1511, and this painting was over the altar of St Catherine. The work could have been given to the church in that year, but it would have to have been painted before then. The canon does not seem to be very old, and Richard de Visch had been a canon since 1443. It is therefore quite likely that the picture had been painted well before 1511. In fact it is similar in style to the Rouen painting, which dates from before 1509. The colours are less varied but intense. Volume is less well rendered, and the composition is like one used by Memlinc for a similar subject. It is reduced to a semi-circle and has no interior movement.

Close examination of Gerard David's small pictures reveals that they are, for the most part, painted with light strokes and a fine brush in the miniaturist manner. This would lead one to think that Guicciardini was talking of Gerard David, and not Gerard Horenbout, when he wrote: '*Gherardo excellentissimo nell'alluminare*'. Many miniatures – particularly in the Breviary of Isabella the Catholic in the British Museum – have so many of David's characteristics that one may also certainly attribute them to him. In any case, it is obvious that the illuminators of the Ghent and Bruges School owed much more to Gerard David than to Jan Memlinc.

☆

Gerard David – like many other artists of the same school – was not Flemish by birth, but he was absorbed by Flanders. His name is mentioned for the first time in the register of artists at Bruges. He was enrolled as a master at the beginning of 1484, with the following mention: '*Gheerardt Jans f[ilius] Davidt, was wremde*' (' Gerard, son of Jan, David, was a foreigner'). He probably came from Oudewaeter,

according to Sanderus, the eighteenth-century historiographer from Ghent. He says that Isenbrandt was a pupil of David, from Oudewaeter: '*Gerardi Davidis Veteraquensis*'. An old collection of epitaphs gives the same information: '*Gheeraerdt Davidts gheboren van Oudewaeter*' ('Gerard David, born at Oudewaeter').

The fact that he was enrolled as master at once shows that he was already fully fledged as an artist. He could possibly have been a pupil of Aelbrecht van Ouwaeter in Holland, though there is no proof of this. At the very most one might see some Dutch characteristics in his art. But certainly ten years after he settled in Bruges – as his works show – he had learned all the secrets of traditional Flemish painting.

Beginning in 1488-9 he was commissioned by the municipal corporation, then again in 1495-6 and 1498-9. He was a juryman of the guild of artists in 1487-8, 1489-90, 1493-4, 1495-6, 1498-9 and dean in 1501. Shortly after 1496 he married Cornelia Cnoop, the daughter of the dean of the guild of goldsmiths. He was enrolled at Antwerp in 1515, but this can only have been a temporary residence. Any dues he paid to the guild there were probably so that he could sell his paintings in Antwerp. Gerard David died in Bruges on 15 August 1523.

THE LAST MASTERS OF BRUGES

ADRIAEN ISENBRANDT

There were many artists in David's circle, but Adriaen Isenbrandt was closest to him stylistically. He never equalled David's idealistic approach, nor the richness and clarity of his colour.

There is no signed or documented work, but several paintings have been attributed to him, taking as their focal point one which has long been regarded as authentic, *The Seven Sorrows of the Virgin* in the Church of Notre Dame in Bruges. It forms a diptych with another panel in the Musées Royaux in Brussels, which shows the donors, and on the reverse a *grisaille Seven Sorrows of the Virgin* as well. The Bruges panel was spoilt during restoration many years ago when a bituminous varnish was used, which made the colours heavier and so diminished their effect. It was cleaned in 1946, revealing several interesting features. The face of the Virgin, for example, could almost pass for slightly inferior work by Gerard David. The line and contours are particularly reminiscent of the volets of his *Baptism of Christ*. But on the other hand several features show that it could not be attributed to David. For example, the Virgin's dress and cloak form a heavy, solid mass of completely unrelieved opaque blue. David would not have been able to resist adding relief to it. The many different shades of red in the seven sorrowful incidents from the life of the Virgin have an explosive quality in the generally dull tonal key of the work as a whole. The shadows in the flesh-tints were added before the highlights and are more brown than those of David. The profiles of the noses are marked by white paint, and the noses themselves are short and straight. The architecture is neither strictly Gothic nor that which was current in Bruges at the beginning of the Renaissance. As in David's paintings, the landscape is mainly brown and green, with clear, firm foliage on the trees, but Isenbrandt adds rocks which look like heavy meteorites or huge cacti which have pushed up through the soil. There are some of the flashes of inspiration one finds in

David, and Isenbrandt has borrowed liberally from other Flemish artists, and even from Dürer engravings.

Isenbrandt is not without feeling. His Virgin shows sorrow nobly endured in a very expressive way. Sadness seems to flow from her headdress down through the whole figuration, but the face shows resignation. Some of the surrounding scenes show deep and sincere emotion.

With this picture, and its other half in Brussels, as a starting point, attempts have been made to find other works in a similar style. But the process of increasing the number of attributed works finally produces an impression of Isenbrandt's style which is further and further removed from the 'type' pictures. In fact one tendency has been to attribute to Isenbrandt anything which seemed to be in the style of David and was not good enough to be by David himself. Extremely wide variants of style were explained away as the result of an influx of commissions which compelled Isenbrandt to use assistants, who watered down his style. It is also stated that he sometimes finished paintings begun by colleagues. If we really want to get to the bottom of the question, then we must stop making any more attributions for the time being and concentrate entirely on the works most closely related to *The Seven Sorrows of the Virgin* in Bruges. These are the following: *St Mary Magdalene* in the National Gallery in London, where the red of the clothing tones in well with the brown rocks and green foliage; *The Entombment of Christ* in the collection of the late E. L. Paget in London, in which the colouring is very delicate; *The Virgin enthroned*, in the Bruyn Collection at Spiez in Switzerland, in which the contours and technique of the Bruges picture are easily recognised – despite the fact that the figure is more human in conception; finally *The Crucifixion* in the Hedborg Collection in Brussels, which is very close to the Bruges painting.

To whom, then, do we attribute *The Seven Sorrows of the Virgin*?

Naturally one turns to Bruges, and looks amongst the better-known artists who followed Gerard David. It is still only a theory, but it is assumed that the artist was Adriaen Isenbrandt. He had certain responsibilities in the Bruges guild of artists; he was one of the few artists of the time to be given the honorary title of Master in the guild's obituary; the only one to be mentioned as a pupil of David (unfortunately by a rather late source, by Sanderus in his *Flandria illustrata* of 1644). Isenbrandt was enrolled as Master on 29 November 1510 as *vreemde* (foreigner) just like David, at that time at the height of his career. He was a juryman (*vinder*) of the guild nine times, between 1516-7 and 1547-8, and twice treasurer (*gouverneur*), in 1526 and 1535. Reference to only one pupil has been discovered, that of Cornelius van Callenberghe, registered on 26 June 1520. Isenbrandt died shortly before 21 July, 1551.

SIMON MARMION

The prestige of Jan Memlinc and Gerard David continued to overshadow several artists who worked in Bruges. Simon Marmion was an excellent miniaturist and painted some beautifully finished works, but he seems to have been quite eclipsed by the two other great artists. He was a contemporary of Memlinc, born in Amiens, and like Memlinc was a foreigner absorbed into the stream of Flemish art. He worked in Valenciennes, Lille and Bruges between 1454 and 1468, and died in 1489.

He is held to have been responsible for *The Legend of St Bertin*, part of which is in the National Gallery in London, and the other in Berlin. His contours are gentle and his composition calm. His reserve shows him to have been a meticulous and honest artist, but not a very impressive personality.

AELBRECHT CORNELIS

Cornelis was a contemporary of Isenbrandt, although we know nothing about his formative years, nor about his admission to the Bruges guild of artists. He is mentioned for the first time in 1512-3 when, as a citizen of the town, he lodged a complaint against a merchant, Rodrigo Cattelan, for having delivered him inferior quality colour. In 1515 he registered an apprentice, Pieter Verlage, with the guild. He was a juryman in 1518-9, and his son Nicolas was enrolled as a master in 1541-2. Aelbrecht Cornelis died at Bruges in 1532.

The Bruges municipal archives authenticate one of his works, a *Coronation of the Virgin* in the Church of St Jacques at Bruges. The contract shows that it was commissioned by the fullers' guild, and from another source we know that it was delivered in 1522. It is a rather mediocre piece of work, and one can understand why his clients lodged a complaint against him in 1519 because he had not painted the picture himself. The artist told them that he was by no means bound to do so under the terms of the contract, and that he was only responsible for the flesh-tints. The magistrates had to abide by the letter of the law, and only obliged the artist to deliver his painting within the year as he was bound to do. One can therefore judge Cornelis' talent only by the flesh-tints. In fact they constitute the weakest feature of the picture. The faces of the several angels are uniformly reddish and are all the same: short noses, cherry-shaped mouths and ringlets. There is absolutely no distinctive feature in the technique. The angels are placed in a circle in which there is nothing artistic, and for which Cornelis himself was doubtless responsible. He chose the simplest solution to the problem of composition here. The only attractive feature is the colouring of the garments, which changes for each choir of angels. There is so little personality apparent in the picture that it would be risky to attempt to group others with it.

THE MASTER OF THE BROTHERHOOD OF THE HOLY BLOOD

Another equally minor artist produced 'primitive' works in Bruges until the first half of the sixteenth century. Several works are attributed to him, and the focal point is a triptych of the *Pietà* in the Musée du Saint Sang in Bruges. The composition of this *Pietà* is merely an impoverished, simplified version of the one by Quentin Metsys. In his other works there are several borrowings from Memlinc, but none from David.

Judging from the *Pietà*, his figures are squat, and the fingers long and parallel. The folds of the garments are hard and broken. Taken by and large, the main feature of his works is the solid colour and firm contours, which are particularly evident in *The Descent from the Cross* in the Liège Museum (though not attributed), which I have no hesitation in including in a list of his work.

JAN PROVOST

The only documented work by the artist is *The Last Judgment* in the Bruges Museum, in its beautiful original frame. It was intended to hang on the chimney breast in the council chamber of the town

xxxvi Master of the Brotherhood of the Holy Blood: *Ecce Homo*
Church of St Jacques, Bruges

hall. The accounts for 1524-5 record the payments made to Preuvost (called Prévost and, more often, Provost in other documents) and, for the frame, to Jacques Kempe. The frame is in the new Renaissance style, though Flemish Renaissance, and not Italian, and is worthy of attention. It has two lions supporting a gold shield with a black two-headed eagle – the arms of Charles V – and the date 1525.

It is worth bearing in mind how Van der Weyden and Memlinc handled the same theme. In the upper register, representing Heaven, they managed to create a vision of hieratic magnificence. In the lower register they showed the joy of the saved and the pain and horror of the damned. One should also bear in mind the powerful conception which Hubert van Eyck had brought to his little panel, now in the Metropolitan Museum of New York. In Provost's work everything is on a less elevated, more human, plane. All the same, one must acknowledge that the figure of Christ is beautifully conceived, in a sort of luminous cloud. Apart from the Virgin and St John the Baptist, the saints all have a look of innocence. This somewhat naïve look is hardly suited to the solemn occasion, however. The resurrection of the dead with the calling of the blessed to Heaven and the consigning of the damned has been condensed into a few strong figures. The most expressive are doubtless the young woman on the left being helped by an angel, in a graceful movement, to put on the white robe of the Elect and the other, on the right, of the damned woman who tears out her hair in despair, poised on the edge of the everlasting abyss. But the overall effect is bereft of deep feeling.

Painted at some date well into the sixteenth century, this picture is full of the reserve of the Primitives. In this way of rendering space, one hardly notices the tendency to place figures and forms in different planes to suggest different directions, or that in some figures the form is more full and supple. Yet there is still no visible sign of the great spiritual renewal which the Renaissance had already awakened in Italy.

This is the only work from which one can make further attributions to Provost, so one must proceed with care.

I have examined *The Glorification of the Virgin* in the Hermitage at Leningrad. Several of the same stylistic characteristics as in *The Last Judgment* are evident: firm contours, soft hair, expressive hands with slim fingers and several other details. In addition, for those who attach importance to similarity of form, some of the characters appear in both pictures. The Leningrad picture is better than that in Bruges, not only as far as technique is concerned, but also by virtue of its composition. The sibyl and prophets are ranged in a semi-circle around the apparition of the Virgin in the sky. The work bears comparison with *The Assumption of the Virgin* in Frankfurt, painted a few years previously by Dürer, and is certainly related to several *quattrocento* Italian works. On the other hand, one must not forget Raphael's *Sistine Madonna*, which is a contemporary work with a quite different kind of expressive beauty.

It seems a very bold step to deduce from *The Last Judgment* alone – dating, as it does, from 1525 – the way in which the artist was painting some thirty years earlier, when he began. Among other works attributed to him are some paintings heavily Mannerist, whereas there is no trace of this in *The Last Judgment*. He is even credited with *Death and the Miser* in the Bruges Museum. A comparison carried out on the spot with *The Last Judgment* shows enormous differences in form and colour. How could one attribute to Provost the two volets of scenes from the life of St Catherine? (one in the Musée Royal in Antwerp and the other in the Boymans-Van Beuningen Museum in Rotterdam). They are vibrant with strong colour whose tonality is much stronger than that of *The Last Judgment*. One must therefore be extremely cautious.

One cannot lose sight of the fact that in *The Last Judgment*, documented and dated to the end of his career, Provost is faithful to fifteenth-century tradition. He retains the reserve, the intimacy, the distinction and the careful technique of the Primitives. He shows no evidence of a strong personality, but he is an excellent representative of his milieu in the town of Bruges, which had once been powerful, but was then in decline.

Once again one sees how great was Flanders' ability to absorb artists throughout this period. Provost

probably came from the north of present-day France. He is mentioned for the first time in the archives of Valenciennes, where he married Simon Marmion's widow shortly before 1491. He might well have learnt his art in Valenciennes. He appears amongst the masters in Antwerp in 1493, two years after Metsys settled there. We do not know whether Provost settled there also, or was simply on a visit to sell a painting, which would have necessitated his enrolment, as we have already seen. The following year he is registered as a citizen of Bruges. The entry says that he came from Mons, from which it has been assumed that he was born there. It is possible that he lived there for some time before finally settling in Bruges. He was a juryman three times for the Bruges guild of artists, treasurer once and dean twice, which would seem to imply that even if he did not possess peerless talent, he had a deep devotion to the artists' cause. In 1520 he was present at the reception given in Antwerp for Dürer, whom he subsequently brought to Bruges, where he was honourably received. In the same year Provost organised the decorations in Bruges for the *Joyeuse Entrée* of Charles v. In 1524-5 Provost was paid for *The Last Judgment*, and the following year for changes he had to make to it. He died in 1529. That is all we know for certain about him. The rest is speculation.

AMBROSIUS BENSON

Bruges' deathbed tenacity in keeping up its old artistic tradition is perfectly illustrated by Benson, who worked there until 1550, always in the Primitive style, and as such steeped in fifteenth-century art.

There are three pictures attributed to him which are signed with the initials A.B., and which have a certain affinity with the style of David. When attempts were being made to identify the artist, the search began at Bruges, among the followers of David, and a study of the archives encouraged the identification with Benson. The three pictures are: *St Antony* in the Musées Royaux in Brussels; a portrait of a woman in the Johnson Collection of the Philadelphia Museum; and a *Holy Family* in the Deutsches Museum in Nuremberg, dating from 1527.

In the paintings attributed to him on the grounds of similarity of style, two tendencies harmonise with each other. In *The Virgin with Prophets and Sibyls* in the Musée Royal in Antwerp, the delicate shading is allied to the solid contours. The almost sculptural quality of this work contrasts with the soft forms characteristic of works contemporary with Isenbrandt. One of the sibyls also appears in a portrait of a woman in the same museum. Among several other portraits rightly attributed to Benson are the portrait of George, Earl of Huntingdon in the Musées Royaux in Brussels, and a portrait of a man in the Johnson Collection of the Philadelphia Museum, dated 1525.

From his enrolment as Master in Bruges in 1519, we know that Benson came from Lombardy, and his Christian name would bear this out. Ambrose is the patron saint of Milan, the capital of Lombardy. He must have been at the height of his powers from this point, for he made rapid progress in the guild of artists. He was a juryman several times in 1521-2 and 1546-7, and dean in 1537-8 and 1543-4. He worked in Bruges until his death in 1550.

Benson was a Primitive lost in the midst of the High Renaissance, but his work shows how arbitrary is the division of art history by centuries.

XXXVII Quentin Metsys: the St Anne Altarpiece.
Detail of central panel showing the Virgin, the Christ
Child and St Anne. See also 152-6, (pp. 214-5.)
Musées Royaux des Beaux-Arts, Brussels

THE SURVIVAL OF TRADITION
AT THE BEGINNING OF THE RENAISSANCE :
QUENTIN METSYS AND JOSSE VAN CLEVE

In the works of those who followed Memlinc and David, the death knell of the great painting of Bruges was already sounding. Cultural life took refuge in Antwerp, which attracted artists from the beginning of the sixteenth century by its opulence and the number of connoisseurs there. On the banks of the Schelde, economic prosperity was developing at an ever-increasing pace. Foreign ships brought their spices and their precious fabrics, and the city exported linen, cloth, pictures, statuary, fine furniture, spinets, tapestries and embossed leather. Such a tide of international commerce favoured the introduction of new ideas, and in the normal course of events would have induced the convulsions of what we now know as the Renaissance sooner than elsewhere in Flanders. But there was no sudden outbreak, and the traditional art of Flanders was not deflected overnight by the new ideas. The better artists took note of what was happening, but basically remained faithful to tradition. Occasionally they borrowed a few details from abroad – a mythological subject or a decorative detail, a more monumental figurative element or a more opaque shadow. But they did not follow the Italian artists. In any case they were not ready for all the implications of the message from Italy. They went on expressing their deep emotions with the reserve and sincerity of their predecessors and with their painstaking technique.

Quentin Metsys, who worked in Antwerp during the first thirty years of the sixteenth century, is a striking example of this faithfulness to tradition.

His main work is the St Anne Altarpiece (*The Holy Kinship*) in the Musées Royaux in Brussels. It is signed and dated: '*Quinten Metsys screef dit 1509*'. From documents we know that it was painted for the Brotherhood of St Anne in the Church of St Pierre at Louvain. In the central panel the artist has shown not the genealogy of the Virgin Mary's mother, as has been stated, but her glorification. St Anne sits beside her daughter on a special seat, with the Christ Child between them. In the foreground, but relegated to the two extremities, are her two other daughters: on the left is Mary Cleophas with her four sons – James the Less, Simon, Jude and Joseph the Just. On the right is Mary Salome, with her two sons – James the Great and John the Evangelist. Behind the seat are the husbands of the Holy Women: Cleophas, husband of Mary Cleophas; Joseph, husband of the Virgin Mary; Joachim, husband of St Anne, and Salome, husband of Mary Salome (71). There is a wood engraving of the central section of the altarpiece, in which the Holy Spirit appears in the upper section. This led people to think that the picture was originally larger, and had a raised central section. However, examination has revealed that the paint stops short one centimetre from the edge of the panel, so that the present shape of the picture is original.

A majestic peace emanates from the group. It is a more genuine *santa conversazione* than any of those from Italian artists. In this work life is concentrated in a very special way. Each character collects his or her thoughts with half-shut eyes in a collective meditation, and even the children at play respect the reserve dictated by the atmosphere.

Some critics have seen this work as an imitation of Italian art, from such features as the baldachino in the style of Perugino, the columns of transparent and coloured marble and the archers on the capitals – but these were common throughout the whole of Western Europe at the time. It can only be a question of influence when the essential elements of a style are identical with those of another.

Others feel that the introduction of such clarity and balance – attributes of Mediterranean art – is a sure indication of a debt to Italy. One can easily point out that balanced composition had been a feature of Flemish art since *The Mystic Lamb*, and that the subject-matter here demanded it in any case.

But in the Low Countries and in Italy, the time was ripe for this sort of classicism, and Metsys was undeniably interested in the new movement which was beginning to reveal itself. His *Virgin* in the Poznan Museum – rightly attributed on stylistic grounds – shows by the attitudes and rhythms that Metsys had at least seen drawings or engravings of Leonardo da Vinci's *St Anne*, now in the Louvre. But at a time when Raphael was devising the well-balanced compositions of his famous pictures of the Virgin, the measured structure of Metsys' great altarpiece could perfectly well have sprung spontaneously from one of the artist's aesthetic emotions. Certainly Metsys does not achieve the stature of the Italian works which use opposing masses so easily and successfully. Certainly he does not manage to create the large, compact movements, the contrasting colour passages or make complete use of all the resources of chiaroscuro. But in his altarpiece one is aware that his clear forms and calm composition are the outcome of long meditation. Metsys imposes a discipline on the figures in his composition, but this does not prevent him from introducing internal movement, and there are some delicate individual effects within the overall scheme.

The colour is adapted to this conception of movement and form. The artist has abandoned the strong, lively tonalities of which there were many examples in the works of his predecessors. His colours are limpid, the shading so subtle that it has rarely been bettered since. His visual approach induced him to paint with devoted care. The contours gently indicate volume, without any sort of pressure. The shadows – and this is very important for the period – remain transparent. The paint is evenly laid and smoothed with a marten hair brush, so that as it has hardened it has taken on the appearance of valuable porcelain. Some critics have attributed this smoothness of colour and glassy appearance to an excessive cleaning. This wrongly supposes that the Primitives worked in successive transparent layers. Doubtless they often did paint in thin layers which are made transparent by the light, since it passes through them and is reflected by the white preparation underneath. But they also painted – as here – in a thick layer which was then smoothed over. In this case no cleaning, not even a severe one, would harm the enamel of the hardened colour. Since this painting has been in the Musées Royaux, Brussels (i.e. since 1879) it has not been touched, and if by chance it had been cleaned before then, the process could only have involved the removal of the opaque varnishes and surface impurities. The reverse sides of the volets are darker. They are covered with an oil varnish which has taken on a duller hue in the darkness in which they are kept. From this it is evident that the overall lightness of the central panel is clearly part of the artist's poetic conception.

In the volets depicting scenes from the life of the saint, the artist has had ample opportunity to abstract himself. The medieval penchant for anecdotal realism reappears.

The outside shows St Anne, still young, dedicating herself with her husband Joachim to the service of the Temple. Together they give the High Priest a box in which is their fortune. On the right – years later – Anne and Joachim are old and have the sacrifice money refused by the High Priest because they have had no children.

226

Inside, on the left, in a landscape painted entirely in shades of blue, Joachim is watching his sheep. He knows that his prayer has been answered. An angel announces the imminent birth of a daughter. On the right, St Anne on her deathbed is surrounded by her daughters. She receives the supreme benediction from her divine grandson whom the artist has suggested in an idealistic vision.

In this triptych Metsys has succeeded magnificently in making his dream concrete and in sublimating reality. This is the ultimate degree of creative power. An artist only reaches such perfection once in his career.

The great *Pietà* Altarpiece in the Musée Royal in Antwerp, was – according to the documents – commissioned by the guild of carpenters of Antwerp for the altar in the Church of Notre Dame in 1508. It was finished in 1511. It is more famous than the St Anne Altarpiece but of inferior quality. The conception is less refined, the play of passions too obvious. But the work is full of pathos, full of pity for the dead Christ stretched out on the ground for the commiseration of the onlooker. The Flemish people well understood the meaning of the work when they immediately called it *Nood Gods* – God's Grief. The Virgin is on the point of collapse; dumb with grief and her eyes flooded with tears. St John prepares to support her, but she takes hold of herself and, remembering that her child is also God, she falls on her knees. A Holy Woman holds the hand of the crucified Christ. Another wipes the blood off His feet. With a gesture of infinite tenderness, Joseph of Arimathaea cleans the wounds on Christ's head caused by the crown of thorns. The other bystanders are weeping. They all form a compact group around the Master, united in their boundless compassion for the God who was tortured until His dying moments.

But there is none of the mystery of the St Anne Altarpiece here. The *Pietà*, on the contrary, gives an impression of declamation, or at least of extravagant, theatrical gestures. The composition does not have the beautiful evenness of the other work. The landscape stretches behind the event like a stage backcloth, and only the story – recalled by the crosses on Calvary and the sepulchre in the rock – relates it to the foreground. Finally, there are too many intense colours around the dark body of Christ, such as the Virgin's blue cloak; St John's red garment; the multi-coloured brocade of Joseph of Arimathaea and the scarlets, browns and greens in the clothing of the Holy Women.

We saw that the volets of the St Anne Altarpiece did not entirely harmonise with the central panel. This effect is even more striking in the *Pietà*. By way of contrast with the relative calm required for the mourning, the volets are full of colour and movement. The left volet shows Herod's feast. The perverseness of the three main characters is clearly shown. Herod has a heavy lower lip and personifies the Oriental basely devoted to pleasure. Herodias, with the point of a knife, picks at the head of the prophet she so detested, and the head is brought to her on a dish by the young Salome, whose supple body still pulsates with the rhythm of the dance.

On the right is the ordeal by boiling oil to which St John the Evangelist was subjected, with the noisy agitation of the crowd and the activity of the executioners in heating up the fire. The disorder of the composition is increased by the riot of colour.

The work has been heavily restored in places (72), but sufficient remains intact to show that the artist worked less carefully and with more *élan* than in the St Anne Altarpiece. This could be a first hint of the quest for truthfulness which began to work on people's minds and to encourage artists to be less reserved. But that kind of truthfulness had nothing in common with the genuine concern which inspired fifteenth-century artists to express abstract ideas and delicate feelings in forms which appealed directly to the senses. Hugo van der Goes, for example, would have handled the theme of this volet in a very different way.

These two documented altarpieces are Metsys' master works. Each one contains the essential qualities of his talent. But although they were painted at virtually the same time, their style is different. The St Anne Altarpiece is a very spiritual work. The forms are calm, broad and clearly established, and the

XXXVIII Quentin Metsys: the *Pietà* Altarpiece. Detail of left volet showing Herod's banquet. Musée Royal des Beaux-Arts, Antwerp

colour is both refined and harmonious. The painting technique is controlled and careful. The *Pietà*, however, is much more physical in its approach. Feelings are expressed by dramatic movements, with several different bright colours, and a very vigorously applied painting technique.

These two very different works, painted some two years apart, are the nucleus around which most of the works which can be attributed to Metsys are grouped. This idea doubtless surprises those who believe in a strict chronology, based on continued progress. Nevertheless it is the only possible explanation when one looks at the works themselves. The style of the various paintings – even those furthest apart chronologically – is related to one or other of these altarpieces.

With the St Anne Altarpiece one can group first of all a work rightly attributed to Metsys, a portrait of a man in the Oscar Reinhart Collection at Winterthur, which dates from 1508, and not 1509 as some people have maintained. The approach and technique show the same delicacy as in the heads in the altarpiece.

Next comes *The Jeweller and his Wife* (73), in the Louvre, signed and dated 1514. The subtle inspiration and discreet intimacy which build up the family atmosphere in the Brussels picture are evident here, and the technique is just as meticulous, but the colour is more powerful.

Two works which must be mentioned together are the portrait of Erasmus in the Galleria d'Arte Antica in Rome, and that of Pierre Gillis (Petrus Aegidius) in the Earl of Radnor's Collection at Longford Castle. The two scholars met in Antwerp in 1517 and decided to present their portraits to Thomas More. He thanked them in a letter dated 6 October 1517, and refers specifically to the fact that Metsys has shown his sitters on the same panel (*in eadem tabula*). The flesh-tints are gently handled in reddish tones, which stand out against a background of light panelling. The technique is careful and smooth. The same calm, dreaming spirituality hovers around the faces of the two humanists as in the characters in the Brussels painting.

The Temptation of St Antony and *The Virgin and Child* in the Poznan Museum are of the same quality. They were painted between 1515 and 1524, given the fact that the landscapes are obviously by Joachim Patenier. An inventory of the Escorial, dated 1574, mentions that the two artists collaborated on *The Temptation of St Antony*. This could only have been between 1515, when Patenier settled in Antwerp, and his death in 1524. The figures in both these works have the suppleness of those in the St Anne Altarpiece, and in addition one notices the subtle distribution of tonal qualities and the accomplished technique.

The same feeling is evident in *The Trinity and the Virgin* in the Alte Pinakothek in Munich. This triptych was commissioned by Luc Rem, who appears with his wife, alongside his coat-of-arms. Metsys must have painted it after 1518, the year in which Rem married. He was originally from Augsburg, and was the Fuggers' agent in Antwerp. In 1519-20 he intervened in the question of the lowering of the spice prices.

Finally, *The Virgin and Child*, in the Louvre, although signed and dated 1529 – a year before Metsys' death – is still in the same spirit as the St Anne Altarpiece. Only the handling of the colour is a little different. The darker tones go with the deep lilac of the cloak and the claret-red sleeves.

There are some more pictures which should be taken with this group, since they are close to them from a stylistic point of view. There are several versions of *The Virgin and Child* in which Metsys' concern to portray maternal love has led him into rather precious affectation. The best example I have seen is *The Virgin with a Cherry* in the E.W. Edwards Collection in Cincinnati. The slightly sensuous handling of the mother kissing her son on the mouth is given a spiritual quality by the facial expressions, the soft contours and the pale colours. The only bright tones are the claret-red dress and the Virgin's red cloak.

Next, *The Seven Sorrows of the Virgin* is an altarpiece which C. Justi says was given by Queen Eleanor, wife of João II of Portugal, to the Monastery of Madre de Deus in Lisbon. There is a central *Virgin of*

the Sorrows with a *Flight into Egypt* (in the Worcester Museum of Massachusetts); *The Circumcision; The Virgin seeking Christ in the Temple; The Virgin witnessing the Carrying of the Cross; The Virgin on Calvary* and *The Virgin returning from the Sepulchre* – all in the Lisbon Museum. The stylistic features of the St Anne Altarpiece are once more apparent. The presentation is clear, the colours bright and well matched and the surface – which has now become vitrified – smooth. However, the colours are brighter and the silhouettes of the figures more clearly delineated against the background.

The same modulations in the light tones – with some stronger moments in the red, carmine and blue of the clothing – are evident in *The Crucifixion* in the Liechtenstein Collection in Vaduz, and in a work on the same theme, but with heavier application, in the Mayer van den Bergh Museum in Antwerp. They are also apparent in secular works, such as *The Courtesan and the Old Man* in the Portales Collection in Paris. But this treatment of forms and subtle tonalities is used to best effect in the works with sacred themes. *St Mary Magdalene,* in the Musée Royal in Antwerp, is one example of the best Metsys in this respect. The two small pictures of *St Mary Magdalene* and *St Mary of Egypt* in the Johnson Collection of the Philadelphia Museum are further typical examples. The flesh-tints are a little dull against the brown and dark green of the landscape, but they are perfectly suited to the treatment of the two penitents. The most beautiful work in this genre is possibly *Christ blessing* in the Winterthur Museum. Metsys has here painted one of the most powerful versions of God-made-Man. The face is emaciated, but has a perfect line, and the expression is calm and penetrating. The clarity of the work comes as much from the glowing colours as from the face, but everything combines to make this manifestation of the Spirit incarnate compelling in its truthfulness. Once again, the artist has followed the dictates of his inner vision with devotion. The face is painted with delicate nuances, the brush has touched the panel lightly, glazing the surface of the paint, and in so doing has produced an infinitely precious work as beautiful to look at as it is moving.

Two works at this point confuse those who believe in regular development. They are a *Pietà* in the Matthiesen Collection in London, and another picture in the same genre, but smaller, in the Frank T. Sabin Collection in London, which was published by M.J. Friedländer. The first painting was on the altar of the coopers in the Church of Notre Dame in Antwerp. They are both, however, different versions of the *Pietà* Altarpiece in Antwerp and yet they share – as much by similarity of conception as by colour and execution – in the tender atmosphere which permeates the St Anne Altarpiece. Everything is handled gently – the figures, the firm, clear contours and the delicate brushwork which scarcely touches the panel. The composition is on a less ample and less dramatic scale than in the Antwerp *Pietà*. The colour is handled in large zones which are not broken down as in the Antwerp altarpiece. The technique is heavier. Possibly these were preliminary works for the *Pietà*.

All these works, so close to the St Anne Altarpiece, belong to very different periods. Those which may be dated with certainty range from 1508 to 1529.

As mentioned earlier, a number of Metsys' works may be grouped with the *Pietà* Altarpiece in Antwerp. They are also spread over a number of years.

First come two which are separated by an interval of thirteen years: a head of a man in the Musée Jacquemart-André in Paris, signed and dated 1513 (75), and *The Adoration of the Magi* in the Metropolitan Museum of New York, dated 1526.

The head of a man is redolent of the rather trivial representations of executioners in the Antwerp altarpiece. On the lines of his contemporary, Leonardo da Vinci, Metsys made studies of facial features often taken to exaggerated extremes. One wonders whether this head could really have been a portrait. It might almost have been inspired by a caricature of Cosimo de' Medici whose profile was engraved on a medallion which Leonardo drew and which Wenceslas Hollar subsequently engraved. The similarities between Metsys' picture and the engraving are so striking that one must agree that the artist saw it. The style is like that of most of the *Pietà* in Antwerp. The face is closely analysed and the artist

has used heavy colour and thick paint. To make it flaccid, every imperfection is reproduced – even the texture of the tanned skin.

The Adoration of the Magi in the Metropolitan Museum of New York, is dated 1526 – the end of the artist's career. It clearly recalls the approach and technique of the Antwerp altarpiece. The composition is compact and the colours bright and varied. The details of the face are heightened and the execution swift.

The brownish flesh-tints of the head of a man in Paris are repeated in the head of an old woman in the Hugh Blaker Collection in England. Nevertheless these two works do not form a pair, as has been suggested. Their measurements discount such a theory. The portrait of an old woman was inspired by a caricature by Leonardo da Vinci of Margaret, Duchess of Tyrol, who was famed at the time for her ugliness (76).

Still in the same vein are *Two Men at Prayer* and *The Money-lenders* in the Doria Collection in Rome. Some of Metsys' followers – such as Marinus van Reymerswaele – were inspired by this kind of picture to produce excessively Mannerist versions of the same subject.

One might suppose that such an inveterate observer of the human face would make an excellent portrait painter, but in this respect Metsys' powers of observation are somewhat superficial. Also, he shows the same dual style as in his other works. We shall take two portraits as examples – neither of which, unfortunately, is signed or dated. In *The Man with a Pink* in the Art Institute of Chicago, the artist carefully controls the overall harmony of the light tonal values. The grey hat stands out against a greenish background, while the rest of the picture is a symphony of light brown with discreet shadows for the facial contours. When the artist uses his *Pietà* style in the portraits, he tends to lose himself in his search for clever colour combinations. In his portrait of Stephen Gardiner, future Bishop of Winchester, in the Liechtenstein Collection at Vaduz, the details are marked by beautiful firm colours and clear brushwork.

The overall picture of Metsys' style as given here hardly indicates gradual evolution – in conception, colour or technique. The overriding impression is rather that of a ceaseless coming and going between two styles which were already established in the two great altarpieces of 1509-11, where his talent is fully apparent.

All the same, one must admit that some of his paintings are those of an artist at the beginning of his development. For example *St Christopher*, in the Musée Royal in Antwerp; *The Virgin enthroned* and the little *Virgin and Child* (nos 540 and 643 in the Musées Royaux in Brussels). There is a feeling of heaviness, the colour is opaque and the contours hard, with brownish shadows – all of which would seem to point to uncertainty. We know nothing definite about this early period, except that some of the iconographic details in *St Christopher* were taken from one of the volets of *The Adoration of the Magi* in the Alte Pinakothek in Munich, which was painted by Dieric Bouts in Louvain, where Metsys spent his youth.

Quentin Metsys – certainly in his maturity – was not only an excellent artist technically, but also a great creative one. He produced what we might today call living art – seeking, above all, shapes which corresponded to his ideas and feelings. Of course he took stylistic elements from his predecessors or his Flemish contemporaries in the same way that he used others from abroad. In his handling of architecture and sculpture, and sometimes in the figuration, he gradually abandoned – throughout his career – Gothic stiffness in favour of suppleness and movement. But basically Metsys remained deeply attached to the traditions of Flemish painting. He still belongs to the Primitives by virtue of his calm conception and, above all, in the actual painting, through his sincerity and application. This did not prevent him from being a very individual artist and creator of several individual forms. From this point of view he certainly deserves the accolade of Thomas More, who knew him and called him '*veteris novator artis*'. This title of 'rennovator of ancient art' had no implication – as some have imagined –

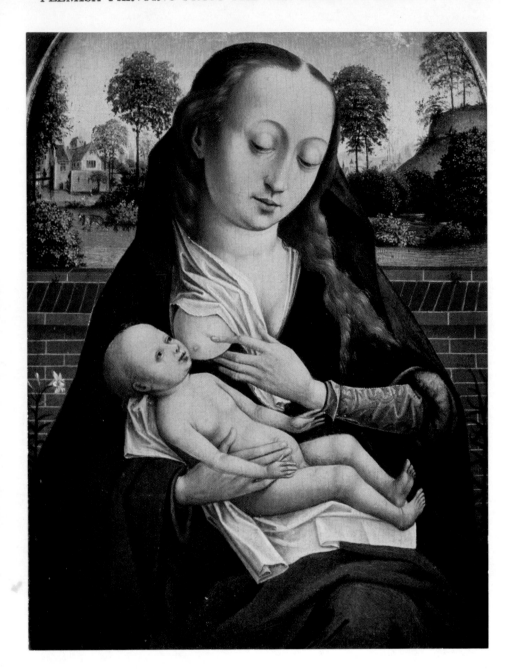

XXXIX Late fifteenth-century Flemish
Master: *Virgin and Child*
Musée des Beaux-Arts, Dijon

that the artist was, in the old Low Countries, responsible for the introduction of classical art restored to a place of honour by the Italian Renaissance.

One may reproach Metsys for not having explored all his potentialities, and sometimes for letting himself become too facile, for repeating himself, and for having been too concerned – as in the School of Milan – to bathe forms in a lukewarm atmosphere, and for not having dared undertake a renewal more equal to his talent.

☆

Quentin Metsys – which some scholars spell Massys, but he signed himself Metsys, and several documents have it this way – has his legend just as Memlinc had. It is even more touching, however. As a young blacksmith he fell in love with an artist's daughter, but her father would only have another artist as a son-in-law. Sick with frustration and despair, Quentin took to his bed, where he whiled away the time colouring engravings. Soon he became an excellent artist, and was able to marry the object of his love. Karel van Mander was responsible for giving the story a factual flavour. There is still a well-head in Antwerp, in front of the old cathedral, on which there is a piece of wrought-iron decoration attributed to Metsys. In recent times an inscription was added in memory of the smith who became an artist through love. In fact it is possible that there is some truth in the story. It appears from the archives of Louvain that Quentin was born there and that his father, Josse Metsys, was a smith.

In a document of 10 September 1494, Metsys claimed to be twenty-eight years old. He would therefore have been born in about 1466. He was married in Louvain in 1486 to Alyt Truyt, by whom he had several children. Two of them, Paul and Catherine, were still minors when their mother died in 1508. We may assume that Quentin studied in Louvain, painting the St Anne Altarpiece, and possibly also *The Virgin enthroned*, in Brussels, for the city. One can pick out the arms of Louvain in one of the stained-glass windows in the Brussels painting. While learning to paint, he probably went to one of the local workshops where the traditions of Dieric Bouts were kept alive, though Bouts himself was dead by then. His sons, however, were working in Louvain at this time. It has already been mentioned that we know of no picture by the eldest son, called Dieric like his father. The youngest, Aelbrecht, was working in Louvain round about 1480 when Metsys was working his apprenticeship. But there is no similarity whatsoever between Metsys in his early days and what is attributed to Aelbrecht Bouts. He is nearer to Dieric Bouts the Elder.

Quentin Metsys was not enrolled as master in the guild of artists at Antwerp until 1491. In 1508 he married a second time, to Catherine Heyns. Immediately afterwards he produced his two great masterpieces; the Brussels altarpiece, which was finished in 1509, and the Antwerp altarpiece finished in 1511. From then on he lived in considerable comfort in Antwerp. In 1520 he received Dürer in his house in rue des Tanneurs – called *De Simme* – and he subsequently lived in another large house, *In Sinte Quinten*, in rue des Arquebusiers, for which he painted murals. He died in Antwerp on 30 September 1530.

QUENTIN METSYS' CIRCLE

Whether it resorted to elegant smoothness or took inspiration from a sense of reality, Metsys' art must necessarily have pleased in an international centre such as Antwerp, where the spirit of the Renaissance was beginning to gain ground. It must no less have seduced many minor artists.

THE MASTER OF THE MORRISON TRIPTYCH

The best of Metsys' followers to choose his smooth style was the Master of the Morrison Triptych, so called from a *Virgin with Angels* in the Hugh Morrison Collection in London. In this 'type' picture the artist has combined the delicacy of Memlinc with that of Metsys. If another work – *The Virgin with*

Saints in a Landscape, in the National Gallery in London – is also by him, one can say that he had some very individual ideas about light. No other painter of his day has so accurately rendered the gentleness of a fine summer evening. An unreal light spreads over the pensive characters and fades off into the darkened foliage of the trees (among which cypresses are recognisable) and still shines in the distant sky seen between the tree trunks. The only other artist painting in such a poetic way and dependent entirely on the interplay of colours at this time was the Primitive Dutch artist, Geertgen tot Sint Jan.

THE MASTER OF THE MANSI MAGDALEN

This artist is so called from a picture formerly in the Mansi Collection at Lucca and now in Berlin. He has more personality than the Master of the Morrison Triptych, but is a lesser artist. Ones sees something of Metsys' *St Mary Magdalene*, in Antwerp, but without its delicate spirituality. The saint has the appearance of a statue seen here full face, in a large dark brown cloak. The rugged and hilly landscape is dark brown, which scarcely goes with the delicate face shaded with deep shadows in the early style of Metsys. The same is true of *Christ giving a Benediction* in the Johnson Collection of the Philadelphia Museum. The artist was doubtless aware of the innovations brought in from Germany, and lifted details for his landscapes from Dürer's engravings. Foreign engravings travelled more easily than paintings. Dürer's *Small Passion* came out in 1511. *The Deposition*, in the Ghent Museum, is taken from it, so at least a part of his career must have been later than 1511.

THE MASTER OF HOOGSTRAETEN

This artist is nothing more than a very feeble imitator of Metsys. In the Musée Royal in Antwerp, there is a series of panels by him, forming part of an altarpiece of *The Seven Sorrows of the Virgin*, believed to have come from the church at Hoogstraeten. The artist is interested in telling the stories he is representing, but his colours are dull, despite smooth application, and the forms he uses are far too old-fashioned. From the coats-of-arms the donors have been identified and the date of the painting fixed, between 1517 and 1533.

THE MASTER OF FRANKFURT

This artist is sometimes spontaneous, lively and individual. He belongs to a group of Metsys' contemporaries who took their inspiration more from his sense of reality; though in his case rather late in the day. The name is purely fortuitous, because he had no other connection with Frankfurt than the fact

that two of his 'type' works are in the Städtisches Völkermuseum there, and other works can be grouped with them.

The first is a large Altarpiece of St Anne, painted for the Dominicans in Frankfurt. It is inferior to Metsys' work from an artistic point of view. The colour lacks vigour and the execution is not particularly good. If the work really dates from 1505, then it is possible that Metsys took the general idea of his own work from it. The Master of Frankfurt has obviously lacked enthusiasm while painting the picture, just as a simple artisan would carry out some commission or other. One sees exactly the same effect in other religious works by him. He takes inspiration from Van der Goes, the Master of Flémalle or even from the Van Eycks.

The second work at Frankfurt is a *Crucifixion*. Klaus Humbracht, a citizen of the town who died in 1504, is represented on one of the volets. His son settled in Antwerp in 1503, and it was probably the son who gave the commission to an artist in Antwerp. This time the colours are brighter. The overall tonality is full of light and in places the addition of pink brings in a more delicate note. Although the artist must have painted some of the work in Frankfurt (several of the donor's children appear on the volets), the tower of Utrecht is visible in the central panel, as it is in *The Mystic Lamb*. Everything in the

XL Master of the Embroidered Foliage:
Virgin and Child
Collection of Prince Philippe de Mérode, Trélon

foreground has rather unusually hard relief for this period. The artist is obviously obsessed with a desire to render the material nature of objects.

This last element is particularly noticeable in the portrait of the artist and his wife in the collection of Baron J. van der Elst in Brussels (77). The picture shows a spoilt and somewhat sullen young man who seems to be as indifferent to the presence of his wife as to the appetising cherries in front of him. In addition to the date of 1496, the frame has the ages of the two people: thirty-six and twenty-seven. At the top are the arms of the guild of artists of Antwerp and their motto: '*Uut jongsten versaemt*' ('United in friendship').

In *The Archers' Festival* in the Musée Royal in Antwerp, the artist has included a portrait of himself, and he seems younger than in the portrait mentioned above, which would lead one to think that this work was painted roughly ten years before the portrait. We see how the citizens of Antwerp amused themselves on a guild holiday. The landscape is rather ordinary, but the costumes and their lively colours are delightful. From the inscription on the frame we learn that Pierre de Gammerel donated the picture. But although the frame is dated 1493, it is modern, so the inscription must have been taken from an older frame. The date is probably the date of the legacy to the guild. It must have been painted before that date, judging from the costumes, the technique and the apparent age of the painter at the time.

Metsys was not a forerunner as far as landscapes were concerned, but it has been pointed out all too rarely that he had some talent in this field. The fact that he sometimes called in Joachim Patenier to paint some of his landscapes has been sufficient for critics to deny him any personal ability in painting landscapes at all. One day it will be appreciated that even there, Metsys gave more than he took. All the same, it is fair to say that the landscape painters who followed him, in particular his son Cornelius (who specialised in landscape), quickly overtook him.

In genre scenes, Marinus van Reymerswaele at first followed Metsys so closely that it is difficult to distinguish his early works from those of the master. But he quickly took his character studies to the point where he became a truly original artist.

There is no place for him, however, in this book, nor for Metsys' son Jan. Both belong to the art of another era.

JOSSE VAN CLEVE

Several works with stylistic similarities have been grouped together around two 'type' works – both showing *The Dormition of the Virgin* – one in the Wallraf-Richartz Museum in Cologne, and the other in the Alte Pinakothek of Munich. The anonymous artist was given the provisional name of the Master of the Dormition of the Virgin. One of the works attributed to him – an *Adoration of the Magi* – recently passed to the Detroit Institute of Art. On it are the initials J.B. The same initials appear on the volets of a picture in the Church of Our Lady in Danzig. Another version in Naples has Jo. B. Cleve. Josse van Cleve is mentioned several times in the register of the guild of artists of Antwerp, sometimes as '*Joos van der Beke, die men heet van Cleve*' ('Josse van der Beke, whom men call of Cleve'); and sometimes as '*Joos van Cleve, alias Van der Beke*'. Nowadays no one questions the fact that he is the Master of the Dormition of the Virgin.

158 Quentin Metsys: *Pietà* (detail)
Matthiesen Collection, London

159 Quentin Metsys: *St Mary Magdalene*
J.G. Johnson Collection, Philadelphia Museum

160 Quentin Metsys: *St Mary of Egypt*
J.G. Johnson Collection, Philadelphia Museum

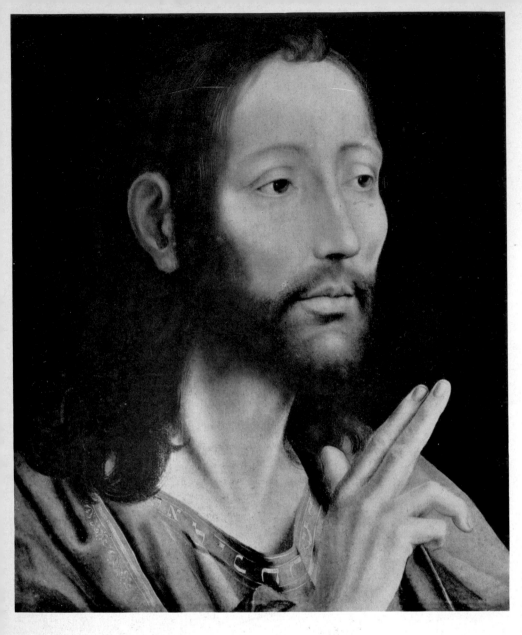

162 Quentin Metsys: the Altarpiece of the
Seven Sorrows of the Virgin (central panel).
Museu de Arte Antiga, Lisbon

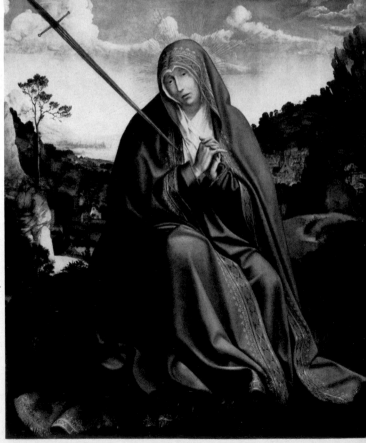

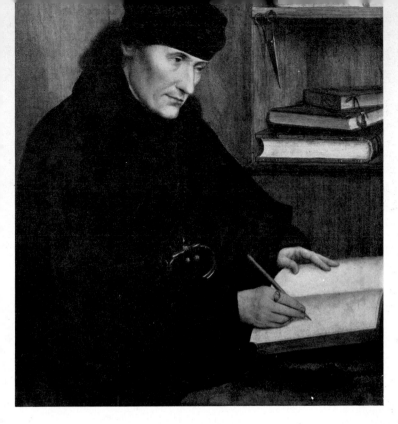

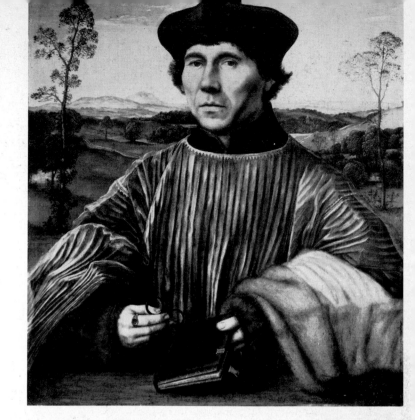

163 Quentin Metsys: portrait of Erasmus.
Palazzo Barberini, Rome

Top right:
164 Quentin Metsys: portrait of a canon
(Stephen Gardiner?).
Liechtenstein Collection, Vaduz

165 Quentin Metsys: head of a man.
Musée Jacqmart-André, Paris

167 Josse van Cleve: *The Virgin with the Pink*
W.R. Nelson Art Gallery, Kansas City

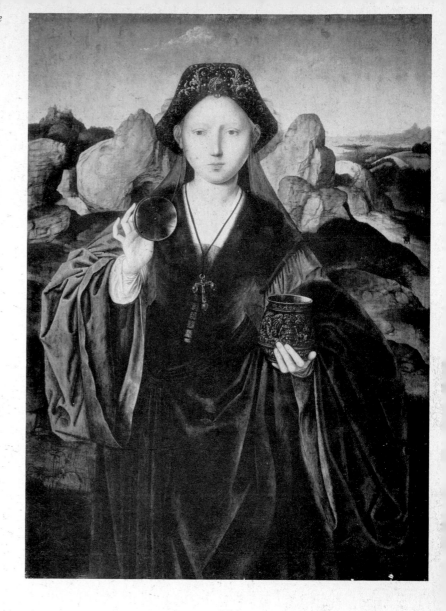

168 Master of the Mansi Magdalen: *St Mary Magdalene*
Staatliche Museen, Berlin

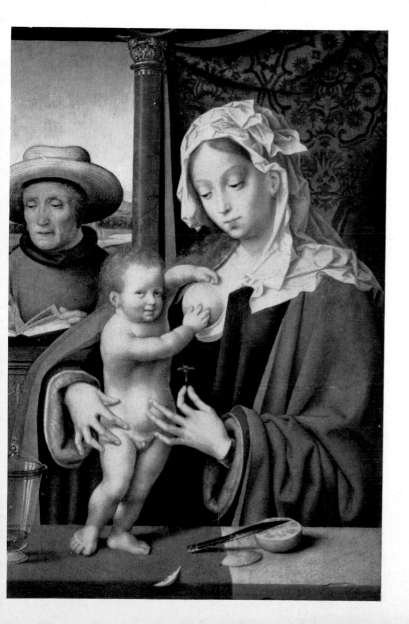

169 Josse van Cleve: *The Holy Family*
Sir Francis Cook Collection, Richmond, England

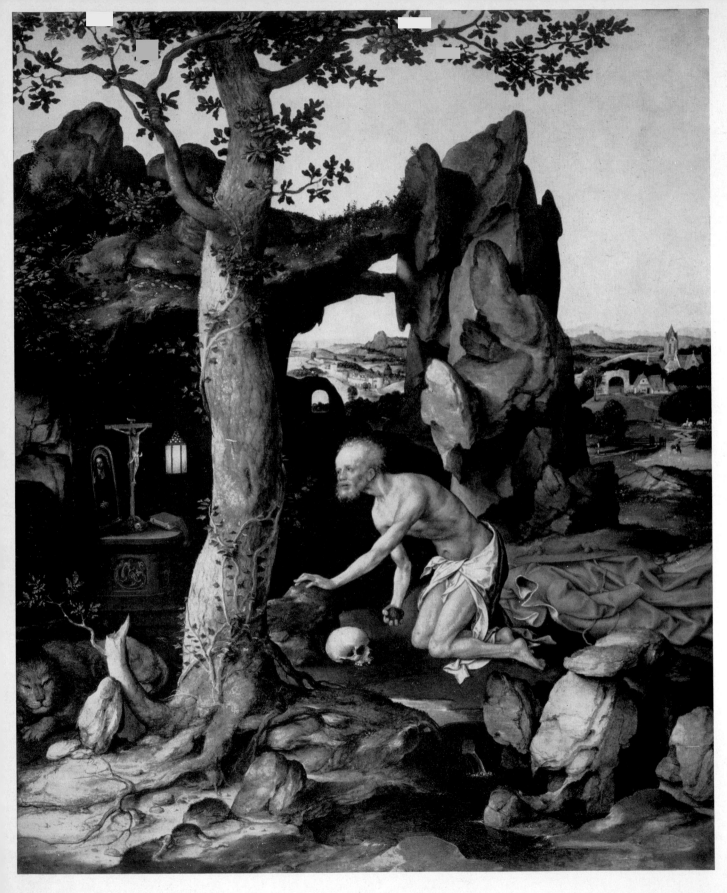

170 Josse van Cleve: *St Jerome*
Haekley Art Museum, Muskegon, Michigan

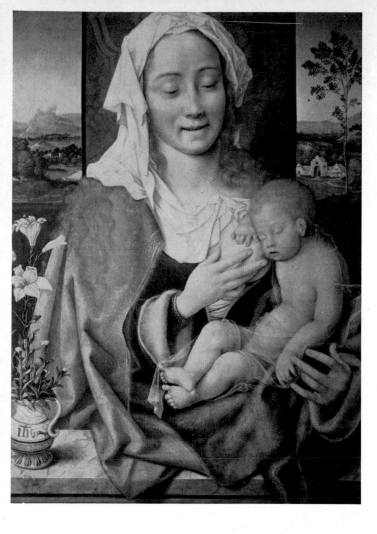

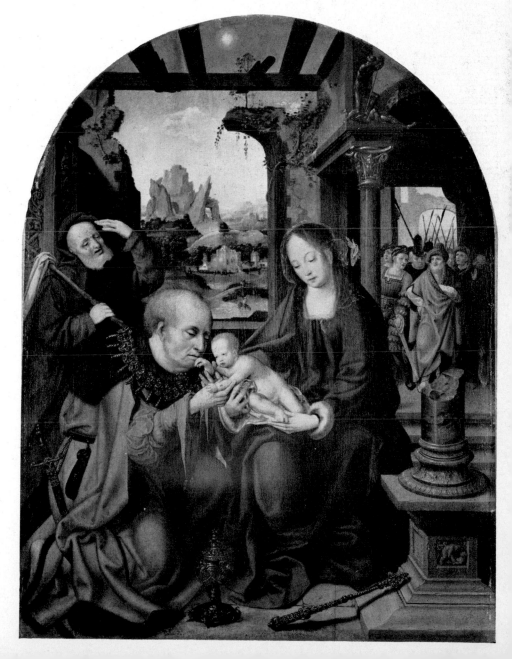

171 Josse van Cleve: *Virgin and Child*
Fitzwilliam Museum, Cambridge

172 Josse van Cleve: *The Adoration of the Magi*
Art Institute, Detroit

173 Josse van Cleve: portrait of a man.
J.G. Johnson Collection, Philadelphia Museum

174 Josse van Cleve: portrait of François I
Walters Art Museum, Baltimore.

Van Cleve frequently received foreign commissions. It was for a German family that he painted the two versions of *The Dormition of the Virgin* from which his style is defined, and for a church in Genoa the Louvre *Pietà* and the Detroit *Adoration of the Magi*. Another *Adoration of the Magi*, still in S. Donato in Genoa, is well known. At the exhibition of old paintings from Liguria held in Genoa in 1946, attention was drawn to a *Nativity* in the Palazzo Balbi in Genoa.

It was quite logical that, to please foreign clients, the artist should sacrifice to the growing taste of his day for daring and novelty. But he remained true to most of his predecessors' principles. He did little more than introduce a few decorative details, particularly favoured by his contemporaries, into his work : pilasters, colonettes, swags and putti. He hardly seems interested in experiments with volume, space or form. He is deaf to the excellent lessons he could have learned from the great altarpieces of his fellow citizen and contemporary, Quentin Metsys.

The Dormition of the Virgin, in Cologne, reveals particularly Josse van Cleve's fidelity to Flemish traditions, above all in the choice of colours, the way in which they are applied and the composition. The grouping here does not correspond to any aesthetic principle. The bed on which the Virgin lies is placed across the room and occupies a large part of the picture. In front of the bed, the large figures of three of the apostles are placed at regular intervals. Those behind the bed are not in true proportion in relation to the perspective. Obviously the artist has not managed to put his figures satisfactorily into the cube of the huge room he saw in his imagination.

The Dormition of the Virgin, in Munich, has better spatial construction. The proportions of the room are more modest, the bed recedes into the depth of the picture and the apostles are no longer separated by large empty spaces. This compactness helps the unity. The artist has also given new thought to the gestures and expressions. The picture is painted with more *élan* and the colours are brighter : the bed-spread is picked out in crimson; the clothing is full of coppery greens, strong blues and beautiful yellows, forming a contrast to the paler faces. The artist has instilled more tension, and even in the brown shadows his small nervous brushstrokes are evident.

In point of fact there is nothing very new here. Only the agitation in the figures echoes to some extent the spirit of the times. One has the impression of witnessing a mystery play on the platform of a school of rhetoric, in which each actor attempts to upstage the rest. Unless one prefers to see in it artistic experiment still in search of mastery. The frame of the Cologne painting has the date 1515, but it is a modern frame. If, however, the date was taken from the original frame, the two works would have been painted shortly after Josse van Cleve was enrolled as a master in 1511.

One should not assume, however, that these are early works. We know nothing about the artist's background. It is very possible that he was already skilled enough by the time he settled in Antwerp to be enrolled immediately as a master.

It has been maintained that he had lived in Genoa before this. Certainly some of his works were, and still are, in Genoa, and Philip of Cleves, Lord of Ravenstein and Master of Genoa from 1501 to 1506 could have attracted the artist there. But this seems a little forced. At the time, commercial traffic between Antwerp and Genoa was very active. There was nothing to prevent Josse van Cleve receiving commissions on behalf of Genoese clients and executing them in the city where he worked.

In any case, it is of little importance whether he actually went to Genoa, or came into contact with Italian art through pictures, drawings or engravings, which came in large quantities from Italy. In fact he assimilated none of the ideas about balanced contrast so much in vogue at that time in Italy. His way of choosing and applying a colour is certainly that of the Flemish Primitives. Of course two or three of his altarpieces are cut off at top in the Italian manner but this could have been imposed by his foreign clientèle. Doubtless also, *The Last Supper* – which forms the predella of the Louvre *Pietà* – is a much diluted memory of Leonardo da Vinci. The artist could have seen drawings. Even so, he is true to the traditions of his fellow countrymen.

If Josse van Cleve brought nothing new to the progress of form, what is the value of studying his work? He has eminently painterly qualities which make him a rival of Metsys. He prefers the modulations of smooth colour – in company with Metsys. He also takes great care in applying paint thickly so that when it hardens it takes on the quality of enamel and enhances the pictorial matter. To an even greater degree than Metsys he is in search of the light which bathes his shapes, and colour rich in itself: cherry red, periwinkle blue or sea green. But there his talents end. There is no point in looking for breadth of vision, formal originality, or even boldness in the figuration. He merits attention only as a painter.

To judge him on these terms one should pass over the large works, and even more so the pictures in which Joachim Patenier's collaboration is readily visible – as in *St Jerome* in the E. and A. Silberman Collection in New York. One should go directly to the more personal and more interesting works with a simple subject: a *Holy Family*, a *Virgin and Child* or a portrait. We shall only consider paintings whose style is clearly related to the signed works.

In general the Holy Families – all of them attributed – give a moving impression of family intimacy, with calm forms, coherent grouping and smooth movements. The overall feeling is one of lasting happiness in the calm of perfect harmony. The artist repeated this theme several times.

The Holy Family in the Musées Royaux in Brussels, is steeped in poetry. The colours are discreet, the contours extremely soft and the faces a waxy brownish grey. Wisps of veiling float gently over the heads and mist the brows. The painting style is in harmony with the emotion.

Often the artist shows family happiness, in which case he uses more intense colours and his presentation is less distant. *The Holy Family* in the Friedsam Collection of New York is particularly successful. The Virgin is taken from *The Virgin of Lucca* by Jan van Eyck – even to the pressure of the maternal hand on the Christ Child's flesh. In this series of paintings the concern with form leads to an ideal of beauty without passion. In *The Holy Family* in the National Gallery in London there is less sincere intimacy, more artistic intervention: St Joseph, busy reading, away from the Virgin, is almost like a scholar; the Christ Child is standing up; the arrangement of the Virgin's veil is too studied. All these formal experiments detract – however little – from the serenity of the composition. It is symptomatic, and this is doubtless a sign of the times, that it was this version – the least deeply felt – which seems to have had most success at the time, since it was the most frequently copied.

One could say the same about the various versions of the Virgin and Child attributed to Josse van Cleve. Occasionally his forms and colours show his respect for the concept of idealisation and spirituality, but on the whole he abandoned this concept in a nervous frivolity inspired by his times. He is less concerned with maternal love than in showing the pleasing nature of a young woman and the freshness and suppleness of a child's pink body. He tends to pay attention to the movement of slim, softly rounded forms, with a marked preference for caressing hands. One must, however, exempt from these criticisms *The Virgin and Child* in the Guggenheim Collection of New York, and that in the Fitzwilliam Museum in Cambridge.

Black-and-white reproductions fatally betray such pictures, whose charm lies precisely in subtle, delicate tones. Although in these small works the artist repeats the same compositional formulae, the magic of the colour renews the artistic vision each time. It is most illuminating in this respect to study in turn two almost identical works – *The Virgin and Child* in the Kansas City Museum and that in the Cincinnati Museum. In the first the colours are strong and carefully chosen. In the second the vermilion on the Virgin's right sleeve lacks brilliance, despite the addition of carmine, and in the left sleeve the coppery green and the brownish green have darkened, and the red cushion has lost its brilliance. The colour scale has been completely modified. It is quite rare for the artist to aim at breadth. In *The Virgin and Child* in the Fitzwilliam Museum in Cambridge (78), the regular and sustained rhythm of the silhouette covers the whole of the Virgin's face, seen full on. The face of the Christ Child, full of

confidence, brings soft curves to the composition. But we are still very much below the standard of the work of Jan Gossart who, at the same time, was much more modernist, developing forms, creating volume as if carving stone, with deep shadows and strong colours.

In the portraits attributed to Josse van Cleve the most important aspect is the delicate painting. The light flesh-tints – generally pinkish – enliven the whole work. Possibly the flesh lacks consistency, as in his Virgins, and the shape of the head is not sufficiently pronounced; the eyes sometimes are dull and the hands lack vigour. But again, the delicacy of his colours and the brushwork express the reserve which the artist wants to give to his characters. For this reason his portraits are precious. Some are quite bright, such as the portrait of a man in the Tietje Collection of Amsterdam, or the portrait of a woman in the Uffizi in Florence, in which a sleeve glows with a magnificent red. The portrait of a young man in the Johnson Collection of the Philadelphia Museum shows a spoilt face surmounted by a bright red headdress. This simple contrast of red and the black in the garment forms a large part of the picture's strength.

Many portraits, all very different, are attributed to Josse van Cleve. Only those with his characteristic fresh flesh-tints and soft contours should, however, be attributed to him. They have been arranged chronologically, based on the dates on some of them, (though dates are in fact extremely rare); on the clothing; the cut of beards; the presentation and the handling of contours. It is evident that, relying on such disparate elements, and on works whose attribution is by no means certain, such a classification can only be speculative.

There is absolutely no doubt about the portraits of the King and Queen of France. In his *Descriptio di tutti I Paesi Bassi* of 1567, Guicciardini says that Josse van Cleve painted portraits at the court of France. There is a portrait of François I in the Johnson Collection of the Philadelphia Museum, and of his wife, Eleanor of Austria, both in the style of Van Cleve. The overall tonality and technique of the first are sufficient to confirm the attribution. There is an excellent version of the bust only in the Walters Art Museum in Baltimore. As for the second portrait, in addition to the flesh-tint, the soft contours of the face and the delicate claret colour of the sleeves all point to Van Cleve.

Although these portraits – of which there are other versions and copies – are carefully conceived and painted, they lack the breadth of vision of the portraits in this manner painted at the same period by the great Italian artists, and those painted in the Low Countries by Jan Gossart.

We do not know where or when Josse van Cleve was born. In 1511 he was enrolled as master in the Antwerp guild. In 1519, and again in 1525, he was dean. He worked in Antwerp throughout his career, and he signed his will there on 10 November 1540. A document dated 15 April 1541 mentions his wife as a widow. His death had occurred, therefore, during the intervening five months.

NOTES

CHAPTER TWO

1. These notes are reproduced in a manuscript by Le Begues who, in 1431, wrote a treatise on colours which was published by Mrs Merrifield in London, 1849, under the title: *Original Treatises on the Arts of Painting*.
2. The manuscript was lost in a fire in 1870, but had been published by Eastlake in *Materials for a History of Oil Painting*, London, 1849-67, and subsequently by E. Berger in *Entwicklungsgeschichte der Mahltechnik*, Munich, 1912. See also Axel Sjöblom, *Die koloritische Entwicklung in der Niederländischen Malerei der XV und XVI Jahrhunderten*, Berlin, 1928.
3. See Leo van Puyvelde, 'Jan van Eyck's Last Work' in *The Burlington Magazine*, LVI, 1930, pp. 3-9.

CHAPTER THREE

4. V. van der Haegen, *Mémoires sur des Documents faux relatifs aux anciens peintres, sculpteurs et graveurs flamands*, Brussels, 1899, p. 38.
5. C. Sterling, *La Peinture française, les primitifs*, Paris, 1938, p. 65.
6. S. Gudlaugsson, in *Kunsthistorische Medelingen*, The Hague, I, 1946, no. 2, pp. 17-22.
7. See my *Schilderkunst en Toneelvertooningen op het einde van de Middeleeuwen*, Ghent, 1912.
8. L.H. Labande, '*Notes sur quelques Primitifs de Provence*', *Gazette des Beaux-Arts*, I, 1932, pp. 392-7, and Jean Boyer in *Arts*, Paris, of 19 March 1948. Jean Boyer draws attention to a reference in Canon Requin's notes, in which he summarises Corpici's will, dated 9 December 1442. In the will, Pierre Corpici – a draper of Aix – wishes to have an altar consecrated on the right of the choir in the Church of St Sauveur, Aix-en-Provence, and leaves 100 florins for a picture of the Annunciation. Monsieur Boyer has been kind enough to provide copies of various references in the archives from which it is evident that Pierre Corpici and several members of his family were buried near the altar, and that an artist from Aix, Jean Rey, accepted a commission in 1552 to paint an altarpiece for the same church in which the face of the Virgin 'would be better and more beautiful than that near the choir of St Sauveur in this town'. Moreover, Pierre Corpici had several dealings with Jean Chapus, an artist of Aix. Monsieur Boyer suggests that Corpici approached Jean Chapus for the Annunciation altarpiece, which was removed during the Revolution and eventually came to the Church of the Madeleine where it now is. But it is just as possible that Corpici, who was still alive in 1449 at least, bought a finished picture from a Flemish artist.

CHAPTER FOUR

9. This question has been gone into in *L'Agneau Mystique*, Paris and Brussels, 1946, by the author of the present work.
10. H. Beenken, *Zur Entstehungsgeschichte der Genter Altars*, Wallraf-Richartz Jahrbuch, 1934, pp. 134 *et seq.*; E. Panofsky, 'The Friedsam Annunciation and the Problem of the Ghent Altarpiece' in *The Art Bulletin*, 1935, pp. 433 *et seq.*; E. Renders, *Deux problèmes résolus*, Brussels, 1950; and Leo van Puyvelde, *L'Agneau Mystique*, Paris and Brussels, 1946.
11. See J. Duverger and E. Bontinck, *Het Grafschrift van Hubrecht van Eyck en het Quatrain van het Gentsche Lam Gods-Retabel*, Antwerp, 1945.
12. P. Faider, in *Revue Belge de Philologie et d'Histoire*, XII, 1933, pp. 1273-90, and *Bulletin de la Société Nationale des Antiquaires de France*, 1934, 28 April.
13. Quoted by P. Durrieu in *Gazette des Beaux-Arts*, 1921, p. 77.
14. See F. Winkler in *Festschrift für M.J.Friedländer*, Leipzig, 1927, p. 99.
15. For the biography of the Van Eycks, see W.H.J. Weale, *Hubert and John van Eyck*, London, 1908, and J. Duverger in *Oud-Holland*, XLIX, 1932, p. 161; L, 1933, p. 64, and in *Kunst*, IV, 1933, p. 161.
16. 'Jan van Eyck's Arnolfini Portrait', *The Burlington Magazine*, LXIV, p. 117.

17. Marcus van Vaernewyck, *Den Spieghel der Nederlandsche Audtheyt*, Ghent, 1568, chapter XLVII.
18. It is mentioned in the Memorial of the Greyfriars of Ypres in 1445 as the work of Jan van Eyck.

CHAPTER FIVE

19. The picture in the Musées Royaux, Brussels, is not a preliminary study for the Mérode picture, but a copy painted by a less competent artist who avoided the difficulties and used thicker paint and more subdued colour.
20. J. Duverger, *De Brusselsche Steenbickeleren uit de XIV^e en de XV^e eeuw*, Ghent, 1933, and *Brussel als kunstcentrum in de XIV^e en de XV^e eeuw*, Ghent, 1935; A. Louis in *Revue Belge d'Archéologie et d'Histoire de l'Art*, 1937, pp. 199 *et seq*.
21. Firmerich-Richartz, in *Zeitschrift für bildende Kunst*, 1898-9, 1 *et seq*.; S. Reinach in *Bulletin Archéologique*, 1918, pp. 74 *et seq*.; P. Jamot in *Gazette des Beaux-Arts*, 1928, pp. 259 *et seq*.; Fr. Lyna, *Rendons à van der Weyden ce qui appartient à Campin, Paginae*, Brussels, 1928; E. Renders, *La Solution du problème van der Weyden, Flémalle, Campin*, Bruges, 1931; M.J. Friedländer, *Alt-Niederländische Malerei*, Leyden, XIV, 1937, pp. 81 *et seq*.
22. The best information about Campin, from the Tournai archives, was provided by Maurice Houtart in a lecture given at the Musées Royaux, Brussels, and published in *Ventes Publiques*, Brussels, 1933, pp. 7 *et seq*.
23. Given by A. Pinchart, *Quelques Artistes et quelques Artisans de Tournai des XIV^e, XV^e et XVI^e siècles*, in *Bulletin de l'Académie Royale de Belgique*, 3rd series, IV, 1882, p. 611.

CHAPTER SIX

24. See V. von Loga in *Jahrbuch der Preussischen Kunstsammlungen*, XXXI, 1910, pp. 55 *et seq*.
25. This church no longer exists. It used to stand in the rue de Tirlemont and belonged to the guild of crossbowmen. There is a copy of the work in the Staatliche Museen, Berlin, with the stamp of the crossbowmen of Louvain on it.
26. J. Molanus, *Historiae Lovaniensium libri XIV*, ed. P. de Ram, Brussels, 1861, and E. van Even in *Dietsche Warande*, IV, 1858, p. 1543.
27. A. Venturi in *Revista storica italiana*, 1884.
28. The New York portrait is not Meliaduse d'Este, as is sometimes maintained. The initials M.E. which appear on the back with the Este coat-of-arms stand for *Marchio Estensis* (Marquis of Este). The word *Francisque* was added later. There is no reason for thinking – as does H. Beenken – that the sitter is Francesco d'Este, the son of Lionello, who was sent to the court of Burgundy to be educated. Francesco was too young at the time, since the sitter is a man of about forty years of age. The inscription on the back is later than the painting of the portrait itself. Many unsuccessful attempts have been made to explain the hammer in Lionello's hand. A recent cleaning has brought to light a ring in the other hand. The most simple explanations are often the best: it is possible that Lionello was an accomplished goldsmith, and that he asked the painter to indicate the fact.
29. See F.J. Sanchez Canton, *Un gran Cuadro de Van der Weyden* in *Miscellanea Leo van Puyvelde*, Brussels, 1949, pp. 59-64.
30. In the obituary of the charterhouse of Scheut-lez-Bruxelles there is the following entry: '*Anniversarium Rogeri de Pascuis pictoris ac consortis eius, dedit semel in pecuniis quam picturis valores c(irc)a XX libres grotas Brabantiae*'. A. Pinchart in *Bulletin des Commissions royales d'Art et d'Archéologie*, 1867, pp. 452 and 476.
31. Comte de Laborde, '*Les Ducs de Bourgogne*', *Preuves*, Paris, 1849-51, II, p. LVIII.
32. In *The Art Quarterly*, Winter, 1939, p. 57.
33. H. Beenken, in his recent book on Roger van der Weyden, draws attention to the similarity between the two damned souls on the right and Masaccio's famous fresco of Adam and Eve driven out of Paradise in the Brancacci Chapel in Santo Spirito, Florence. The legs are in fact placed the same way. One may agree that this is not mere coincidence, but there the matter must rest, for the figuration is of a totally different conception. It would be going too far to conclude from this that *The Last Judgment* must necessarily have been painted after Van der Weyden's trip to Italy. He could have seen a drawing based on Masaccio's fresco.
34. *The Virgin with Saints* is painted on oak. This is no proof that it was painted in the Low Countries. The artist could have had such panels in his luggage with the intention of using them in Italy. This panel only measures 53 × 38 cms (21 × 15 ins). But in any case it was painted for Cosimo de' Medici: Saints Cosmos and Damian were the patron saints of Cosimo's sons Piero and Giovanni.
35. E. Panofsky dates the pictures after 1451 – probably 1453 (*Art Bulletin*, XXXIII, 1951, pp. 39 *et seq*.). H. Beenken, *Rogier van der Weyden*, 1951, p. 92, wrongly takes it to be a workshop production, whilst M.J. Friedländer says that it is an important work from the period around 1441 or the early 1450s (*Alt-Niederländische Malerei*, II, 1928, p. 16).
36. Dubuisson-Aubenay, *Itinerarium Belgicum*, 1627, published by L. Halkin, *Revue Belge d'Archéologie et d'Histoire de l'Art*, XVI, 1946, p. 60; Rombaut, *Bruxelles illustré*, Brussels, 1777, II, p. 342.

37. This light picture with its creamy background is such an unusual phenomenon in Flemish painting at this time that H. Beenken recently maintained that Zanetto Bugatto – the young Milanese apprenticed to Roger van der Weyden – must have had a hand in it. This hypothesis breaks down when one recalls that the Berlin *Man with Jowls* is also painted on a creamy ground, and is currently attributed to the Master of Flémalle, alias Robert Campin, who was Roger van der Weyden's teacher. The difference of vision is explained by the more spiritual approach of Van der Weyden.

38. 1426 does not take into account the 'new style' of dating. In this year Easter fell at the end of March and, in addition, at Tournai only ecclesiastical events were reckoned from the Easter dating.

39. There was another *Maître Roger* at Tournai who worked on the town hall from 1436-7. But at this time Roger de le Pasture was working in Brussels. There are two references, dating back to 1428, which concern this Roger, and are therefore prior to the date when Roger de le Pasture was enrolled as master. The Roger in question is probably Roger Wannebac or Wannebecq – as A. Pinchart has suggested.

40. M.E. Kantotowicz nevertheless maintains that the artist never went to Italy, and that the portrait of Lionello d'Este is that of his son Francesco, who would have made a journey to Flanders. See *Journal of the Courtauld and Warburg Institutes*, London, III, 1939-40, pp. 165-180.

41. A documentary biography was published by Maurice Houtart, *Jacques Daret*, Tournai, 1908. Despite the fact that it is little known, it is excellent.

42. See Antonio Morassi, *Catalogo della Exposizione della Pittura ferrarese del Rinascimento*, 1933.

CHAPTER SEVEN

43. E. van Even, *Louvain monumental*, Louvain, 1860, p. 206; *idem*, *L'ancienne École de peinture de Louvain*, Brussels and Louvain, 1870, pp. 144-53.

44. The accounts were published by Schaeys in *Bulletin de l'Académie de Belgique*, XIII, 1846, I, p. 341.

45. M.J. Friedländer, *Alt-Niederländische Malerei*, III, Berlin, 1934, p. 16.

46. G. Hulin de Loo, in *Mélanges Henri Pirenne*, Brussels, 1926, I, pp. 257 *et seq.*

47. A view of the Hague has been identified in *The Apparition of the Sibyl to Emperor Augustus* (Victor de Stuers in *Oud-Holland*, XXV, 1907, p. 27). From this it has been deduced that the artist must have been Dutch. W.R. Valentier says that it could be by Aelbrecht van Ouwaeter in *The Art Quarterly*, Spring, 1943.

48. See Marguerite Wéra's excellent '*Contribution à l'étude d'Albert Bouts*', in *Revue Belge d'Archéologie et d'Histoire de l'Art*, XX, 1951, pp. 139 *et seq.*

CHAPTER EIGHT

49. E. de Busscher attributes this mural on the evidence of forged documents produced by Théodore Schellinx, but for fifty years believed to be authentic. See Victor van der Haegen, *Mémoire sur des Documents faux*, Brussels, 1899, p. 134.

50. *Itinerarium sive peregrinatio excellentissimi viri artium ac utriusque medecinae doctoris Hieronymi Monetarii de Feltkerchen, cives Nurembergensis*, from a copy of the travel diary made by Münzer's friend, Hartmann Schedel. The MS is no. 431 in the Munich library, and published by E. P. Goldschmidt in *Humanisme et Renaissance*, 1939, VI, fasc. 1-4, partially republished by Paule Ciselet and Marie Delcourt, *Monetarius, Voyage aux Pays-Bas 1495*, Brussels, 1942. Münzer's text is as follows: '*Quidam alius magnus pictor supervenit volens imitari in sio opere hanc picturam et factus melancolicus et insipiens.*'

51. In the text concerning the estate of Dieric Bouts (1479-80): 'For this it has been paid to his children, in the opinion and valuation of one of the most famous artists able to be found in the surrounding country, and who was born in Ghent and now lives at Roode Kloster in the forest of Soignes, the sum of florins thus: IIVJ gul. XXXVJ pl.'. The original text is in *Bulletin de l'Académie Royale de Belgique*, XIII, 1861, p. 343.

52. Ghent municipal archives, *Registre scabinal* fº 131. Act of 5 May 1467 published by Van der Haegen, *Mémoire sur des Documents faux*, Brussels, 1899, p. 56.

53. *ibid.*

54. Original text in *Bulletin de l'Académie Royale de Belgique*, XIII, 1861, p. 343.

55. G. Ofhuys, *Originale Cenobii Rubevallis in Zonia prope Bruxellam in Brabantia*. Bibliothèque Royale, Brussels; MS published by A. Wauters in *Bulletin de l'Académie Royale de Belgique*, II, 1863, pp. 723-43.

56. The faces have been restored and have been largely retouched with tiny grey strokes.

57. Vespasiano da Bisticci, *Opere*, ed. Bartoli, Bologna, 1892, I, p. 295.

58. When it was discovered, this picture formed the top of a table. It was bought by the English firm of Woodburn in 1845, and then sold to the Prince Consort.

59. I have verified in the Blumenthal Collection, New York, that the picture has not been transferred to canvas, as one leading authority had maintained.

60. It comes from the chapel of the Dukes of Frias at Medina de Pomar, near Burgos.

61. The text appears in the accounts of the town for 1467-8, but indulgences might be obtained as of Advent 1467.

CHAPTER NINE

62. See Leo van Puyvelde, *Schilderkunst en Toneelvertooningen op het einde van Middeleeuwen*, Ghent, 1912, pp. 210 *et seq.*
63. *The Burlington Magazine*, 1928, I, p. 160.
64. Sir John Donne of Kidwelly appears in the picture as donor, and may be identified by his coat-of-arms, which is on one of the capitals. Two limits may be fixed for the dating. Sir John wears the insignia of the order of Edward IV, instituted in 1461, and then he was killed at the Battle of Edgecote on 26 July 1469. Possibly Memlinc went with Louis Gruuthuuse to England when the latter was negociating the marriage between Charles le Téméraire and Margaret of York. But it more likely that Sir John went as part of the large retinue which accompanied the princess to Flanders for her marriage ceremony in 1468, and that he commissioned the work then from Memlinc. This would explain the presence of Lady Donne and the eldest daughter in the painting, and the absence of the two sons who were quite young.
65. C. van den Haute, *La Corporation des Peintres de Bruges*, Bruges, no date, pp. 28 and 35.
66. A. Pinchart, in *Messager des Sciences Historiques*, Ghent, 1858, p. 156.
67. Philippe de Comines, *Mémoires*, ed. Dupont, Paris, 1840-7, I, p. 19.

CHAPTER TEN

68. W.H. J. Weale, *Le Beffroi*, II, 1864, p. 289.
69. *ibid.* p. 234.
70. The picture is not *The Marriage of St Catherine*. This incident is only included to make a link between one of the three saints and the central group. Martin Davies, in the catalogue of the National Gallery, London, thinks that the donor is Richardus de Capella. I prefer James Weale's opinion.

CHAPTER ELEVEN

71. The names are as they appear in J. Bertaud, *Encomium Triarum Marianum*. Paris, Jod. Badius, Ascensius and Galliot du Pré, 1529.
72. See F. J. van der Branden, *Geschiedenis der Antwerpsche Schilderschool*, Antwerp, 1883, I, p. 62.
73. I am ignoring the usual title – *The Banker*. The man is drawing up a list of the jewels spread out on the table. It is possibly the same picture as that which was listed amongst the works in Rubens' house as no. 186: '*un pourtrait de marchand de joyaux de maistre Quintin*' (' a portrait of a merchant of precious stones by master Quintin'). Possibly it is also the same picture as that mentioned as being by Metsys under the title of *Het Juwelierken* ('the little jeweller') in the inventory of the pictures in the house of Diego Duarte at Antwerp in 1682 (*Vlaamsche School*, 1847, p. 88).
74. *The Virgin lamenting the Death of Christ* has been lost since it was mentioned by C. Justi as being in the collection of M. de Fidéi, engineer and friend of King Ferdinand of Portugal.
75. The artist has used the same head in *Christ among the Doctors* and in *The Courtesan and the Old Man*.
76. Leonardo's drawing was engraved by Hollar (Parthey no. 1567). There is another Hollar engraving in which a similar woman is shown next to a man, and on which he wrote '*Rex et Regina de Tunis*' (Parthey no. 1603).
77. Although it has been maintained that it is the work mentioned in the inventory of Margaret of Austria of 1516 as: '*ung aultre tableau d'ung homme et une femme qui est fait d'une bonne main et est bien vieul : l'homme tient une tasse et la femme une fleur*' ('another picture of a man and a woman, painted by a good hand and very old : the man holds a cup and the woman a flower') – the fact is by no means certain. In 1516 the picture was scarcely very old.
78. I cannot accept that *The Virgin with the Cherries* in the Faust Collection, St Louis, is by this artist. The work is of Milanese inspiration.

THE LOW COUNTRIES
in the fifteenth century

North Sea

Haarlem
Amsterdam
The Hague
Utrecht
Rotterdam

R. Maas
R. Rhine

Bois - le - duc ('s Hertogenbosch)

Bruges
Antwerp
Ghent
R. Schelde
Maaseik
Alken
Malines
Diest
Louvain
Maastricht
Cologne
Ypres
Brussels
Liège
Lille
Tournai
Tirlemont
Mons
Arras
Valenciennes
R. Meuse
Cambrai

THE EMPIRE

Frankfurt

Amiens

R. Moselle

Rouen

R. Seine
Caen
Paris

KINGDOM OF FRANCE

R. Loing

R. Loire

Dijon
Bourges
Autun
Beaune
L. de Neuchatel
SWISS
CONFEDERATION

Moulins

R. Saône
L. Geneva

Lyons
R. Rhône

PROVINCES OF THE HOUSE OF BURGUNDY
in the fifteenth century

North Sea

COUNTY

OF

HOLLAND

THE EMPIRE

R. Swin

FLANDERS

BRABANT

MALINES

LIMBURG

Cologne

ARTOIS

Brussels

Liège

R. Rhine

PICARDY

HAINAUT

R. Meuse

DUCHY OF LUXEMBURG

R. Seine

R. Moselle

Paris

KINGDOM OF FRANCE

253

TABLE OF ARTISTS

I. COLOUR ILLUSTRATIONS

II. BLACK AND WHITE ILLUSTRATIONS

INDEX

261